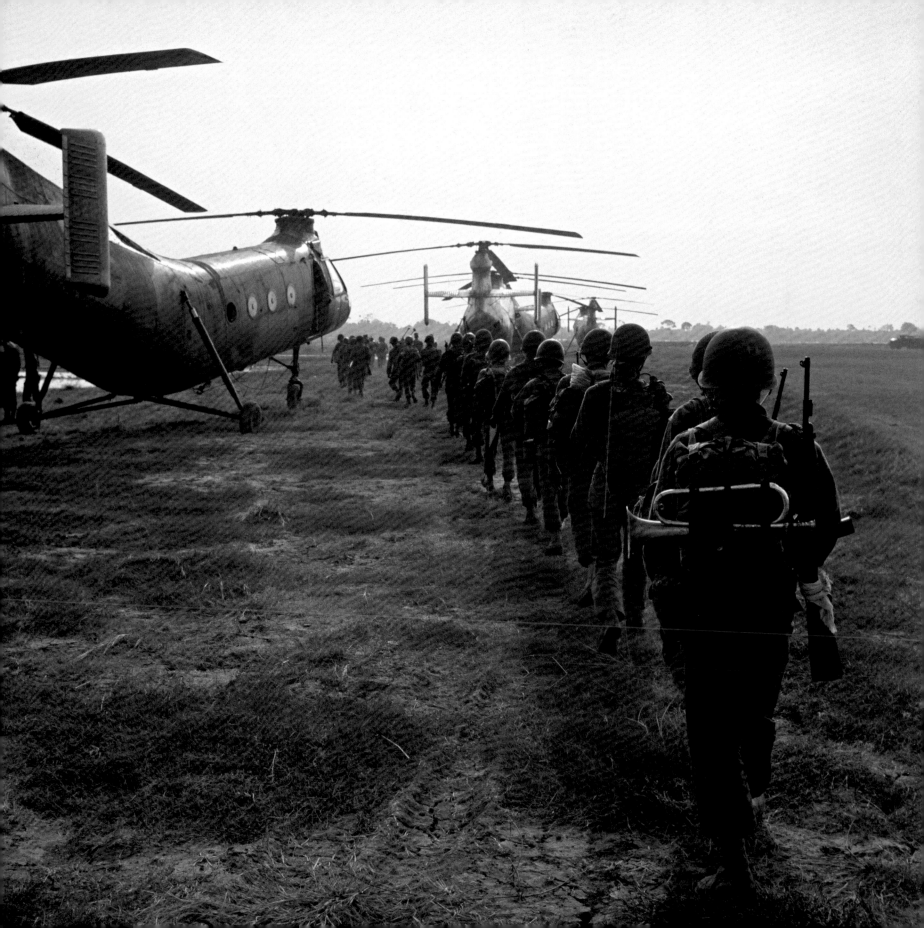

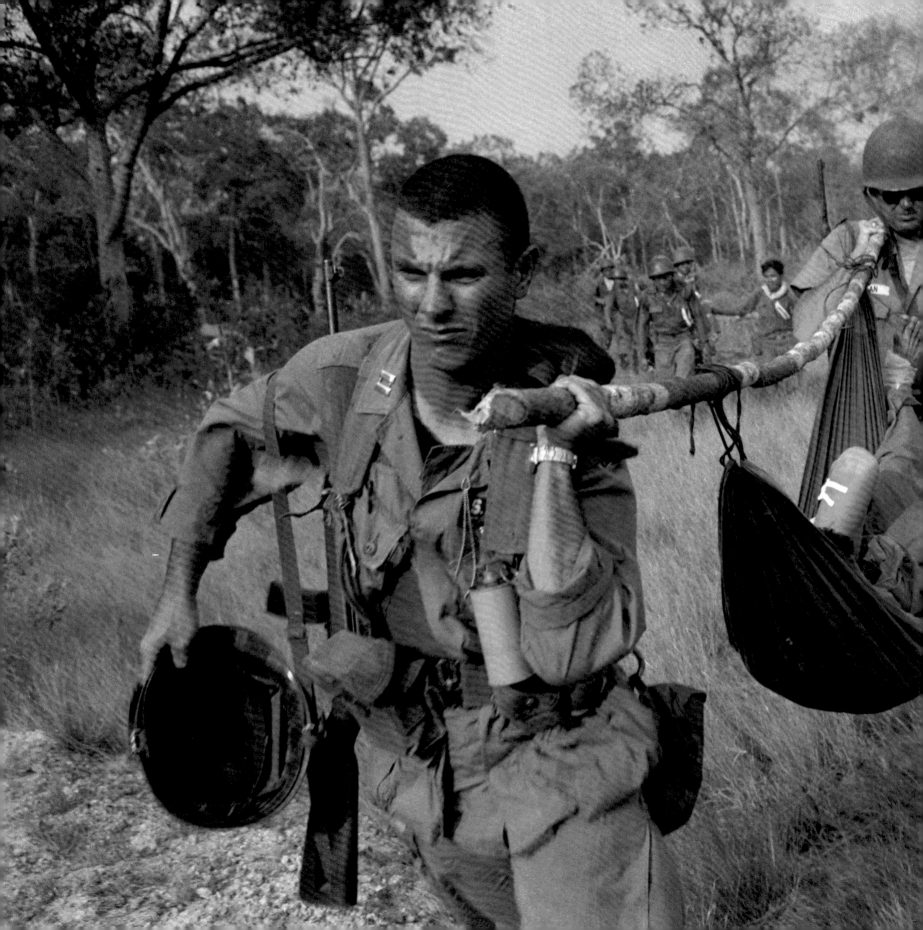

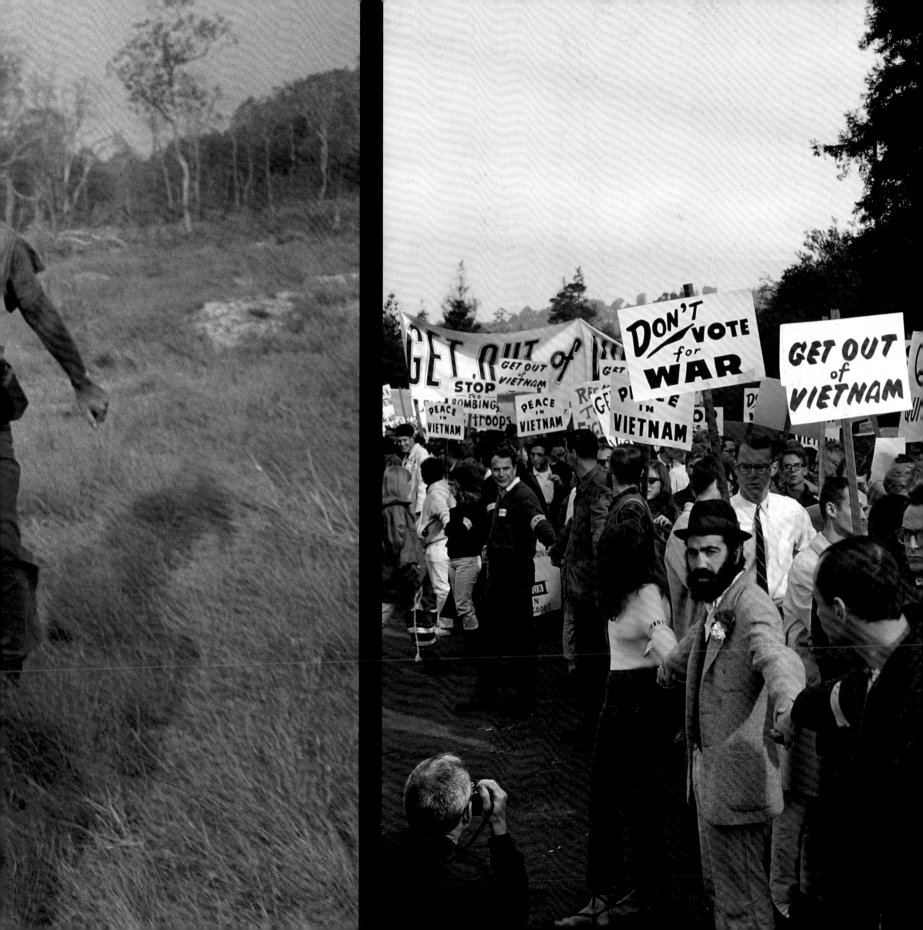

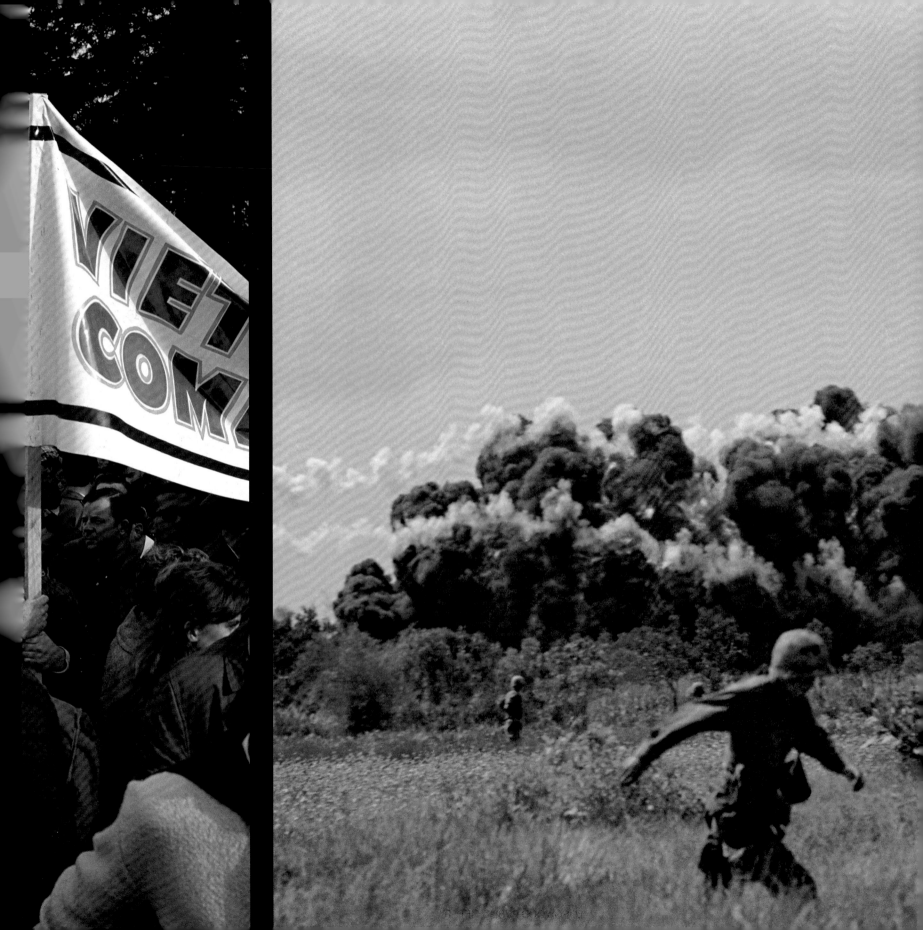

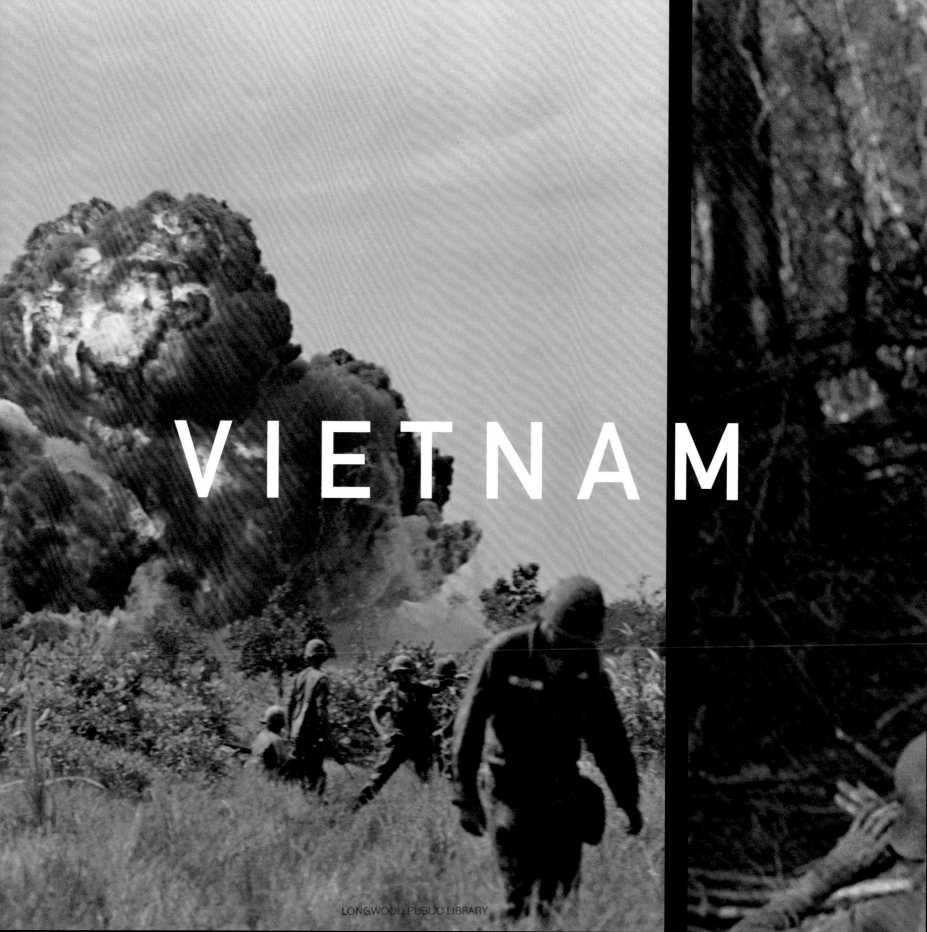

VIETNAM

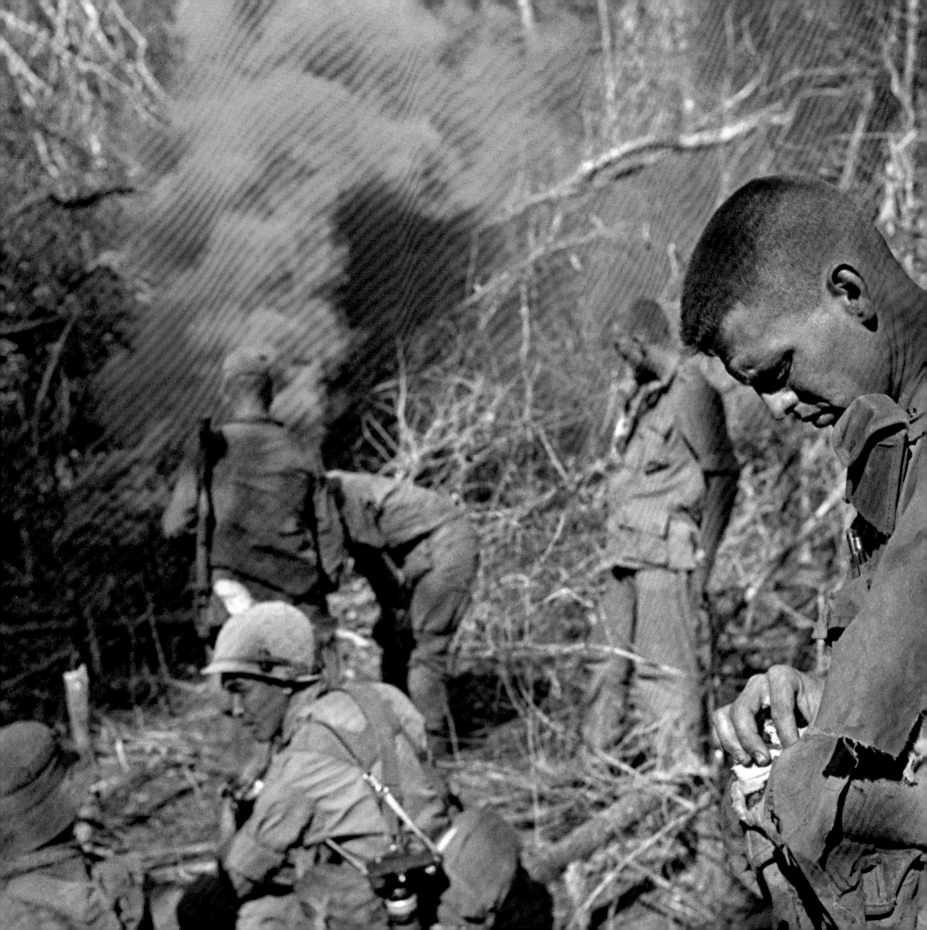

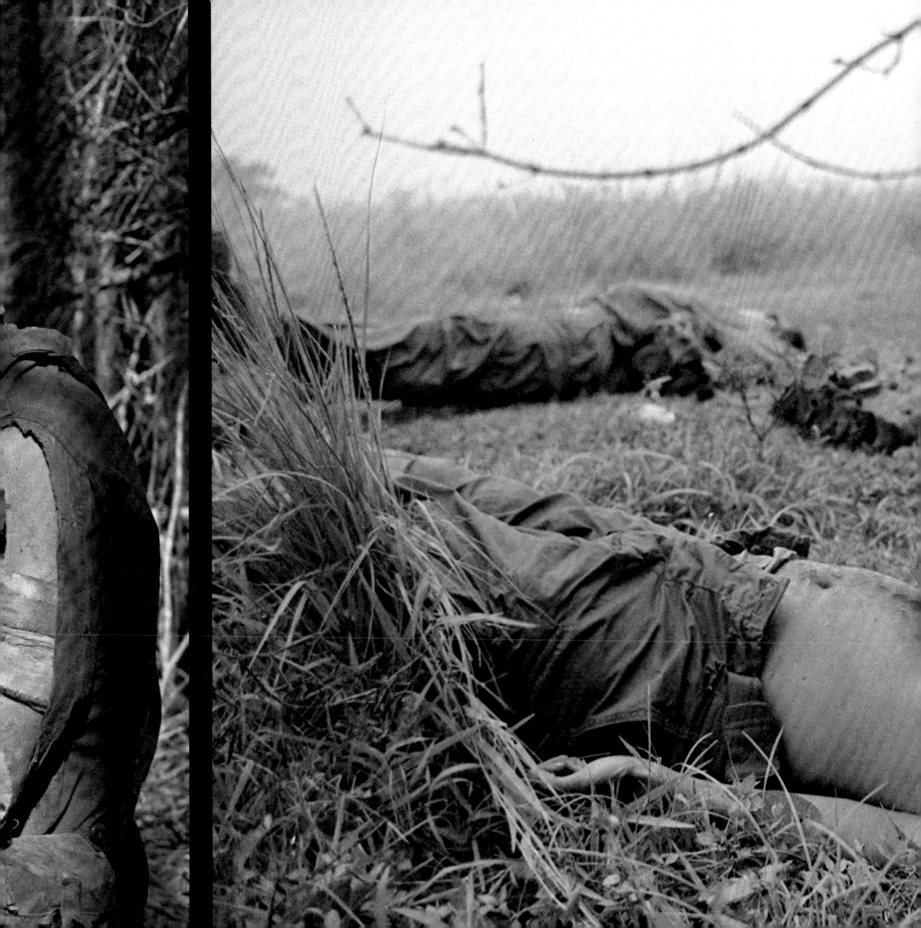

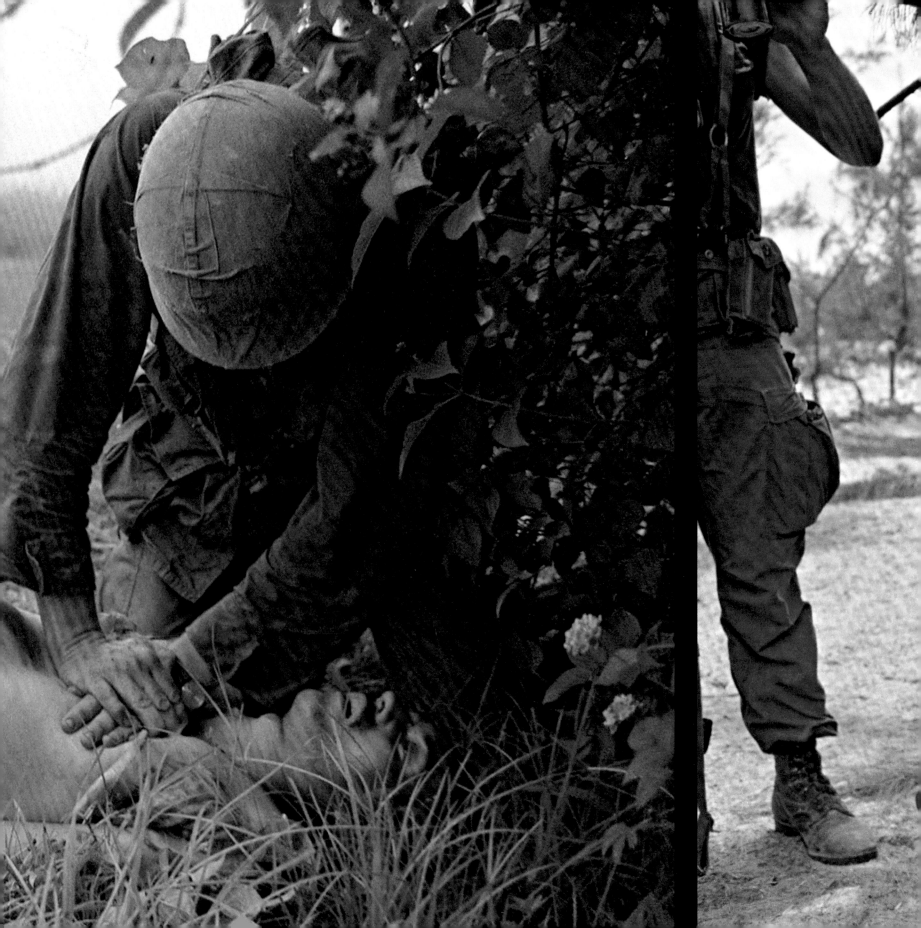

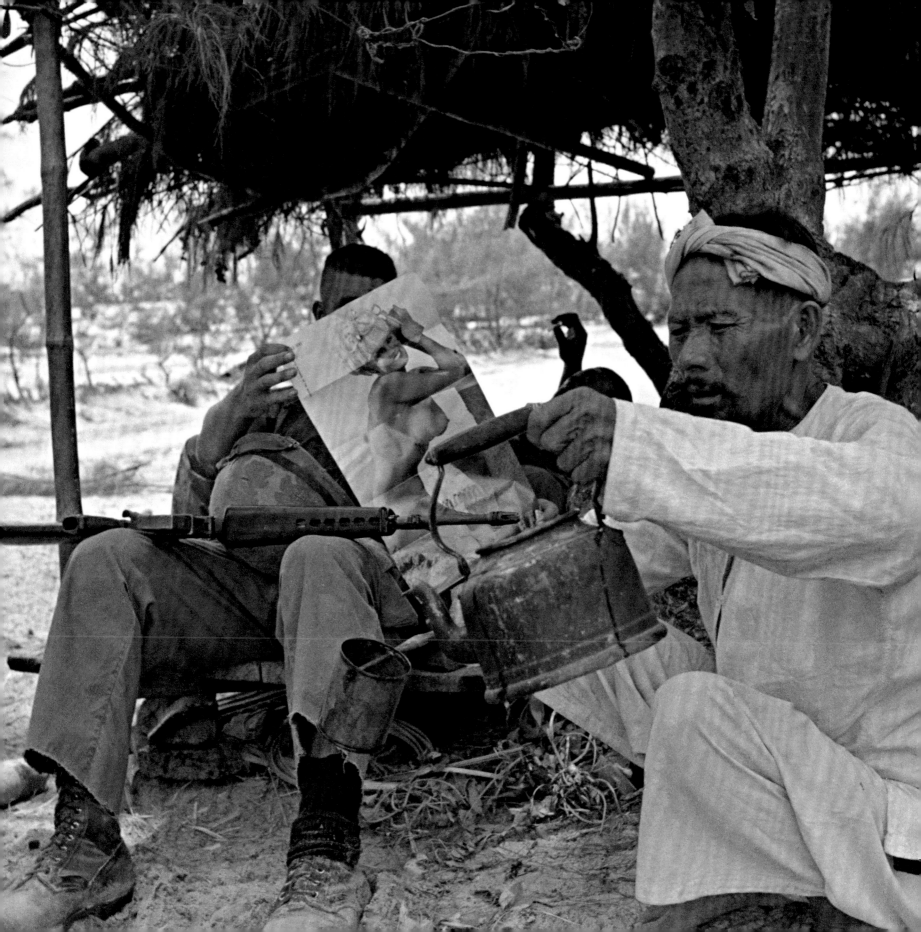

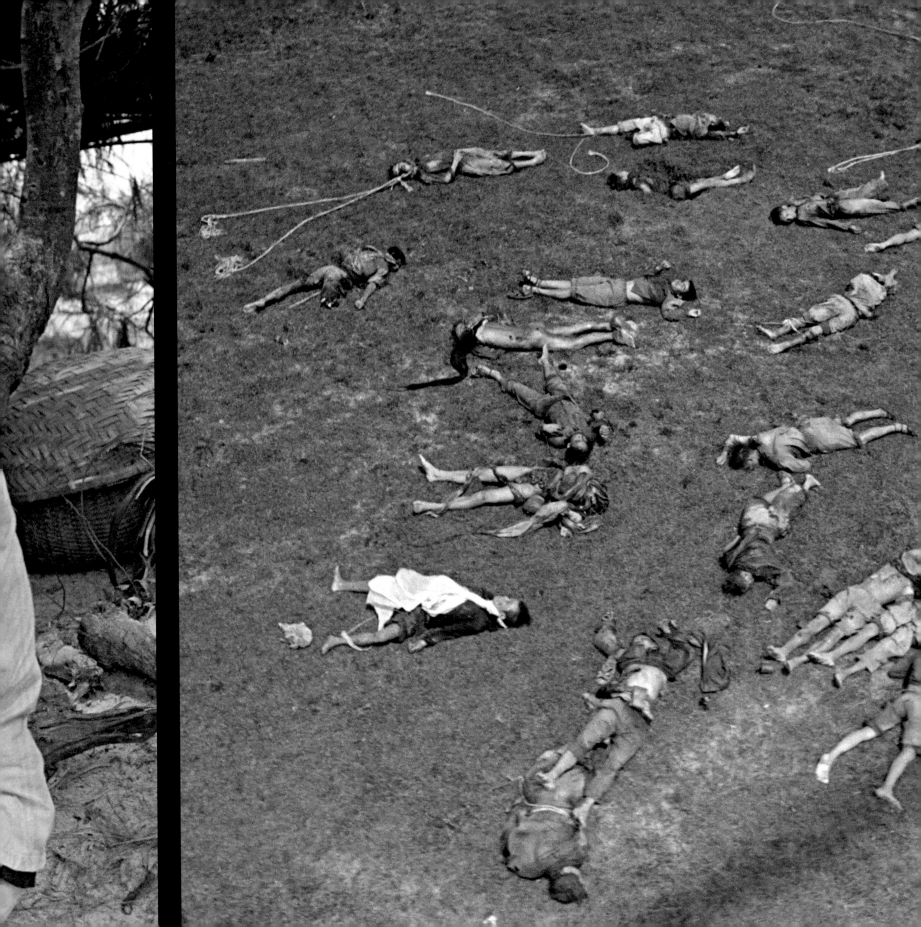

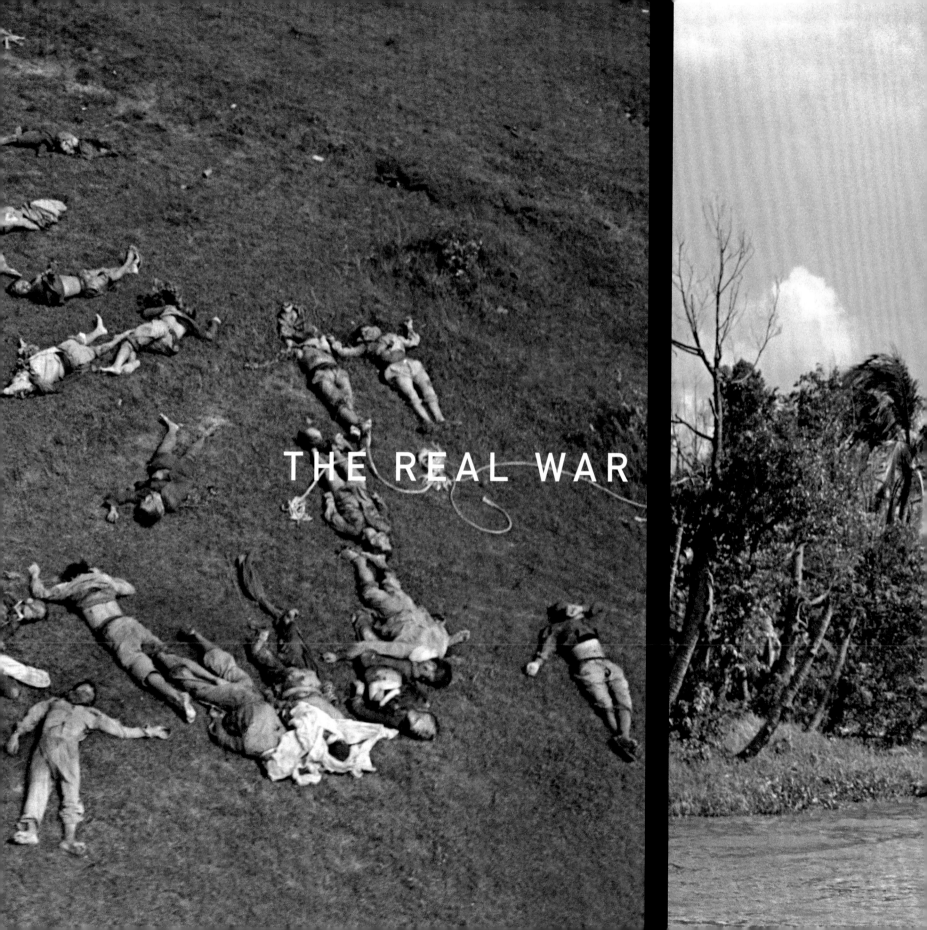

THE REAL WAR

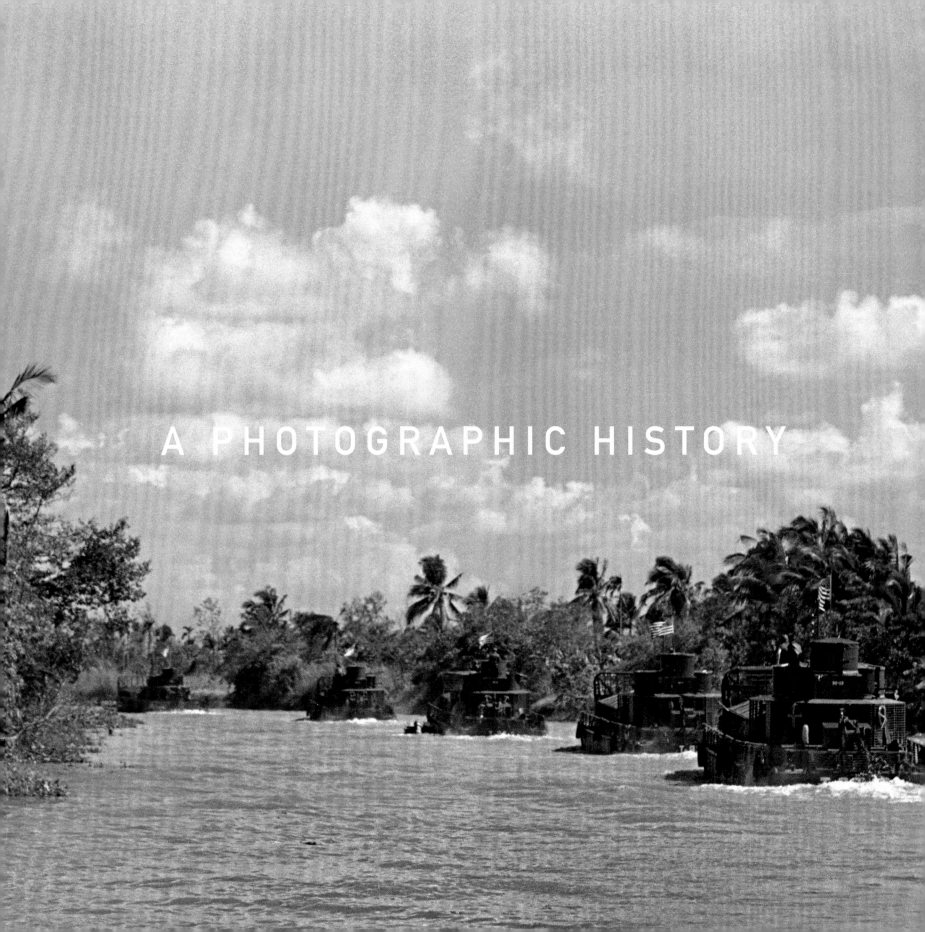

A PHOTOGRAPHIC HISTORY

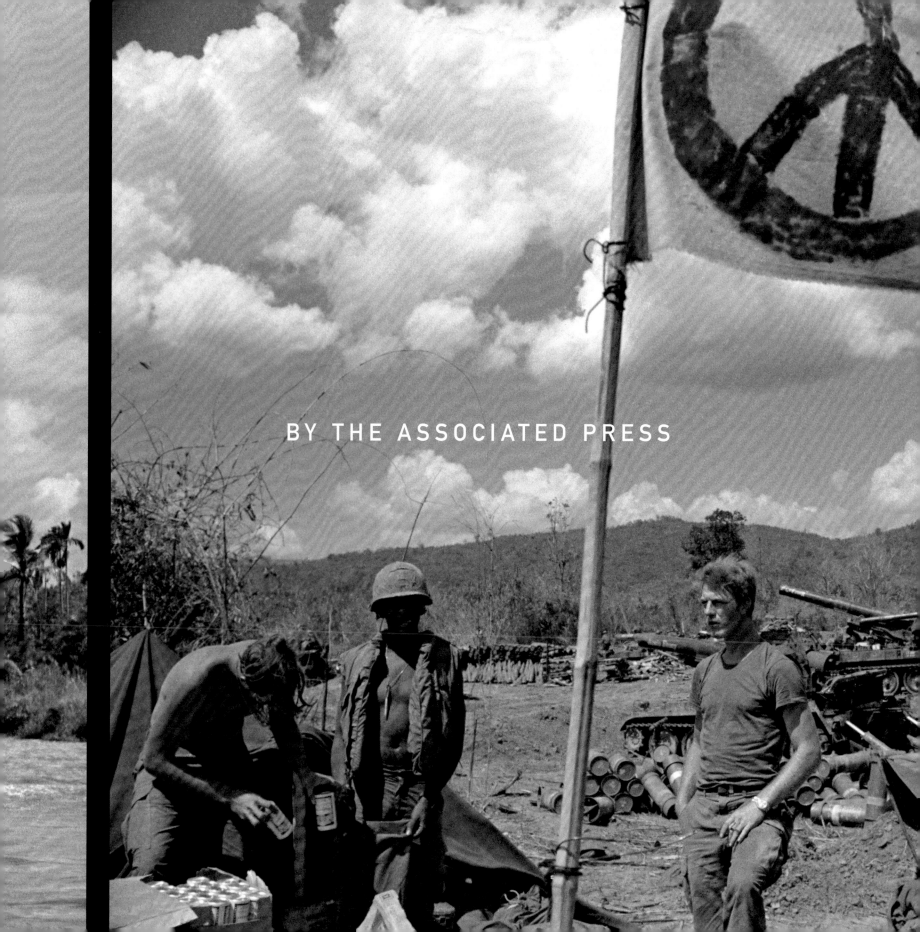

BY THE ASSOCIATED PRESS

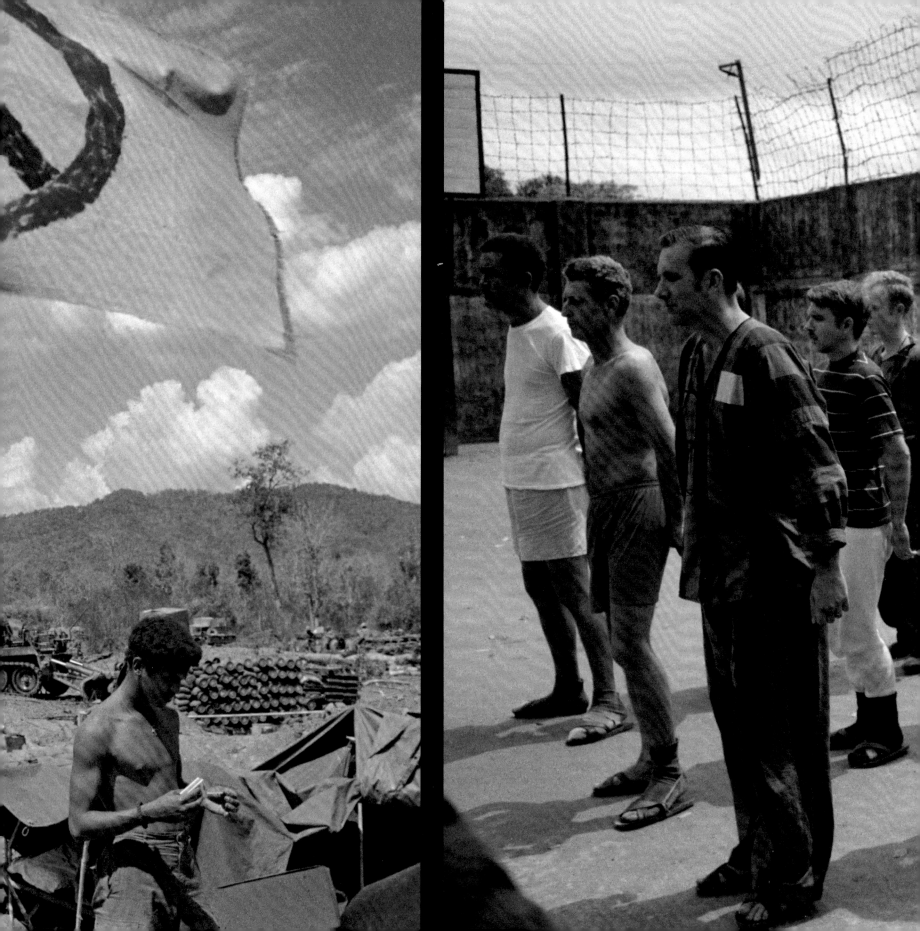

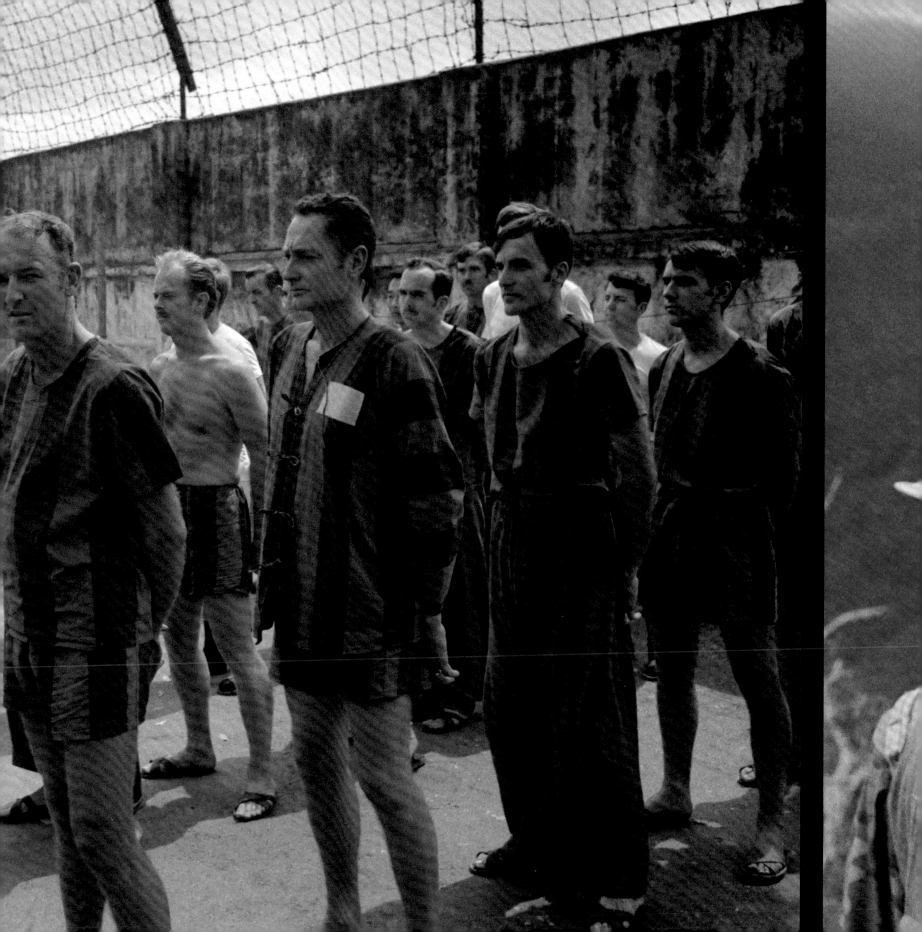

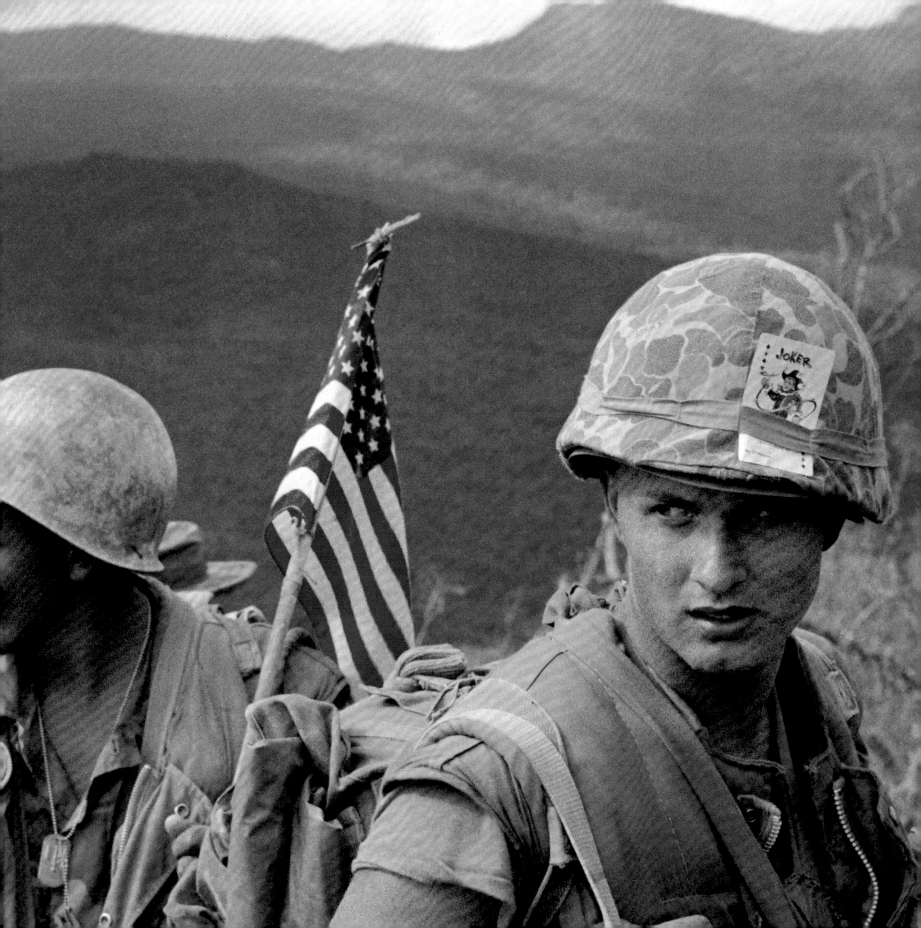

VIETNAM

THE REAL WAR

A PHOTOGRAPHIC HISTORY BY THE ASSOCIATED PRESS

INTRODUCTION BY PETE HAMILL

ABRAMS, NEW YORK

CONTENTS

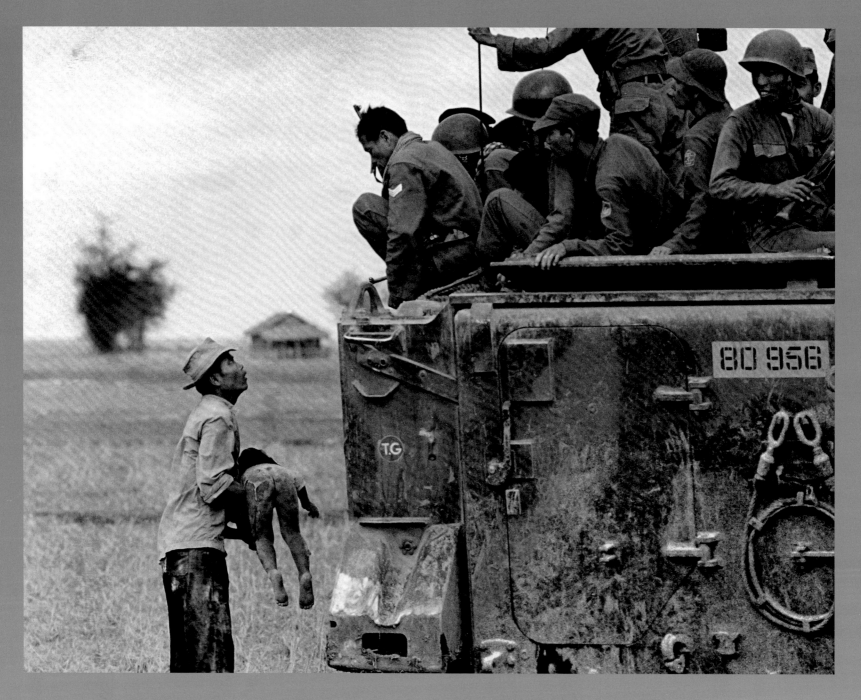

A distraught father holds the body of his child as South Vietnamese Rangers look down from their armored vehicle. March 19, 1964.

The child was killed as government forces pursued guerrillas into a village near the Cambodian border.

From the portfolio by photographer Horst Faas that received the 1965 Pulitzer Prize for Photography.

INTRODUCTION

I. THAT WAS IN ANOTHER COUNTRY

"Yo lo vi" [I saw this].
> *—Francisco Goya.* The Disasters of War, *plate 44 (c. 1810)*

Years later, after the war was long over, the great war correspondent Peter Arnett was asked two questions. He had arrived in Vietnam as a reporter for the Associated Press when he was twenty-seven and stayed on for thirteen years. Did he have a single enduring image of the war? And did it ever enter his dreams?

"Without a doubt," he answered, "Horst Faas's 1964 photograph of a dispirited Vietnamese farmer, standing beside a stationary armored personnel carrier, his outstretched arms holding his dead child up towards an indifferent group of South Vietnamese soldiers riding the vehicle (opposite). Napalm bombing had been used that day against several Mekong Delta villages thought to harbor Viet Cong. The child had been caught in the fiery blasts; large patches of its burned skin curled loosely off its body. Horst took several other similar photographs before the soldiers drove off without offering any assistance to that and other victims." [1]

And the dreams?

"When I do . . . I dream of that despairing father and his child and the wasted lives they represent."

Arnett is not alone. At the midnight hour, many others still dream of Vietnam. The dead, of course, do not dream.

In my own memory, it is January 1966 and I'm in the rooftop bar of the Caravelle Hotel on Lam Son Square in Saigon, watching distant flashes of artillery. I'm with John Harris of the Hearst papers, a generous older guy who is one of my many guides to the war. We're smoking cigarettes, drinking 33-brand beer. The far-off flashes have an odd beauty.

"As long as they are aimed out," Harris says, with a chuckle, "and not in, we're okay."

The bar is packed, the air gray with nicotine fog. Many of us are new arrivals, sent by newspapers and magazines to cover a war that only entered the American consciousness with the battle of the Ia Drang Valley the previous November. That bloody encounter with North Vietnamese forces told editors and others that the American part of the conflict was no longer about isolated casualties among "advisers." When it was over, more than 200 American soldiers were dead. Several hundred were wounded. Most were draftees in a time when a private first class earned $99.37 a month. Before the war ended in 1975, the American dead would total 58,220,[2] along with more than 500 Australians and about 5,000 South Koreans. The Vietnamese dead have been estimated at 3 million. Nobody will ever be sure.

The enemy at the time was the Viet Cong, called "Charlie" by most, or "Mr. Charles" by those who had witnessed their abilities in battle. They were, of course, presumed to be fighting for the Communist cause in that era when the Soviet Union still existed, the hard Communism of Mao Tse-tung (Mao Zedong) ruled neighboring China, and above all, Ho Chi Minh presided over a Communist regime in North Vietnam. Most of the experienced correspondents in Saigon doubted that many Viet Cong hidden in their jungle spider holes were debating the Marxist theory of surplus value. Nationalism was a much more powerful motivator. They definitely wanted to get the foreigners the hell out of their country.

In the smoky Caravelle bar, a mash of theories, rumors, gossip, and hard facts were the currency of most Saigon evenings. Along with women, of course, among the loose male customers, or tips on the best black market stall for turning dollars into piastres, or the names of good translators (for almost nobody could speak Vietnamese). Most talk was also spiced by the dark humor that is rooted in fatalism. In those bars and restaurants in Saigon, I never saw Peter Arnett or Horst Faas or Eddie Adams. They were somewhere else. Covering the war, with little time to talk about it.

But at the Caravelle on those evenings, friendly correspondents whispered that a major operation was planned near Da Nang. Someone had heard that President Johnson was ordering another twenty thousand troops into 'Nam. Soon. Not yet confirmed. But believable, because escalation of the American presence was in the air. Just pulling out was not. Among some, you could feel the pumping of war-zone adrenaline. Normalcy was another world, where you went shopping with your wife, or attended PTA meetings, or took the kids to movies on Saturday afternoons. This was Saigon. The energy of the night obviously resembled the rush often felt by combat soldiers. Those young human beings called grunts.

If you might die tomorrow, you told yourself, use every goddamned minute of today. Or tonight. Say yes to that woman in the pale blue *ao dai*, the one with the perfect features, the cool face, the welcoming eyes. Listen to her whisper about Saigon Tea. Hell, try the opium pipe she brings to the room. After all, even here in the Caravelle, we were all vulnerable. Just a few months earlier, a bomb had caused great damage on the fifth floor. On the streets of Saigon, young men driving mopeds were slashing at any strolling American civilians on the sidewalks and then escaping into alleys. They were hard to capture. After all, it was their city. Some of the slashers had grown up in those alleys. In such a place, life itself was a lottery.

Across Lam Son Square was the Continental Palace Hotel, with chairs and tables spread across a wide outdoor terrace. Safe from grenades or claymores, said the gossip, because of payoffs by the Corsican owner to the Viet Cong. Or perhaps because it housed the Polish delegates to the International Control Commission, established to monitor the armistice arranged in Geneva after the French defeat in 1954. Like the Caravelle, a place to exchange information, sip booze, laugh in the evening air.

More than a decade earlier, the writer Graham Greene, during four trips to Vietnam in the time of the French War, had sat on that terrace making notes for his 1955 novel, *The Quiet American*. Like other reporters, in that time when the literature of Vietnam was sparse, I had carried Greene's novel with me from New York. Greene loved Vietnam, for its beauty, eroticism, complexity, and danger—and,

according to his biographer, Norman Sherry, loved his frequent opium pipes too.

In Greene's time, Tu Do Street (Freedom Street) was still called the rue Catinat, full of boutiques and restaurants, cafés, bookstores, and seduction. The French colonial style was a blend of irony and cynicism. They had taken over Indochina in the mid-nineteenth century, proclaiming it their duty to protect French Catholic missionaries in their civilizing project. Naturally, they also celebrated sin, but never on the record. Now it was the turn of the Americans, whose initial claims to moral (and military) exceptionalism were devoid of irony or cynicism. Driven by some blurry combination of Cold War paranoia, democratic idealism, and naïveté, they were now pouring troops and treasure into South Vietnam to defend it against the evil Communists from the North. One theme of Greene's prophetic novel was that innocence could end up killing many people. The American of the novel's title was, of course, an innocent.

Among the young correspondents in Saigon, there was very little mention of the French, but there were remnants of the French era in many places. More than a few buildings bore traces of the Art Nouveau style imported from Paris. There was a cathedral called Notre Dame. There were French books in the bookstores. Older Vietnamese civilian and military bureaucrats (including many post-1954 migrants from North Vietnam) conversed easily in French, clumsily in English.

And there were other traces of the past, even along Tu Do Street. One night I was dining in a crowded Saigon restaurant with two other correspondents. We could hear music from the muted sound system. I heard Eartha Kitt singing "C'est Si Bon" in a mixture of English and French, and we chuckled. A group of four Caucasian men, all in their forties, were dining at a large corner table with four younger Vietnamese women. The men laughed at the song that made us chuckle. Then, as our food arrived, I could hear Edith Piaf.

She was singing one of her great hits. "No Regrets." In English.

No! I will have no regrets

All the things that went wrong –

And then one of the men stood up, his face serious now, and began to sing with Piaf, but in French.

Non, rien de rien

Non, je ne regrette rien . . .

And the others stood, raised wine glasses, and joined the singing, and around the restaurant, here and there, more men stopped dining and began singing with them. No, they had no regrets. The tone was defiant. The rough male voices overpowered the subtle voice of the woman known as the Little Sparrow. Some of the men had tears in their eyes. The Vietnamese women did not sing. The men had obviously seen *Casablanca* when they were younger. With subtitles. And here they were, twelve years after Dien Bien Phu. With no regrets. None of us there could yet imagine the things that were coming in the nine long years ahead of us. None of us, that is, except possibly those Vietnamese women.

A few weeks later, near Da Nang, I was moving through jungle with a patrol of Marines. There was no shooting. We found ourselves at a small cemetery, dark from the shadows of tall trees. Most of the modest tombstones were leaning at angles, mossy from time and weather, looking oddly forlorn. One was flat on its back. All the names were French. The carved dates told us that most had died young. The place was a kind of monument to delusion, lost and forgotten, and a suggestion of what was lying up ahead. In my head, I could hear Piaf, in English.

II. THE HEART OF THE MATTER

None of these often subtle levels of the Vietnam story mattered much to most editors in the United States. They wanted bang-bang. That is, stories about combat, with all its violence, heroism, and sacrifice. "We" were always the good guys. The other side was always bad. If generals too often fought the last war, reporters and photographers were expected to do the same. It didn't take them long

to learn that Vietnam was different. As more and more reporters arrived in Saigon—some passing through (like me), some to remain for years—they learned the basics of covering this war, while staying alive to file the reports. Not easy in a war that had no front, as Korea did, as World Wars I and II did. Sometimes the action in Vietnam was a few blocks away. Sometimes it required a trip through morning darkness to catch a military flight from Tan Son Nhut Air Base to a place of raging or imminent battles. Where they discovered that the action was thirty miles in another direction.

If the reporters and photographers had credentials, and there was room, they were usually made welcome on a U.S. military airplane or helicopter. The rest depended upon chance or luck. Sometimes, of course, the luck was bad. Human beings die in wars. Press cards are not bulletproof. But there was no censorship, and for the first time in American history, and almost certainly the last, the thing that mattered most was the truth. The elusive, frustrating truth.

As a media story, most reporters agreed then (and now) that the Associated Press owned Vietnam. Before the war was over, AP journalists would win six Pulitzer Prizes, journalism's highest honor. Four would be for photographs displayed in this book, two for the war reporting of Peter Arnett and Malcolm Browne.

The AP had more reporters, photographers, stringers, and translators than any other news organization in Vietnam. The reporters adhered to traditional hard-news standards of objectivity, including the part of the Vietnam story that was political (and even religious). They supplied the Who, the What, the Where, the When, and they also wrote analytical pieces that provided the Why. But as the war grew more brutal and the casualties mounted, the best journalists found themselves increasingly assailed for their reporting. An angry political struggle began to rage in the United States, and part of the anger from the right was directed against the media, including the relatively new medium of television. That tactic was familiar, of course. If in doubt, blame the messenger. But the messengers were out there in the mud and blood of the Iron Triangle, the Mekong Delta, Pleiku and Khe Sanh and Bong Son, and hundreds of other places now forgotten. Their critics slept at home.

Malcolm Browne (center) with fellow reporters David Halberstam of the *New York Times* (left) and Neil Sheehan of United Press International, ca. 1964.

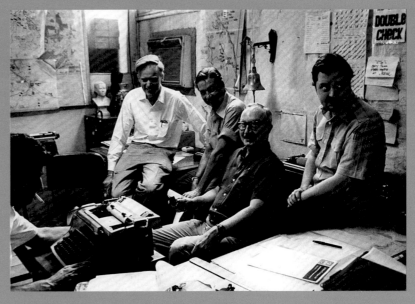

Five past, present, and future Saigon bureau chiefs in the AP office, April 28, 1972. From left, at typewriter, George Esper (1973–75); Malcolm Browne (1961–65); George McArthur (1968–69); Edwin Q. White (1965–67); and Richard Pyle (1970–73). The first four all would die within a fourteen-month period in 2012–13, leaving Pyle as the only survivor.

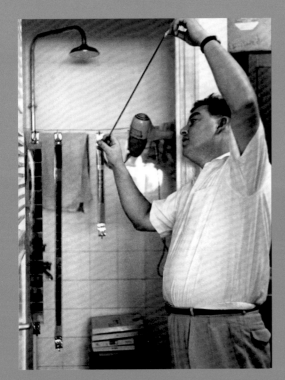

Horst Faas examining film in the bathroom darkroom of the cramped AP bureau on rue Pasteur, ca. 1963–64.

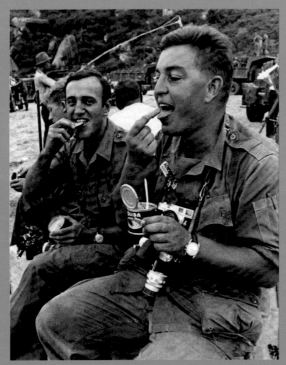

Peter Arnett (left) and Horst Faas, dining on C-rations (date unknown).

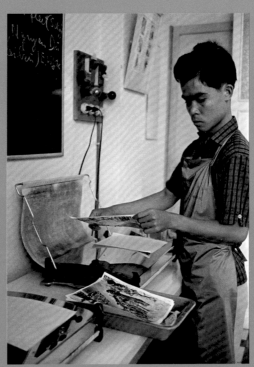

Nick Ut in the darkroom of the AP bureau in the Eden Building, ca. 1966. The AP moved there in May 1965.

The commitment of the AP reporters was to the truth of the war itself. None of them was an ideologue. Like most journalists, with words or pictures, they had learned young that ideology is not thinking; it's a substitute for thinking. The photographers, in particular, were committed to capturing what the great Henri Cartier-Bresson had called "the decisive moment." The image that overwhelmed thousands of words, above all the words of flacks. Across the years of the war in Vietnam, the AP photographers saw more combat than any general. This book shows how good they were. As a young reporter, I had learned much from photographers about how to see, not merely look. From Vietnam, photographers taught the world how to see the war. Say the word "Vietnam" today to most people of a certain age; the image that rises is usually a photograph. An AP photograph.

And they had another function that was perhaps even more important: They were the verifiers. As the war became more intense, more violent, with more and more young people coming home in body bags, the domestic debate about Vietnam got nastier. The photographs were a way of showing truths beyond any reasonable doubt.

In Vietnam, the AP also had institutional memory. The first AP bureau was established in Saigon in 1950, a one-man affair in the hands of a fine young reporter named Seymour Topping. After his Army discharge in the Philippines in early 1946, he had covered the triumph of Mao's Communist armies in China for more than three years, first as a $50-a-month stringer for International News Service, then as a staffer. He switched to the AP in 1948 and stayed to the end of that long, bloody civil war the following year. Back home on leave, Topping got married, then was assigned to Hong Kong. He was waiting in Hong Kong for military permission to cover some of the final Communist mop-ups in China when a message arrived from New York.

"I received a cable from the foreign desk asking me to go down to Saigon, Indonesia," he remembered years later.[3] "I wasn't quite sure where Saigon was, but I knew that Saigon was not in Indonesia."

Within days, he and his new wife, Audrey, were aboard a "rickety"

French airplane, heading for Saigon, in Indochina. French Indochina. They checked into the Continental.

"And as we were unpacking our clothes," Topping remembered, "there was an enormous explosion. We rushed to a window and there was a café opposite and we looked out. A cyclo (wheeled rickshaw) driver had obviously thrown a bomb. All the rickshaw drivers were scattering in all directions. The bar was blown up and there were bodies of French soldiers and sailors lying all over the inside of the bar and on the sidewalk outside. One staggered out, holding his gut while we watched. That was our introduction to Vietnam."

Topping soon discovered a "hidden war." Surprise attacks by the guerrillas, savage French reprisals, very little reporting. There were no other American correspondents in Saigon, no British either. Topping worked briefly with AP reporters Kenneth Lykes and Larry Allen. His primary colleague was French stringer Max Clos, who filed to Paris, where his dispatches were translated into English and sent out. Topping and his wife found a small apartment at 90, boulevard Charner and set up the first AP bureau in a small alcove. He originally thought he would be in Vietnam for a month. He stayed for two years. While the Toppings' first child, Susan, was being born in a Saigon hospital, the French doctor who delivered the infant was spattered with the blood of French soldiers, wounded in a nearby firefight. The soundtrack was a mixture of heavy explosions and small arms fire. It did not take Topping long to realize that the French cause was almost surely doomed.

In those days, Topping had little opportunity to use a camera while making notes on the actions he witnessed. The great old Speed Graphic was too large and clumsy in a land of jungles, marshes, rice paddies, and swamps. The Rolleiflex required the photographer to look down into the viewfinder, not good for your health when there was danger on all sides. By the early 1960s, the 35mm camera was in general use: the Leica, the Nikon, the Canon. Or cheaper imitations. And by then, even the reporters were being asked to carry cameras.

One of the first was a tall, laconic young man named Malcolm Browne.

Born in New York City in 1931, Browne attended a Quaker school in Manhattan for twelve years and then Swarthmore, where he studied chemistry. He worked in a lab for about five years after graduation, and in 1956 he was drafted. He was trained by the Army in tank warfare and was then sent to South Korea. His young wife—like all other wives of soldiers in South Korea—was not allowed to join him. The shooting war had stopped with a truce in 1953, but there was no peace. There were still incidents along the Demilitarized Zone (DMZ) that separated North and South Korea. Shots were fired. People got hurt. Too dangerous for wives.

After a long voyage across the northern Pacific, Browne landed in the port of Inchon, then was taken north to his deployment at a base along the DMZ. On his first day there, he wandered into a PIO (Public Information Office) tent and fell into conversation with a private from New York, who told him that there was an opening on the PIO staff, starting the next day. The job was his, he was told, if he wanted it. Browne considered it for about a minute. He soon moved into a bunk in the back of the PIO.

"On that day," he later wrote, "I became a journalist." [4]

He learned the raw fundamentals in the Army job, wrote mostly "cheerleading" puff pieces for the mimeographed base paper, and contributed to the more professional Pacific edition of *Stars and Stripes*. His marriage suffered the fate that befalls that of many soldiers: It disintegrated. After discharge, he tried (and failed) to find a decent job in Japan, having fallen in love with Asia, so he went home and landed at a fine small paper called the *Middletown Daily Record* in Orange County, New York. This was his graduate school. From there he found his way to the AP, working in Baltimore, where a second brief marriage ended. In 1961, he was offered a post at the AP bureau in Saigon, replacing a correspondent named John Griffin. He accepted. On November 11, 1961, he took up residence as the AP's Saigon correspondent.

In his memoir, Browne tells the story of finding a room without windows at the Hotel Catinat (with a packed swimming pool on the roof) and buying some cheap tropical clothes, including a tuxedo for

reporting on embassy special events or the doings of le tout Saigon in places like the tennis courts of the Cercle Sportif. He began to sort out the supporting cast for the still-limited American involvement: spooks from the Central Intelligence Agency, academic specialists paid by the CIA, others with hidden agendas. He also came to believe that Graham Greene's novel, "unlike news accounts, sketched the setting of the war, including its everyday routine, its uneventful lulls and its all-important political undercurrents." [5] In Vietnam when Browne arrived, the political undercurrents were also religious, with the puppet government of the ruling Ngo family dominated by Catholics—in a largely Buddhist country. Among many Vietnamese, there was a sense that the deck was stacked against them. Tensions grew. With the Viet Cong more active in the countryside, the problems in Saigon worsened. Browne was part of the younger generation of correspondents that also included David Halberstam of the *New York Times* and Neil Sheehan of United Press International. In the one-room AP office at 3, rue Pasteur, shared with an office boy and a Chinese American assistant, Browne clearly needed help.

And help he got, in a major way, when two young men arrived on the same day: June 26, 1962. One was a New Zealander named Peter Arnett. The other was a German named Horst Faas. Browne gave each a copy of his twenty-four-page mimeographed memo called *A Short Guide to News Coverage in Vietnam*. This pamphlet, written in plain English, displaying the analytical skills of a man trained in science, explained the complexity of the Vietnam story, and how to cover it. It gave practical advice on surviving a battle: "If you hear a shot and think it's not from your own side, don't get up and look around to see where it came from. The second shot might get you." It urged skepticism about pronouncements by military officials: "In covering a military engagement, you must make every effort to count the bodies yourself before accepting any tabulation of results." And it gave tips on cultivating embassy sources: "A resident correspondent in Saigon is invited to three to five cocktail parties a week, sometimes more. It is wise to attend as many as possible." [6]

Neither Arnett nor Faas was a neophyte, but each learned something from Browne, and Arnett discussed the memo at length in his 1994

memoir. Both men would play central parts in the drama that would follow. Each saw, in the dailiness of the war, that the larger story would be a tragedy, with no happy endings.

By the late spring of 1963, Browne was playing his own crucial role in the tale, covering the growing protests of the Buddhist monks. These were nonviolent protests—except for the clumsy overreactions of some Vietnamese security forces. Browne methodically covered Buddhist press conferences (where some handheld signs were in English, in hopes of influencing people in the United States), visited pagodas, got to know some of the leaders, and filed stories that were run in the back of newspapers, if at all. Most correspondents lost interest. No bang-bang. Then, one hot June night, Browne got a tip from one of his Buddhist sources. About a very special event the following morning. He knew he should bring a camera.[7]

Browne and Ha Van Tran, from the AP bureau, arrived at the pagoda before dawn, and there was already a crowd. Finally, a procession started, headed by an old Austin sedan with five monks crowded together inside. Vietnamese police led the way, to keep traffic flowing. The Austin stopped at the intersection of two main streets. Three monks emerged, one of them feeble with age. The two younger monks helped the old man to the heart of the intersection.

"A horror show was at hand, I realized," Browne wrote in his 1993 memoir, "and the sweat started from my brow as I cocked my camera."

The old monk assumed the lotus position on a square cushion.

"The two assisting monks lugged a large, plastic gasoline can from the car," Browne continued, "and then, rather hastily, they sloshed the pink fluid over the seated monk, soaking his face, body, robes and cushion.

"As they stepped away from him, I saw Thich Quang Duc strike a match in his lap and let it fall. Instantly, he was enveloped in a column of smoky, yellow flame."

Browne's photographs (see pages 64–67) of that self-immolation (and his account of the event, and its context) moved the Buddhist part of the Vietnam story out of the back of newspapers onto the front pages of the world. There was far more to the story than Cold War simplicities. The photographs proved it.

III. GETTING CLOSER

If your photographs aren't good enough, you're not close enough.
—*Robert Capa (killed in Indochina by a land mine, 1954, his camera in his hand)*

Most photographers would have agreed with those words. And in Vietnam, they surely would have seconded the words of David Douglas Duncan, a Marine photographer during World War II in the Pacific, the great photographer in Korea (for *Life* magazine), and present with a camera in the ferocious battle for Khe Sanh in 1968. He said about his Korean photographs: "I wanted to show what war did to a man. . . . I wanted to tell a story of war, as war has always been for men through the ages. Only their weapons, the terrain, the causes have changed."[8]

The AP photographers in Vietnam—as this book shows—wanted to do the same, as did such others as Tim Page, Larry Burrows, and Kyoichi Sawada, who worked alongside them. But they carried out their task beyond the earlier visions of Capa and Duncan. Each, in different ways, was showing what war did to all human beings. Not simply to the warriors, but to the civilians. In Vietnam, it was often impossible to separate them. Day after day, hour after hour, the photographers reminded us that these civilians were more than mere statistics. They were human beings.

Many photographers moved in and out of the AP bureau during the Vietnam War. Some were freelancers, offering their film for a price (in Browne's day it was $5 a photo). But those on staff were among the best who ever practiced their dangerous craft. Consider, for purposes of compression, only these names: Horst Faas, Eddie Adams, Henri Huet, Nick Ut, Dang Van Phuoc.

Faas was a burly man, born in Berlin in 1933, the same year that Adolf Hitler came to power. When he was nine, he was compelled, like all other German kids his age, to join Hitler Youth. Later, he remem-

bered the war for his constant hunger, and for the oddly beautiful sight of American bombers in the sky, and tracer bullets trying to destroy them. At war's end, his parents took him and the other Faas children out of the devastation of Berlin, fearful of the arrival of the Red Army, and they made their way to the West. His education was eclectic (it included eight years of Latin and a course in journalism that stopped at Gutenberg), but at eighteen he found a job as a clerk for the Keystone photo agency in Munich. His job: helping to comb through a roomful of several million photographs, organizing them into files. He first learned about photographs by studying them. Within a few years, he was carrying a camera and making them. By 1951, he was covering major stories in Europe, including the 1954 peace conference in Geneva about a place on the other side of the globe: Indochina. Just before Christmas, 1955, he was hired by the AP. He was soon in Bonn, the capital of West Germany. He was the AP's only photographer in that city, with competition from UPI and the German press. He had no guidance. Just assignments from Frankfurt or New York.

"I didn't know what I was doing," he remembered years later, "and I had to follow my peers from the opposition to see what and how we worked there."[9]

At the AP he was handed a Speed Graphic, a camera that he hated for its clumsiness and the way focusing sometimes robbed him of that "decisive moment." But it was the AP. And the AP was driven with urgency.

"Working for AP," he remembered, "it was always that you worked in fear. Fear of the events that have not happened yet... And it invariably happened at three in the morning."

After five years in Bonn, the AP sent him to his first war: in the Belgian Congo. He had volunteered for the assignment. He thought he would be in the Congo for a few weeks, and parked his car at the airport. He would be gone for a year and a half. But he didn't mind. At last he had a chance to make good pictures in a truly bad place. Out there, in the great wide world, with a Leica he had paid for himself. First stop: Leopoldville.

"It was my chance to get into international journalism," he said later, "and I used it and jumped and never came back."

In the Congo, tribal forces, regular Congolese army troops, and United Nations peacekeepers were fighting one another in a country of rivers, swamps, and jungle. Faas met other correspondents, including a small group from Fleet Street, and a young man from the *New York Times* named David Halberstam, who was then twenty-seven, passionate and intense about his craft. They were present together at some of the battles in the three-way combat in Katanga. Other times Faas went alone into fierce combat and, when he returned to Leopoldville, would brief Halberstam (and some other reporters). Sometimes Halberstam introduced Faas to people the German could not easily meet, including U.S. Embassy analysts and CIA spooks. Horst and David became friends for life.

"Yeah, he was a friendly American," Faas later said, "as authoritative as he always was. He always taught us to be serious journalists, dress seriously and act seriously, and responsibly.... Not play around with the world of news."[10]

After a year and a half, a worn-out Faas told his AP bosses that he wanted to go skiing. He had seen enough victims of assassinations, torture, and treachery in the exhausting heat of the Congo. They agreed that he could leave and thanked him for a job well done. He went skiing in Tours. A few days later, he was called by the AP in Paris and told to go to Algeria. Another war, marked by assassinations, torture, and treachery, was under way in an outpost of the eroding French Empire. Faas went. The war was almost impossible to cover, and very dangerous, particularly for reporters and photographers. Many of them had been marked for killing. The killers might have pledged allegiance to Algerian nationalism, to continued French sovereignty, to Islam, to simple vengeance for old injuries. The cause didn't matter. The effect was death. Not simply in Algeria, but increasingly from the right-wing OAS, in the heart of Paris. Faas did his best for ten weeks, and then got another call from the AP bosses. Now they wanted him to go to Laos. In Indochina.

In Laos, he met Peter Arnett and confronted another baffling, three-

sided local struggle, with Americans from the virtually faceless CIA controlling all access to the action. Or actively preventing that access. And then Arnett and Faas were told to move on to Saigon. To help cover the Buddhist crisis. That destination, and the work they performed there for the AP, would define the lives of both men.

IV. THE BAND PLAYS ON

Men cannot act before the camera in the presence of death.
 —Ernest Hemingway. Narration for the 1937 film
 The Spanish Earth.

With the addition of Faas and Arnett, the AP bureau was turning into the Basie band of Vietnam coverage. As he evolved into the photo editor, Faas didn't merely sit in the office, clerking the work of others. Neither did the bureau chiefs. They also went into the field. Soon, all members of the bureau were doing double duty. The print reporters, including Arnett, carried cameras. The photographers made notes, to be fed to the bureau. In the Basie band, Count Basie also played piano.

"Up until my assignment to Vietnam at age twenty seven," Arnett told me, "I rarely took photographs of anything. The photographers at the small newspapers and magazines I had worked at functioned independently. This changed in Vietnam where Horst encouraged Malcolm Browne and me to take pictures when we could. However, Horst was reluctant to lend us any of his precious Leicas. For a while, I was using my then-girlfriend's (and later wife's) camera, which was an early model Leica." His one memorable picture, he said, was of another self-immolating monk, three months after Browne had made his shocking photo. "The *New York Herald Tribune* took me to task, demanding in an editorial to know why I had not intervened to prevent the suicide rather than just photographing it. The AP asked me to respond, and I did so, pointing out that the young monk took the few reporters there by surprise with his action and was in flames within seconds. We were in summer dress, slacks and sport shirts, hardly equipped to intervene, and any intervention on our part might be seen as supportive of the draconian policies of the Diem regime."

But Arnett also learned about the power of a photographic image.

"I had more reaction from that photograph," he said, "than from all the stories I had written in 1962 and 1963."

In those early years, Faas also did all he could to improve the working conditions for resident and visiting AP photographers. When he arrived, there was no darkroom in the cramped space on rue Pasteur, and photographers would go to local photo shops to get their film developed. Faas commandeered the tiny bureau bathroom and filled it with processing equipment. He appointed an assistant as master of the crude lab. He also had technical problems to solve, starting with the absolute basics. First, how to develop black-and-white film in the smothering heat and humidity of Saigon, especially in summer. (Fans blowing over ice buckets was one solution.) Then, how to get the pictures out of Saigon for distribution to the world. Before 1962, the AP bureau had no photo transmitter, so human couriers, known as "pigeons," carried film out by air. Eventually, a transmitter was sent to Saigon—the cylindrical Wirephoto drum that could send one print in about fifteen minutes. But it couldn't be used from the bureau; it had to be hooked up to the balky international circuit at the postal, telegraph, and telephone office (PTT). Sometimes the transmission would fail, and precious time was taken to try again. And, of course, there are only so many minutes in a day for a news agency like the AP, where there can be a deadline every minute. Faas understood the power of photography to document the escalating conflict. Images made this new American war feel real to people who would never see it for themselves. So he developed an intricate distribution system, a bit like an air traffic controller who decides which planes have to land immediately at the airport and which can circle longer. The "hot news" photos would be taken to the PTT and transmitted; the ones that could wait—the vast majority—were developed, captioned, and shipped off along with the negatives by air to Tokyo, Manila, or Frankfurt for further relay to New York.

More and more reporters were arriving in Saigon, and all wanted to stop at the AP for guidance, renewal of friendships, or simply to scan the AP ticker for news beyond Saigon. Faas's comrade from the Congo, David Halberstam, arrived in August 1962, replacing the

great Homer Bigart as the *New York Times* guy in Vietnam. He and Faas were soon sharing a small villa, and Halberstam (who hung out for a while at the AP office) quickly became part of a small group labeled the Young Turks, one that included Browne, Neil Sheehan of UPI, Nick Turner of Reuters, and Arnett. The label was absurd: They were not organized in any formal way. They were all working against each other, while covering the same growing story.

But collectively, their hard-nosed independent reporting infuriated many officials both in the Diem dictatorship in South Vietnam and in the Kennedy administration in Washington. They also angered some veteran correspondents, such as Marguerite Higgins and Joseph Alsop, whose "get on the team" attitudes were forged amid the moral certainties of World War II. The Young Turks refused to simply print the official handouts. They checked them against the facts on the ground, and too often found them wanting. This became known as the "credibility gap." Across the long years ahead in the American part of this long war, that gap never went away.

As more reporters arrived, there was never enough room at the bureau office on rue Pasteur. In May 1965, the AP bureau finally moved to larger quarters. Now it looked down upon Lam Son Square from the six-story Eden Building at 106, boulevard Nguyen Hue, Room 422. The building faced south and was flanked by the Rex Hotel, home of JUSPAO, the Joint U.S. Public Affairs Office, which contained a small theater for the daily briefing, known among the press as the "Five O'Clock Follies." The NBC office was down the hall from the AP. In the Eden, Horst Faas and the other photographers now had a proper darkroom (though they still had to transmit their photos from the PTT).

In March 1965, another superb photographer was added to the AP team. His name was Eddie Adams. Born in New Kensington, Pennsylvania, in 1933, he had discovered photography on his high school newspaper, and after joining the Marine Corps in 1951 went on to serve as a photographer in Korea. Alas, as happened to Malcolm Browne, he arrived a bit late and saw little combat because of the cease-fire between North and South. But he told me years later that he was a huge admirer of David Douglas Duncan, not simply for his

extraordinary work in the Korean War, but for his marvelous later work with Pablo Picasso.

"The thing about being a photographer," he told me, "is that there are more subjects than one. You have the whole world in the viewfinder."

After discharge, Adams made his way to the *Philadelphia Bulletin*, one of the best newspapers in the country. Like many others of his generation, he had high aspirations for his work, and on a daily newspaper he covered three or four stories a day. All of them taught him something about technique, the avoidance of mistakes, and respect for his subjects. He knew, as other photographers and reporters knew, that there could be no art without craft. By the time he moved on to the AP in 1962, he had mastered his craft and wanted to practice it on a wider stage. The big story was now in Vietnam. When someone at the AP heard that his beloved Marines were going into Vietnam, Eddie Adams told them he must go. The AP sent him. Semper Fi, baby.

From the Saigon bureau, Eddie Adams often moved north to Da Nang, where the Marines were based. He became a friend of the top Marine commander, Maj. Gen. Lew Walt, and that assured access to the action, and to the quieter stories that often revealed deeper truths. Like many others, when it was time to play, to laugh, to relax, that is what Eddie Adams did. But when he was out there with young soldiers, he treated his work as a matter of life and death. Which it was.

To be sure, there was a problem within the bureau: a seething unhappiness on the part of Adams, focused on Horst Faas. I met Eddie briefly in 1966, and he showed no hostility to Horst. But long after the war had ended, we became friends in New York, and when I mentioned Horst a few times, he shook his head, made a dismissive gesture with his hand, and said nothing except: "He made some good goddamned photographs."

When I asked Peter Arnett about it, he told me:

"The animosity was all one-sided, Eddie's... Eddie came to Vietnam to take the pictures he wanted to take, an individual in a very well-

organized news team. There were several other staff photographers and numerous stringers. Horst managed them all like a magician, assembling darkroom boys and photo editors to process sometimes fifty to eighty rolls of film a day, often while Horst was covering the war himself.

"Eddie wanted to do it his way."

Arnett spent much time with Adams up near Da Nang.

"He had great rapport with the soldiers and took fine pictures. But he was finding reasons to be unhappy. He complained that not enough of his pictures were being used by New York, and blamed Horst for not selecting them. By then Horst had won the 1965 Pulitzer Prize and Eddie took to playfully ridiculing him, imitating his German accent and talking about 'the Kraut.' By year's end, Eddie was actually telling colleagues that Horst was sabotaging his film, secretly selecting the best pictures and destroying them. I challenged him to prove it to me, or officially complain to New York headquarters, but he didn't."

Eddie Adams stayed in Vietnam for a year and then moved on (he would return in late 1967 in time to cover the Tet Offensive). What matters now is his work. In 2008, four years after Eddie died, David Halberstam said of that work: "If you look at Adams's remarkable body of work, so quietly elegant, it has one great connecting link: the singular humanity that runs through his photos. And at first that humanity seems to be solely that of the subjects, and then you see more and more of the photos, and you realize that in so many of the portraits it is as if the photographer was magically able to peer into the very soul of the subject, and the humanity is as much Eddie's as it is that of the subjects themselves." [11]

Adams was also responsible for one hire that added to the dominance of the AP coverage, while weakening its major competitor. He convinced the AP (clearly through Horst Faas) to hire a talented young man away from UPI. His name was Henri Huet. It was like persuading Ben Webster to carry his horn to the Basie band.

Huet was born in 1927 in the lovely mountain town of Dalat, more than five thousand feet above sea level in the Central Highlands of Vietnam. His father was a French engineer. His mother was Vietnamese. When he was four, they moved to France, so the boy could get educated in Brittany, far from the confusion and strife of Indochina. In his teens, he decided to become a painter and went to art school in Rennes. When he was twenty-two, he joined the French navy. He never did explain that decision, because he spoke very little, even to friends, about the details of his own life. The French officers learned about his art-school background and started training him to be a photographer. He was soon in Indochina, in Vietnam, the country of his birth. By then, Henri Huet was a handsome, modest young man, using his cameras to see, not just look.

He was discharged from the navy in 1952, but unlike so many other French military men, he did not go home. He was home. He stayed on in Vietnam, finding a way to make a living with his camera, working for a time in a Saigon photo studio. And as the French War evolved into what the Vietnamese called the American War, he turned to photojournalism, joining UPI in 1964 and moving to AP the following year. Along the way, he got married and had two children, but he stayed on after the marriage collapsed. The fighting absorbed him more and more. Almost everybody remembered him the same way: quiet, reticent about his personal life, humble about his extraordinary talent. Old pros or neophytes: All learned something from Henri Huet about empathy.

The war, after all, was not about him. For Henri Huet, it wasn't about the tanks or the helicopters or the generals. It wasn't about the press conferences, either. It was about the casualties of war. About all those who had found themselves in harm's way. The baffled peasants and their children. And out there, in the field, the foot soldiers. The grunts. With a camera in hand, it was impossible for Huet, or any other photographer, to sentimentalize his subjects. But the camera didn't take the picture. The photographer did.

Look closely at his photographs in this book, and you will come as close to the experience of combat as is possible for anyone fortunate enough never to have seen a war.

Like Horst Faas and Eddie Adams, Huet was also a fine, generous teacher. Most remember him for his soft-spoken patience with neophytes, his ability to show them the possibilities of the camera, to think about the fine art of anticipation. And the more difficult skill of staying alive. One of those he helped instruct, with words and demonstrations and example, was a young Vietnamese who came to be called Nick Ut.

His full name was Huynh Cong Ut. He was the younger brother of photographer Huynh Thanh My, who had been an actor, and then worked for CBS before being brought to the AP staff by Faas. Thanh My was small (five-foot-three, 110 pounds) and very brave. Faas wanted him to cover more of the Vietnamese part of the developing story, and he did, often traveling into combat zones with the ARVN (Army of the Republic of Vietnam). In early 1965, he was wounded, but when he healed, he returned to the war. On October 13, 1965, while covering a fierce battle in the Mekong Delta between the ARVN and Viet Cong, he was again badly wounded. He was waiting to be carried away by a medical evacuation (medevac) helicopter when the Viet Cong overran the position. They shot all the wounded, including Huynh Thanh My. Virtually the entire Saigon press corps turned out for his funeral.

A few days later, his younger brother showed up at the AP bureau. He was then sixteen, and looked even younger. He announced that he now belonged to the AP. Everybody was kind, and tried to move him to the door. He insisted. So they took him on, and his education began, from the darkroom and then to the streets with camera in hand. Soon he was in the field, covering the war. Nick Ut would be wounded three times, but kept coming back. On June 8, 1972, he was on a road just south of Trang Bang, about twenty-five miles northwest of Saigon.[13] Other reporters were on the scene, some with television cameras.

"I saw many refugees leaving the village," he later told Hal Buell for the AP Oral History project (August 15, 1997), "and all black smoke by bomb, air strike there." The attack was being made by South Vietnamese airplanes against the Viet Cong, and it hit civilians too. "I took a lot of picture. And I say I want to leave, because I took pictures of the air strike all morning. I had enough photos." Rain started falling, and photographers began hiding their cameras to protect them. "Then I saw smoke. And hear two strikes. They dropped four bombs at one time. Then another one, then dropped the napalm right at my camera." Ut saw a running mother carrying a one-year-old boy. "She's screaming: 'Please help, please help my children!'" The baby died in her arms. Then came five more children, and a screaming chorus: "Please help, please help! Too hot! Too hot!"

One of them seemed to be running directly at Ut. He saw her in his viewfinder.

"First," he said, "I thought the girl don't have clothes."

And the girl, whose name was Phan Thi Kim Phuc, screamed at him: "Please help! I will die!"

The nine-year-old girl was, in fact, naked. And she had been hit with napalm, which was burning the flesh off her body. Ut put down his camera to help. He drove her in his van to a village hospital, where doctors and nurses saved her life. She lives today in Toronto. By June 12 (after a struggle at AP in New York about moving a photo of a naked girl), the photo was on the front pages of the world (see pages 276–77). The girl's name became part of the Vietnam story. So did the name of Nick Ut.

And then there was Dang Van Phuoc, the one Faas called "our secret weapon."[13] Long before Phuoc learned how to use a camera, an image of war's brutality had been seared into his brain. In 1945, when he was just ten years old, the Viet Minh (forerunner of the Viet Cong) took over his village near Quang Ngai on the central coast. His father, the mayor, was sentenced to death, and then, as Faas described it, "they buried him alive in the sand on the beach and then beheaded him, and Phuoc and his mother had to watch that." Perhaps the experience created his desire to make others see and understand the horrors of war. His photographs, Phuoc felt, accomplished that better than words ever could. "I am like small sand in the beach," he would say years later, looking back on his career. "I cannot say and talk, so I have the picture, can tell more than I do."[14]

Faas hired him in 1965, the same year Ut began to work for AP.

Already thirty, Phuoc had come of age on the streets of Saigon doing odd jobs on movie sets and getting to know Ut's brother. When Huynh Thanh My was killed, Phuoc went to his funeral and then headed straight for the AP bureau looking for a job. Faas showed him photographs of Huynh "screaming in pain with an arm injury," but Phuoc was undeterred. "Oh, that doesn't bother him. The idea doesn't bother him that he gets injured," Faas recalled. "He wants to take pictures." And take pictures he did—hundreds, thousands of them over the next decade, often risking his life for a better view of the action—from the Mekong Delta to the DMZ. For Phuoc, it was simple necessity: "If you don't go to front line, you can't have picture." Decades later at a reunion of Vietnam War journalists in Southern California, former UPI correspondent Ray Herndon would single him out as "the bravest photographer in the war."[15]

That bravery went beyond taking risks for a photo. On May 10, 1968, while covering the mini–Tet Offensive in Saigon, he saw a wounded American soldier in the line of fire. Despite a steady stream of sniper bullets, the 115-pound Phuoc rushed over, picked up the 180-pound soldier, and carried him to safety on his back. He received a commendation from the 9th U.S. Army Infantry Division. Not surprisingly, Phuoc was wounded repeatedly, and by 1968 his personnel file contained X-rays showing thirteen fragments of metal in his body. One memo to AP headquarters reported that "while covering street fighting in Saigon, he was struck in head by a rocket." He was lucky that time and only slightly injured. But in February 1969, as he accompanied a Ranger battalion near Da Nang, a Viet Cong grenade exploded and cost him his right eye. That injury would have ended the career of many photographers, but Phuoc retrained himself to shoot with one eye and soon was back on the job. Photo editors say it's difficult to see any difference in his photographs before and after the incident. Indeed, it is the consistent quality of his pictures over time, rather than one or two iconic images, that distinguishes Phuoc's work in Vietnam. In one way or another, all of these images fulfill his goal of making sure "the world see it."

Both Phuoc and Ut left Vietnam before the war ended and eventually resettled in Southern California. Phuoc went on to a successful career as a portrait photographer, and Ut became a staffer in the AP's Los Angeles bureau.

V. THE THINGS THEY CARRIED

They carried all they could bear, and then some, including a silent awe for the terrible power of the things they carried.
—Tim O'Brien, The Things They Carried

The reporters and photographers who died in Vietnam totaled more than 70, a tiny fraction when compared to the more than 58,000 names on Maya Lin's Vietnam Veterans Memorial in Washington, D.C. The AP lost four, all of them photographers. The things they carried were notebooks and pens, 35mm cameras and Kodak Tri-X film, along with condoms to protect exposed film from torrential rain, from mud, from blood.

Death claimed Bernard Kolenberg just eight days before the death of Huynh Thanh My. Born in 1927, Kolenberg spent twenty years as a photographer for the *Albany Times Union*, photographing everything from politicians and lobbyists to criminals and sports stars. In the spring of 1965, he went for a few weeks to Vietnam for the Albany paper. Those weeks weren't enough. On leave from the paper, he returned in late September on temporary assignment with the AP. When he arrived at the bureau, he announced, "It's great to be back!" A week later, near Qui Nhon, he was dead, killed when his A-1 Skyraider collided with another in flight.

Death claimed Oliver E. "Ollie" Noonan on August 19, 1969, near Da Nang. Noonan was a star at the *Boston Globe*, the son of a photographer. He had photographed the civil rights movement in the American South, the Reverend Martin Luther King Jr. in the March on Washington, the aftermath of the murders of King and Robert Kennedy, the expanding turmoil of the antiwar movement. But as it was for so many reporters and photographers, for Noonan the Big Story was in Saigon. He went there at his own expense, on leave from the *Globe*, and carried his cameras on temporary assignment with the AP. He didn't drink, rarely smoked, listened to classical music for his

nerves, and wrote excellent poetry. On the last day of his life, in a fierce firefight, he stopped using his cameras so he could help carry the wounded to medevac helicopters. Then he boarded a helicopter to bring his film to Da Nang. The chopper was shot down, and Oliver E. Noonan was killed. He was thirty.

Death claimed Henri Huet on February 10, 1971. He was in a UH-1 "Huey" helicopter over Laos, heading to witness another attempt to destroy the Ho Chi Minh Trail in the ever-expanding war. With him were Larry Burrows of *Life* magazine, Kent Potter of UPI, and Keisaburo Shimamoto of *Newsweek*.

"They were four of the premier photojournalists in Saigon," wrote Richard Pyle, one of the last AP bureau chiefs in the war and a superb reporter. "No one could have seriously questioned their right to a first shot at seats." [16]

But once the copter rose into the air, it started moving about a mile off course. North Vietnamese gunners were waiting, and blew it out of the sky. The remains were not found for more than twenty years. The men who found the fragments of those destroyed lives were Horst Faas and Richard Pyle. Among the things Faas and Pyle carried was memory. [17]

Eddie Adams never forgot either. In late 1967, he returned to Vietnam for the AP. Adams was there in late January when the Tet Offensive began all across Vietnam. On February 1, 1968, he hurried with an NBC crew to Cholon, the Chinese neighborhood of Saigon. There he saw the South Vietnamese police chief interrogating a suspect in civilian clothes. Eddie's instinct took over, he raised a camera, and in 1/500th of a second captured the outstretched arm of the chief, revolver in hand, and the face of the suspect as a bullet passed through his brain (see pages 196–97). The last second of the man's life.

The photograph won the 1969 Pulitzer Prize for Spot Photography, along with many other awards, and is often credited as one of the crucial images that helped bring an end to the war. But it haunted Eddie. He felt he had ruined the life of the police chief, a man named Nguyen Nuoc Loan, and later apologized to him. He never apolo-

gized for the photograph he did not take: of a dying Marine lying beside him in the mud. To photograph his dying moments, Eddie insisted later, would have been an obscene invasion of privacy. But he carried both photographs—the one he took of the execution, and that one he did not take—for the rest of his life.

Eddie Adams would have a marvelous postwar life. At last, he was able to see how large his talent might be, making hundreds of portraits ranging from Ronald Reagan to Malcolm X, Clint Eastwood to Fidel Castro, most of them for *Parade* magazine. In 1988, at his studio north of New York, he founded Barnstorm: The Eddie Adams Workshop, dedicated to passing on the lessons of craft (and life) to younger people aspiring to be photographers. Eddie died in 2004; the Workshop continues to this day.

But some strands of the AP narrative in Vietnam were personal. Eddie Adams, for example, considered Horst Faas to be his nemesis, and most veterans in the bureau sensed the enduring hostility. But there were some complicated aspects to that part of the tale. In 1967, Horst Faas was savagely wounded, and almost lost a leg. But he did not depart for the French Riviera to recuperate. He stayed on in Saigon, continuing to function as the photo editor. Even Eddie said of Faas years later (to me): "The Kraut was a brave son of a bitch. God damn him."

Faas remained with the AP long after the war ended in Vietnam. He won a second Pulitzer in Bangladesh in 1972 and in 1976 took the post of senior photo editor in London. He did that job until 2004. But Vietnam stayed with him. With the superb young photographer, Tim Page, Faas had helped create a splendid memorial volume called *Requiem: By the Photographers who Died in Vietnam and Indochina*. It was published in 1997 and saluted about 135 photographers who died in the Indochina wars, or went missing and were never found. By reminding the readers that the endgame was often death, the book also saluted the survivors. Even those who didn't like each other.

I remember being at the launch party for *Requiem* in New York, moving among some of the greatest photographers and reporters of the era. At one point, Faas was introduced, and there, off on the side of the stage, joining in the applause, was Eddie Adams. There was an ironical smile on his face.

Many photographers in that safe, neutral room had lived through the most wretched times of the Vietnam War. By the early 1970s, tales of personal and military collapse among American soldiers were too often arriving in Saigon from the field: the fragging of officers and noncoms, mini-mutinies (at least one was covered by Peter Arnett), more and more drug use, including heroin. After all, the American troops had arrived in the era of sex, drugs, and rock 'n' roll. Few photographers captured any of this. In 1973, President Nixon completed his Vietnamization program, the transfer of combat operations to the army of South Vietnam. At almost the same time, the military draft ended, and the passion went out of the antiwar movement. All roads now were leading to the finale. When it came on April 30, 1975, Arnett was in Saigon, along with George Esper (the last AP bureau chief) and reporter Matt Franjola. They had chosen to stay on, to cover the final hours of the story. The images included those of the frantic human lottery at the U.S. Embassy, with desperate Vietnamese trying to board helicopters escaping from the roof. Another was the entrance of a North Vietnamese tank through the smashed gates of the presidential palace in Saigon. The war was over.

All of those who survived Vietnam would carry it, of course, throughout their lives. Most moved on. But all were marked by the experience, its horrors, its anguish, its unacceptable losses. In May 2012, Horst Faas died, and Malcolm Browne three months later. Almost certainly, each carried Vietnam to the end. Their work lives on. We all know someone who got over 'Nam, to watch children graduate from college, or the arrival of grandchildren, or an anniversary waltz after decades. And then something triggers memory: Aretha Franklin singing "Respect"; the sound of a helicopter in the sky; a TV commercial for a war film; or a photograph in a magazine in a dentist's office. And then the war suddenly returns in a rush. Full of fear. Screaming. Pain. Loss.

The journalists would not be immune to such attacks. Most moved on with their professional lives, happy to report on a Super Bowl or a flower show. Others covered fresher conflicts in Northern Ireland, Lebanon, Nicaragua, Kosovo, and the Persian Gulf. There is never an end to human folly. After September 11, 2001, a few who had been young in Vietnam traveled to Iraq and Afghanistan. But most never wanted to hear another explosion, another *brrrrrup* of a machine gun, another whirring of helicopter blades, another human scream, another call in the dark for a medic or for Momma.

All understood the power of the things they carried. Including memory.

1. Peter Arnett to Pete Hamill, in an e-mail of August 19, 2012.

2. This figure is from the Defense Casualty Analysis System, which is maintained by the Defense Manpower Data Center for the Department of Defense.

3. Seymour Topping, interviewed by Claude Erbsen, August 14, 2006, 18. Oral History Collection, AP Corporate Archives, New York, NY.

4. Malcolm W. Browne, *Muddy Boots and Red Socks: A Reporter's Life* (New York: Times Books, 1993), 47.

5. Ibid., 84.

6. Malcolm W. Browne, "A Short Guide to News Coverage in Vietnam," January 1963. Saigon Bureau Records, AP Corporate Archives, New York, NY.

7. Browne, Muddy Boots, 10ff.

8. David Douglas Duncan, *This Is War! A Photo-Narrative in Three Parts* (New York: Harper & Brothers, 1951).

9. Horst Faas, interviewed by Valerie Komor, May 21, 2007, 21. Oral History Collection, AP Corporate Archives.

10. Ibid., p. 29.

11. Alyssa Adams, *Eddie Adams: Vietnam* (New York: Umbrage, 2008). 11.

12. *Breaking News: How the Associated Press Has Covered War, Peace, and Everything Else* (New York: Princeton Architectural Press, 2007), 329.

13. Horst Faas, interviewed by Valerie Komor, May 21, 2007, 48. Oral History Collection, AP Corporate Archives, New York, NY.

14. Dang Van Phuoc, interviewed by Valerie Komor, May 16, 2011, 32. Oral History Collection, AP Corporate Archives, New York, NY.

15. *Orange County Register*, May 15, 2011.

16. Richard Pyle, "Saigon Quartet," *Vanity Fair*, December 1999.

17. Richard Pyle and Horst Faas, *Lost over Laos: A True Story of Tragedy, Mystery, and Friendship* (New York: Da Capo Press, 2003).

AMERICANS KNOW LITTLE ABOUT THIS WAR IN INDOCHIN

IS BOUND TO HAVE TREMENDOUS EFFECT UPON THE COURSE

FOR COMMUNISM'S KNOCKING AT THE DOOR OF SOUTHEAST AS

ASSOCIATED PRESS CORRESPONDENT SEYMOUR TOPPING H

A TEN-WEEKS TOUR OF VIETNAM, THE FRENCH-SUPPORTED S

DURING WHICH HE INTERVIEWED FORMER EMPEROR BAO DAI

FIGURES. IT WAS THE LONGEST ASSIGNMENT IN THE COUN

REPORTER SINCE THE VIETNAM STATE CAME INTO BEING.

HE FOUND. TOPPING WRITES WITH A BACKGROUND OF FOUR

EAST, THE LAST THREE SPENT IN CHINA.)

-O-

BY SEYMOUR TOPPING

(ADVANCE) SAIGON, INDOCHINA, MAY 6-(AP)-THE UNITED

THAT A SHAKY GOVERNMENT INSTALLED BY FRANCE IN INDO

POPULAR SUPPORT IT NOW LACKS--AND BECOME A BULWARK

COMMUNISM IN SOUTHEAST ASIA.

IF THE GAMBLE FAILS, INDOCHINA WILL FALL TO THE

YET ITS OUTCOME

WORLD HISTORY.

.

JUST COMPLETED

IN INCOCHINA,

OTHER KEY

FOR AN AMERICAN

HE TELLS WHAT

ARS IN THE FAR

ATES IS GAMBLING

NA WILL WIN THE

INST THE TIDE OF

MUNISTS, PERHAPS

THE FRENCH DEBACLE

1945–54

Vietnam, a long, narrow, S-shaped country that hugs the eastern edge of the Indochinese peninsula, was colonized by the French in the nineteenth century (along with present-day Cambodia and Laos). The Japanese invaded during World War II, but after their defeat, France moved to restore its rule.

Communist leader Ho Chi Minh had other ideas and declared independence for his nation in 1945. A coalition of Communist and nationalist fighters known as the Viet Minh then initiated a guerrilla war against French forces that would last nearly ten years.

The first American death came early in that struggle, and, ironically, given the tens of thousands of Americans who would fall in Vietnam in later years, it was due to a case of mistaken identity. Lt. Col. A. Peter Dewey, head of the Vietnam mission of the U.S. Office of Strategic Services (OSS)—forerunner of the Central Intelligence Agency (CIA)—was shot in the head while riding in a Jeep in Saigon on September 26, 1945, ambushed by Viet Minh fighters who thought he was a Frenchman.

Ho wrote to President Truman expressing regret for the incident and saying he was "touched by the death of any American in this country." He also appealed repeatedly for aid in defeating the French,

< In this May 6, 1950, story analyzing U.S. policy toward Vietnam, Seymour Topping spells out for AP's readers for the first time how the Americans were "gambling" on a puppet government set up by the French as a "bulwark against the tide of Communism in Southeast Asia." Topping, who had covered the civil war and Communist victory in China, established the AP's first bureau in Saigon and would report from there for the next two years.

Foreign Bureau Correspondence, AP Corporate Archives

by the 1949 Communist victory in China, Truman began sending military advisers and weaponry to help the French.

President Eisenhower continued that policy, citing the "domino theory," which would rationalize ever-expanding U.S. military intervention. Speaking at an April 7, 1954, news conference about the danger of a Communist victory in Vietnam inspiring revolutions elsewhere in Southeast Asia, Eisenhower said, "You have a row of dominoes set up. You knock over the first one, and what will happen to the last one is the certainty that it will go over very quickly."

But despite U.S. assistance, the French found themselves in deep trouble. By 1953, a series of military commanders had failed to defeat the Viet Minh, and the guerrillas had overrun large parts of Laos, a semiautonomous French ally to the west of Vietnam.

On March 13, 1954, the French initiated what would become their last battle. Hoping to lure the Viet Minh into a trap, about thirteen thousand French troops dug in at Dien Bien Phu, a fortified valley outpost deep in the northern mountains near Laos. But the French turned out to be the ones in the trap: They came under siege by forty thousand Viet Minh troops, who commanded the high ground on all sides. What is more, the Viet Minh had assembled antiaircraft artillery, which they used to prevent airplanes from bringing in supplies.

The French appealed to Eisenhower to send in U.S. troops, but he refused. Finally, worn down and suffering huge losses over the course of fifty-four days, the French forces surrendered on May 7.

Their dreams of remaining a colonial power in Asia shattered, the French agreed to a peace conference in Geneva. The resulting treaty temporarily divided Vietnam into two zones, northern and southern, separated by a demilitarized zone (DMZ) near the 17th parallel, splitting a total population of about thirty million roughly in half. The treaty also called for reunification through free elections in 1956 — a prospect that did not appeal to the United States, whose goal was to guarantee the survival of a non-Communist state in the South at any price. The U.S. government said it would observe the treaty but was not bound by it.

The denouement for France eerily foreshadowed the U.S. experience in Vietnam nearly two decades later. Then as well, a militarily superior Western power that could not defeat a more resilient and ideologically committed foe on the battlefield would be forced to look to the peace table to save face.

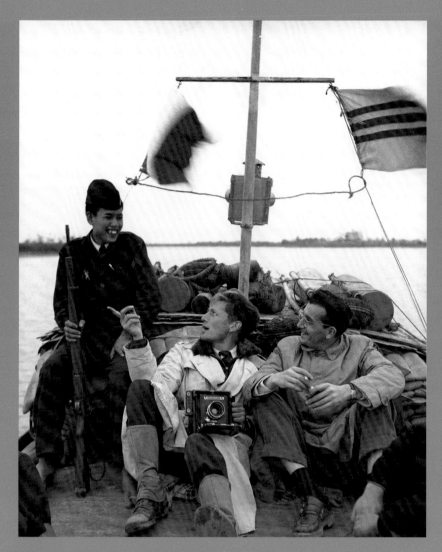

AP photographer Jean-Jacques Levy (center) riding up the Red River on a motor boat flying the French and Vietnamese flags. On the left is a Vietnamese soldier, and on the right is Jean Marie Juge, correspondent of Agence France-Presse, March 16, 1951. Levy, a photographer in the AP's Paris bureau, was on temporary assignment in Indochina.

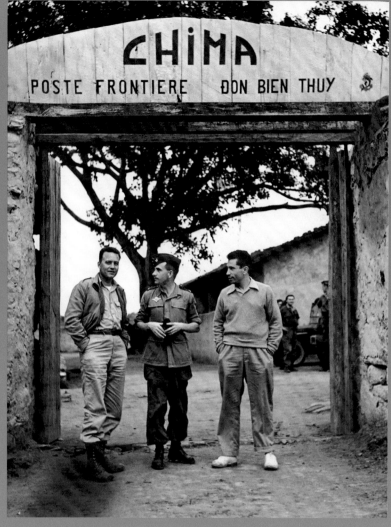

AP's Saigon correspondent Seymour Topping (right) at the French Army outpost at Chi Ma, on the border of Vietnam and China, March 1950. Also pictured are Wilson Fielder of *Time* magazine (left) and Lt. Andre Wastin of the French Foreign Legion.

Photograph by Carl Mydans, courtesy Seymour Topping.

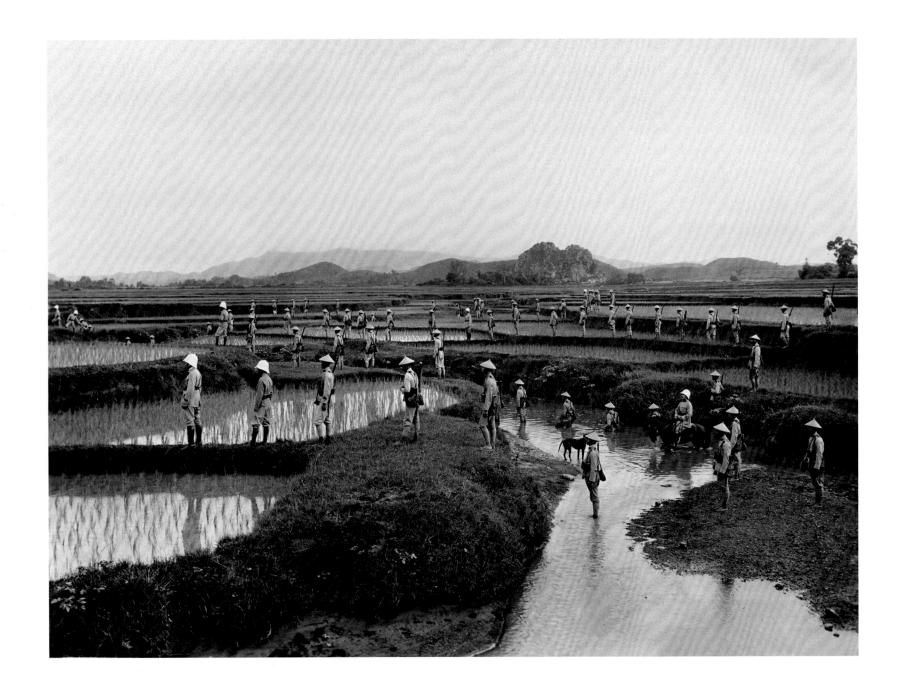

Vietnamese soldiers in the French colonial army practice war maneuvers in a rice field, early 1937. France stepped up its military drills in an effort to protect its dominion over Indochina after Japan formed its "Axis" alliance with Germany and Italy in 1936.

Japan would invade Vietnam in September 1940, a few months after German troops marched into France.

AP Images Archive

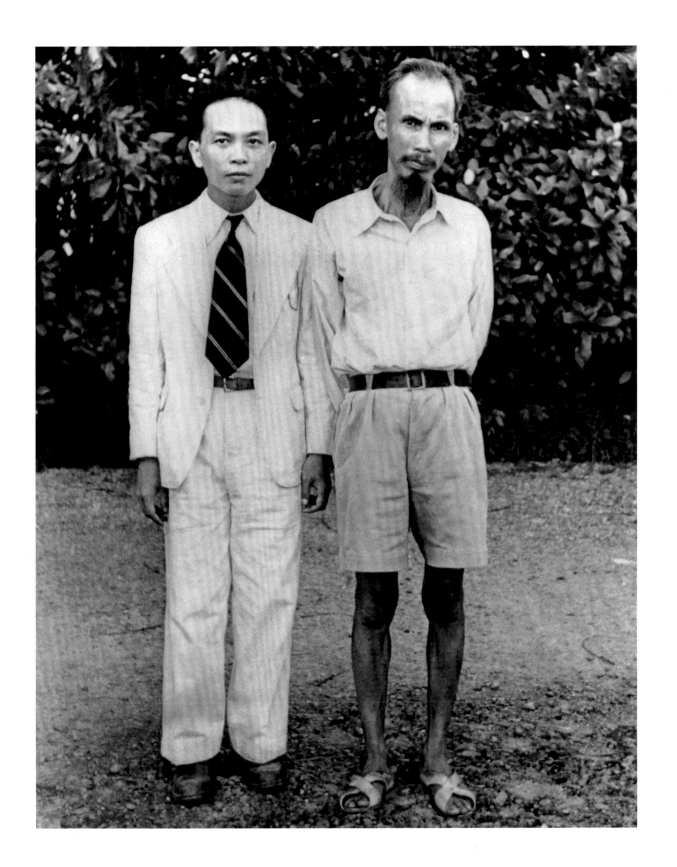

The two men who would lead Vietnam's decades-long struggle for independence, first against the French and then against the Americans, stand shoulder to shoulder at the Bac Bo (Tonkin) Palace after the August Revolution, September 1945.

At left is Gen. Vo Nguyen Giap, the principal military commander and strategist. At right is Ho Chi Minh, a founder of the Vietnamese Communist Party who would become president of North Vietnam. Ho would die in 1969 but Giap lived to see his nation united under Communist rule.

Photograph courtesy Vietnam News Agency.

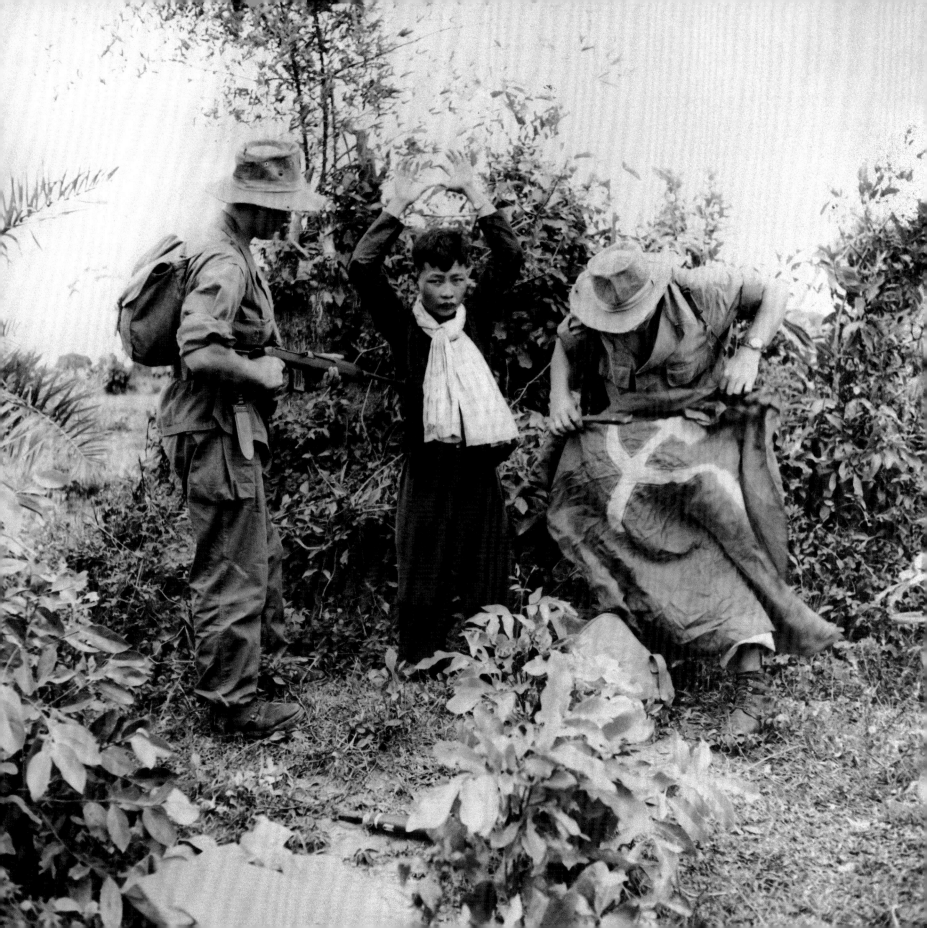

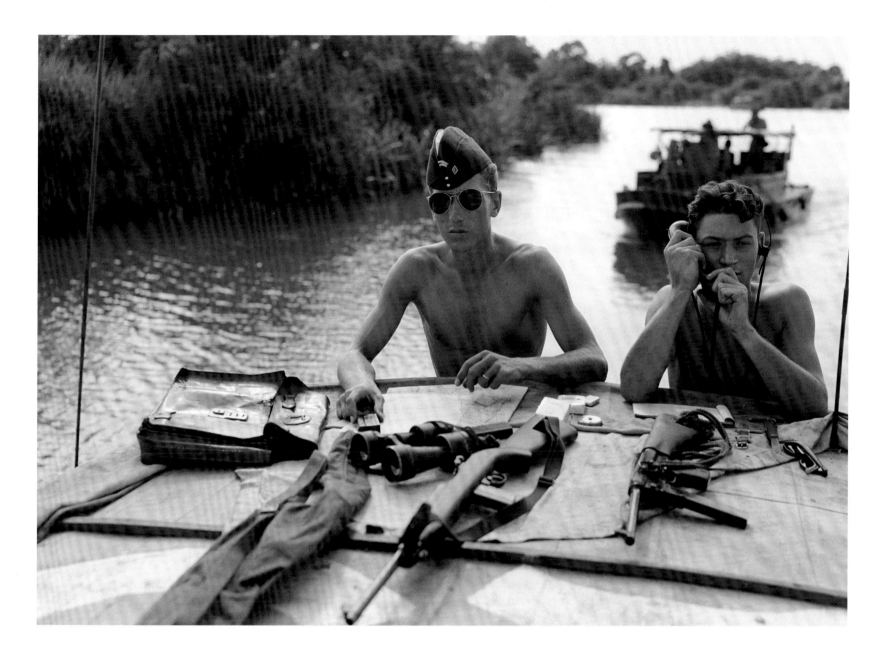

Armored boats of a French cavalry regiment protect a supply convoy against possible attack by the Viet Minh as it heads toward the Michelin rubber plantation near Dau Tieng, forty-five miles northwest of Saigon, February 10, 1951.

The facility, established in 1925, was the largest rubber plantation in Vietnam. Its workers were brutally exploited, and the plant became widely hated as a symbol of the harshness of colonial rule. Many of the tires used in French automobiles were manufactured from Vietnamese rubber. Seen here are Lt. Pierre Willemetz, the commander, and radioman Jacques Lange.

Photograph by Jean-Jacques Levy.

Two soldiers of the French Foreign Legion hold a captured Viet Minh fighter at gunpoint south of Saigon, November 1950.

One of the Legionnaires is inspecting the guerrilla's flag, which is emblazoned with the Communist symbol of the hammer and sickle.

AP Images Archive

43

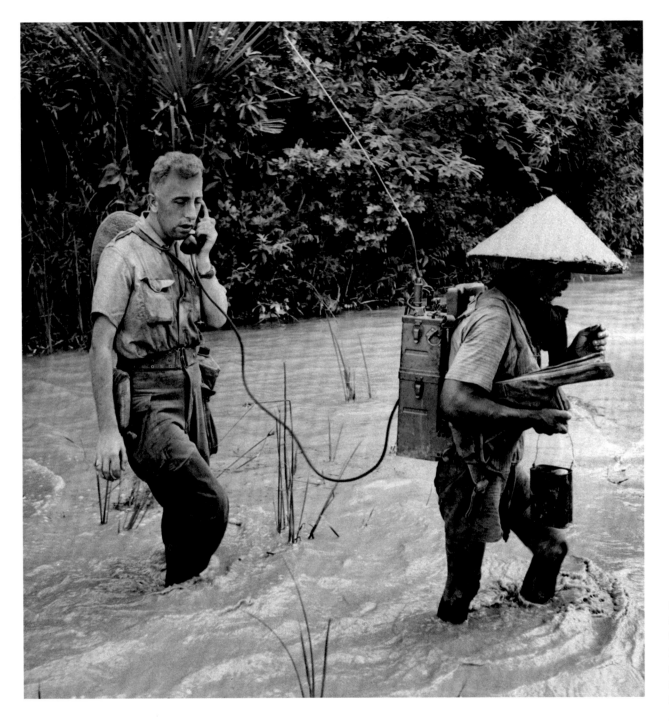

Assisted by a Vietnamese man carrying a portable radio strapped to his back, Sergeant Major Poncelet of Ecouviez, France, signals his position to his unit commander in the French colonial army, July 1951.

They were conducting an operation in territory held by the Viet Minh twenty-five miles northeast of Saigon.

AP Images Archive

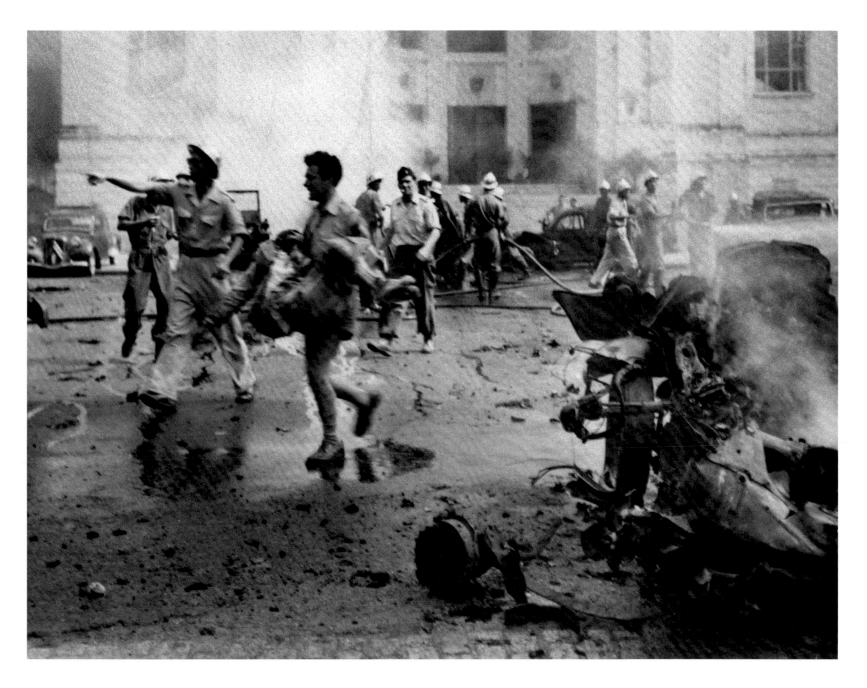

Vietnamese firemen hose down cars set ablaze by bomb explosions in Saigon's Place du Théâtre, while soldiers and police remove the dead and wounded, January 1952.

The bombings, among a series of attacks that took place in the city within days of one another, were blamed on guerrillas at the time. But many historians now believe they were carried out by U.S. intelligence agents hoping to discredit the Viet Minh and thus create support for a "third force," independent of both the French and the insurgents.

AP Images Archive

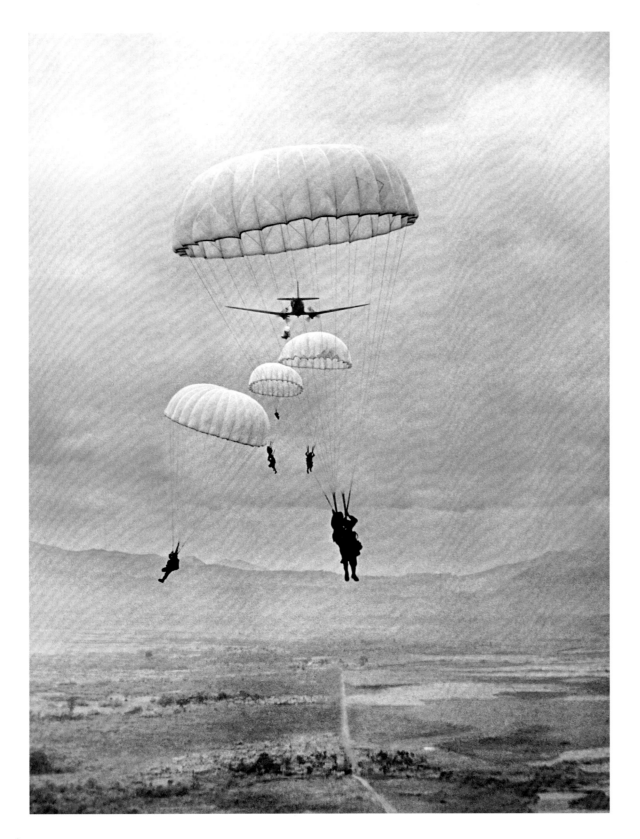

French paratroopers descend on the fortified outpost at Dien Bien Phu to provide reinforcements for soldiers trying to hold out against a siege by the Viet Minh, March 16, 1954.

The outpost's isolated location deep in a valley meant that the French required a constant stream of fresh men and supplies by air. But the Viet Minh were able to shoot down many of the planes. In early May, they overran the fortress and the French surrendered.

French military photograph by Daniel Camus/Jean Péraud.

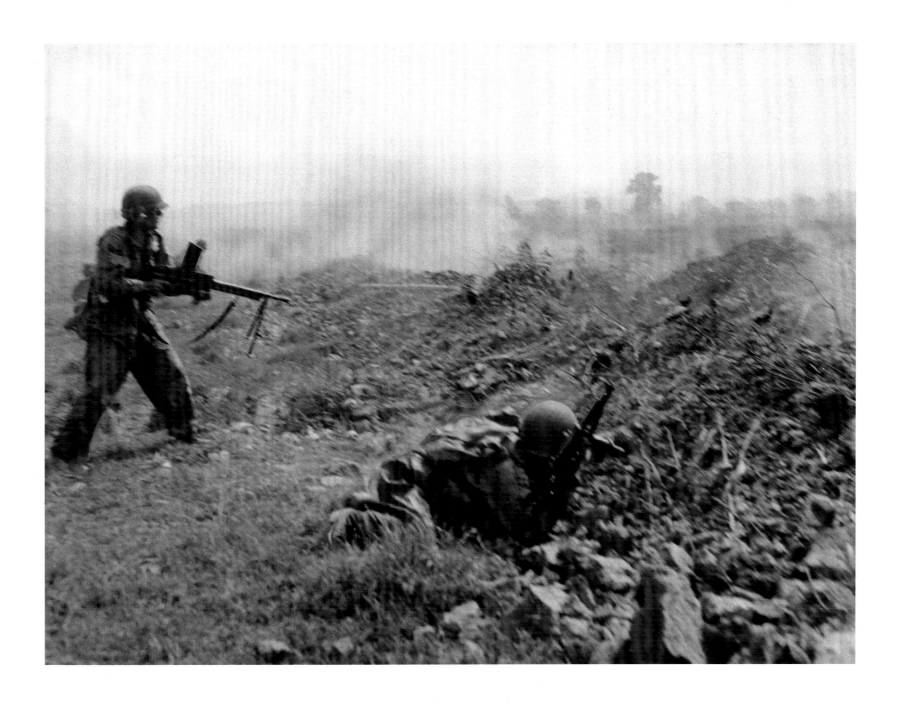

French soldiers return enemy fire on the shell-blasted battlefield at Dien Bien Phu, March 1954.

Two months later, France's defeat at the besieged outpost effectively signaled the end of French colonial rule in Indochina.

French military photograph by Daniel Camus/Jean Péraud.

French prisoners of war arrive in Hanoi after their release by the Viet Minh, August 1954.

They were part of a POW exchange that followed the signing of the Geneva Accords formalizing the end of French rule. The soldiers were handed over at Viet Tri and brought by boat about forty miles down the Red River to Hanoi.

Photograph by Fred Waters.

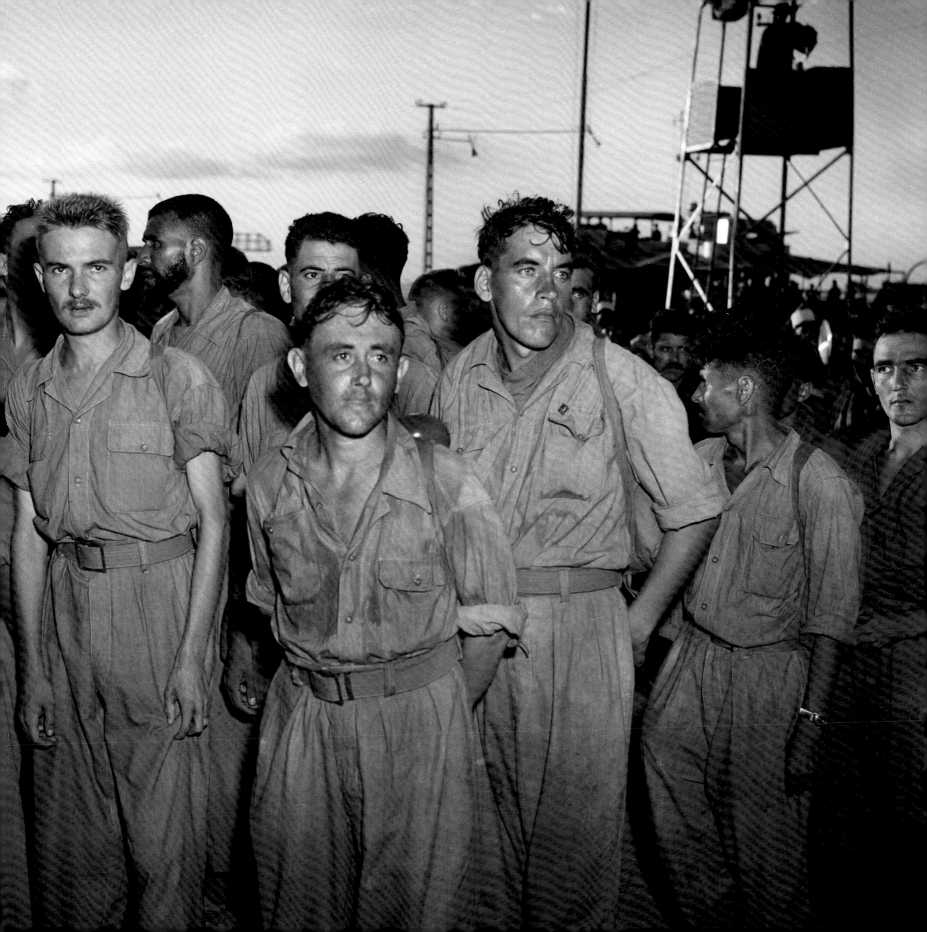

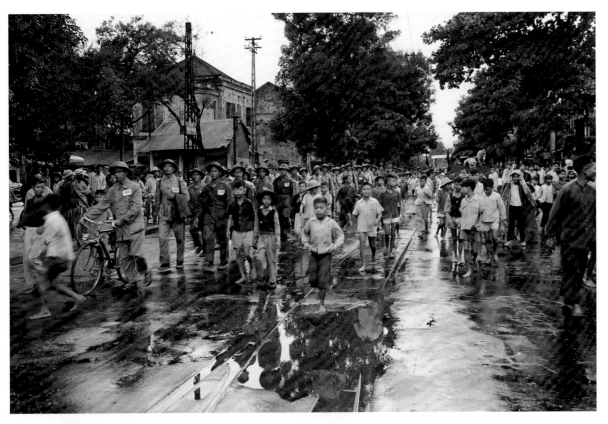

Barefoot children are among the first to welcome Viet Minh soldiers as they march into Hanoi to take over the city. October 9, 1954.

Under terms of the Geneva Accords, the country was divided into North and South Vietnam. Unification elections were supposed to be held in 1956, but these never took place.

AP Images Archive

Hanoi residents wave flags and hold banners as they wait for the parade to pass. October 9, 1954.

The red flag with a yellow star was officially adopted as the national flag of the Democratic Republic of Vietnam (North Vietnam) a year later. The slogan on the banner translates as "Respect and protect public property. Strictly keep order."

Photograph by Fred Waters.

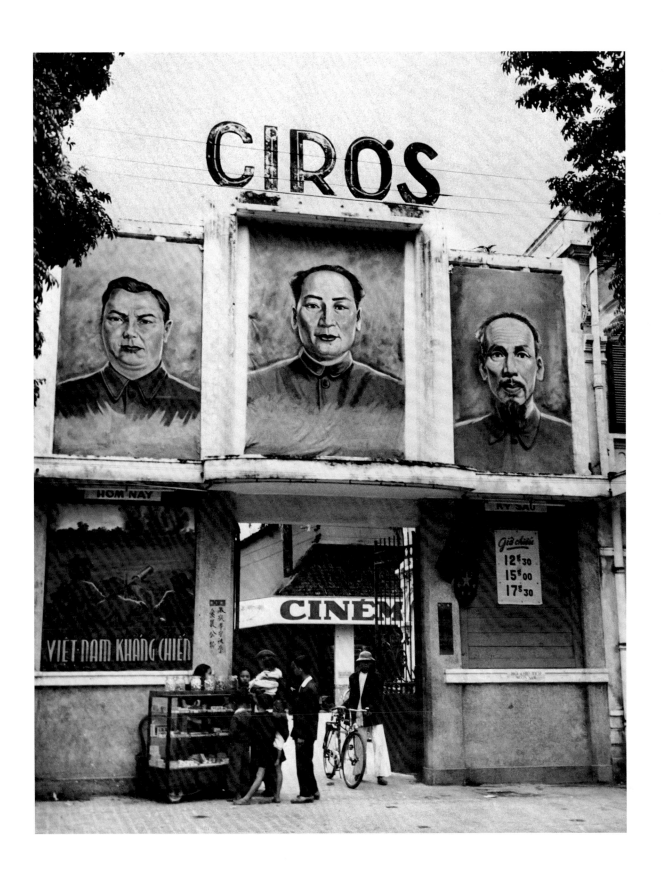

A Hanoi movie theater shows a film titled *The Vietnamese War of Resistance,* October 1954.

Atop the roof are portraits of (from left) Soviet prime minister Georgy Malenkov, Chinese Communist leader Mao Tse-tung, and Ho Chi Minh.

AP Images Archive

THE ASSOCIATED PRESS

P. O. BOX 782

SAIGON

PRIVATE

Mr. Ben Bassett
Foreign Editor

*WG — I propose t devel[...]
FYI— I propose t[...]
ask him try to devel[...]
a story about
BB[...]/9 Sept[...]*

Dear Ben:

A note in private just to let you know my [...]
Please don't let this get anywhere near a tele[...]

I think America in general is incapable of [...]
situation in Viet Nam, and to the extent that s[...]
on Washington efforts it will fail. For the la[...]
watched at close range while U. Alexis Johnson [...]
wrestled with the problems, and the whole thing [...]
babies turned loose in a tiger's cage. First, [...]
that there are excellent U.S. intelligence men [...]
the top officials here and in Washington don't [...]
them. They don't know the value of the informat[...]
which we, incidentally, get from some of them [...]

CHAPTER 1

UNITED STATES INTO THE BREACH

1954–64

With Vietnam partitioned, Ho and the Communists controlled the North from the capital of Hanoi.

In the South, Emperor Bao Dai, who had been the French puppet head of state, moved to exile in Paris. He appointed as prime minister Ngo Dinh Diem, who was closely allied with the United States in the person of Col. Edward G. Lansdale, an Air Force officer and CIA operative in Saigon.

Diem, a staunch anti-Communist and deeply conservative Catholic in a nation where 70 percent of the population were Buddhists, took over the presidency in a rigged referendum in October 1955.

Diem refused to allow the reunification elections specified in the Geneva Accords, and he and his brother, Ngo Dinh Nhu—his chief political adviser—initiated a campaign to root out elements of the Viet Minh and other opponents of his regime.

He requested and got U.S. instructors for the Army of the Republic of Vietnam (ARVN). The first Green Berets arrived in 1957 to work with South Vietnamese troops at a commando training center in the coastal city of Nha Trang.

This advisory force would grow to more than seven hundred by the time Eisenhower left office, and to more than three thousand by the end of 1961.

< *This private and prescient memo of September 15, 1964, from Saigon correspondent Malcolm Browne to foreign editor Ben Bassett likens the faltering efforts of U.S. diplomats to "so many babies turned loose in a tiger's cage" and concludes that "America in general is incapable of handling the situation in Vietnam." Bassett, in his handwritten note at the top, recommends to general manager Wes Gallagher that Browne develop his observations into a story.*

Foreign Bureau Correspondence, AP Corporate Archives

By 1957, insurgents had resumed guerrilla activities in South Vietnam, assassinating more than four hundred local governmental officials. Thirteen Americans were wounded in bombings in Saigon on October 22. And in July 1959, guerrillas killed two U.S. advisers: Maj. Dale R. Buis and M.Sgt. Chester M. Ovnand were with a group in the mess hall at the Bien Hoa military base watching the 1957 movie *The Tattered Dress*, starring Jeanne Crain, when the room was sprayed with automatic weapons fire. Theirs are the first two names on the Vietnam Veterans Memorial in Washington.

Meanwhile, Diem and Nhu implemented a program in 1959 to remove the neutral population from contact with the guerrillas by displacing them from their ancestral villages and resettling them into large communities. This effort, a forerunner of the Strategic Hamlet Program that the United States would implement three years later, backfired: It created resentment among the peasants and, if anything, tended to increase their support for the guerrillas. Both programs would eventually be abandoned.

In December 1960, with help from Ho, insurgents in South Vietnam established the National Liberation Front (known as the Viet Cong). This successor to the Viet Minh encouraged participation of non-Communists in a nationalist movement to reunify the country. The Viet Cong quickly gained control of large sections of the countryside, especially in the southern portions of the agriculturally rich Mekong Delta to the west of Saigon.

As the military situation worsened, Vice President Johnson visited Asia on behalf of the new Kennedy administration. Meeting with Diem in Saigon on May 12, 1961, Johnson praised him as the "Churchill of Asia" and promised additional military aid.

In October, after a fact-finding mission to South Vietnam, Gen. Maxwell Taylor reported to Kennedy a "double crisis of confidence"—concerns about the U.S. commitment to Southeast Asia and fears that Diem's methods would not defeat the Communists. Kennedy followed his advice to send additional advisers and military aid, but the president turned down Taylor's recommendation to send in eight thousand ground troops posing as a "flood control team."

If there were an official date marking the start of the U.S. war in Vietnam, many would cite December 11, 1961. On that day, the aviation transport carrier USNS *Core* arrived in Saigon, delivering thirty-three helicopters along with four hundred air and ground crewmen to operate and maintain them in support of the ARVN. These H-21C helicopters, known as "flying bananas," were assigned to quickly airlift South Vietnamese troops into combat, and the surprise element in this new air mobility would set the Viet Cong back for a year or more until the guerrillas learned to adapt.

Sixteen American deaths were blamed on the war in 1961, according to statistics maintained by the Defense Department's Defense Casualty Analysis System. Other tallies vary slightly, but the DoD is the official record keeper and is the source for all the annual U.S. casualty figures used in this book.

At the beginning of 1962, the United States launched Operation Ranch Hand, a program in which Air Force planes sprayed dense vegetation with chemical defoliants—including the notorious Agent Orange, which contained dioxin. Millions of gallons of these powerful herbicides would be sprayed on 10 to 20 percent of Vietnam and parts of Laos from 1962 to 1971 to remove vegetation from around U.S. bases, clear away forest cover, and wipe out crops to cut into the insurgents' food supply.

Throughout 1962, the United States continued its buildup, now under Gen. Paul D. Harkins. In May, Secretary of Defense Robert S. McNamara visited South Vietnam and reported, "We are winning the war." By year's end, there were eleven thousand Green Berets and other U.S. military personnel and technicians in South Vietnam.

In all, fifty-three Americans died in Vietnam in 1962.

But despite the influx of manpower and McNamara's optimistic view, the war was not going well. Much of the problem was the unwillingness of South Vietnamese troops and their commanders to engage the Viet Cong aggressively for fear of suffering heavy casualties themselves.

This weakness became particularly clear in January 1963 at the battle of Ap Bac, a village in the Mekong Delta fifty miles southwest of

Saigon. Despite tremendous superiority in firepower and troops, the ARVN 7th Division failed to capture a much smaller guerrilla outfit. The South Vietnamese lost sixty-eight men, with one hundred more wounded. Three Americans were killed and ten wounded. In addition, five helicopters were destroyed; by now the Viet Cong had learned how to shoot the choppers down.

Just as telling as the refusal of government troops to pursue the enemy was the disconnect between the high command's verdict and that of advisers on the ground.

Harkins described the outcome in glowing terms. Speaking to reporters as he was about to fly back to Saigon from an airfield near the battle, the general boasted, "We've got them in a trap, and we're going to spring it in half an hour."

But there were no Viet Cong left in the vicinity to trap. John Paul Vann, the U.S. adviser to the 7th Division, gave a very different assessment: "It was a miserable damn performance," Vann said of the South Vietnamese. "These people won't listen. They make the same mistakes over and over again in the same way."

Harkins would leave South Vietnam in June 1964, replaced by Gen. William C. Westmoreland.

Meanwhile, Diem's hold on power began to weaken. On May 8, 1963, his Civil Guard killed nine people in a crowd in Hue protesting a ban on flying the Buddhist flag on Buddha's birthday.

Further demonstrations were violently suppressed, and on June 11 the first of several Buddhist monks committed suicide by setting himself on fire. Associated Press reporter Malcolm Browne's photos of Thich Quang Duc drew worldwide outrage—as did the comments of Diem's sister-in-law, Madame Nhu, who mocked the suicide as "a barbecue" and stated, "Let them burn, and we shall clap our hands."

Diem declared martial law, and in August the secret police raided Buddhist temples. These actions only intensified opposition.

By now, the United States had concluded that Diem was a liability, and the U.S. government secretly gave encouragement to a dissident group of South Vietnamese generals. On November 1, Diem and his brother were overthrown in a coup, and the next day they were executed. In the resulting power vacuum, a series of military and civilian governments jockeyed for control.

The Viet Cong, meanwhile, used the unstable political situation to launch offensives that increased their influence over the rural population of South Vietnam.

The U.S. death toll for 1963 totaled 122.

When Lyndon B. Johnson became president following John F. Kennedy's assassination on November 22, he was at first as reluctant as his predecessors to commit ground troops. But he raised the stakes in several ways. Starting in January 1964, he approved covert actions against North Vietnam, including ARVN commando raids on coastal installations. In March, secret U.S.-backed bombing raids, conducted by mercenaries flying old American fighter planes, began targeting the Ho Chi Minh Trail inside Laos. Actually a complex jungle transportation network, this was the main route for moving troops and supplies from North to South Vietnam.

Despite Johnson's escalation, without a large U.S. ground presence a Gallup poll in May 1964 found that 63 percent of the American public was paying "little or no attention" to the war.

That would change after the commando raids led to a confrontation. On August 2, three North Vietnamese PT boats, responding to attacks on their territory in the waters of the Gulf of Tonkin, exchanged fire with the USS *Maddox*. Two days later, the USS *Turner Joy* reported being attacked as well, although that account has since been discredited.

Johnson ordered Seventh Fleet carrier aircraft to retaliate on August 5 by hitting military targets in North Vietnam, including bases used by the torpedo boats. Two days later, he asked Congress to approve the Tonkin Gulf Resolution, which handed the president virtually unlimited power to conduct war in Vietnam.

The House passed the resolution 416–0 and the Senate 88–2, with the only "No" votes cast by Sens. Wayne Morse of Oregon and Ernest Gruening of Alaska. Said the latter: "All Vietnam is not worth the life of a single American boy."

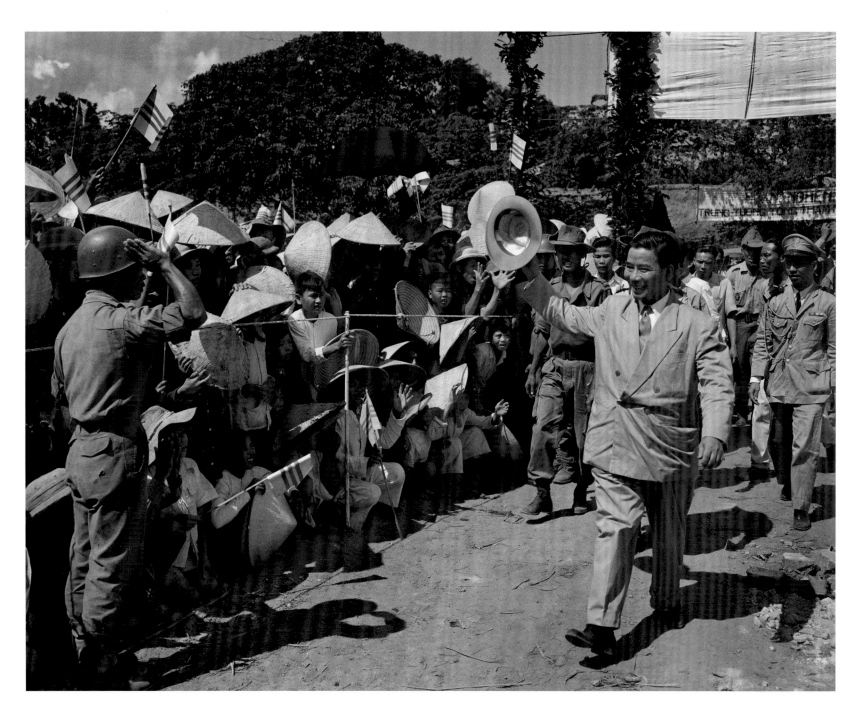

Ngo Dinh Diem, then the South Vietnamese prime minister, waves his hat to villagers who watch from behind a rope line during his visit to the coastal town of Binh Dinh, June 1955.

A few months later, Diem would be elected president.

Photograph by Fred Waters.

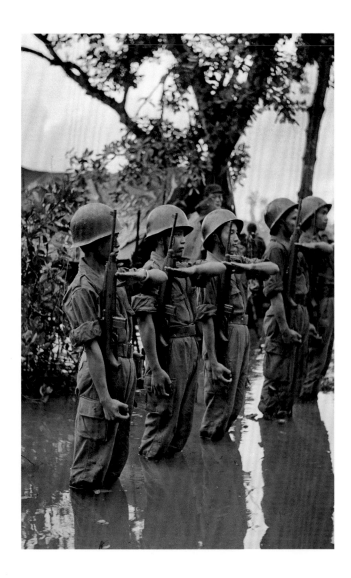

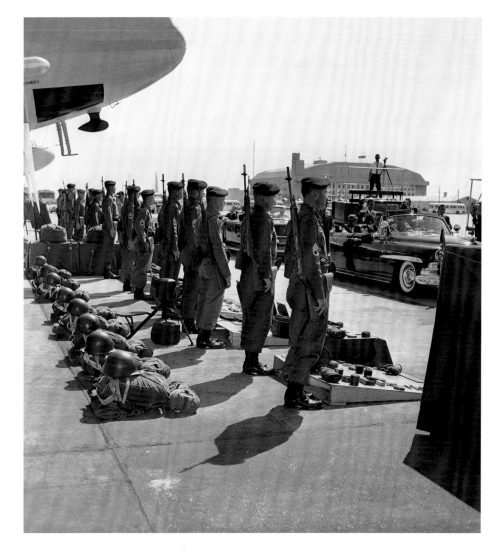

Standing knee-deep in swamp water,
South Vietnamese infantrymen
salute Diem as he tours the Rung Sat
swamplands, October 1955.

He was congratulating the soldiers on
their victory over paramilitary forces
of the Binh Xuyen, an organized
crime group that controlled drugs,
gambling, and prostitution. Diem
saw the elimination of such factions
as essential to consolidating his
control over the country.

AP Images Archive

President Kennedy, riding in an open
limousine, reviews the 1st Air Com-
mando Group at Eglin Air Force Base,
Florida, May 4, 1962.

The outfit was trained for guerrilla
warfare, and some of its members had
returned from action in Vietnam.

AP Images Archive

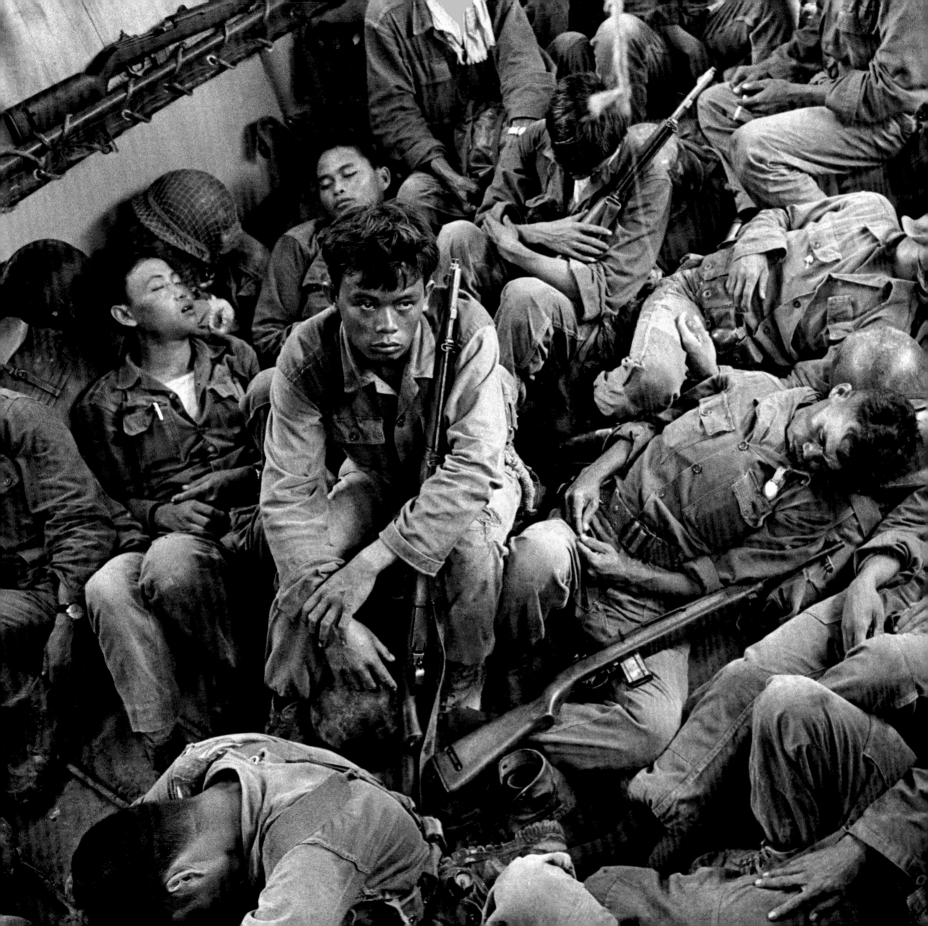

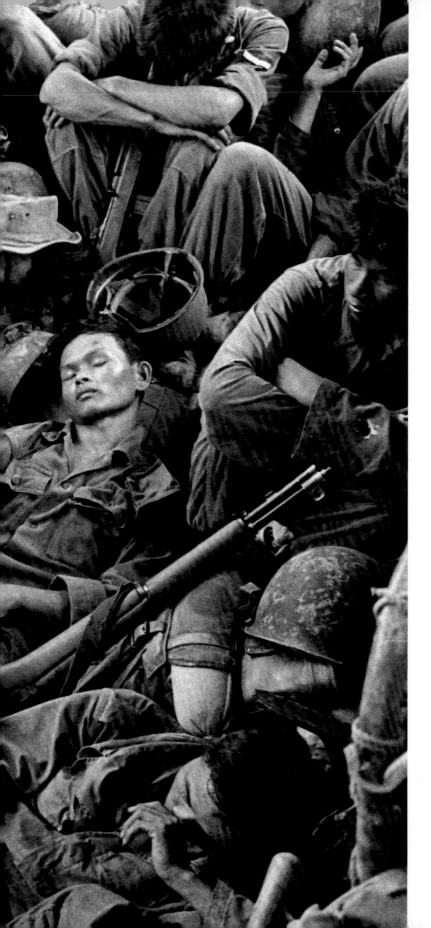

Exhausted South Vietnamese soldiers sleep on a U.S. Navy troop carrier taking them back to the provincial capital of Ca Mau, August 1962.

The infantry unit had been on a four-day operation against the Viet Cong in swamplands at the southern tip of the country.

Photograph by Horst Faas.

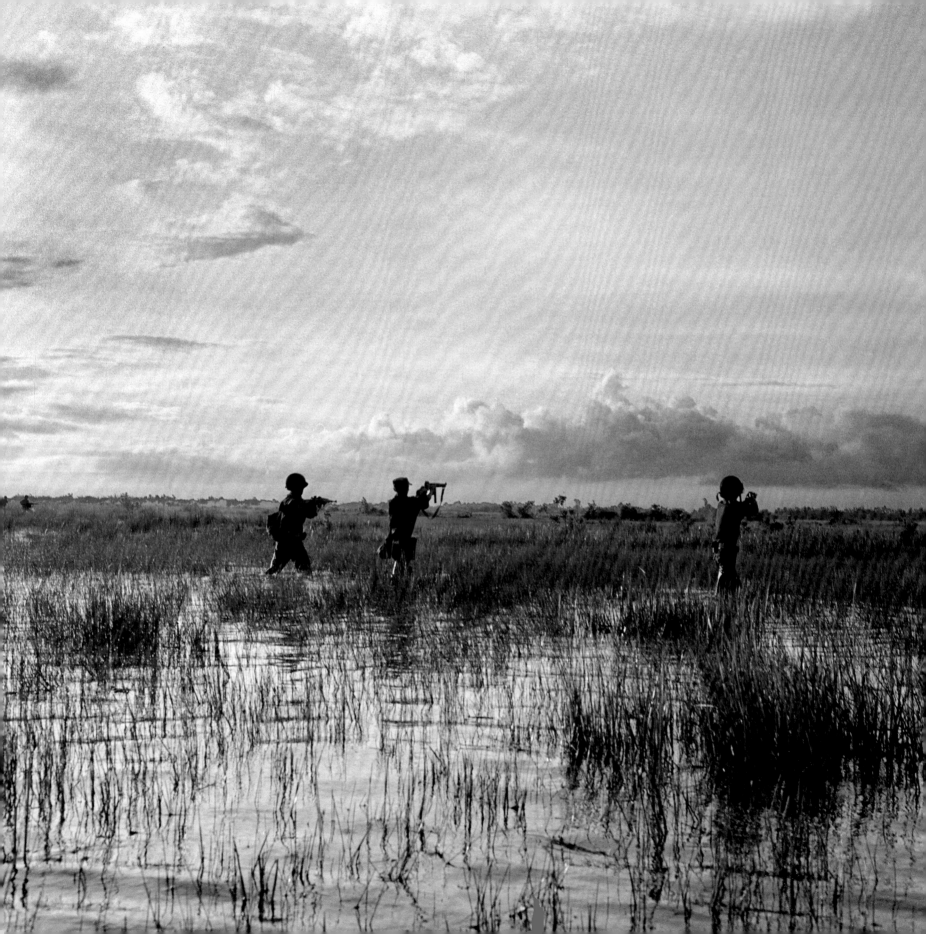

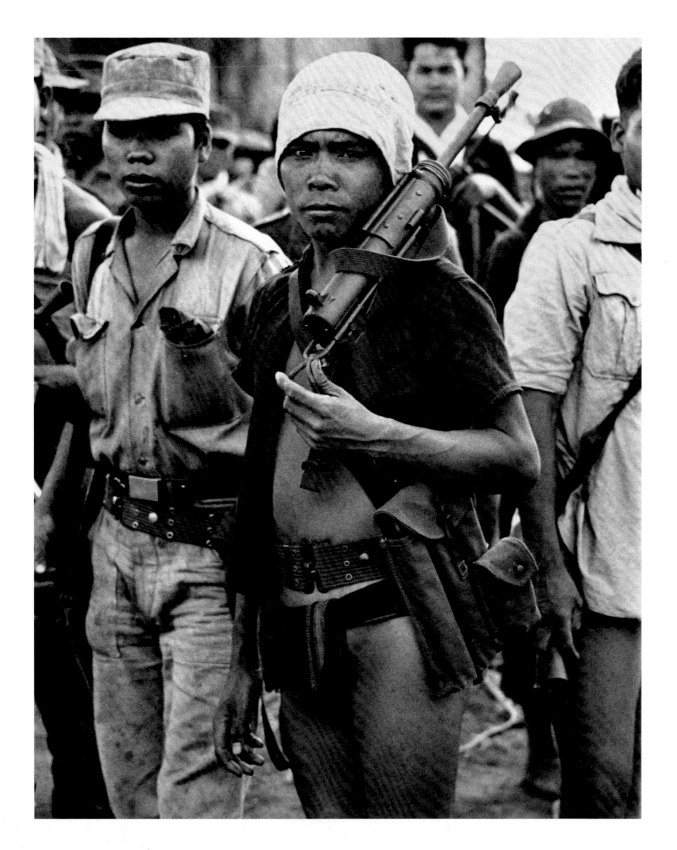

OPPOSITE: Members of the South Vietnamese Civil Guard advance across a paddy, firing all the way, toward a line of woods along a canal where the Viet Cong were hiding in the Mekong Delta, October 5, 1962.

An estimated seventy Viet Cong were killed in the operation, along with more than twenty government troops and an American helicopter machine gunner. The photographer, Horst Faas, was under fire much of the time.

A Montagnard tribesman in the Central Highlands of South Vietnam carries an automatic weapon as he receives military training, late 1962.

Uniforms were not issued to the trainees, who instead wore loincloths, old French uniforms, or discarded European clothing. The Montagnards, an oppressed ethnic minority within the Vietnamese population, were recruited by the U.S. Army's Special Forces, and up to forty thousand of them fought against the Viet Cong. After the war, many fled with their families as refugees to the United States.

AP Images Archive

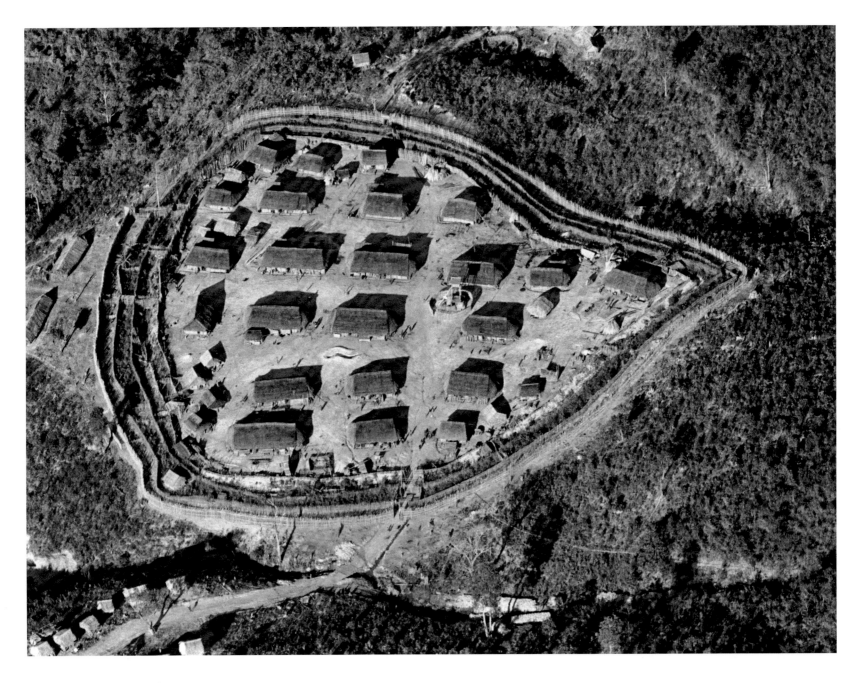

An aerial view of a fortified "self-defense" village into which Montagnard families were moved near Kontum in the Central Highlands, December 1962.

The village was built as part of a resettlement program by the U.S. and South Vietnamese governments, designed to reduce the ability of the Viet Cong to operate freely among the population in the area. Before resettlement, most of these tribal people lived in units of two or three families.

Photograph by Horst Faas.

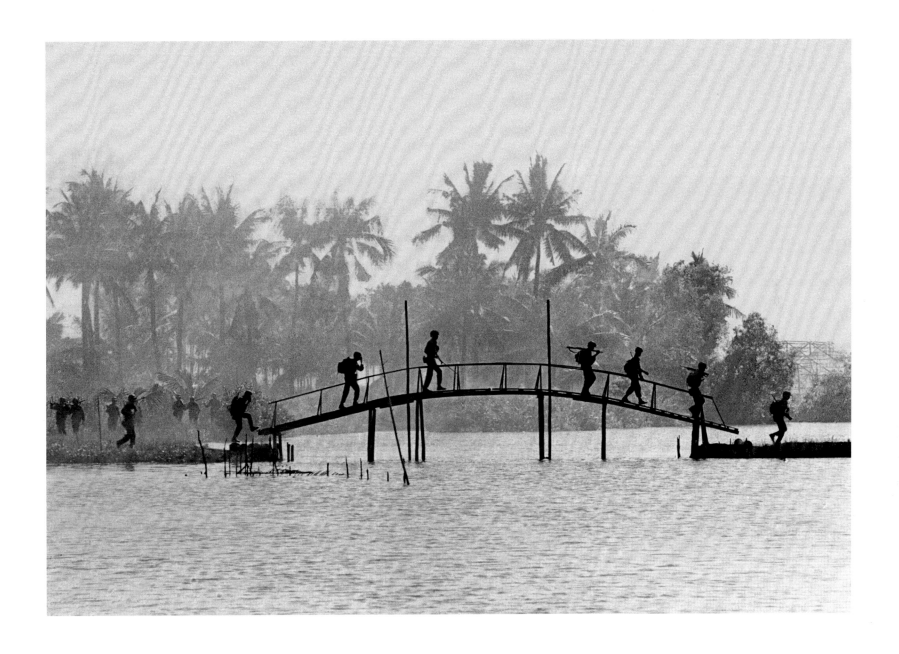

South Vietnamese troops are silhouetted against a background of palm trees and jungle as they cross a wooden bridge en route to the village of Ap Ba Nam, deep in southern Ca Mau Province in 1962.

About 4,000 troops were on a five-day mission in the Viet Cong stronghold.

Photograph by Horst Faas.

In the first of a series of fiery suicides by Buddhist monks, Thich Quang Duc burns himself to death on a Saigon street to protest persecution of Buddhists by the South Vietnamese government, June 11, 1963.

The photograph aroused worldwide outrage and hastened the end of the Diem government. With the photo on his Oval Office desk, President Kennedy remarked to his ambassador, "We're going to have to do something about that regime."

Photograph by Malcolm Browne.

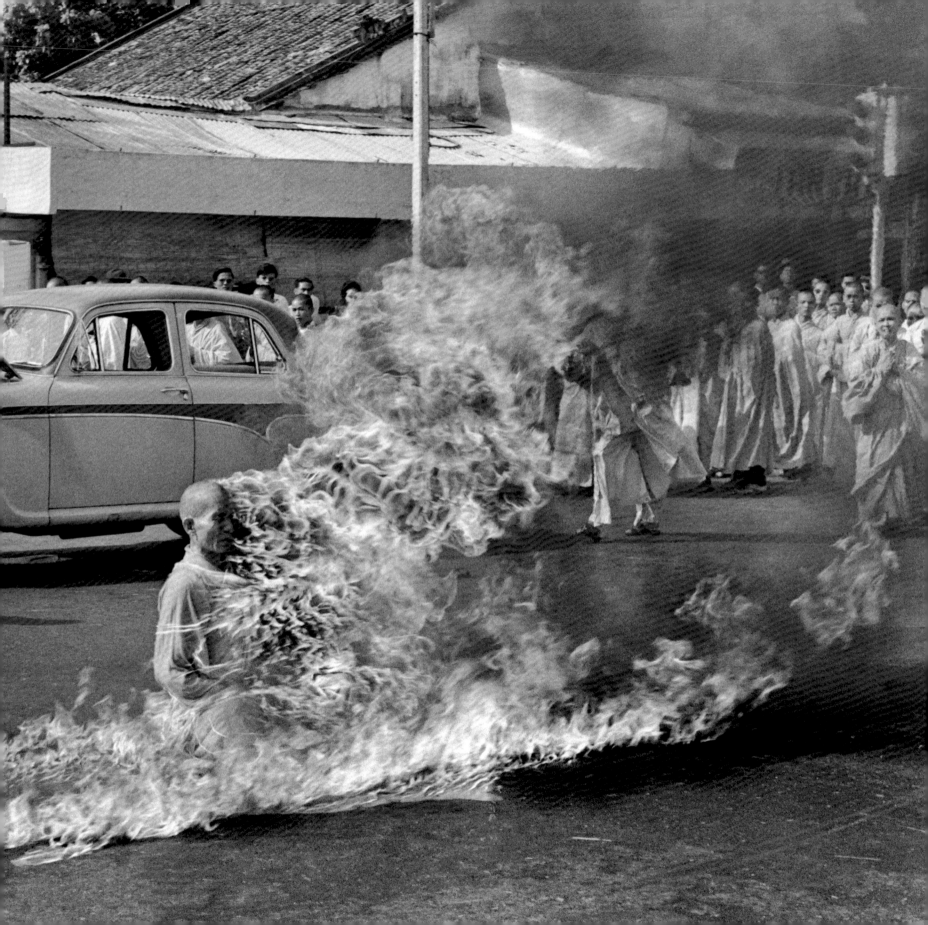

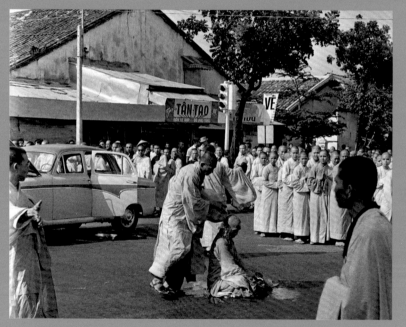

"At that point he pulled out a box of matches and struck one of them and dropped it in his lap. And the flames of course engulfed him immediately, and his face winced. You could tell from his expression that he was in terrible pain, but he never cried out. And he burned for, oh, I suppose, ten minutes or so; it seemed like an eternity . . . and the monks and nuns were crying out and screaming. A fire truck arrived and tried to get through the circle, but a couple of the monks dashed under the front wheels and lay down on the pavement, so that it could advance only by rolling over them, and all this while I was taking pictures of course. The only thing that sort of keeps you going in war or in times of crisis like that is having something to

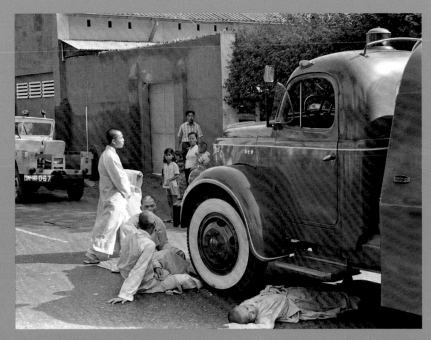

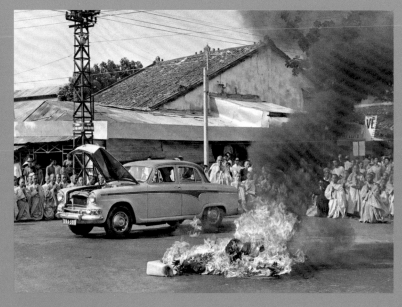

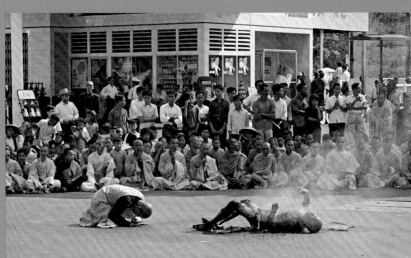

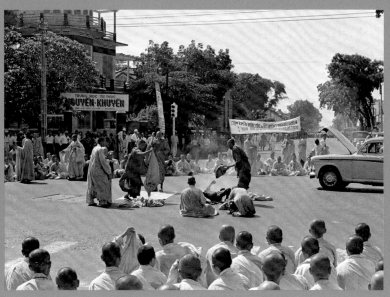

do, and so I just—it was technically a very easy series of photographs to take. . . . I suppose I took, I forget, four or five rolls of Tri-X film. And in due course, he toppled over, absolutely

rigid. He was so rigid with his arms out that they couldn't get him into the wooden coffin that they had been carrying, so they just placed him on top of it, and then marched him back to

the Xa Loi Pagoda . . . where he lay in state for a couple of days."

—Malcolm Browne, from an interview with Hal Buell, April 21, 1998, for the AP Corporate Archives Oral History Program.

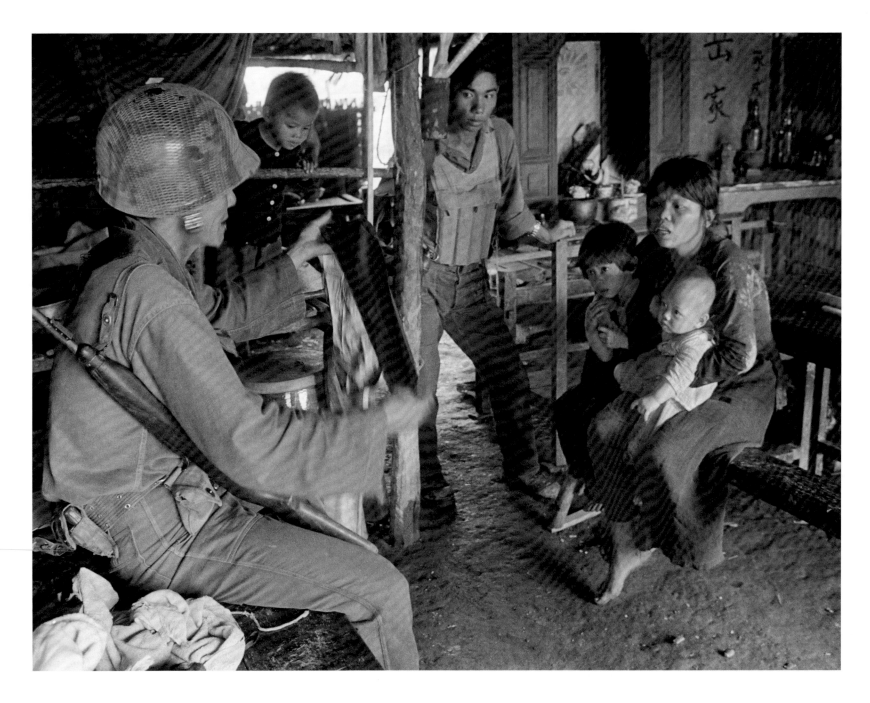

A woman clutches her two children as she is questioned about her husband by a soldier at Ca Mau, in the swampy delta area at the southern tip of South Vietnam, December 11, 1962.

Her husband, a suspected Viet Cong guerrilla, was missing when government troops raided the village. Documents relating to the insurgency were found in the house.

Photograph by Horst Faas.

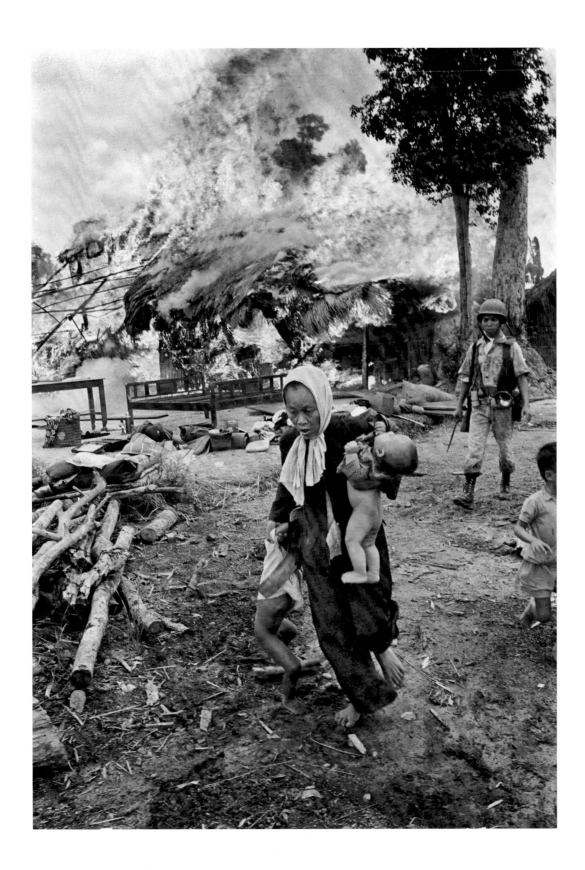

Their home burning in a fire set by South Vietnamese troops, a Vietnamese woman carries a baby and pulls her daughter toward safety near Tay Ninh, about sixty miles northwest of Saigon, July 1963.

In the background are a few of their salvaged belongings. The village was believed to be a supply depot for about one hundred Viet Cong guerrillas.

Photograph by Horst Faas.

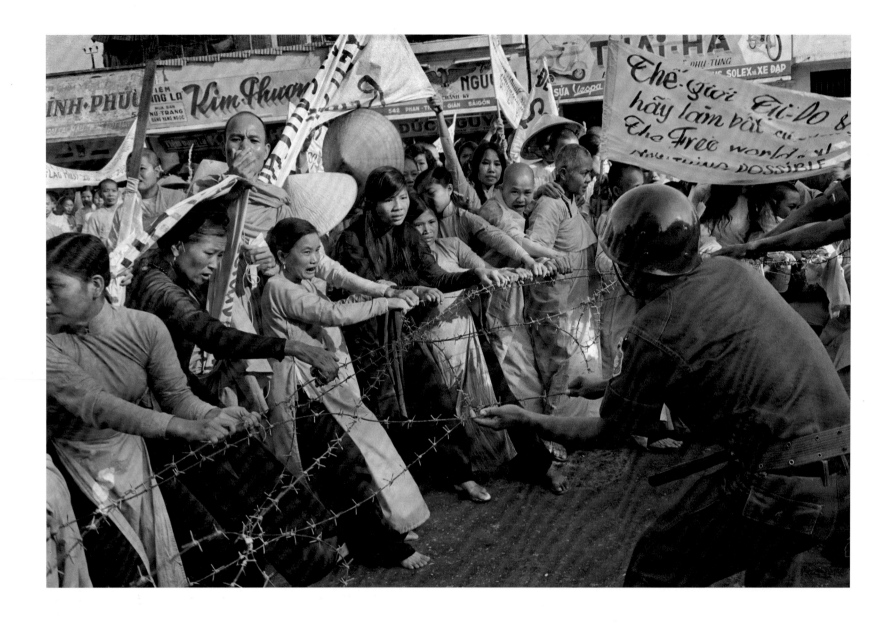

Buddhist monks and women pull at a barbed-wire road barricade that was set up in front of Saigon's Giac Minh Pagoda to halt a demonstration, July 17, 1963.

Police wielding clubs injured at least fifty people during the protest, one of many during this period by Buddhists opposed to the Diem regime. The following month, secret police raided temples throughout the country, an act that only heightened anger against the government.

Photograph by Horst Faas.

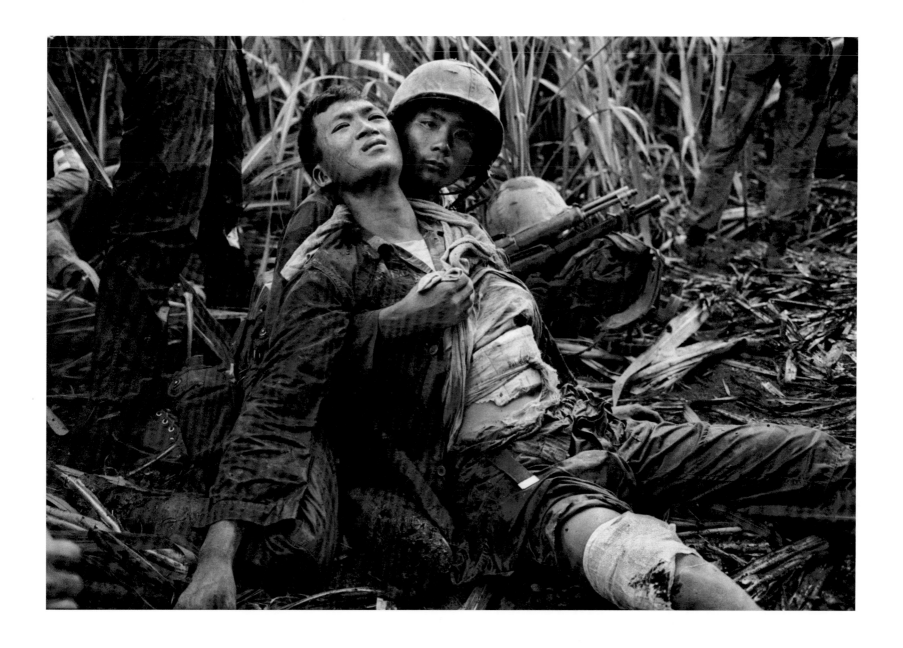

A South Vietnamese Marine, severely wounded in a Viet Cong ambush, is comforted by a comrade in a sugarcane field at Duc Hoa, August 5, 1963.

A platoon of thirty Marines was searching for guerrillas when a long burst of automatic fire killed one Marine and wounded four others.

Photograph by Horst Faas.

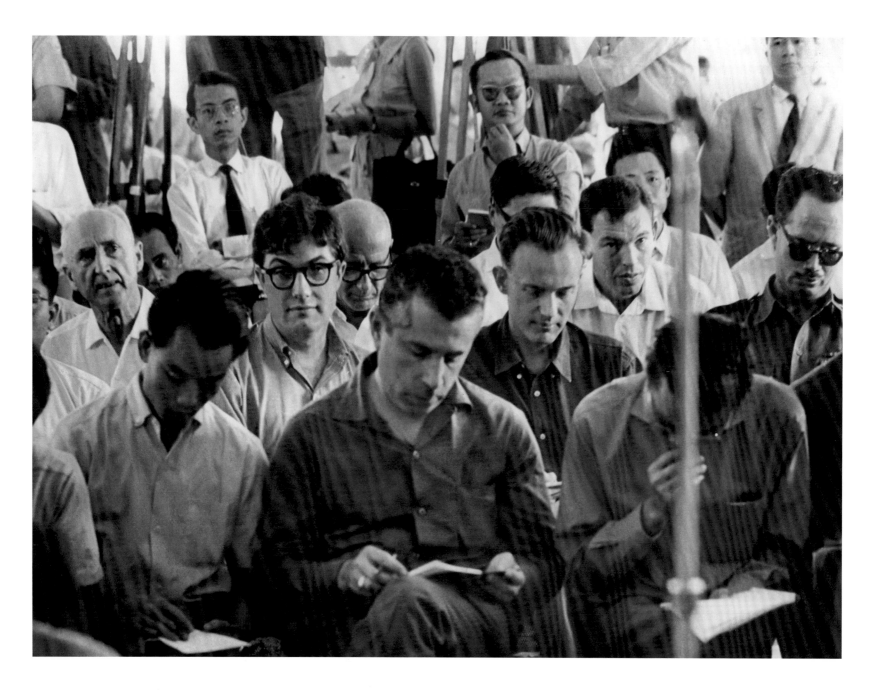

Journalists attend a briefing by military officers in Saigon, around 1963.

These regular briefings became known derisively as the "Five O'Clock Follies" because much of the information released there was inaccurate and misleading. At center in the foreground is Seymour Topping, a former Associated Press correspondent in Saigon then working for the *New York Times*. Immediately behind him to the left, with dark-framed glasses, is Neil Sheehan of UPI; behind Topping to the right is Malcolm Browne of the AP.

AP Images Archive

Ngo Dinh Nhu, brother of Diem, sits in front of a map of Southeast Asia during an interview with foreign journalists in his study in the presidential palace, September 5, 1963.

Nhu, chief of the secret police, would be assassinated along with his brother less than two months later.

Photograph by Horst Faas.

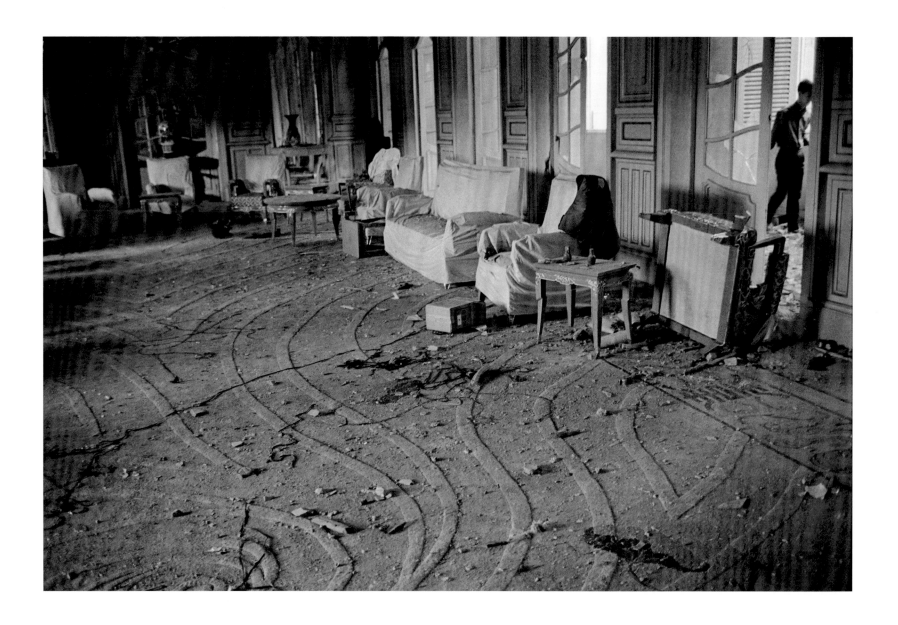

Destruction visible inside Gia Long Palace in the wake of the successful military coup against the Diem regime, November 2, 1963.

Diem and Nhu escaped from the presidential palace through a tunnel but were later arrested and then killed while being driven in a convoy to military headquarters.

AP Images Archive

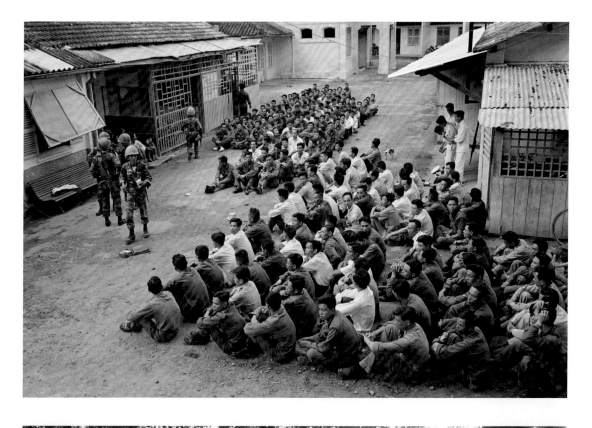

Seated in rows in the presidential palace courtyard, Diem's guards are themselves under guard after being captured in fighting during the coup, November 2, 1963.

AP Images Archive

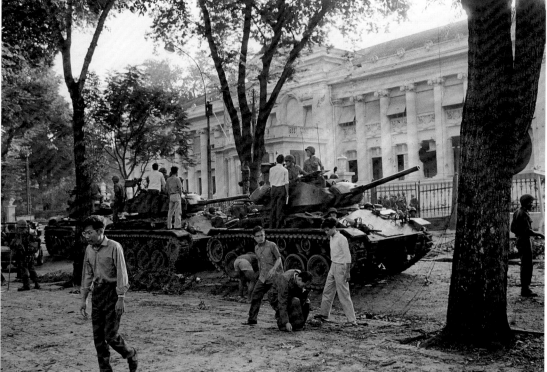

Rebel tanks remain in front of the presidential palace, November 3, 1963.

AP Images Archive

Wearing sunglasses, Madame Nhu is helped through a throng of reporters along with her daughter, Le Thuy, as they leave a Los Angeles hotel on their way to a villa in Bel Air, five days after the coup that resulted in the killings of her husband and brother-in-law, November 6, 1963.

The glamorous and polarizing unofficial "first lady" of South Vietnam had been out of the country on a speaking tour. Refused permission to return home, she and her children moved to Rome, and she spent the rest of her life living there and in southern France. She died on April 26, 2011, at age eighty-six.

AP Images Archive

saturday: manneck and merron continue c[...]

hugh mulligan flies to division headquarte[...]

cover return of units to base. arnett retur[...]

sunday, monday etc: manneck and merron c[...]
final phases of operation, with mulligan wr[...]
units to an khe. mulligan, while waiting t[...]
officer of one ambushed unit, ~~the~~ _Which_ saw these [...]
on personnel board: killed , enlisted men 1[...]
wounded, enlisted men 121, officers seven. [...]
six. total battalion strength 569. These fi[...]
ambush.

division paper itself called this actio[...] (NEWS)
term one ~~of~~ of things that upset[...]
coffey apparently saw merron and sawada [...]

hours in the field. If he had stayed around [...]
~~men~~ were in other areas when he dropped in. [...]
seen the rest of us. incidentally merron, w[...] (U.S.)
~~was~~ an australian, is a former paratrooper w[...]

CHAPTER 2

ESCALATION BY LAND AND BY AIR

1964–65

Although he now had the power to escalate U.S. involvement, Johnson was also running for a full term as president on a peace platform. Campaigning in the autumn of 1964, he declared: "We are not about to send American boys nine or ten thousand miles away from home to do what Asian boys ought to be doing for themselves."

But even as he spoke those words, he and his advisers were planning to do just that, if they deemed it necessary.

And events as 1964 came to a close made it clear how dire the situation was becoming:

• By autumn, China had massed troops along its border with North Vietnam as a show of support.

• On November 1, two days before the presidential election, the Viet Cong shelled the airfield at Bien Hoa Air Base, twelve miles north of Saigon, with mortars. Four Americans were killed, seventy-six wounded, and twenty aircraft destroyed. It showed the guerrillas that they could disrupt U.S. air operations with direct attacks on bases—and there would be more than four hundred such attacks before the war ended.

• In December, ten thousand North Vietnamese soldiers arrived in the Central Highlands of South Vietnam via the Ho Chi Minh

< *Peter Arnett responds in this December 22, 1965, memo to foreign editor Ben Bassett's request for a detailed account of how AP covered the battle of Ia Drang, the bloodiest of the war up to that point and the first in which U.S. troops directly faced the North Vietnamese. As Arnett points out in one of his handwritten insertions, AP's use of the word "ambush" to describe an attack on a retreating U.S. battalion "upset" the "brass," even though a military newspaper had used the same term. AP's reporting had also been called into question by Raymond Coffey of the* Chicago Daily News, *who, as Arnett observes here, arrived at the scene late and left early.*

Saigon Bureau Records, AP Corporate Archives

Trail, bringing arms provided by China and the Soviet Union.

• Combined forces of the North Vietnamese Army (NVA) and Viet Cong began attacking troops in villages around Saigon.

• On December 24, Viet Cong terrorists set off a car bomb at the Brinks Hotel, a U.S. officers' residence in downtown Saigon. Two Americans were killed and more than fifty wounded. Entertainer Bob Hope had been scheduled to perform there that day and was an apparent target. He later joked: "A funny thing happened to me when I was driving through downtown Saigon to my hotel last night. We met a hotel going the other way."

Weeks after winning election in a landslide, Johnson met at the White House on December 1 with his top aides, including McNamara, Secretary of State Dean Rusk, and National Security Adviser McGeorge Bundy. They agreed to gradually increase U.S. involvement, but at this point Johnson still dismissed recommendations for sustained air strikes against North Vietnam.

By the end of 1964, there were twenty-three thousand U.S. military advisers in South Vietnam.

During the year, 216 Americans had been killed.

It was not long into 1965 before Johnson changed his mind about the bombing. On February 6, the Viet Cong attacked Camp Holloway, a U.S. base near Pleiku in the Central Highlands, killing eight Americans and wounding more than one hundred. "I've had enough of this," Johnson told senior advisers, and he ordered retaliatory bombardment of North Vietnam the next day. The campaign, known as Operation Flaming Dart I, marked the official start of the air war.

That war would soon be expanded. In early March, the Viet Cong bombed a barracks at Qui Nhon, killing twenty-three Americans. In response, the U.S. military initiated "continuous limited air strikes," known as Operation Rolling Thunder. These strikes would be carried out almost without interruption for more than three and a half years—yet they never achieved their goal of stopping the North Vietnamese from aiding the Viet Cong.

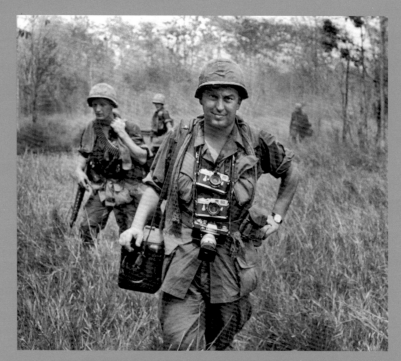

Horst Faas, accompanying U.S. troops in War Zone C (date unknown).

Now the United States began deploying ground troops as well. On March 8, 1965, the first combat troops, the 9th Marine Expeditionary Brigade, arrived in South Vietnam to defend the U.S. airfield at Da Nang. In May, they were followed by more Marines and Army units of the 173rd Airborne Brigade.

These deployments triggered the first major protests in the United States. A "teach-in"—featuring seminars, rallies, and speeches—took place at the University of Michigan, in Ann Arbor, on March 24, and similar events soon spread to other campuses. On April 17, more than twenty-five thousand people in Washington demonstrated against the war. In autumn, there would be more large protests in the nation's capital and other cities.

The South Vietnamese government, meanwhile, finally attained a measure of stability in June after ten coups in two and a half years. Nguyen Cao Ky, the flamboyant chief of the Air Force, became prime minister with Gen. Nguyen Van Thieu of the ARVN as his

figurehead chief of state. Two year later, Thieu would be elected president with Ky as his running mate.

The United States backed their regime, but by July the military situation had become so precarious that Johnson granted Westmoreland's request for a significant new influx of ground forces. At a July 28 news conference, Johnson announced that he was sending forty-four combat battalions, increasing the U.S. presence to 125,000 men.

"I do not find it easy to send the flower of our youth, our finest young men, into battle," Johnson said that day. "I have seen them in a thousand streets, of a hundred towns, in every state in this union—working and laughing and building, and filled with hope and life. I think I know, too, how their mothers weep and how their families sorrow."

In August, U.S. Marines engaged in their first major combat, Operation Starlite, against a Viet Cong regiment that was planning to attack a U.S. installation at the seaport of Chu Lai. The guerrillas, deciding to test the new American military machine, stood their ground and fought, instead of slipping away as they often did in the face of superior firepower. The result was heavy casualties on both sides.

The first large-scale direct clash between U.S. forces and North Vietnamese units occurred in November in the Ia Drang Valley, southwest of Pleiku in the Central Highlands. Again there were heavy casualties: more than two hundred killed on the U.S. side in just four days, while the North Vietnamese lost many times that figure. Both sides claimed victory, but in a memo to Johnson, McNamara cited the battle as troubling evidence of "the increased willingness of the Communist forces to stand and fight, even in large-scale engagements," and he told the president that without substantial further escalation, the U.S. effort would prove futile.

By the end of 1965, U.S. troop levels neared two hundred thousand.

The year saw 1,928 Americans killed in Vietnam. That was nine times the toll of the previous year, and the figures would continue to rise dramatically for the next three years.

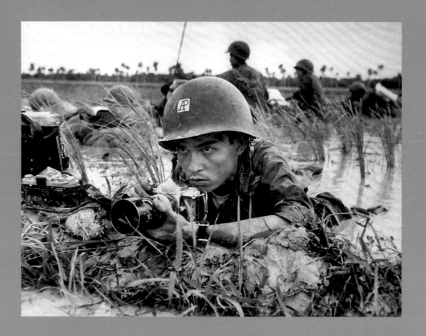

Huynh Thanh My, pinned down with a Vietnamese battalion in a Mekong Delta rice paddy, about a month before he was killed while covering combat on October 13, 1965. His younger brother, Nick Ut, later came to work for the AP as a photographer.

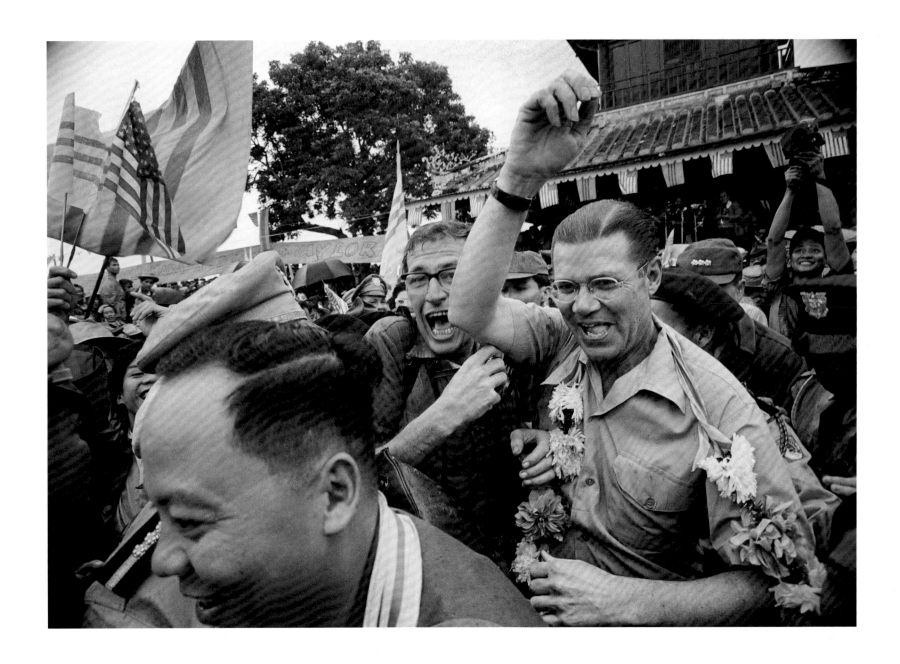

Robert McNamara, his floral neck wreath torn by well-wishers, works his way enthusi-
astically through a crowd in Hue, March 11, 1964.

At left in front of the secretary of defense is the South Vietnamese prime minister, Maj.
Gen. Nguyen Khanh. They were attending a mass rally, at which McNamara promised
that the United States would give its full support to defeat the insurgency.

Photograph by Horst Faas.

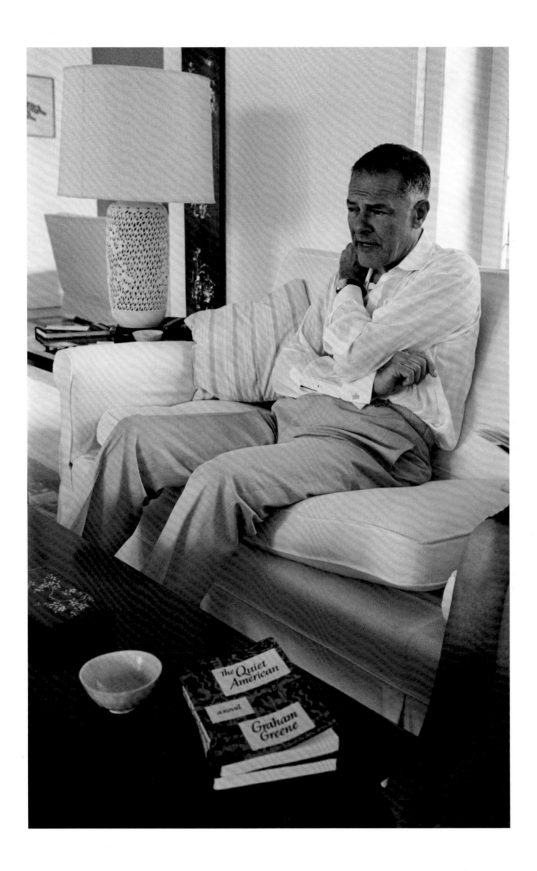

U.S. Ambassador Henry Cabot Lodge relaxes at home in Saigon, May 15, 1964.

On the coffee table is a copy of *The Quiet American*, a 1955 novel by Graham Greene that foreshadowed the disastrous consequences of U.S. involvement in Vietnam.

Photograph by Horst Faas.

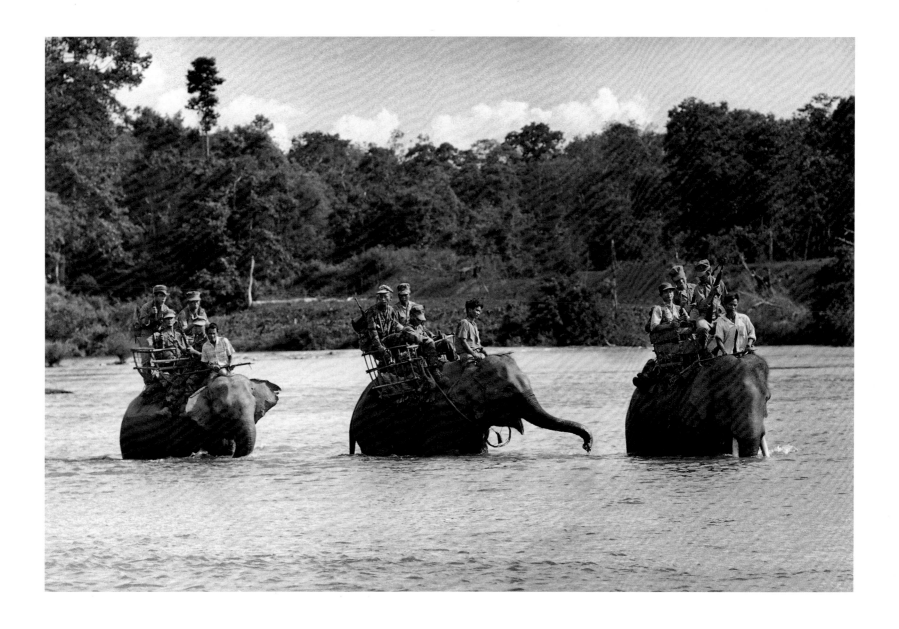

South Vietnamese soldiers ride elephants across a river in the Ba Don area, about twenty miles from the Cambodian border, as they patrol in search of Viet Cong guerrillas. June 1964.

In some conditions of jungle warfare, the animals proved a better means of transport than modern vehicles.

Photograph by Horst Faas.

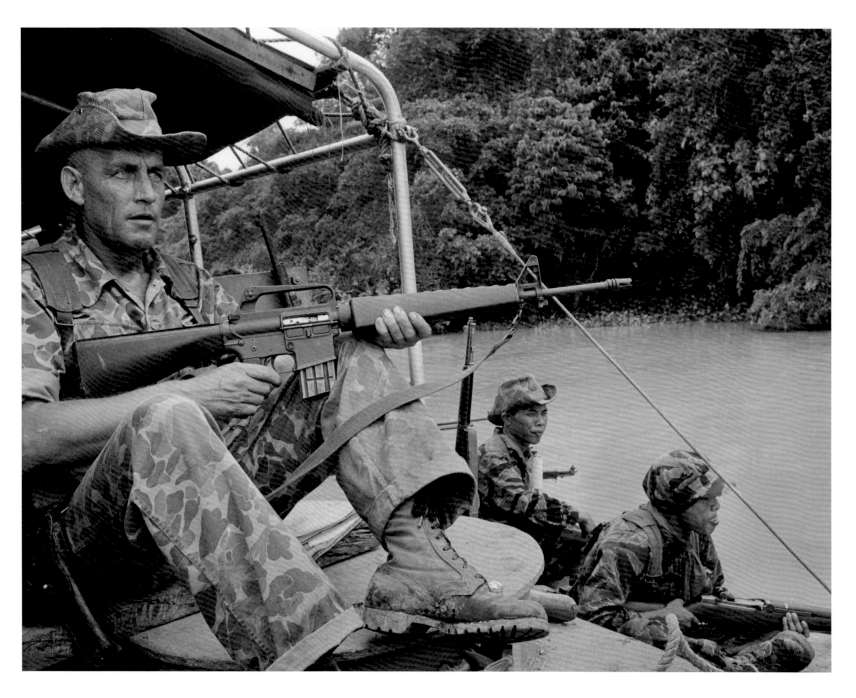

A U.S. adviser accompanies South Vietnamese soldiers on a river patrol near the Cambodian border. June 1964.

The patrol later came upon a suspected Viet Cong encampment. No men were found, but the soldiers evacuated the women and children and then destroyed the buildings, livestock, and food.

Photograph by Horst Faas.

85

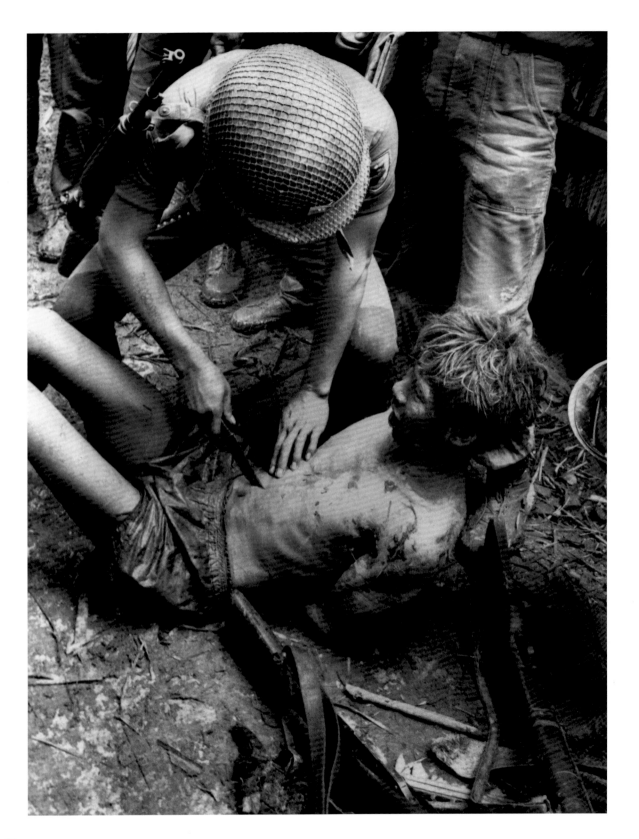

A South Vietnamese soldier presses the point of a knife against the belly of a Viet Cong prisoner while interrogating him, October 1964.

The guerrilla was one of four captured in an operation in the Mekong Delta. Eventually the prisoner revealed the location of a cache of hidden weapons.

Photograph by Horst Faas.

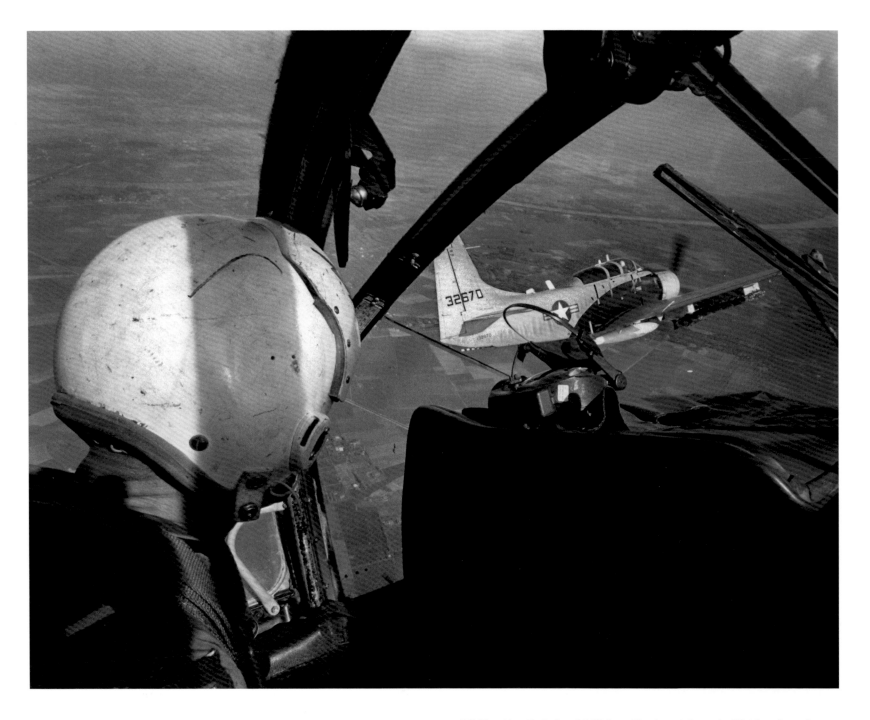

U.S. Skyraider attack aircraft fall into position for a strike against Viet Cong bases in South Vietnam, December 26, 1964.

The planes, carrying bombs, napalm, and 20 mm cannons, were piloted by Vietnamese fliers, with U.S. advisers riding along.

AP Images Archive

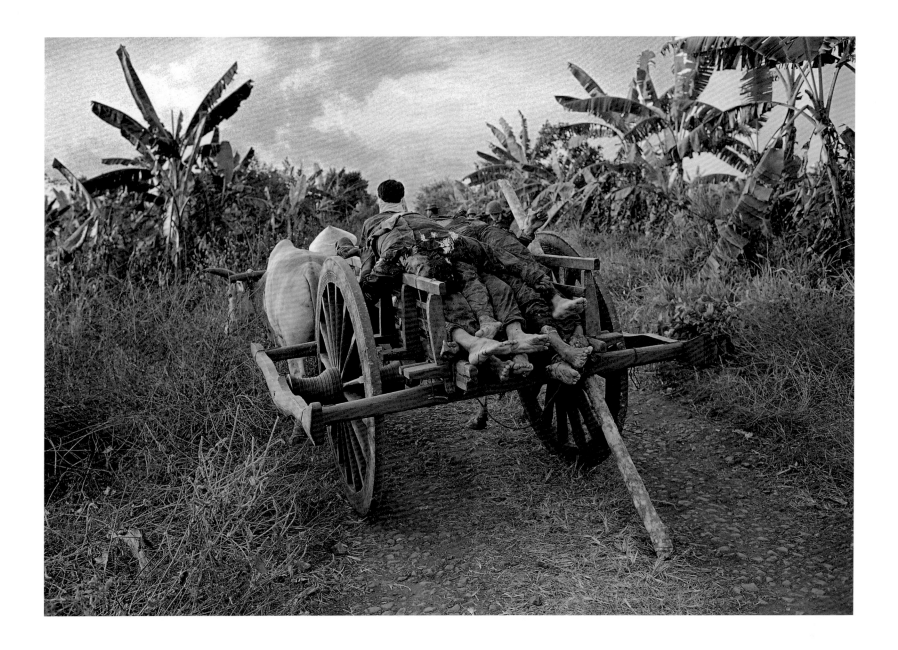

An oxcart loaded with bodies of South Vietnamese soldiers killed in the battle of Binh Gia is pulled from the jungle near the village, forty miles southeast of Saigon, December 29, 1964.

About two hundred government troops died in the fight, which lasted more than a week. The battle was one of the first large set-piece offensives initiated by the Viet Cong, and it helped convince President Johnson that South Vietnam could not defeat the insurgents without assistance from U.S. ground troops.

From the portfolio by photographer Horst Faas that received the 1965 Pulitzer Prize for Photography.

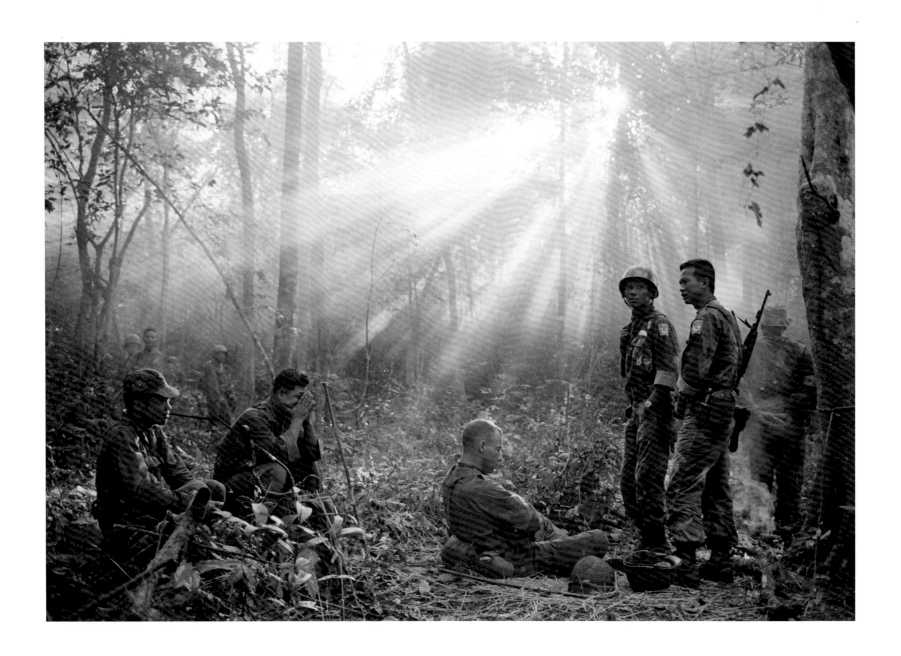

Sunlight breaks through dense foliage around the town of Binh Gia as South Vietnamese troops, joined by U.S. advisers, rest after a cold, damp, and tense night of waiting in an ambush position for a Viet Cong attack that did not come, January 1965.

One hour later, the troops would move out for another long, hot day hunting the guerrillas in the jungles forty miles southeast of Saigon.

Photograph by Horst Faas.

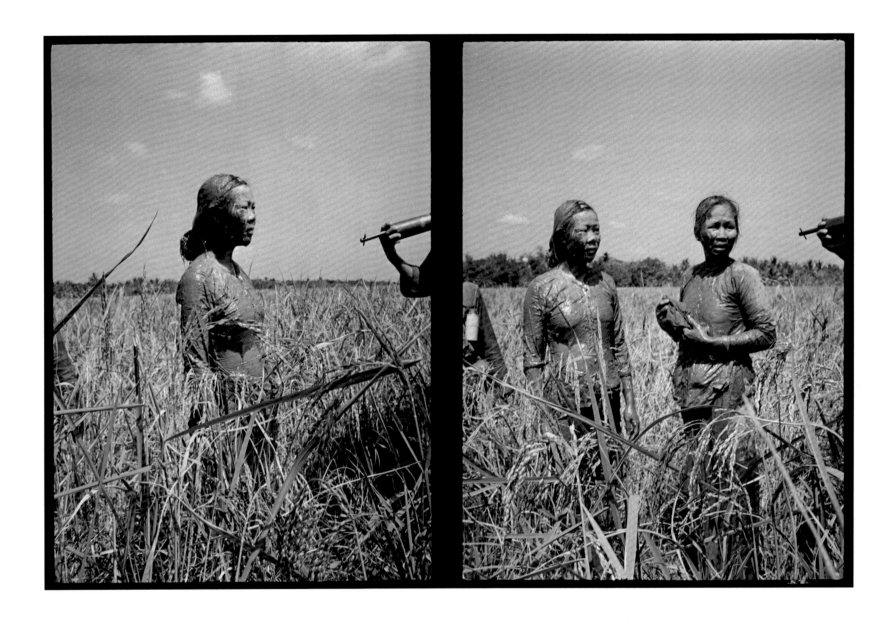

Smeared with mud, a Viet Cong nurse stands in a rice paddy in the Mekong Delta in Chuong Tien Province, 140 miles southwest of Saigon, January 16, 1965.

She was taken prisoner, along with eleven other guerrillas, by a unit of the 44th Vietnam Ranger Battalion that had been dropped into the area by U.S. helicopters.

The two photos shown above were taken with a "half-frame" camera that was able to shoot two separate images in the space of one normal 35mm frame. By the time the photo at the right was taken, the photographer had moved to a different angle, and a second prisoner had moved next to the nurse.

AP Images Archive

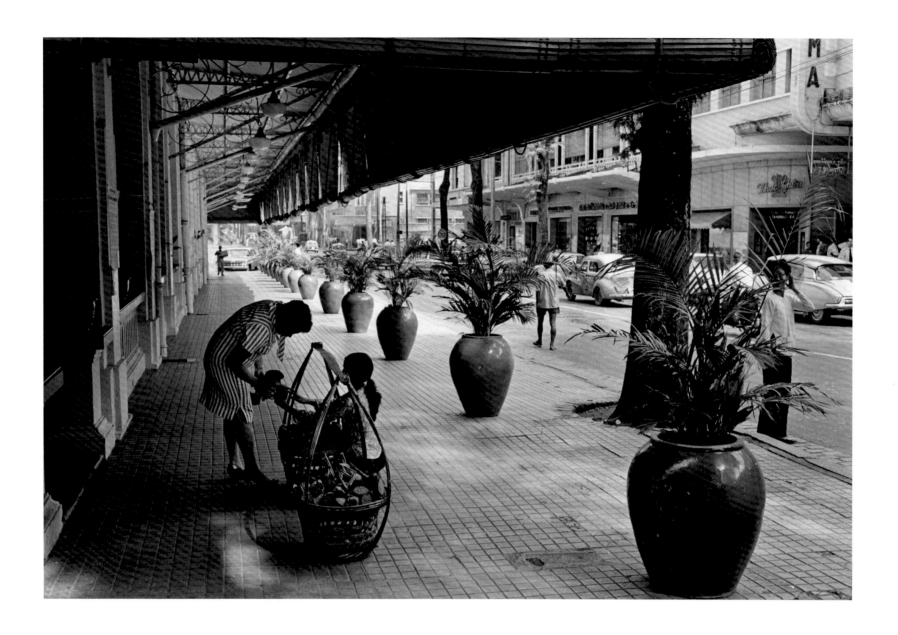

The sidewalk in front of the Continental Palace Hotel in Saigon is uncharacteristically deserted except for flowerpots and a lone peddler and customer. March 4, 1965.

Normally the space would be crammed with tables that made up one of the most famous sidewalk cafés in French Indochina, but they had been temporarily removed because of security concerns.

Photograph by Horst Faas.

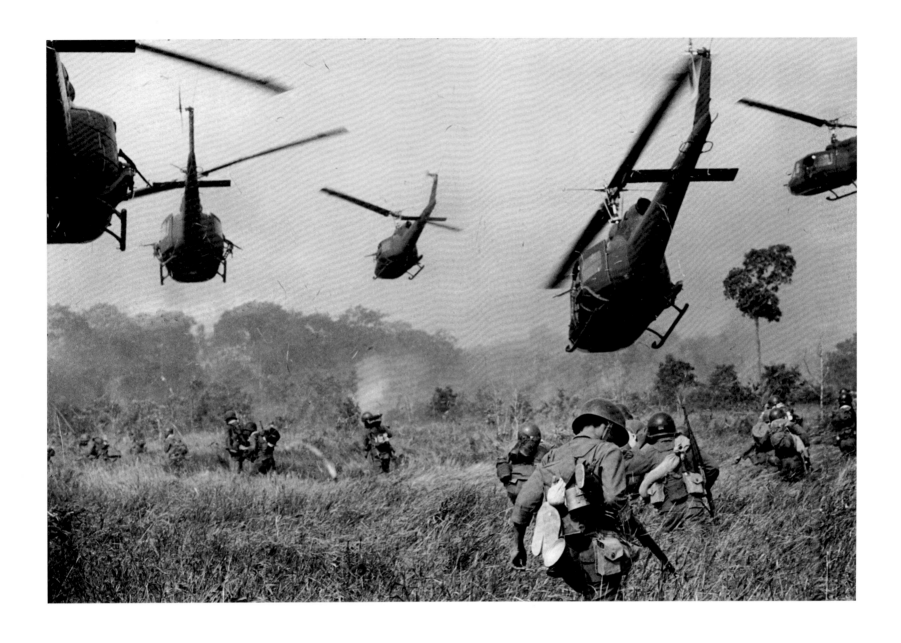

Hovering U.S. Army helicopters pour machine-gun fire into the tree line to cover the advance of South Vietnamese ground troops as they attack a Viet Cong camp eighteen miles north of Tay Ninh, near the Cambodian border, March 1965.

Photograph by Horst Faas.

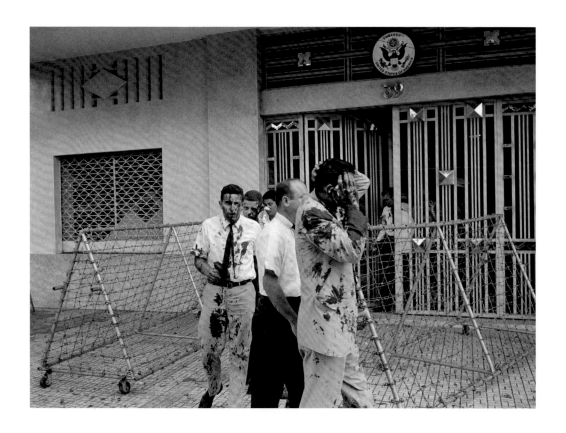

Spattered with blood, U.S. officials pass barbed-wire barricades outside the U.S. Embassy in Saigon after it was heavily damaged when a bomb exploded in a car parked on Ham Nghi Boulevard, March 30, 1965.

Many American in the building were injured by flying glass and bricks, and twenty-two people were killed, most of them Vietnamese. The U.S. government opened a new embassy in a more secure compound near the presidential palace in 1967.

Below, Air Force S. Sgt. Lyle Goodin carries the body of an elderly woman who was peddling food on a nearby corner when the bomb went off.

Photographs by Horst Faas.

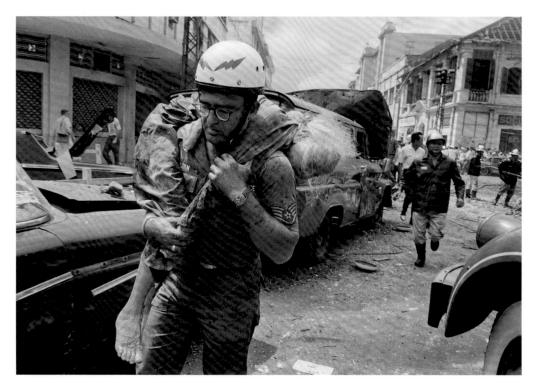

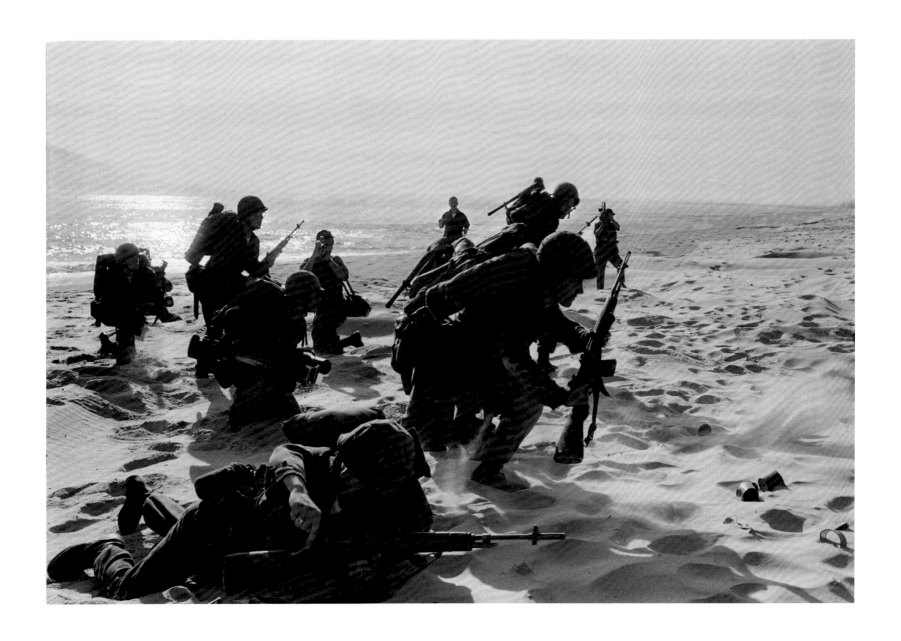

Freshly landed U.S. Marines make their way through the sands of Red Beach at Da Nang, April 10, 1965.

They were on their way to reinforce the air base as South Vietnamese Rangers battled guerrillas about three miles south of the beach. In the background are photographers who were covering the action.

Photograph by Peter Arnett.

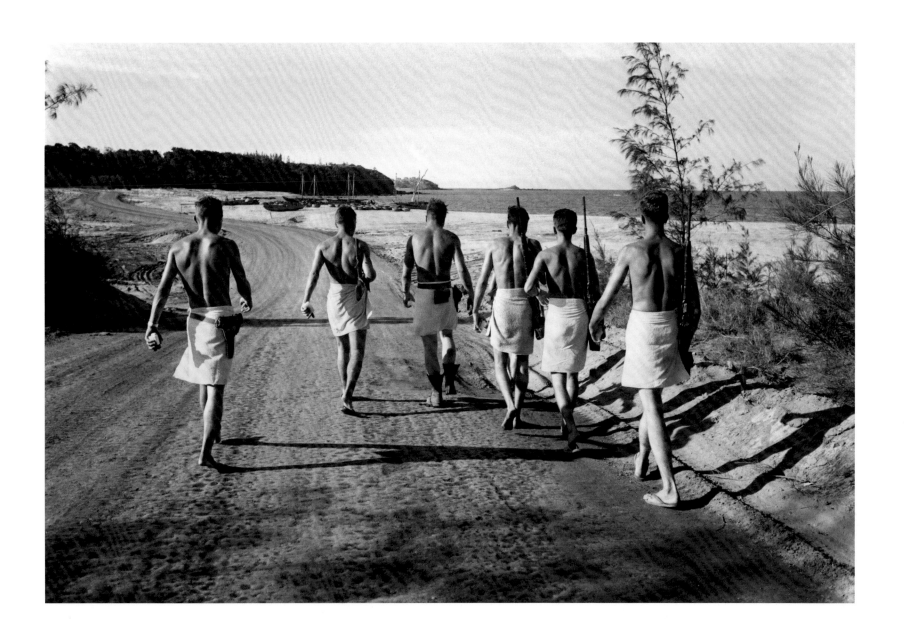

Marines carry their weapons with them as they go to bathe near their camp at Chu Lai, 1965.

Photograph by Eddie Adams.

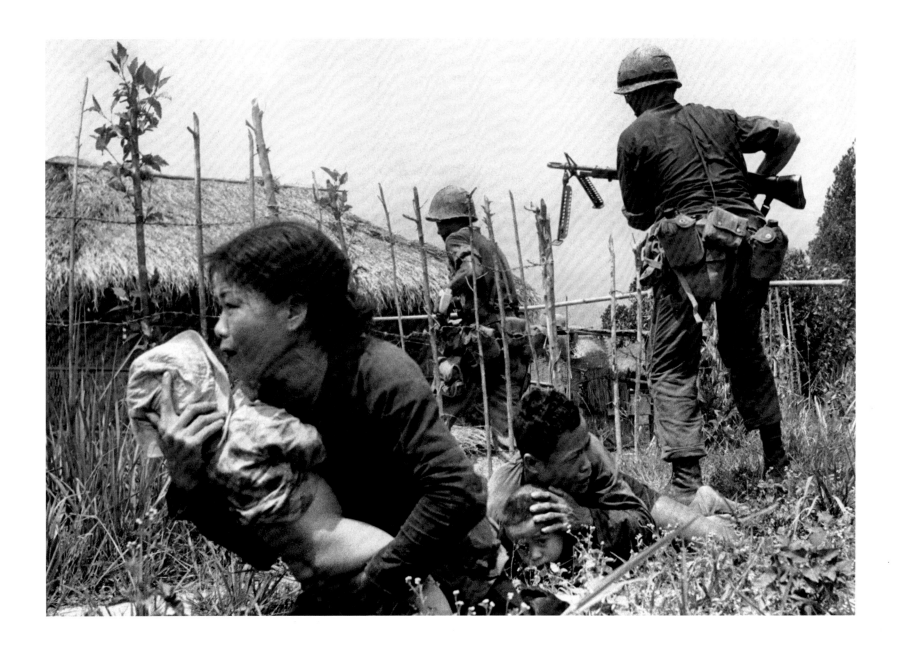

Under sniper fire, a Vietnamese woman carries a child to safety as Marines storm the village of My Son, near Da Nang, searching for Viet Cong insurgents, April 25, 1965.

As was typical in such situations, the men of the village had mostly disappeared, and the remaining villagers revealed little when questioned by the Marines.

Photograph by Eddie Adams.

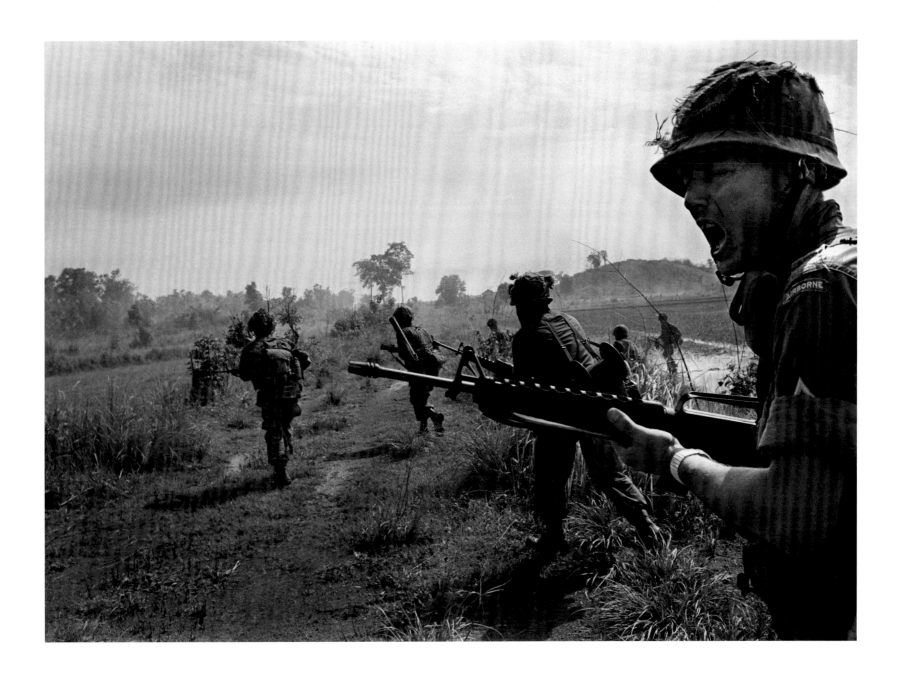

A paratrooper sergeant shouts orders to his squad of the 2nd Battalion, 173rd Airborne Brigade, as they rush across an abandoned road from a rice paddy while subject to sniper fire, June 1, 1965.

The scene is near Ben Binh, twenty miles northeast of Bien Hoa.

Photograph by Horst Faas.

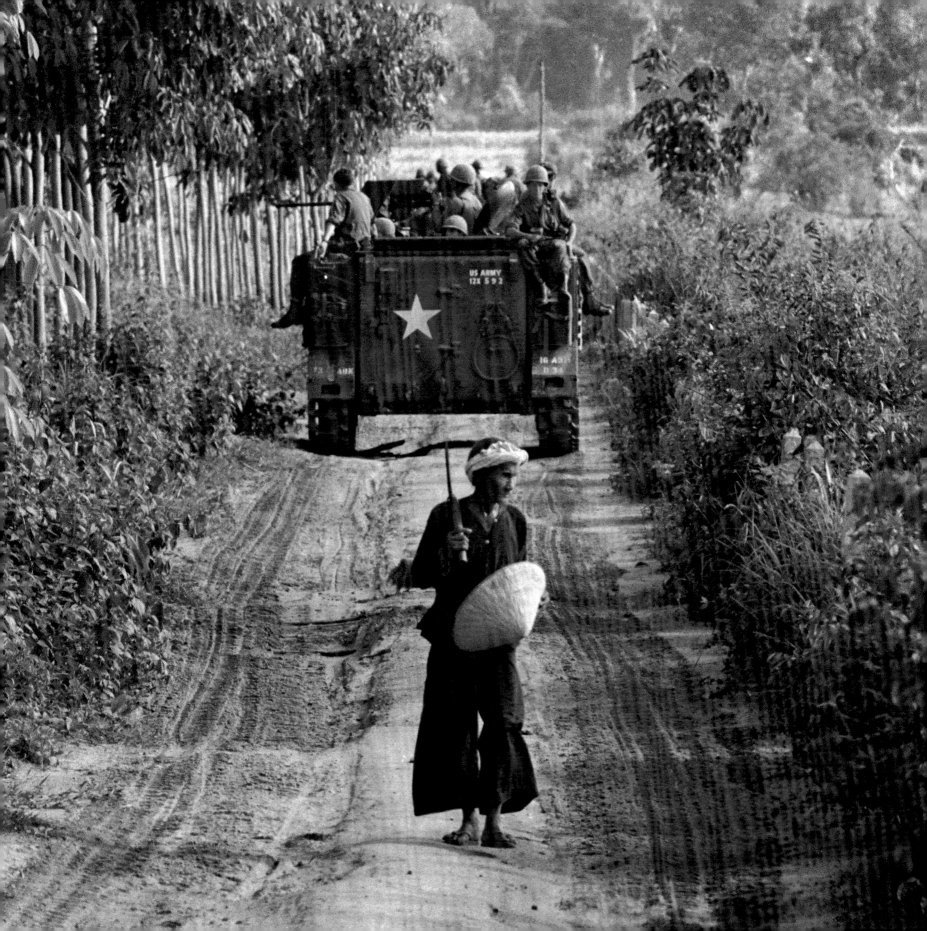

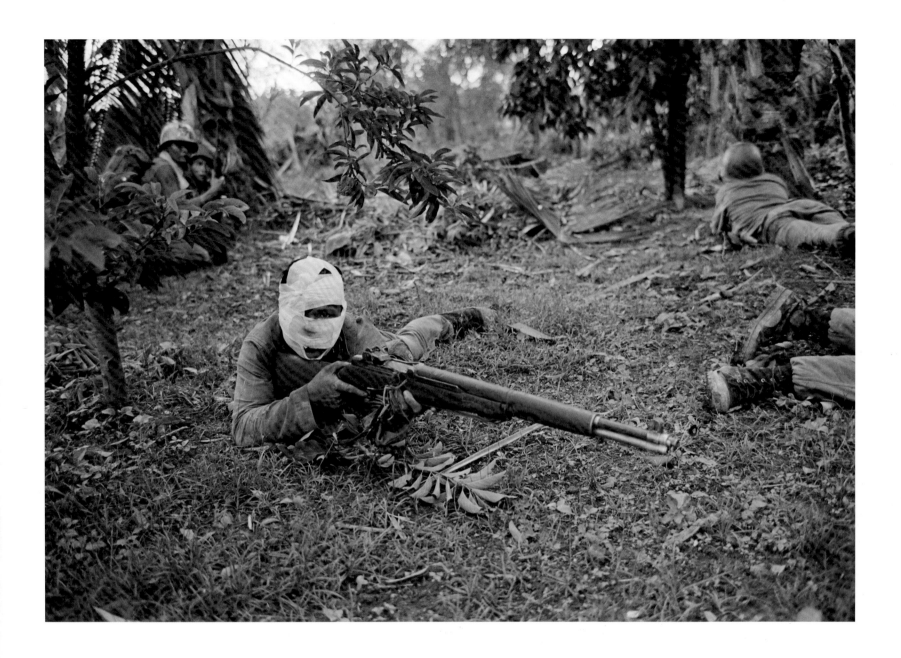

A wounded South Vietnamese Ranger keeps his weapon ready to answer a Viet Cong attack during the battle of Dong Xoai, June 1965.

As part of their summer offensive, the Viet Cong had overrun the military headquarters of the district capital, about sixty miles northeast of Saigon. In the fighting that ensued, the South Vietnamese lost more than three hundred soldiers, and about twenty Americans were killed or wounded. After four days, heavy U.S. air strikes eventually helped drive off the insurgents.

Photograph by Horst Faas.

A Vietnamese peasant walks down a road with a sickle over his shoulder as a U.S. armored personnel carrier passes through Bien Hoa on a reconnaissance mission about twenty miles northeast of Saigon, June 1965.

Photograph by Horst Faas.

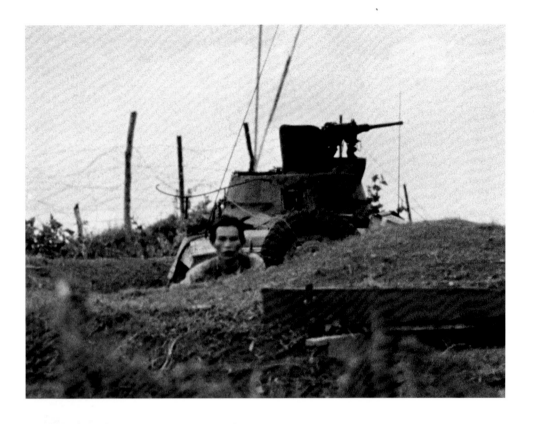

A Viet Cong soldier peers over a bunker at South Vietnamese troops who are pinned down by machine-gun fire at Dong Xoai, June 10, 1965.

An armored vehicle abandoned by government troops stands in the background.

Photograph by Horst Faas.

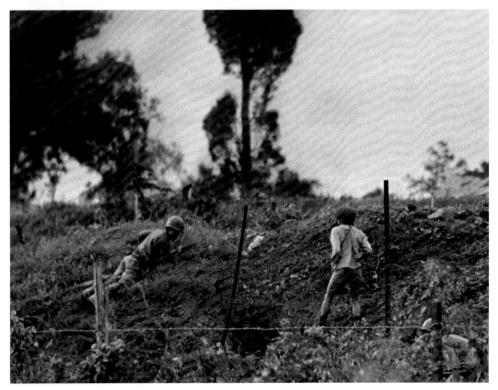

A Viet Cong guerrilla (right) shoots a South Vietnamese soldier who is lying wounded on a mud wall at Dong Xoai, June 10, 1965.

The soldier was trying to get across the wall to join government Rangers who had just landed by helicopter one hundred yards away.

Photograph by Horst Faas.

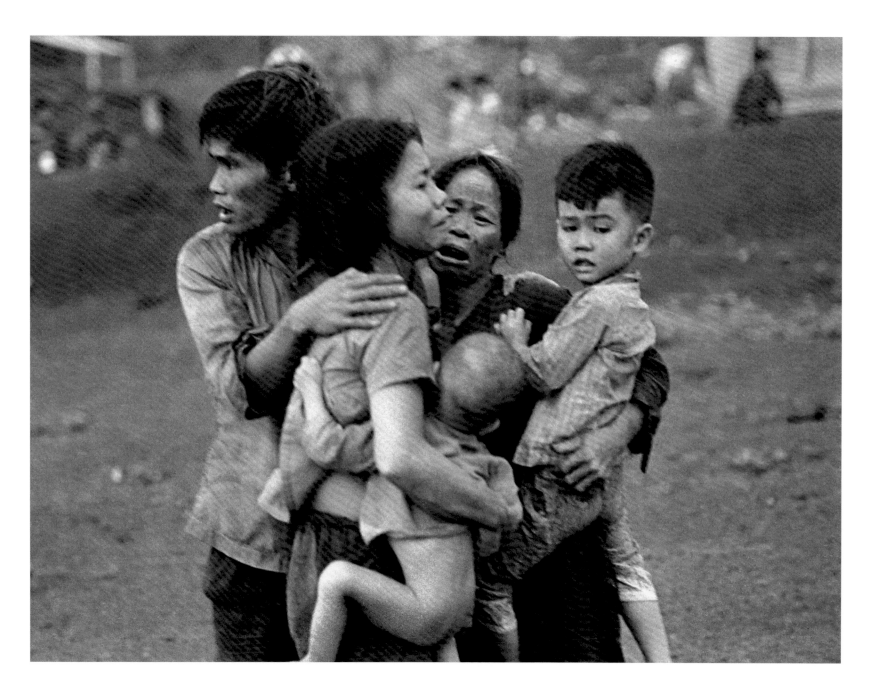

Civilians caught in the middle during two days of heavy fighting huddle together in the aftermath of an attack by South Vietnamese troops to retake their post at Dong Xoai. June 1965.

Just a few of the several hundred people who sought refuge at the post survived the days-long barrage of mortars and bombardment. After the government recaptured Dong Xoai, the bodies of 150 civilians and some 300 South Vietnamese soldiers were discovered.

Photograph by Horst Faas.

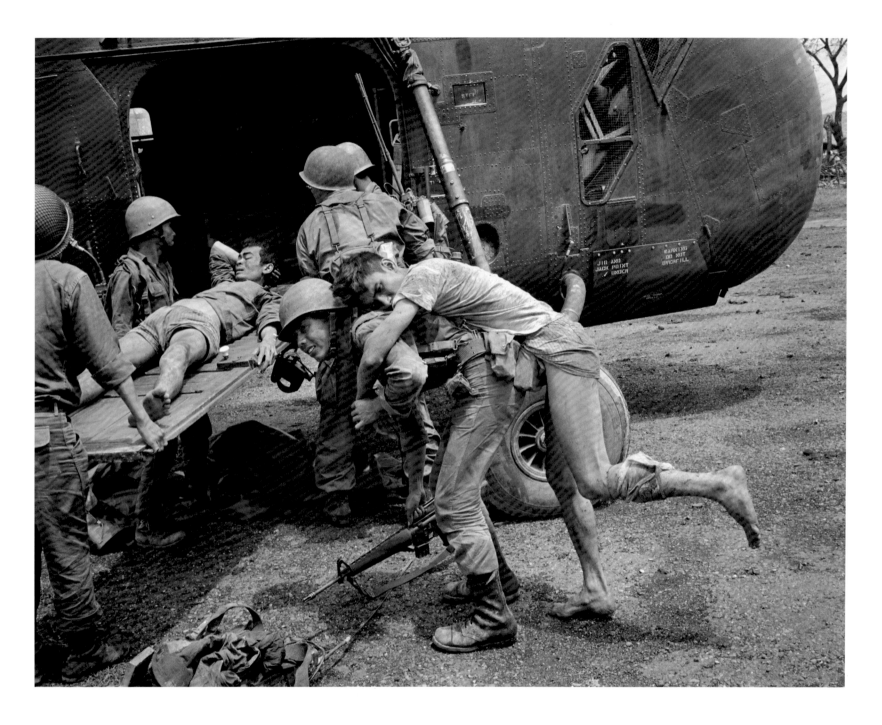

A South Vietnamese paratrooper drags a wounded comrade from the 7th Battalion to a rescue helicopter near the rubber plantation town of Thuan Loi. June 12, 1965.

His unit was ambushed by the Viet Cong from inside the plantation buildings, and the paratrooper, who hid in brush, was one of the few survivors.

Photograph by Horst Faas.

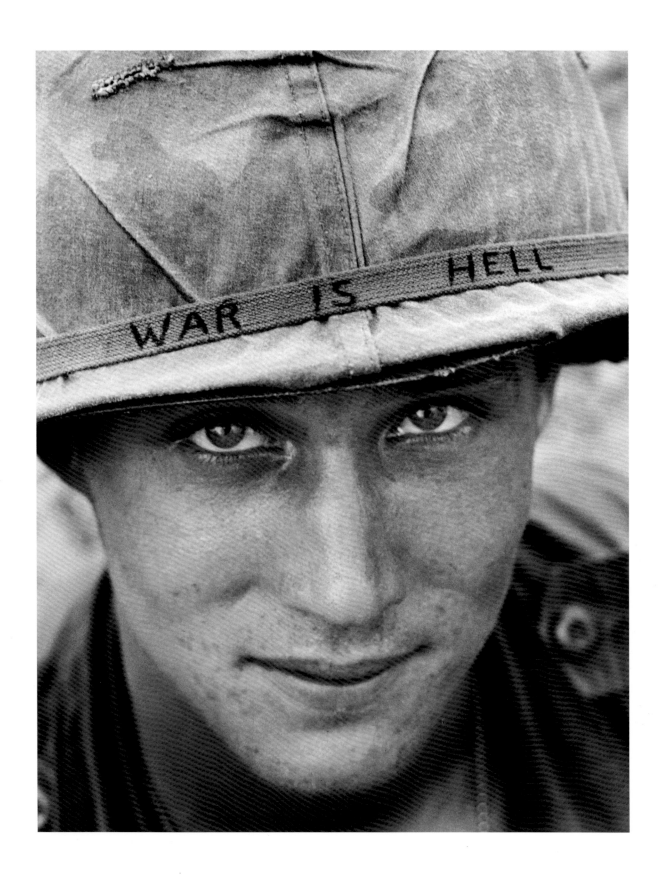

An unidentified American soldier
wears a hand-lettered slogan on his
helmet, June 1965.

The soldier was serving with the
173rd Airborne Brigade on defense
duty at the Phuoc Vinh airfield.

Photograph by Horst Faas.

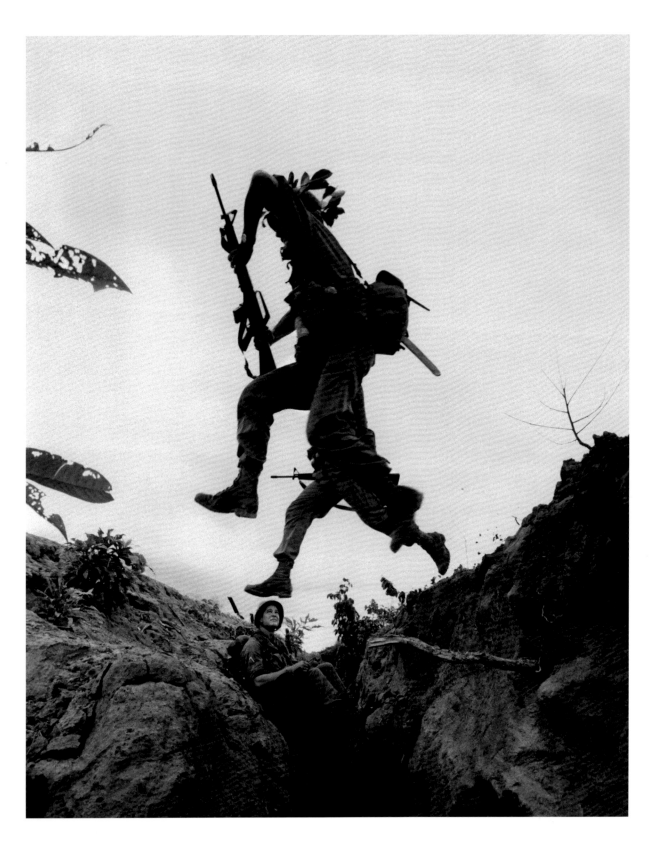

U.S. paratroopers jump over a trench as they take their positions around the Phuoc Vinh airfield to protect it from possible Viet Cong attack, June 1965.

The airfield was just south of embattled Dong Xoai, where heavy casualties were reported from fighting between insurgents and government forces.

AP Images Archive

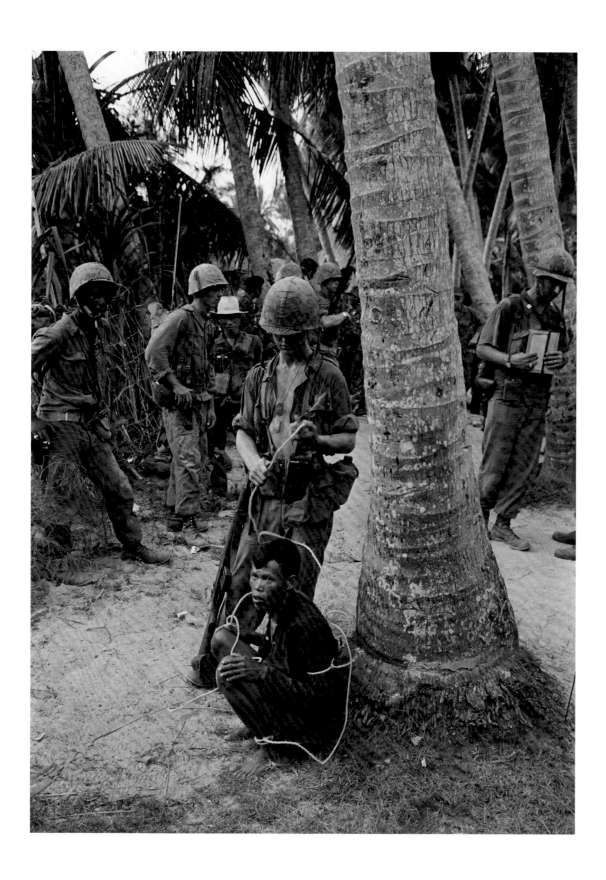

A Marine stands guard over a Viet
Cong suspect at An Hoa, July 1965.

Photograph by Eddie Adams.

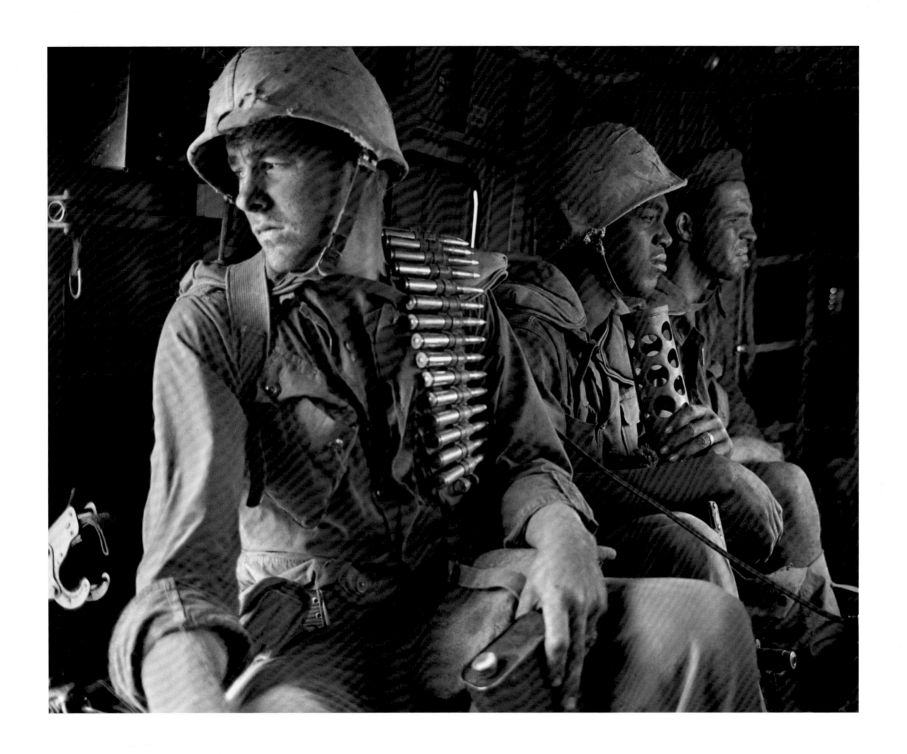

Marines sit in a helicopter at Van Tuong, July 1965.

Photograph by Eddie Adams.

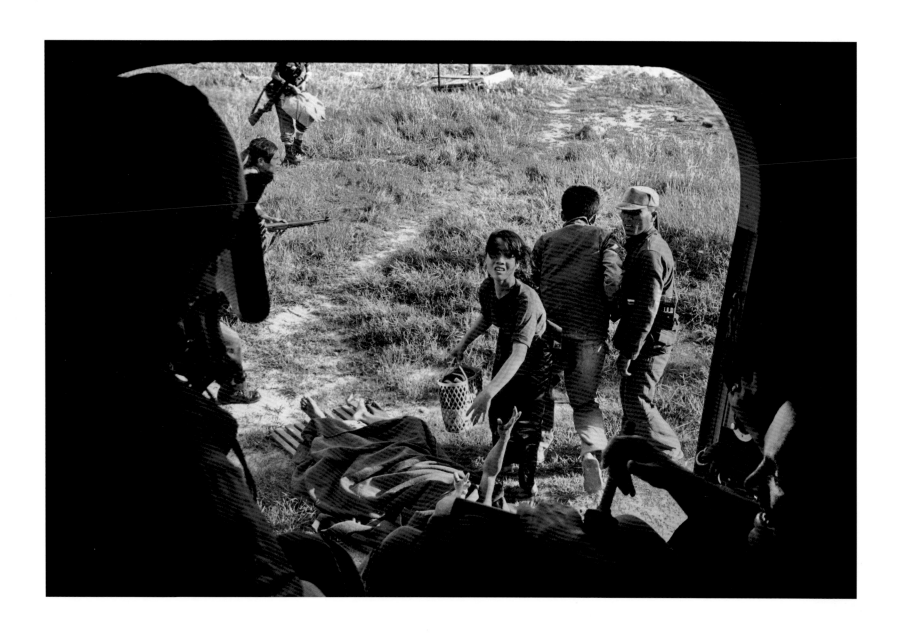

As her wounded husband raises his arm, a Vietnamese woman begs to be taken aboard a U.S. evacuation helicopter so they can escape a Viet Cong attack in Ba Gia, July 1965.

The couple was left behind.

Photograph by Eddie Adams.

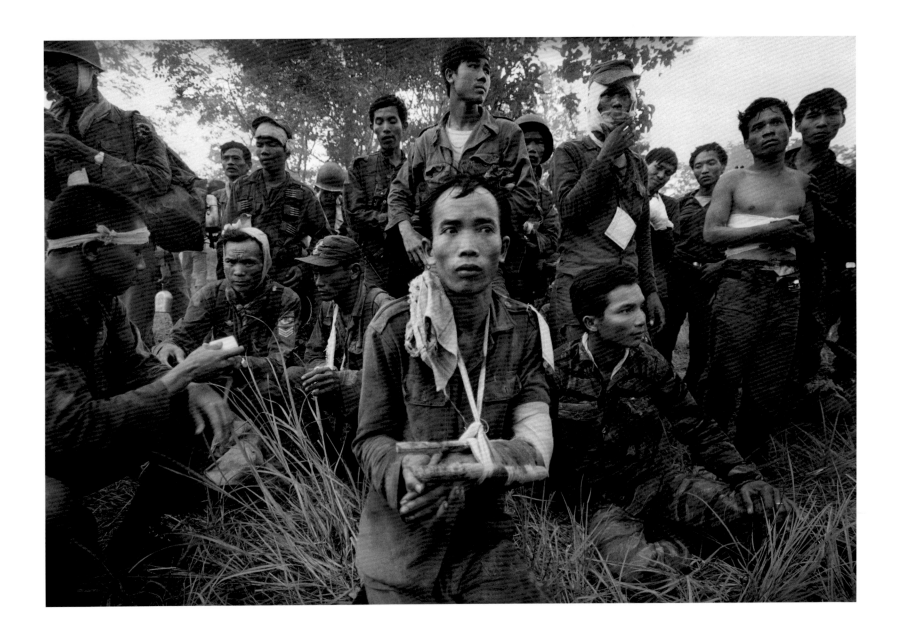

South Vietnamese forces nurse their wounds after fierce fighting with the Viet Cong at Cheo Reo, early July 1965.

Photograph by Eddie Adams.

A Viet Cong suspect gasps for breath as water is poured on a cloth held over his nose and mouth by South Vietnamese soldiers, July 25, 1965.

The suspect, one of thirteen captured by U.S. Marines in a joint operation near Tam Loc, revealed the location of an arms cache after being subjected for more than twenty minutes to this Vietnam-era version of waterboarding. The operation was conducted on a peninsula forty miles southeast of Da Nang air base.

Photograph by John T. Wheeler.

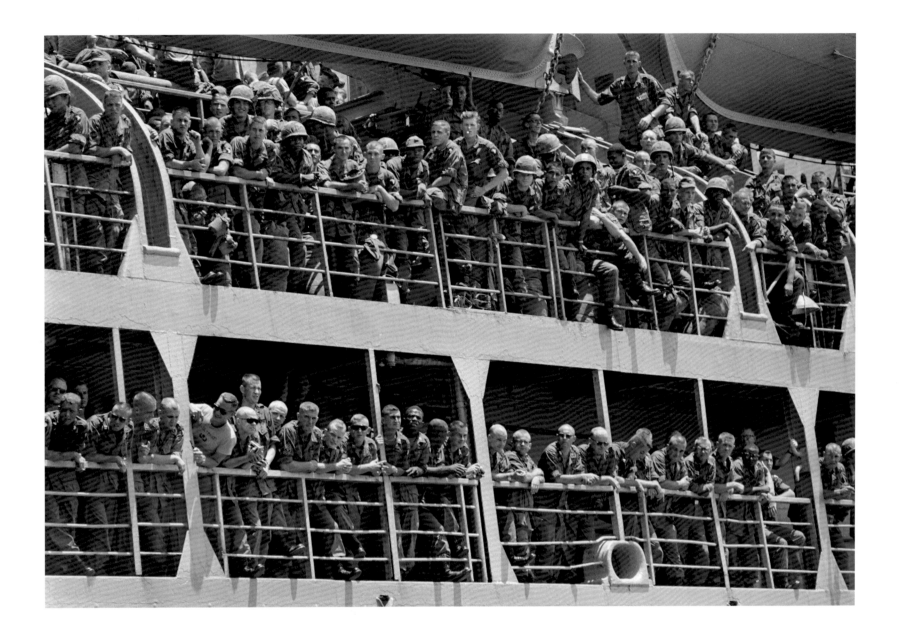

In a scene reminiscent of World Wars I and II, U.S. paratroopers of the 1st Brigade, 101st Airborne Division, look to shore following their arrival at a pier in Cam Ranh Bay, July 29, 1965.

The troopers disembarked via a gangplank for deployment to an undisclosed location.

AP Images Archive

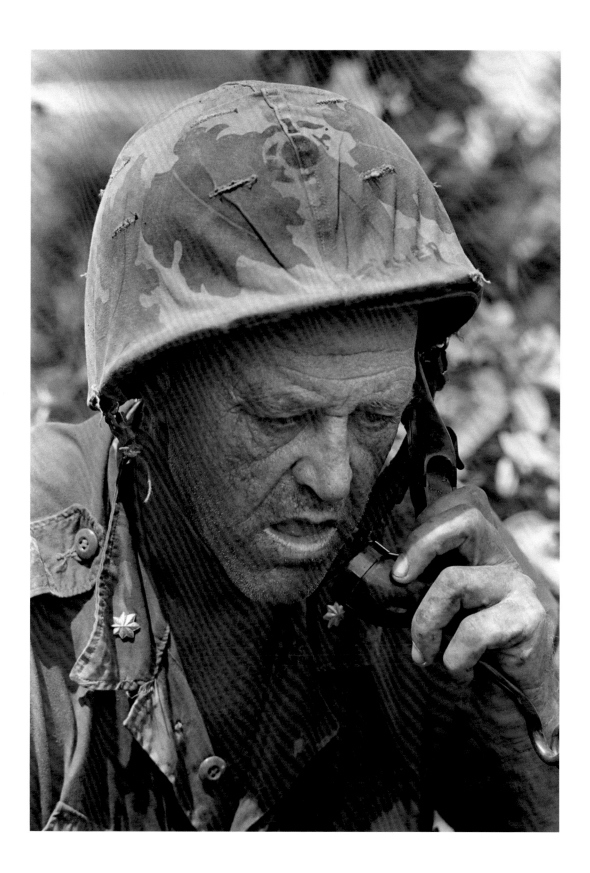

Lt. Col. J.R. "Bull" Fisher, commander of the 2nd Battalion of the U.S. Marine 4th Regiment, uses a field telephone at the end of a three-day battle against the Viet Cong on Van Tuong Peninsula, August 1965.

Fisher and his troops were part of Operation Starlite, the largest Marine combat engagement since the Korean War.

Photograph by Eddie Adams.

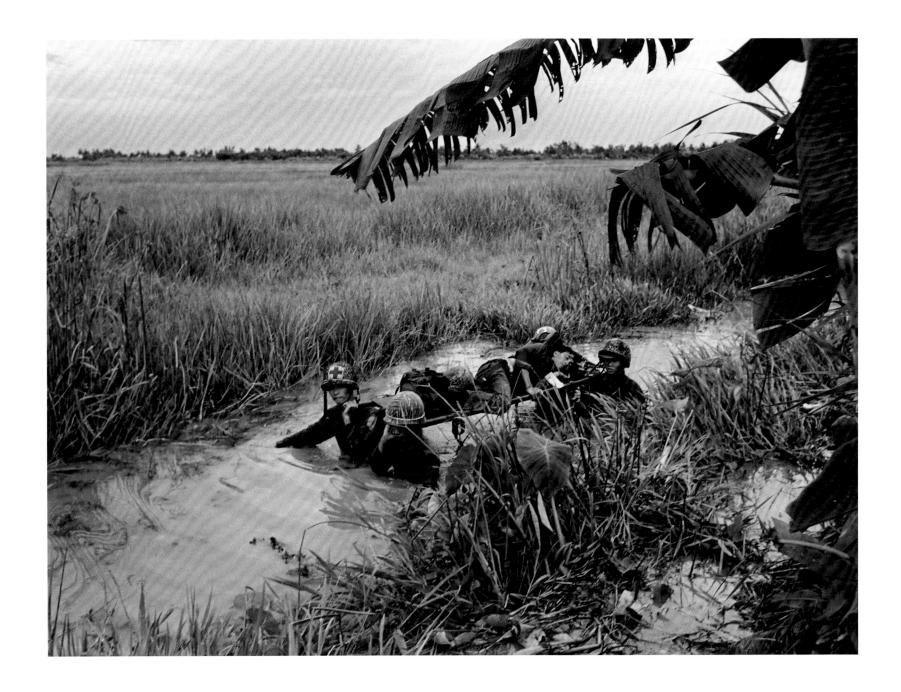

South Vietnamese medics evacuate a seriously wounded comrade on a stretcher, carrying him through the waist-deep water of a canal while under guerrilla fire from the tree line in the background, August 27, 1965.

Government forces suffered heavy casualties after they were dropped by U.S. helicopters on Viet Cong lines just north of Rach Gia in southwest Vietnam.

Photograph by Michel Renard.

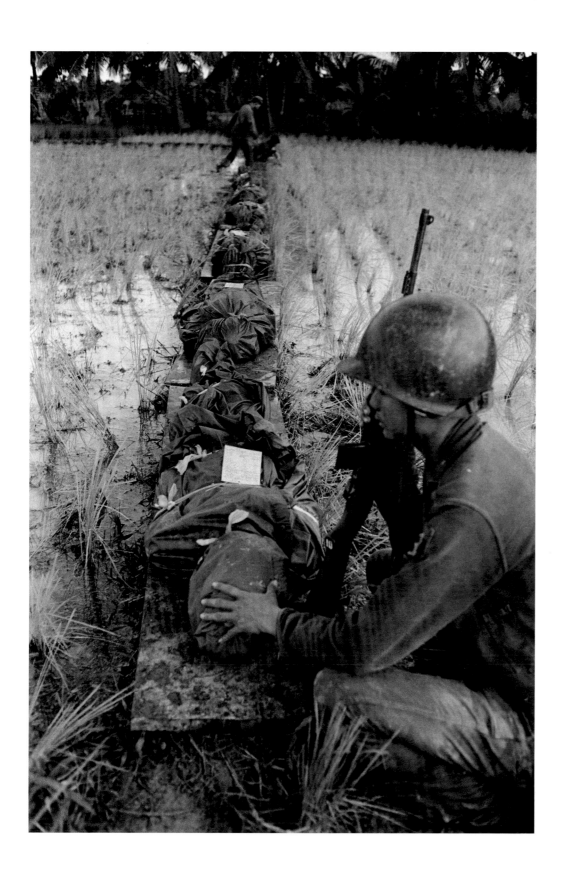

A South Vietnamese soldier kneels at the edge of a row of dead comrades laid out in bags on the perimeter of a paddy on Tan Dinh Island, in the Mekong Delta, September 3, 1965.

After two days on patrol without enemy contact, the unit had been surrounded by Viet Cong fire. Then U.S. helicopters—mistaking the South Vietnamese for Viet Cong—rained friendly fire on the unit. The dead were later recovered by helicopter.

Photograph by Huynh Thanh My.

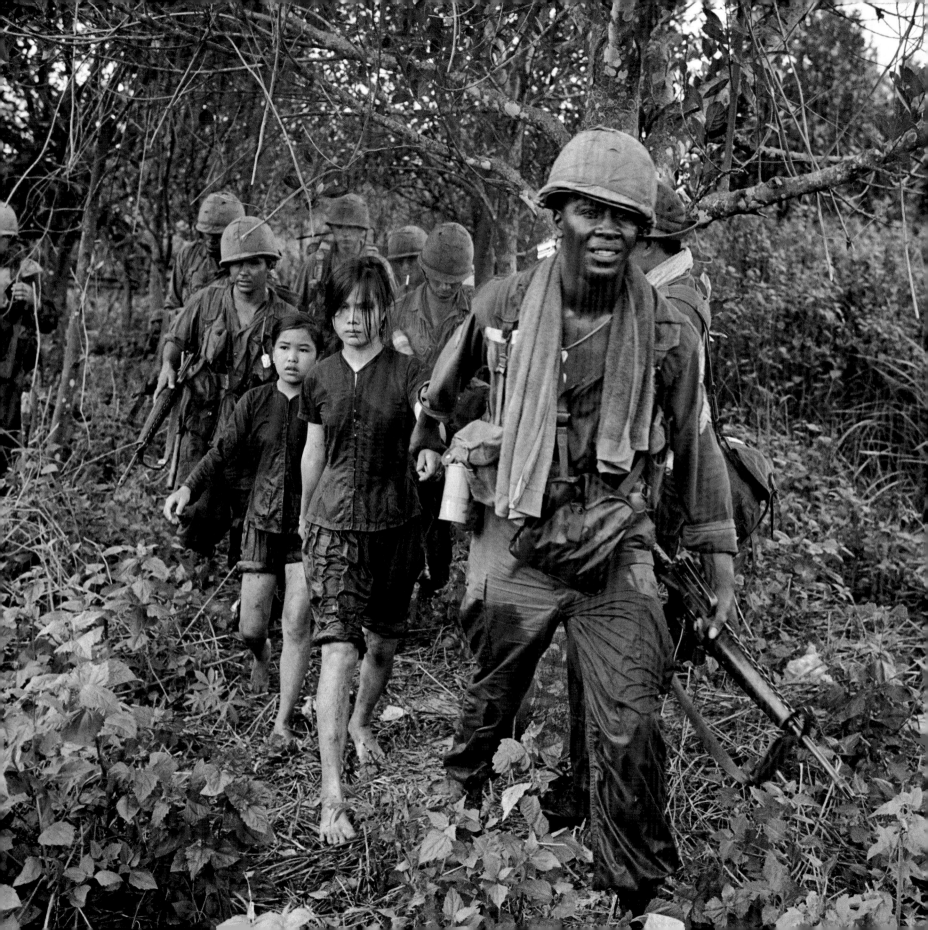

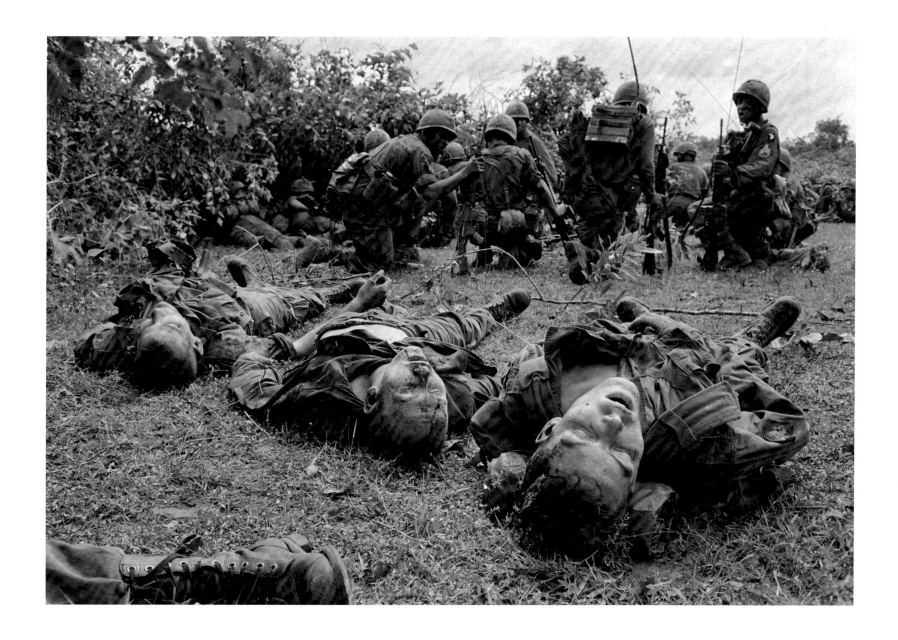

U.S. paratroopers of the 1st Battalion, 173rd Airborne Brigade, lead two girls from a captured Viet Cong training camp in the Long Nguyen area, about thirty-five miles northwest of Saigon, September 19, 1965.

The girls, seventeen and fourteen years old, said they had been at the camp for two and three months, respectively.

Photograph by Horst Faas.

Bodies of U.S. paratroopers lie near a command post during the battle of An Ninh, September 18, 1965.

The paratroopers, of the 1st Brigade, 101st Airborne Division, were hit by heavy fire from guerrillas that began as soon as the first elements of the unit landed. The dead and wounded were later evacuated to An Khe, where the 101st was based. The battle was one of the first of the war between major units of U.S. forces and the Viet Cong.

Photograph by Henri Huet.

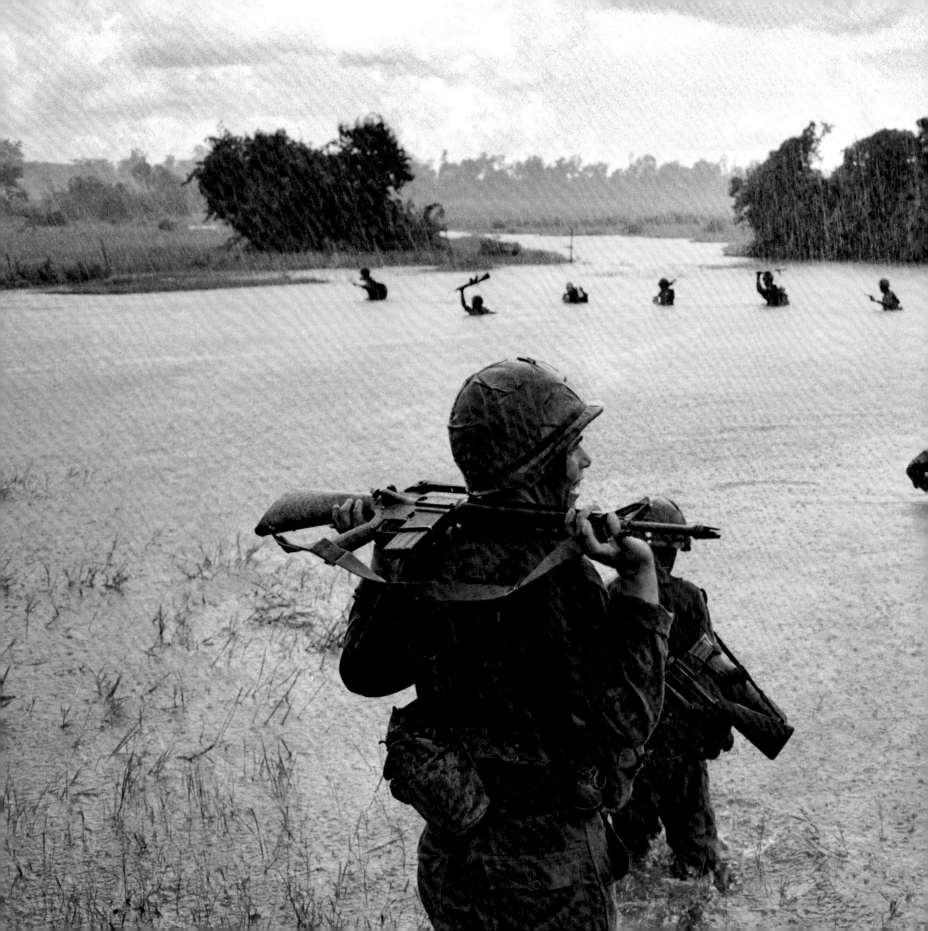

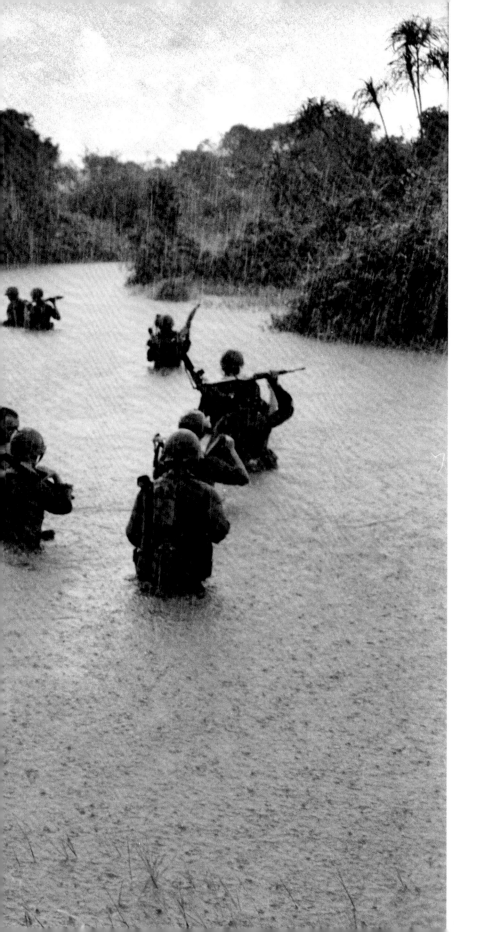

U.S. paratroopers of the 2nd Battalion, 173rd Airborne Brigade, hold their automatic weapons above water as they cross a river in the rain during a search for Viet Cong positions in the jungle area of Ben Cat, September 25, 1965.

The paratroopers had been combing the area for twelve days with no enemy contact.

Photograph by Henri Huet.

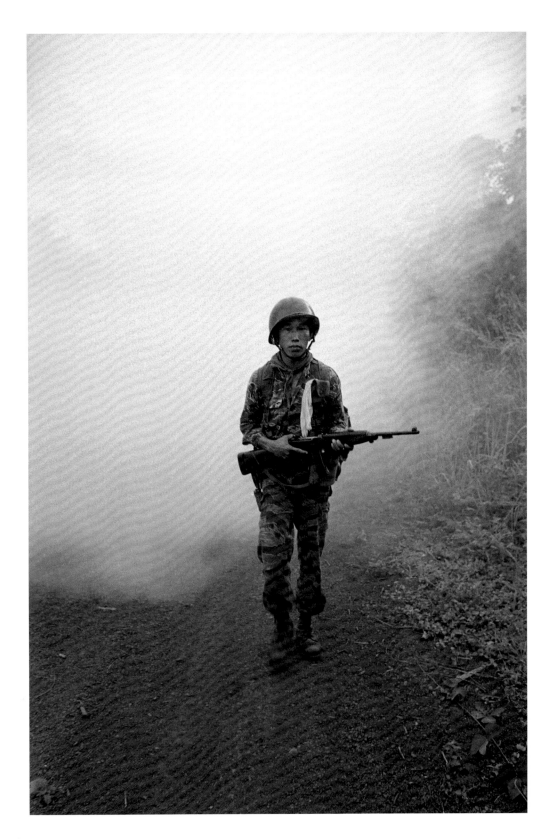

A South Vietnamese soldier at Plei Me, south of Pleiku in the Central Highlands, October 1965.

Plei Me was the site of a Special Forces camp that had come under siege by a regiment of North Vietnamese.

Photograph by Eddie Adams.

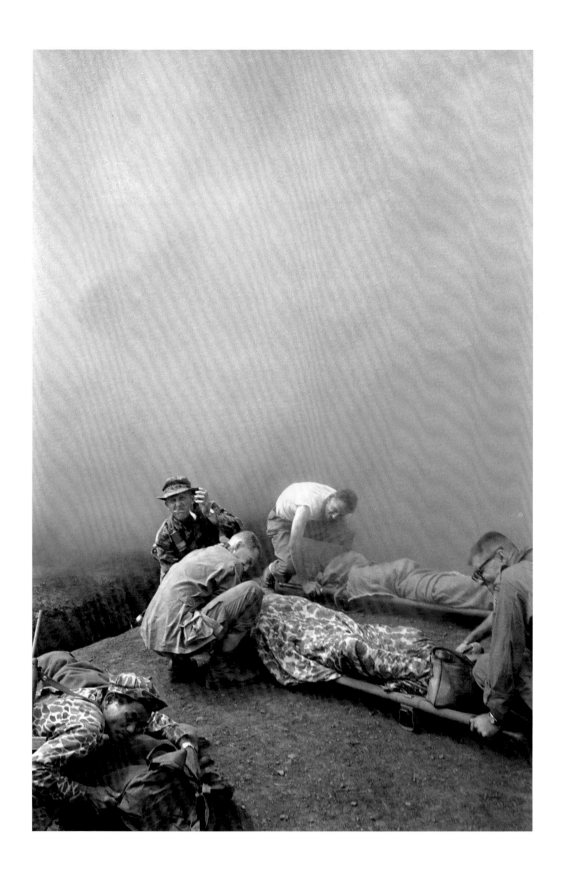

U.S. Marines and South Vietnamese soldiers tend to the wounded amid fighting at Plei Me, October 1965.

Photograph by Eddie Adams.

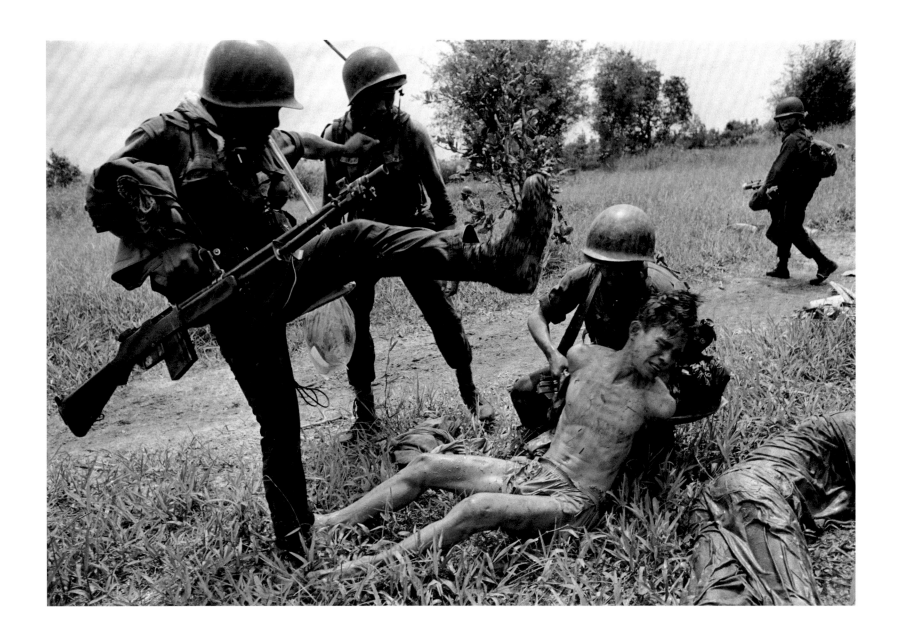

A South Vietnamese soldier holding a rifle kicks a Viet Cong suspect, while another soldier attempts to tie his hands, October 22, 1965.

The prisoner was one of fifteen captured the day before in a raid near Xom Chua, in the Plain of Reeds.

Photograph by Rick Merron.

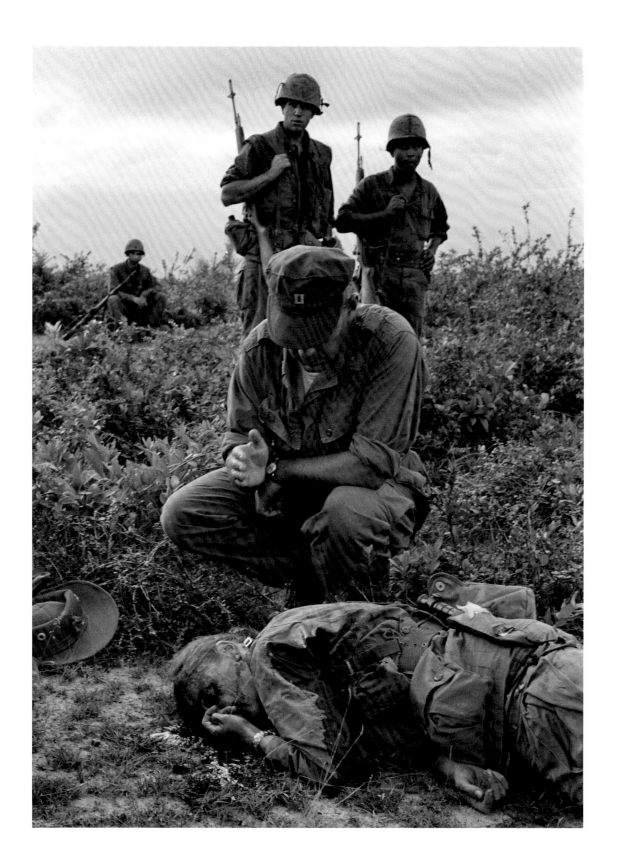

Chaplain John McNamara of Boston makes the sign of the cross as he administers last rites to photographer Dickey Chapelle, November 4, 1965.

Chapelle was covering a U.S. Marine unit on a search-and-destroy operation near Chu Lai for the *National Observer* when she was wounded, along with four Marines, by a mine accidentally tripped by a lieutenant in front of her. She died in a helicopter en route to a hospital. Chapelle was the first female American war correspondent to be killed in action.

Photograph by Henri Huet.

121

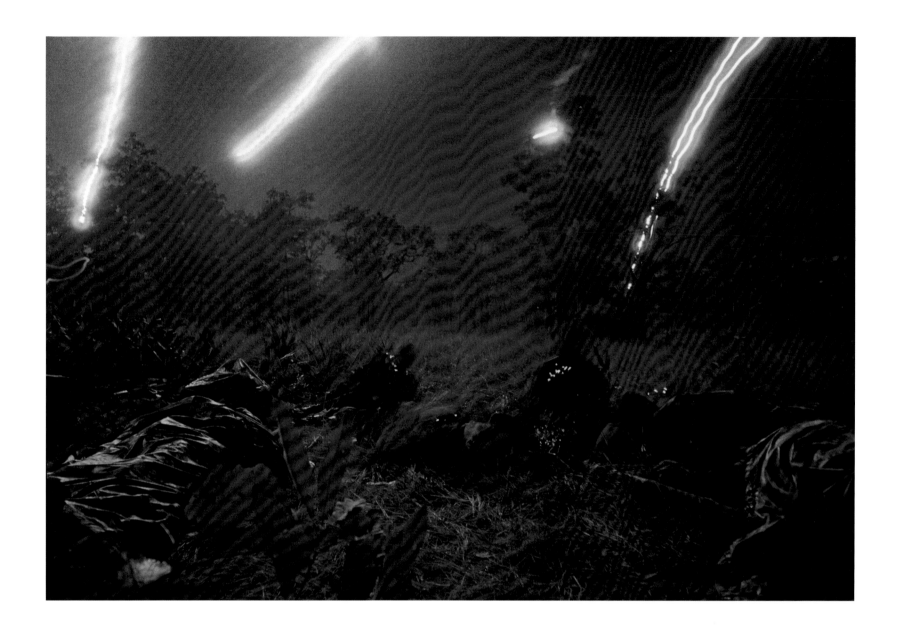

Flares from planes light a field covered with the dead and wounded of an ambushed battalion of the U.S. 1st Cavalry Division north of the Ia Drang Valley, November 18, 1965.

These men had fought their way out of the initial ambush several hundred yards away, but many died of their wounds overnight. The battle of Ia Drang, which began four days earlier, was the first large-scale confrontation of the war between Americans and North Vietnamese. The fighting is depicted in the 1992 book *We Were Soldiers Once . . . and Young*, by Lt. Gen. Harold G. Moore and Joseph L. Galloway of UPI. It was adapted into a 2002 movie that starred Mel Gibson.

Photograph by Rick Merron.

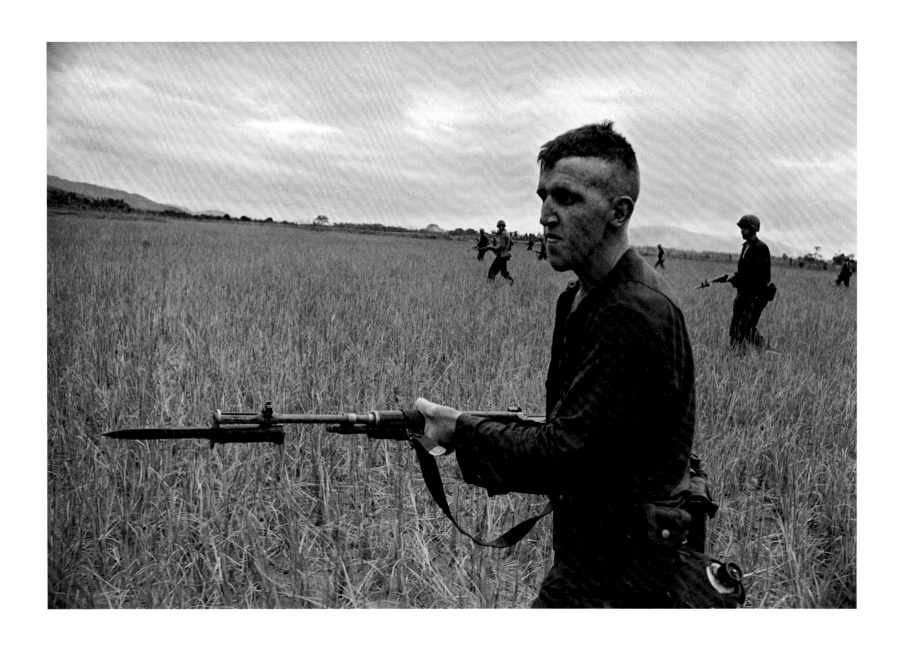

A young Marine goes into battle, ca. 1965.

Photograph by Eddie Adams.

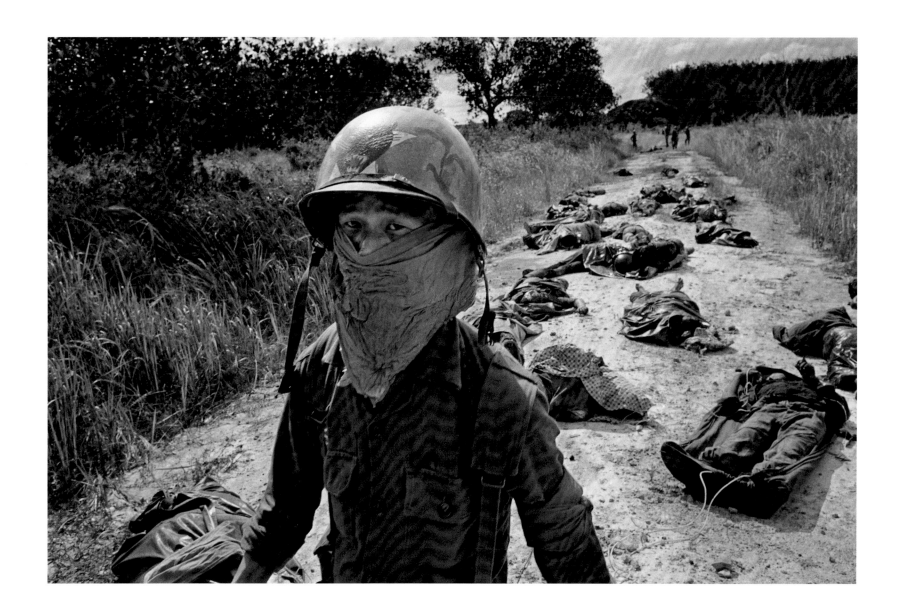

A South Vietnamese stretcher-bearer wears a face mask to protect himself from the smell as he passes the bodies of U.S. and South Vietnamese soldiers killed fighting the Viet Cong in the Michelin rubber plantation, November 27, 1965.

More than one hundred bodies were recovered after the Viet Cong overran South Vietnam's 7th Regiment, 5th Division, killing most of the regiment and several U.S. advisers. The plantation, situated midway between Saigon and the Cambodian border, was the scene of frequent fighting throughout the war.

Photograph by Horst Faas.

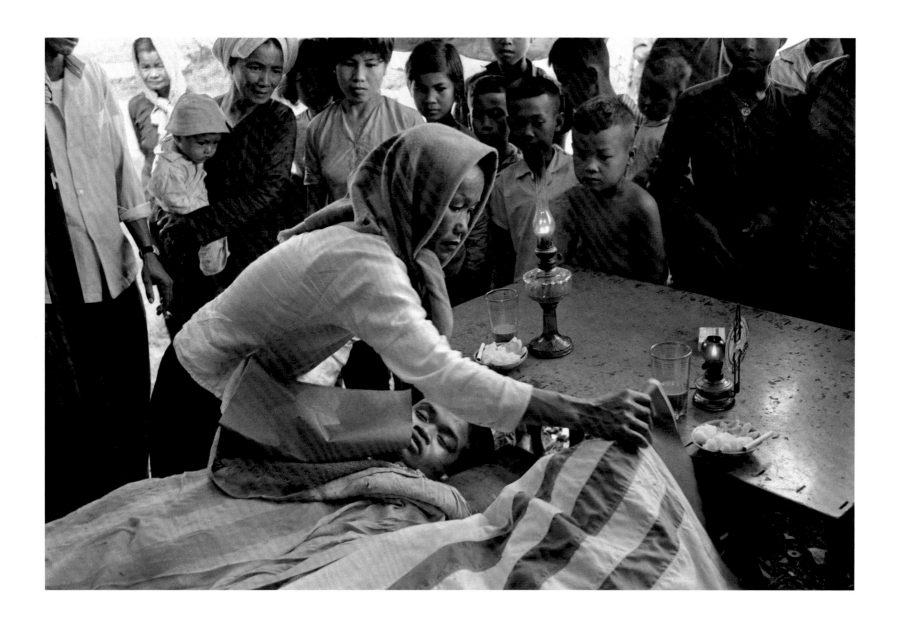

A Vietnamese woman reaches over the body of her slain son to cover that of her husband during funeral preparations at Tan Thuan Dong, December 26, 1965.

The two were killed when their hamlet, less than two miles south of Saigon, was attacked during the night by insurgents. On the table are Buddhist articles of mourning.

Photograph by Le Ngoc Cung.

Actress Carroll Baker snaps her fingers at sailors cheering from the bridge as Bob Hope leads her across the stage on the flight deck of the USS *Ticonderoga,* December 1965.

More than twenty-five hundred sailors saw the Hope troupe's show aboard the aircraft carrier. The comedian included South Vietnam in his annual holiday season visits to troops from 1964 to 1972.

AP Images Archive

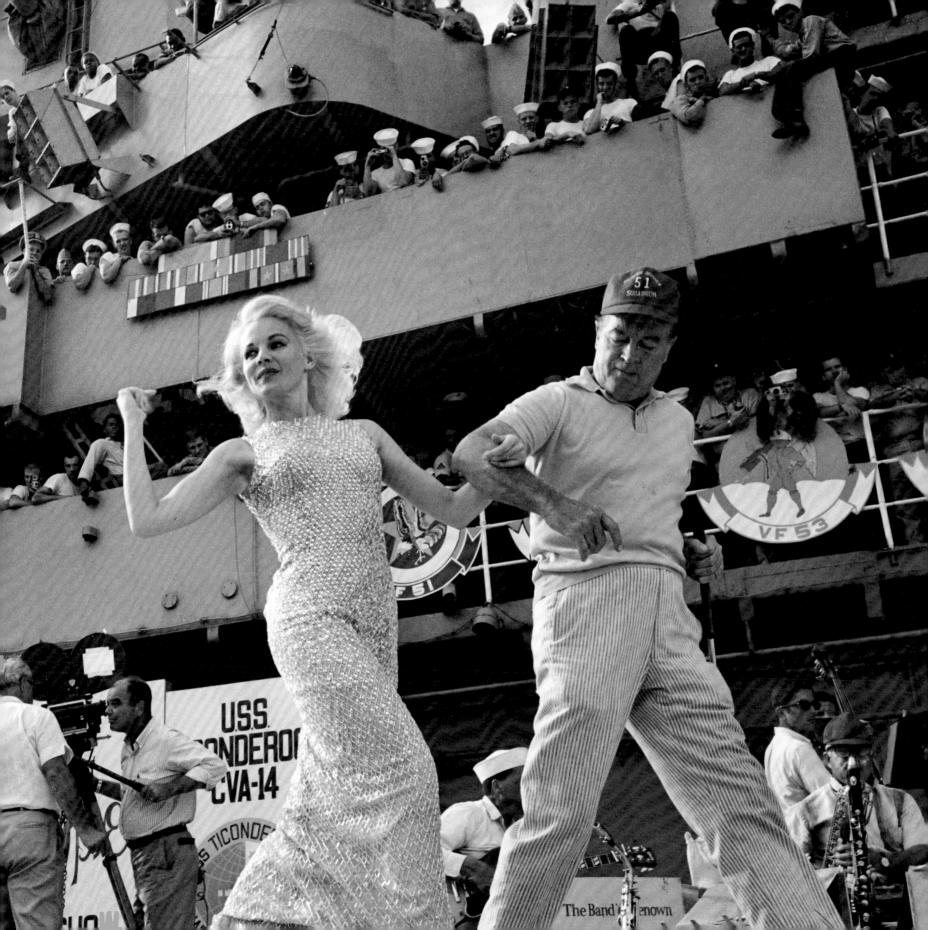

press photographer horst faas accompanied tr

of the mission. here is his report.)

by horst faas

ben suc, vietnam, jan. 10 (AP) - the fifty

tensely in the old, burned out schoolhouse as

province official told them: "you and your pec

town, abandon it.

"you cannot take your houses, but we will

your cattle, your chickens and your children.

taken to a refugee center," the official said

os at the start

village elders sat

e vietnamese

e must leave this

range transport for

u will be safely

RAGING WAR, RISING DISSENT

1966–67

To feed the war effort, the U.S. military was drafting more and more young men: 112,000 in 1964, an additional 231,000 in 1965, and 382,000 more in 1966.

And the accelerating draft intensified the antiwar movement. On March 26, 1966, thousands demonstrated in New York, Washington, Chicago, and several other U.S. cities. There were also coordinated protests in London, Oslo, Tokyo, and other world capitals.

Nevertheless, a Gallup poll taken that month showed a majority of Americans still supported the war, 59 percent to 25 percent.

Perhaps the highest-profile figure to add his voice to the protests was heavyweight boxing champion Muhammad Ali, who had converted to Islam and applied for conscientious objector status. Ali said, "I ain't got no quarrel with them Viet Cong."

In Vietnam, meanwhile, the influx of U.S. soldiers and equipment was bringing some victories. In a forty-two-day search-and-destroy operation, troopers of the 1st Cavalry Division helicoptered into battle zones in Bong Son Plain, near the coast, and engaged in fierce combat. By March, the area was restored to South Vietnamese control. In all, 228 Americans were killed and 788 wounded, and NVA losses were put at more than 1,000. The South Vietnamese also took control of the major cities of Hue and Da Nang.

< In this January 10, 1967, story, photographer Horst Faas provides an eyewitness account of the forced deportation by U.S. troops of the nearly six thousand residents of Ben Suc, a town on the fringes of the Iron Triangle that was a center of Viet Cong activity. After the entire population had been moved to a relocation camp, the military burned and bulldozed their homes and crops and destroyed miles of tunnels used by the insurgents. But the Viet Cong soon returned to the area, and the operation became a textbook example of the futility of U.S. policy.

Saigon Bureau Records, AP Corporate Archives

The United States stepped up its air attack as well. April saw the first use of B-52 bombers against North Vietnam. In June, oil depots were targeted around Hanoi and Haiphong. And in July, for the first time, the U.S. military bombed NVA troops in the DMZ, the buffer area separating North and South Vietnam.

North Vietnam's allies responded. In August, Hanoi announced that China would provide economic and technical assistance. Two months later, the Soviet Union said it would send military and economic aid. Fear of how these nations might react was one factor that kept Johnson from widening the war still further with a ground invasion of the North.

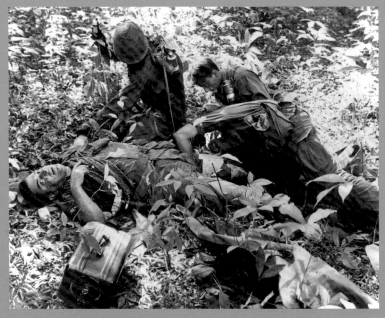

Horst Faas treated for shrapnel wounds on a stretcher near Bu Dop, December 7, 1967. Faas credited medic Joe Zeoli (second from left in background) and other members of the team with saving his life.

Photograph by John T. Wheeler.

The largest combined operation to date by U.S. Marines and South Vietnamese troops took place in July during a three-week series of battles against 10,000 North Vietnamese soldiers who had crossed the DMZ into Quang Tri Province. Operation Hastings ended with the NVA pulling back after losing more than 800 soldiers. The Marines suffered 126 dead and 448 wounded.

On October 26, Johnson made the first of two visits to South Vietnam as president. "We in America depend on you, on the young and on the brave, to stop aggression before it sweeps forward," he told the troops at Cam Ranh Bay.

By the end of 1966, more than 1 million soldiers were in South Vietnam to fight the insurgents: 385,000 Americans, more than 700,000 South Vietnamese, and smaller numbers from South Korea, Australia, New Zealand, the Philippines, and Thailand.

During the year, 6,351 Americans died in Vietnam.

In January 1967, U.S. and South Vietnamese forces carried out a major search-and-destroy campaign called Operation Cedar Falls. A combined force of thirty thousand troops attacked a Viet Cong headquarters consisting of a vast network of tunnels in the Iron Triangle, just twenty-five miles northwest of Saigon. But the Viet Cong showed how resilient they could be: Rather than stay and fight, the outnumbered guerrillas retreated into the jungle. The troops then leveled the nearby villages and forcibly relocated the residents. The idea was to make sure the area was swept clean of guerrillas and their supporters—but all the action really accomplished was to heighten the villagers' resentment against U.S. and South Vietnamese forces. Once the troops left, the guerrillas simply returned and rebuilt their headquarters.

The next month saw an even longer and bloodier search-and-destroy mission, Operation Junction City. Some forty-five thousand U.S. and South Vietnamese troops—including paratroopers used in a major assault jump for the first time since the Korean War—formed a cordon around a Viet Cong base camp near the Cambodian border northwest of Saigon. By the time fighting ended in late May, nearly three thousand Viet Cong had been killed, along with almost three hundred Americans and South Vietnamese.

In the United States, spring saw some of the biggest protests yet, as hundreds of thousands demonstrated in New York and San Francisco. The Reverend Martin Luther King Jr. spoke out against the war, calling the United States "the greatest purveyor of violence in the world."

Heavy fighting persisted through the summer, and by August McNamara had become convinced that it would be virtually impossible to bomb North Vietnam into submission. Testifying before the Senate Armed Services Committee, he said the only bombing campaign that might work would be one so vast that it caused "the virtual annihilation of North Vietnam and its people." McNamara would resign on November 29.

He was not the only one whose mind was changed by the war's toll. As demonstrators marched in another wave of protests in thirty cities across the United States in October, a new Gallup poll showed how radically opinion had shifted from nineteen months earlier. Now 46 percent said it had been a mistake for the country to send troops to Vietnam, while 45 percent thought it had been the right thing to do.

But Westmoreland persisted in putting a positive spin on the progress of the war. Visiting the United States in November, he spoke of seeing the "light at the end of the tunnel." That was the same phrase used twenty-four years earlier by French commander Henri Navarre—shortly before he led his forces to disaster at Dien Bien Phu.

By the end of 1967, U.S. troop levels reached 485,000. More than 1 million American soldiers had rotated through Vietnam on tours of duty lasting one year.

The U.S. death toll for the year was nearly twice that of the previous year—11,363.

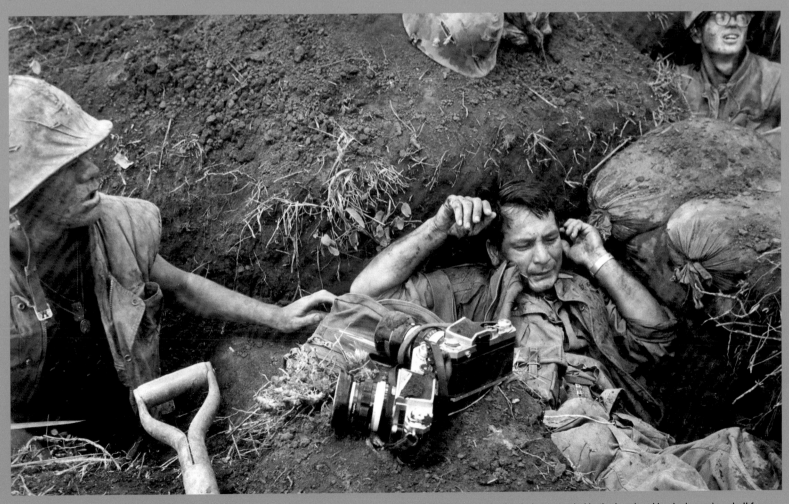

Henri Huet in a trench after being wounded in the hand and leg by incoming shell fragments at the Con Thien Marine outpost near the DMZ, September 22, 1967.

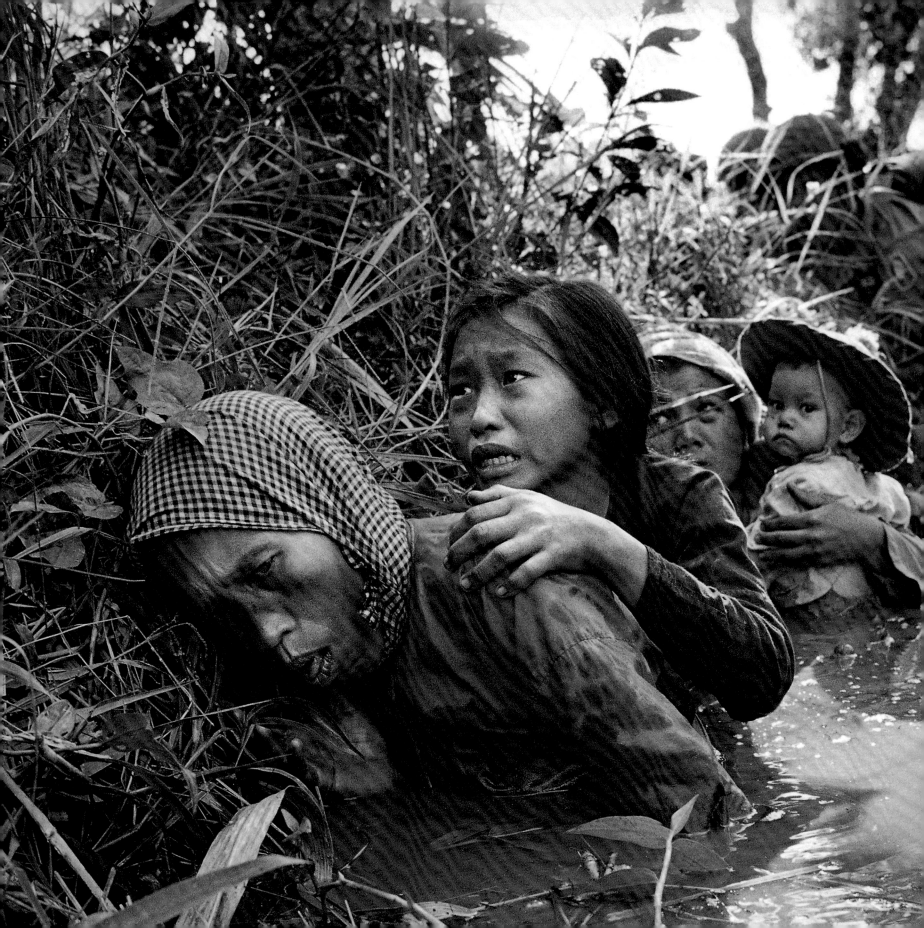

Women and children crouch in a muddy canal as they take cover from intense Viet Cong fire, January 1, 1966.

Paratroopers of the 173rd Airborne Brigade (background) escorted the civilians through a series of firefights during the U.S. assault on a Viet Cong stronghold at Bao Trai, about twenty miles west of Saigon.

Photograph by Horst Faas.

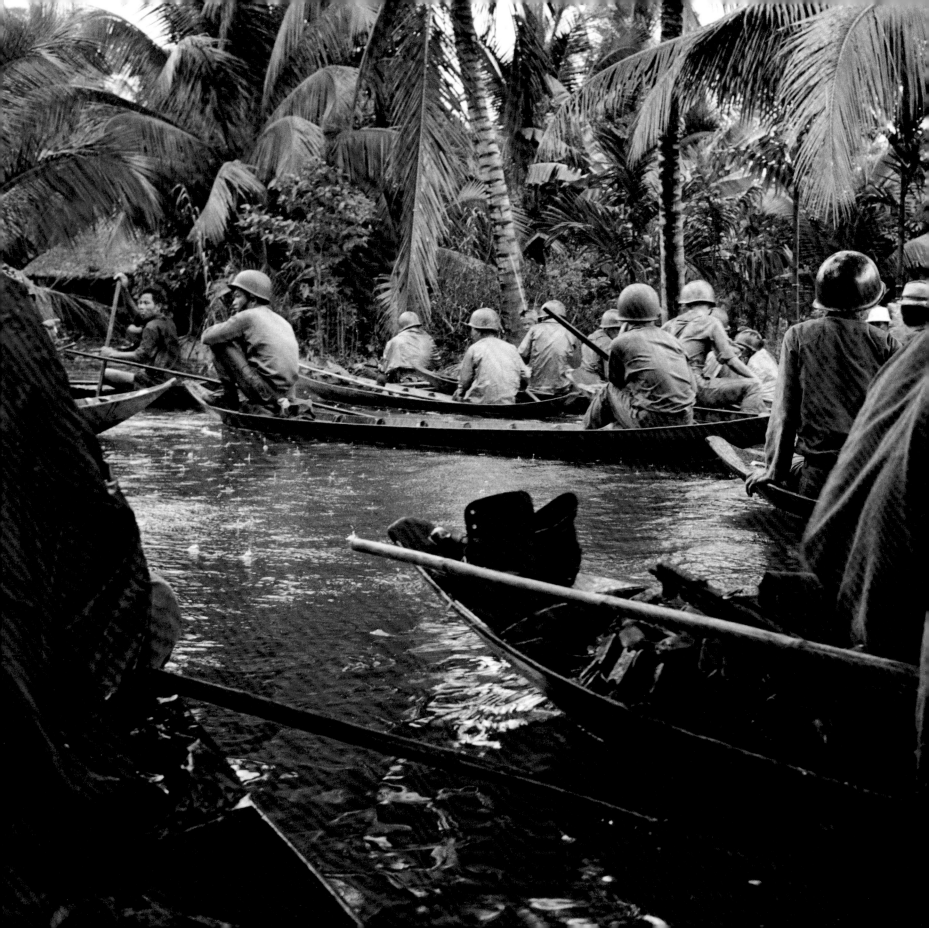

Caught in a sudden monsoon rain, part of a company of about 130 South Vietnamese soldiers moves downriver in sampans during a dawn attack on a Viet Cong camp. January 10, 1966.

Several guerrillas were reported killed or wounded in the action thirteen miles northeast of Can Tho, in the flooded Mekong Delta.

Photograph by Henri Huet.

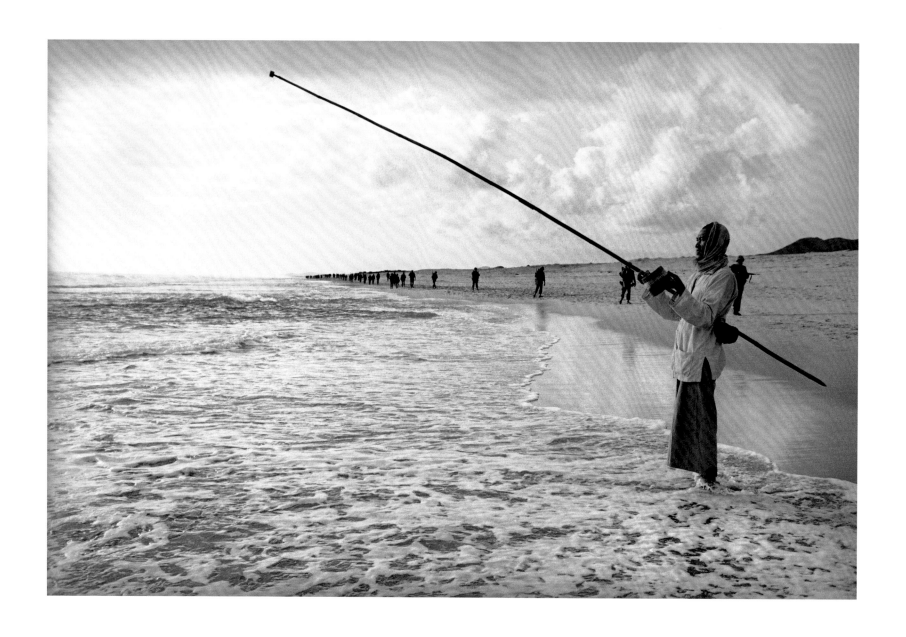

A Vietnamese fisherman keeps his line in the surf as a seemingly endless column of U.S. Marines files along the beach south of Quang Ngai, January 28, 1966.

The troops were among four thousand Marines who came ashore in what was said to be the biggest amphibious assault landing since Inchon in the Korean War. They were there to make a push against Viet Cong forces who had long been in control of the area.

Photograph by Eddie Adams.

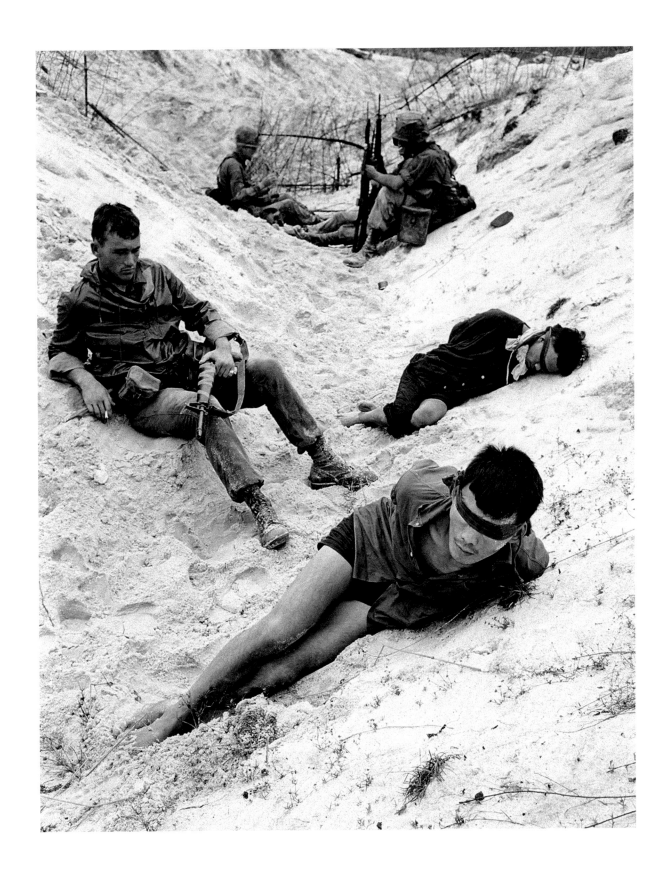

Two captured Viet Cong guerrillas, blindfolded and hands tied behind their backs, are guarded by GIs of the 1st Cavalry Division during the battle of An Thi, on the central coast of South Vietnam, January 29, 1966.

Photograph by Henri Huet.

137

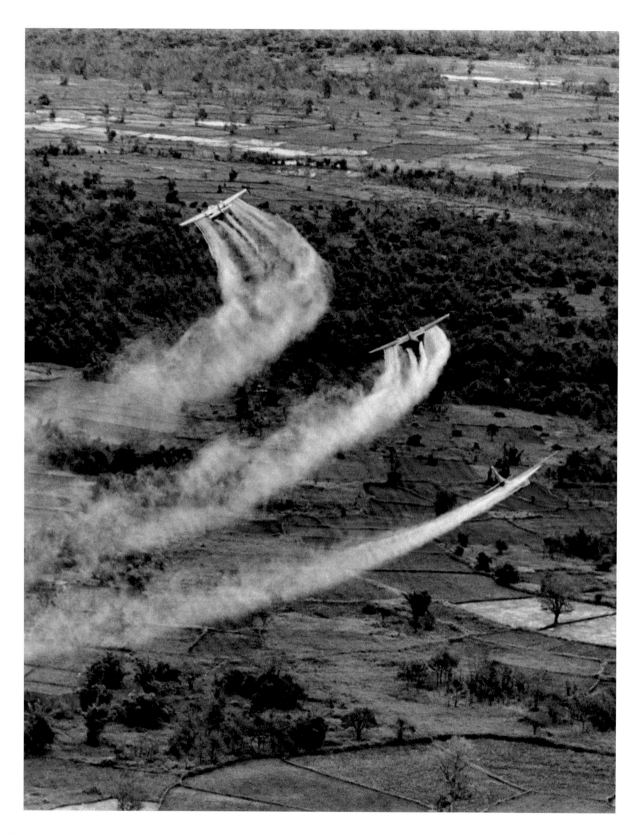

U.S. Air Force planes spray the chemical defoliant Agent Orange over dense vegetation in South Vietnam. 1966.

Millions of gallons of herbicides were sprayed on lands in Vietnam and Laos from 1962 to 1971 to remove forest cover, destroy crops, and clear vegetation from around U.S. bases. Agent Orange, the most widely used defoliant, contained dioxin, which many scientists have blamed for cancer and other serious health problems among the Vietnamese and returning American veterans alike, as well as for birth defects in their children.

AP Images Archive

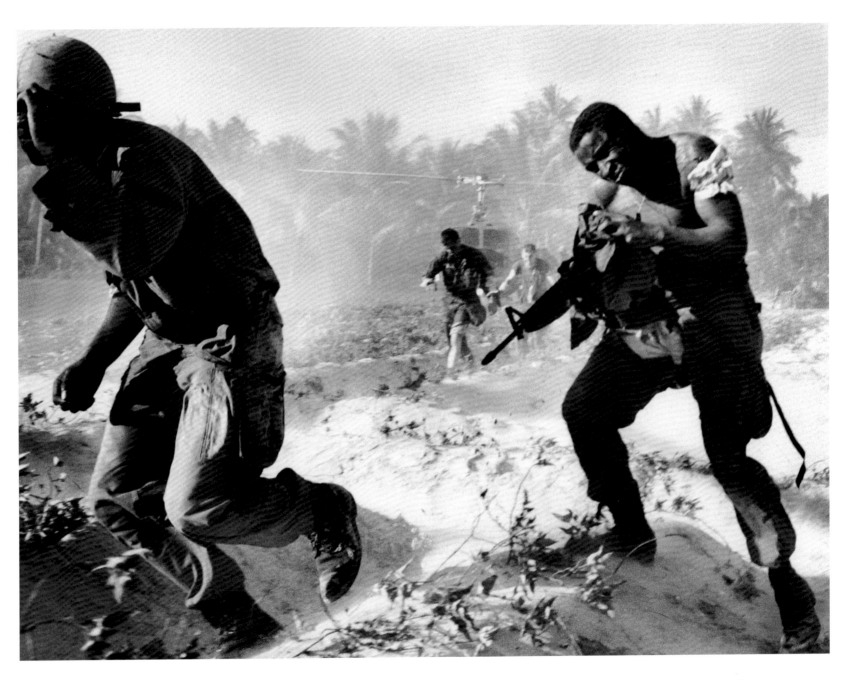

Their faces contorted and clothing ripped, troops of the 1st Cavalry Division dash through a battlefield under fire from the Viet Cong to reach an evacuation helicopter, January 31, 1966.

In the background, other helicopters can be seen leaving the site near Hoai Chau graveyard. Those who stayed behind ended up pinned down in a deadly crossfire with friendly forces.

Photograph by Eddie Adams.

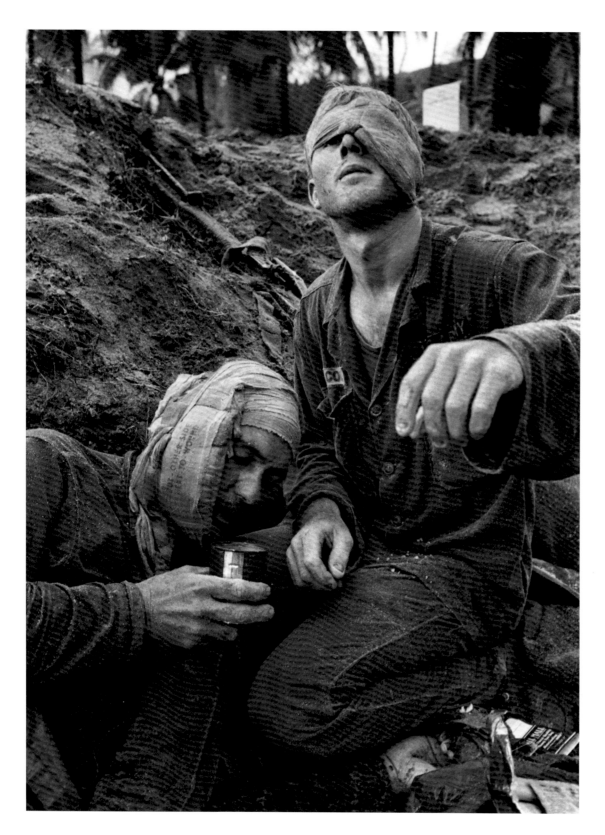

Medic Thomas Cole of Richmond, Virginia, looks up with his one unbandaged eye as he continues to treat wounded S.Sgt. Harrison Pell of Hazleton, Pennsylvania, during a firefight, January 30, 1966.

The men belonged to the 1st Cavalry Division, which was engaged in a battle at An Thi, in the Central Highlands, against combined Viet Cong and North Vietnamese forces. This photo appeared on the cover of *Life* magazine, February 11, 1966, and photographer Henri Huet's coverage of An Thi received the Robert Capa Gold Medal from the Overseas Press Club.

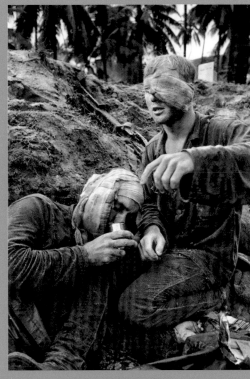

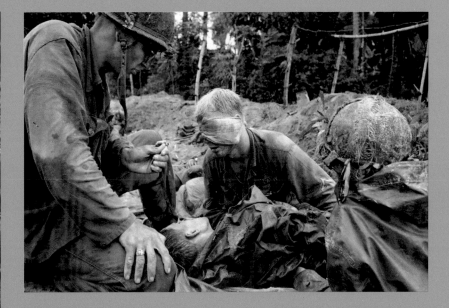

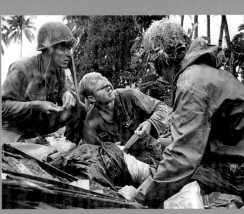

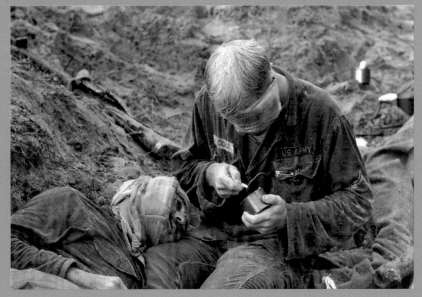

"A U.S. infantryman . . . was crawling back, bullets splattering around him. He flopped into our trench wounded in the hip. A medic floundered across the sprawling panorama of dead and wounded that had stacked up in the trench all that afternoon. . . . Medic Thomas L. Cole, from Richmond, Virginia, already wounded himself in the head, helped tend the wounded lying sprawled in the mud of that trench. He was nearly blinded by the bandage wrapped around his head. But Cole kept on going, answering the plaintive cry of a wounded man here, a dying man there. Cole spent one hour in mouth-to-mouth resuscitation trying to revive one terribly wounded soldier. The man died. Late afternoon, Cole had civilian casualties to tend to, a whole civilian family. They had been hiding in a house in the tiny village nearby. . . . Daylight Saturday brought a clear sky, but . . . only after several hours did the reinforcements come. Only then could we rise from our trench and move out across the sand and mud to the defense line of the now-disappeared Viet Cong. And only then could the wounded be properly treated and the dead be moved out on their long ride back to the United States."

—Henri Huet, from an eyewitness AP story describing his two days with the U.S. 1st Cavalry Division during a battle in the Central Highlands near An Thi, January 28–29, 1966.

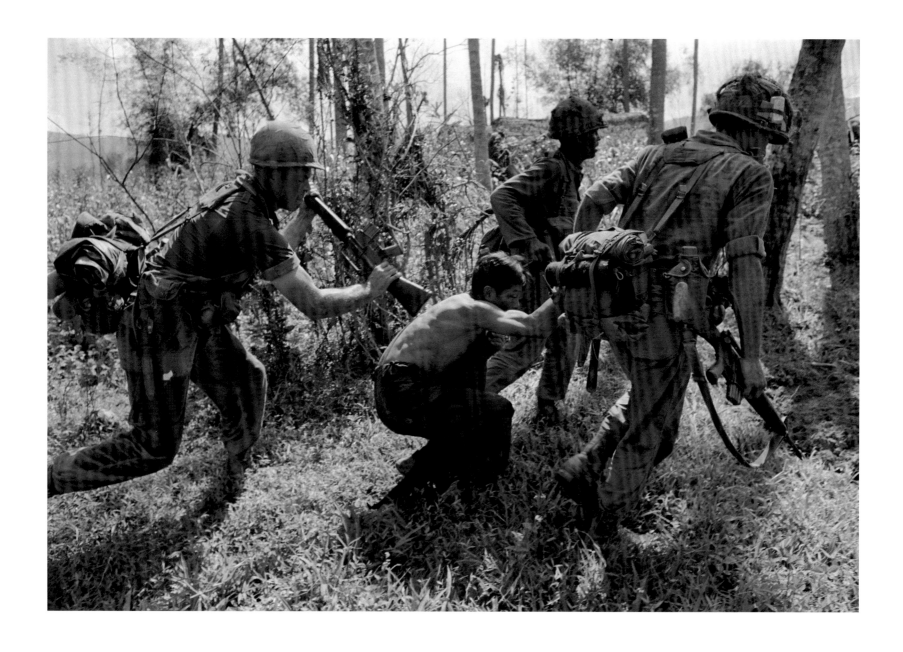

A U.S. soldier swings the butt of his automatic rifle at a Viet Cong guerrilla who refused to walk after being captured near Bong Son, 280 miles northeast of Saigon, February 12, 1966.

Americans from the 1st Cavalry Division were on a search operation in the area.

Photograph by Rick Merron.

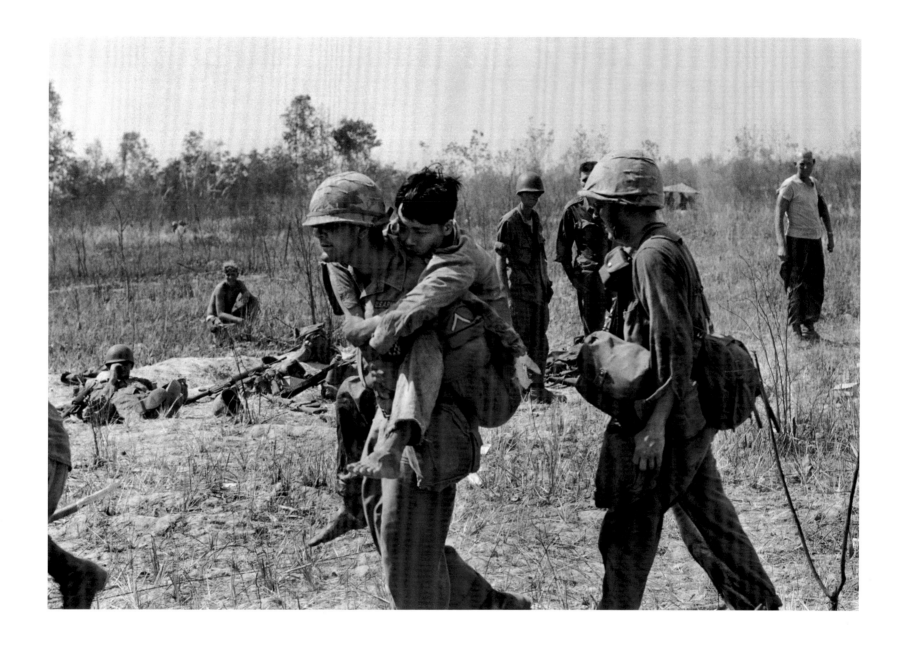

Pfc. John Stanaback of East Paterson, New Jersey, carries a Viet Cong soldier to a first aid station near Bau Bang, thirty miles north of Saigon, March 5, 1966.

Soldiers of the 2nd Battalion, 28th Infantry Regiment, fought off a multi-battalion Viet Cong attack and found this man left behind, bloodied, barefoot, and unarmed.

Photograph by Horst Faas.

Pfc. Clark Richie sniffs the scent of a letter from a girl back home in Jay, Oklahoma, April 1966.

A short while later, his B Company, 2nd Battalion, 25th Infantry Division, was to take part in an assault on a tunnel-riddled Viet Cong stronghold near Cu Chi.

Photograph by John Nance.

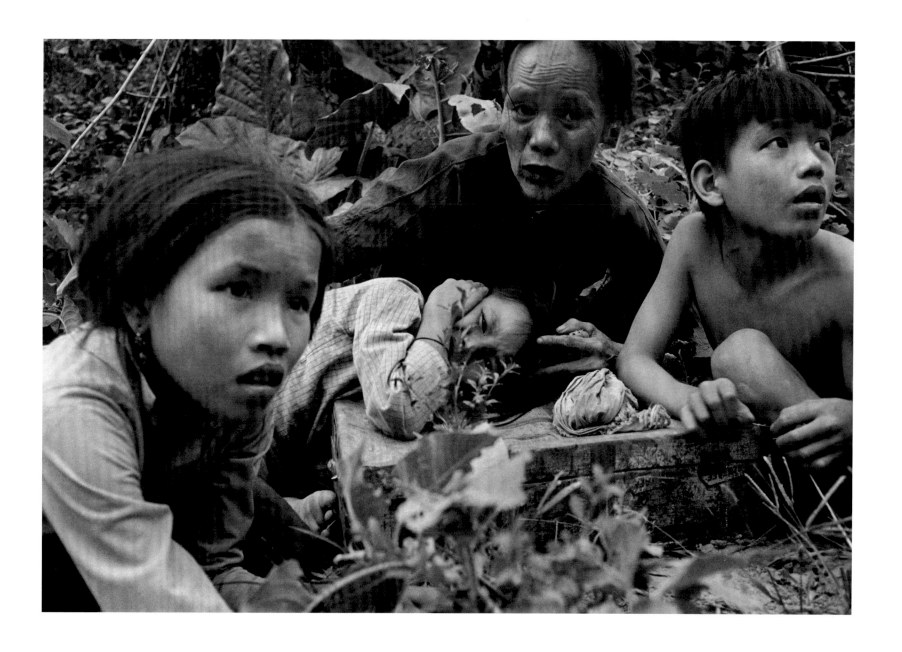

A Vietnamese mother huddles with her three children during a battle between U.S. Marines and Viet Cong snipers in the village of Ngoc Kinh, twenty-five miles southwest of Da Nang, April 7, 1966.

Photograph by George Esper.

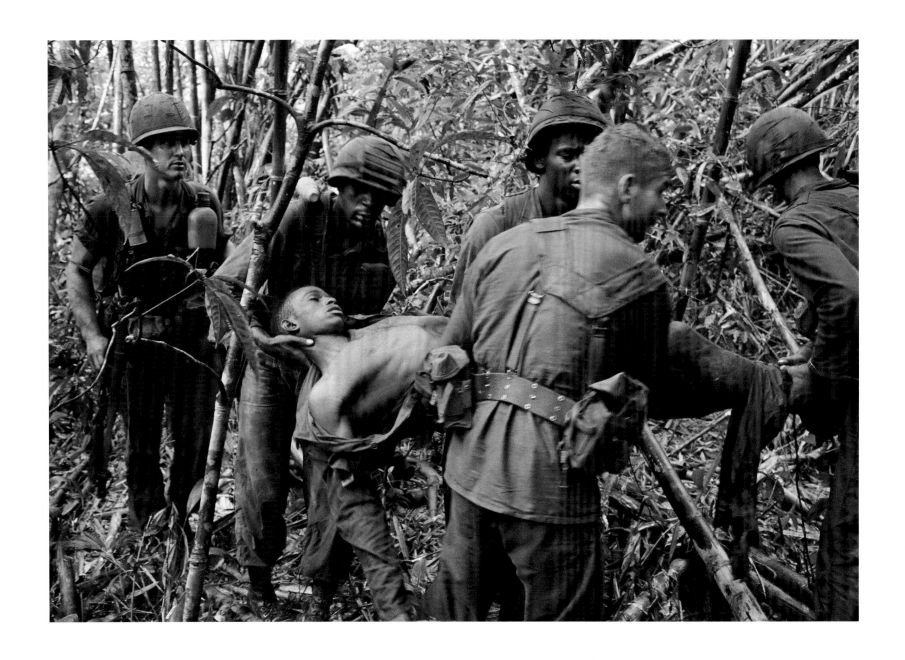

Soldiers of the 101st Airborne Division carry a wounded comrade through the jungle, May 1966.

Photograph by Henri Huet.

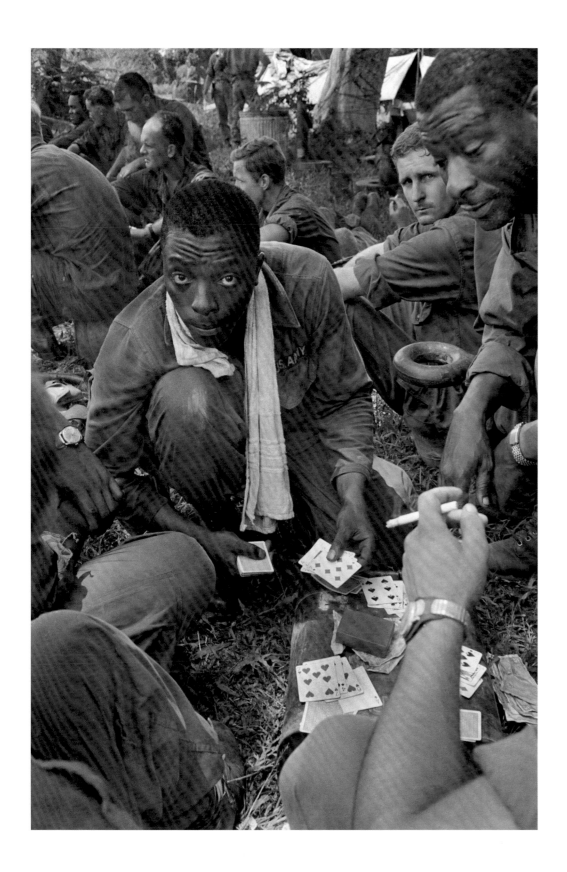

GIs of the 1st Infantry Division play a hand of cards as they await transport between operations from their base camp at Binh Long, near Bien Hoa, July 9, 1966.

Photograph by Le Ngoc Cung.

The body of a U.S. paratrooper killed in action in the jungle near the Cambodian border is lifted up to an evacuation helicopter in War Zone C, May 14, 1966.

The zone, encompassing the city of Tay Ninh and the surrounding area north of Saigon, was the site of the Viet Cong's headquarters in South Vietnam.

Photograph by Henri Huet.

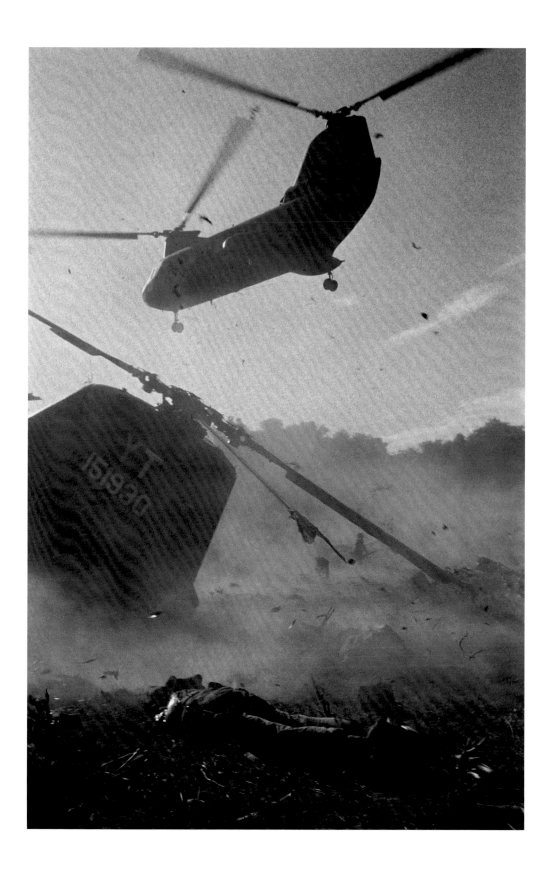

Dust, debris, and smoke fill the air after a U.S. Marine helicopter crashed while landing in the Song Ngan Valley, a short distance from the DMZ, mid-July 1966.

In the foreground, a Marine has been felled by the chopper blades; above, another helicopter tries to get into the landing zone.

Photograph by Horst Faas.

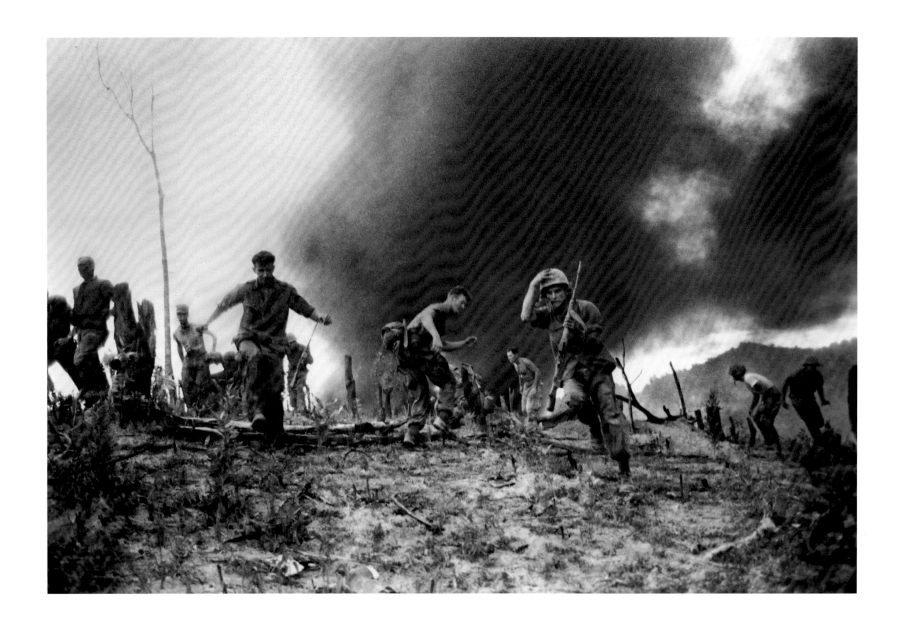

Marines scatter as a CH-46 "Sea Knight" helicopter burns in the background after being shot down by the Viet Cong in the bivouac area of a Marine unit about a mile south of the DMZ, July 15, 1966.

At least thirteen Marines were reported killed in the crash. Opposite, a stunned and burned gunner, one of three survivors, walks out the jungle after being pinned down by enemy fire. U.S. troops had to fight off snipers before he could emerge from the cover of brush.

Photographs by Horst Faas.

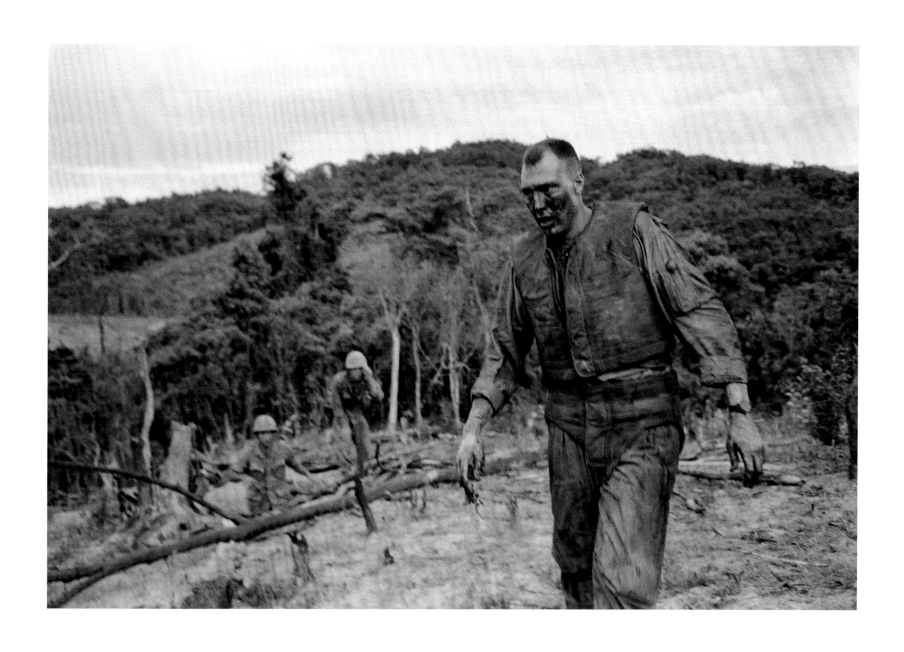

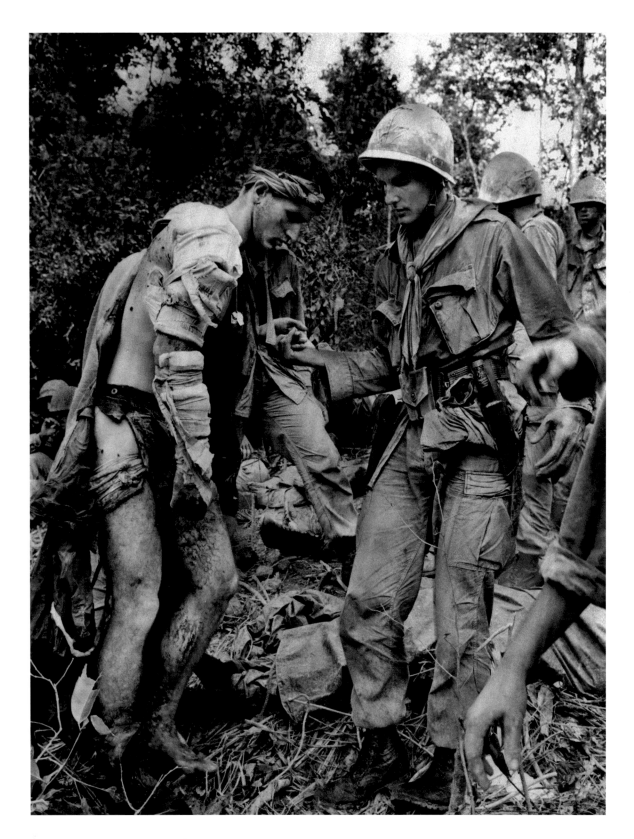

A medic leads a wounded, half-naked Marine of India Company from the battle area to a helicopter evacuation during Operation Hastings. July 24, 1966.

The company suffered heavy fatalities and saw almost half its number wounded in the encounter, which succeeded in pushing the North Vietnamese Army back across the DMZ.

AP Images Archive

Paratrooper Sgt. James R. Cone of Clarksville, Tennessee, holds a puppy that nipped him as he groped about in a cave entrance on a riverbank in Lam Dong Province, July 24, 1966.

At left is Pfc. George R. Rosen of Whitehall, Montana. Troops of the 173rd Airborne Brigade were searching for Viet Cong guerrillas in the caves, but the men had fled, leaving only women and children—and one dog.

Photograph by Henri Huet.

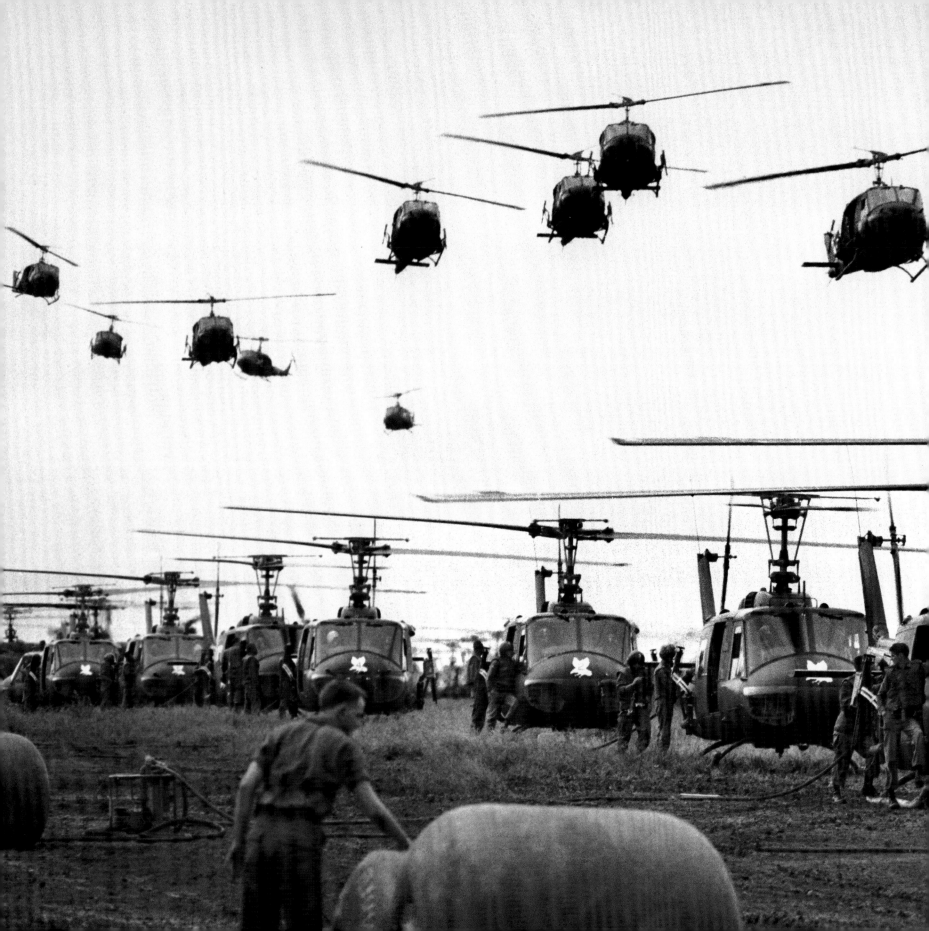

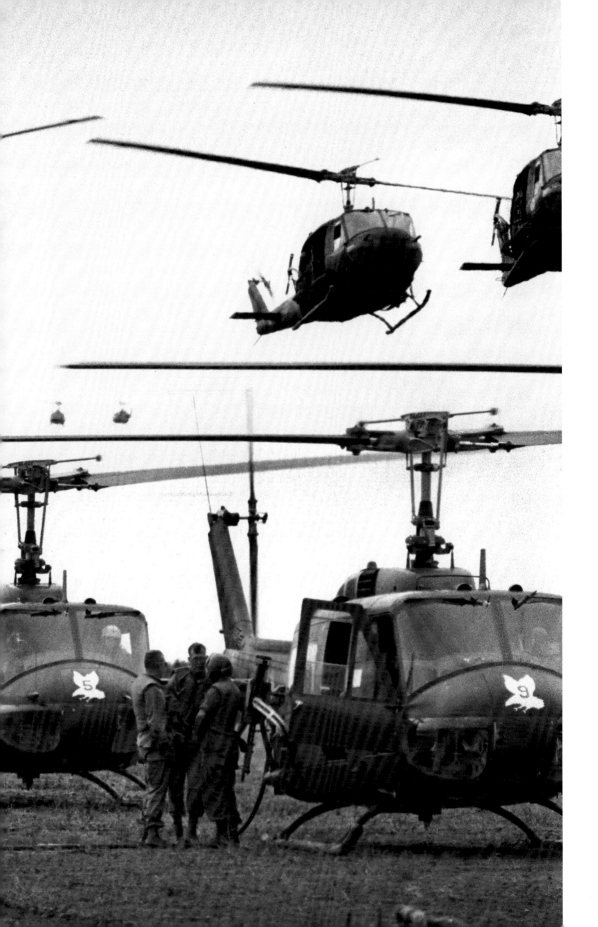

Army helicopters providing support for U.S. ground troops fly into a staging area fifty miles northeast of Saigon. Bladders in the foreground hold fuel for the aircraft. August 1966.

Photograph by Henri Huet.

155

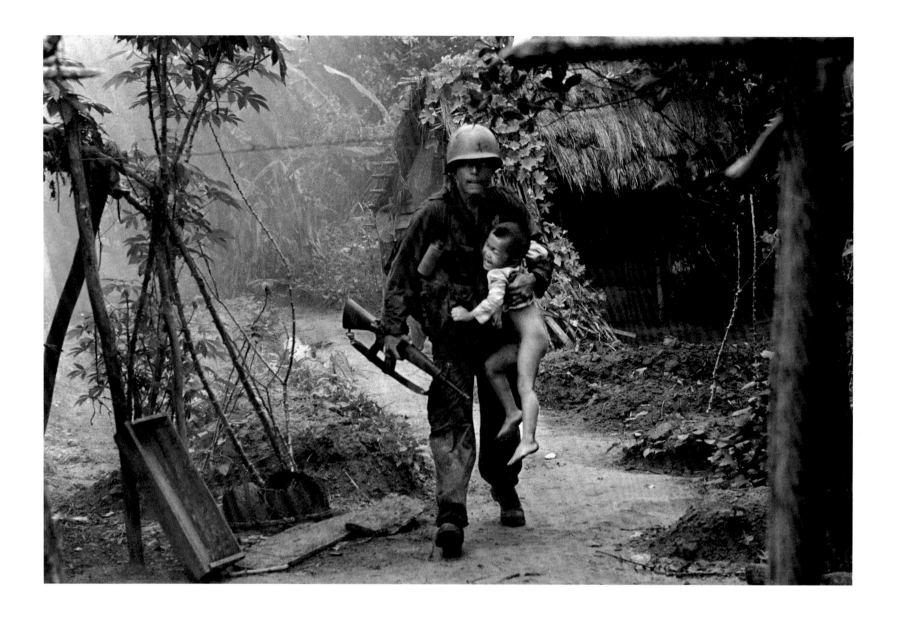

A U.S. infantryman from A Company, 1st Battalion, 16th Infantry Regiment, 1st Division, carries a crying child from Cam Xe village after dropping a phosphorus grenade into a bunker cleared of civilians, August 22, 1966.

A platoon of the 1st Infantry Division raided the village near the Michelin rubber plantation northwest of Saigon looking for snipers who had inflicted casualties on them. GIs rushed about forty civilians out of the village before artillery bombardment ensued.

Photograph by Horst Faas.

Pfc. Eugene Cabbagestalk of Pittsburgh pushes back his helmet to wipe sweat from his face, August 1966.

Cabbagestalk, who had been in Vietnam only a month when this photo was taken, was killed the following January at age twenty.

Photograph by Henri Huet.

157

With Saigon nightlife in full swing in the Cholon section, flares burst just two miles away as U.S. planes and helicopters attack Viet Cong guerrillas who were infiltrating two southern precincts of the capital, September 9, 1966.

AP Images Archive

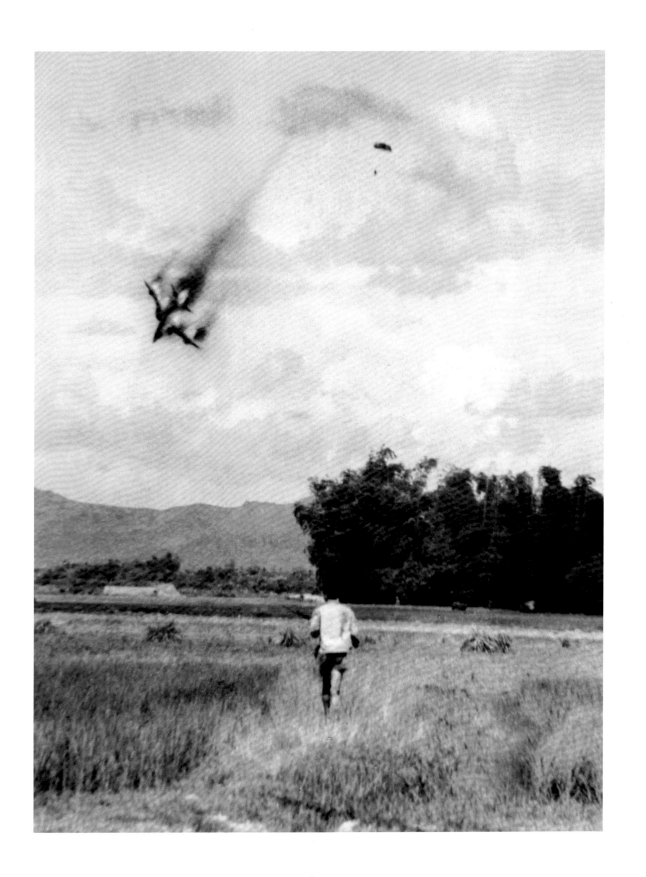

A U.S. F-105 warplane is shot down, and the pilot ejects and opens his parachute near Vinh Phuc, north of Hanoi, September 1966. The pilot was captured and held in a North Vietnamese camp until the release of POWs in 1973.

This photograph by Mai Nam of *Tien Phong* newspaper was one of the most recognized images by a North Vietnamese photographer during the war.

Photograph courtesy OnAsia.

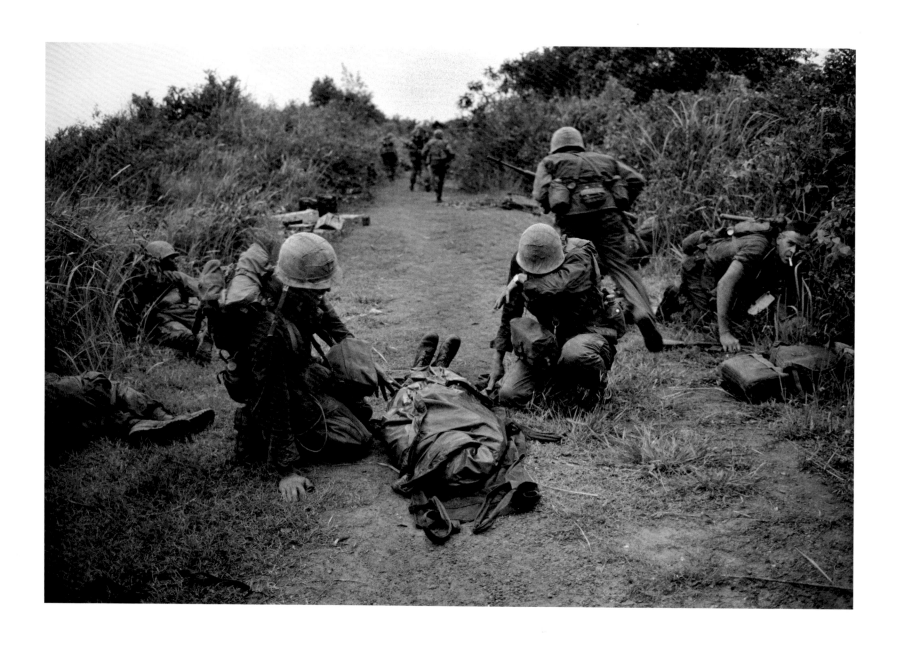

A Marine wipes tears from his face as he kneels beside a body wrapped in a poncho during a firefight near the DMZ, September 18, 1966.

Other dead and wounded lie at the side of the road as the fighting continues.

Photograph by Horst Faas.

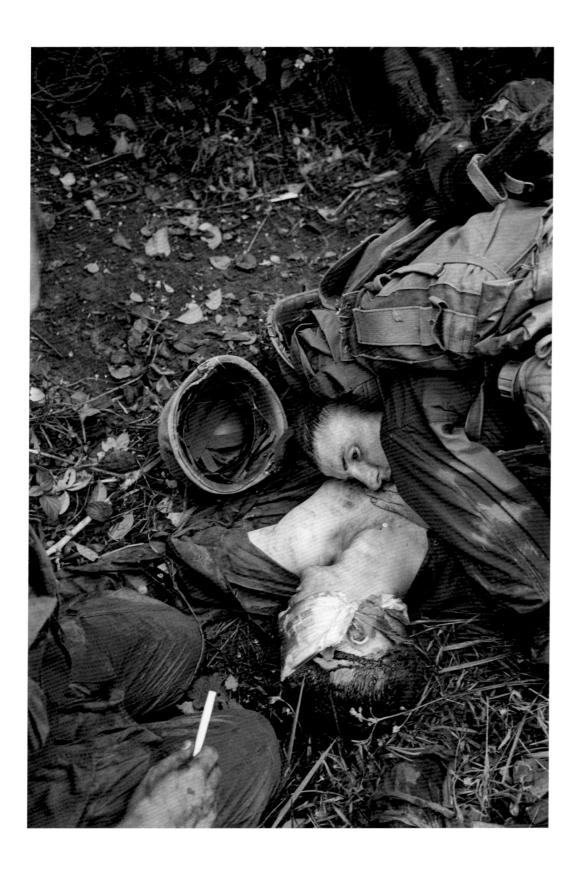

A U.S. Marine listens for the heart-beat of a dying buddy who suffered head wounds when the company's lead platoon was hit with machine-gun fire as they pushed through a rice paddy near the DMZ, September 17, 1966.

Photograph by Horst Faas.

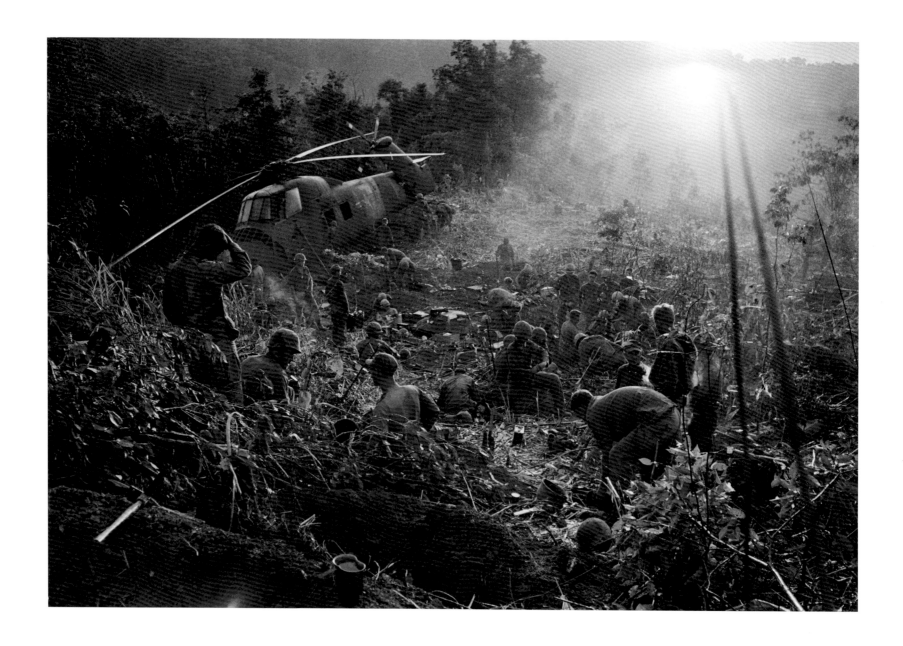

Marines emerge from their foxholes south of the DMZ after a third night of fighting against North Vietnamese troops, September 1966.

The helicopter at left was shot down when it came in to resupply the unit.

Photograph by Henri Huet.

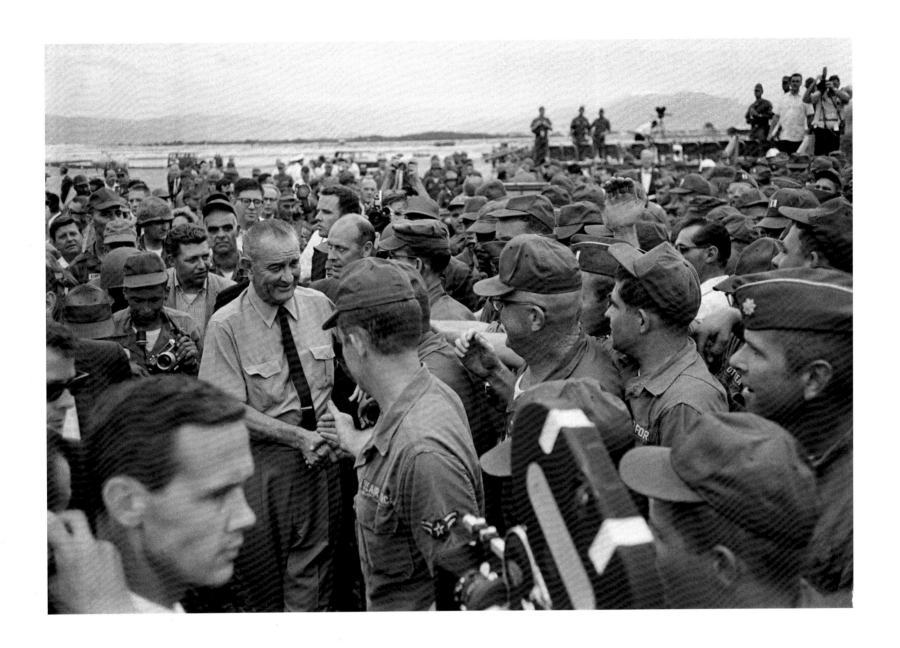

A crowd of U.S. soldiers swarms around President Johnson shortly after his arrival at Cam Ranh Bay to visit troops. October 26. 1966.

This was the first of Johnson's two visits to the heavily fortified air base two hundred miles northeast of Saigon, on the South China Sea. The second would come just before Christmas a year later.

Photograph by Henry Burroughs.

Spec. 4 Ruediger Richter of Columbus, Georgia, watches the sky for a medevac helicopter that has been signaled by a smoke grenade in a jungle clearing in Long Khanh Province. October 1966.

Sgt. Daniel E. Spencer of Bend, Oregon, stands by the poncho-wrapped body of Pfc. Daryl R. Corfman, of Sycamore, Ohio, who was killed by mortar fire. All three men were serving with the 4th Battalion, 503rd Infantry Regiment, 173rd Airborne Brigade. Richter, a former French Foreign Legionnaire, survived the war. Spencer was killed in action with the 1st Special Forces in November 1968.

Photograph by Pfc. L. Paul Epley of the 173rd Brigade.

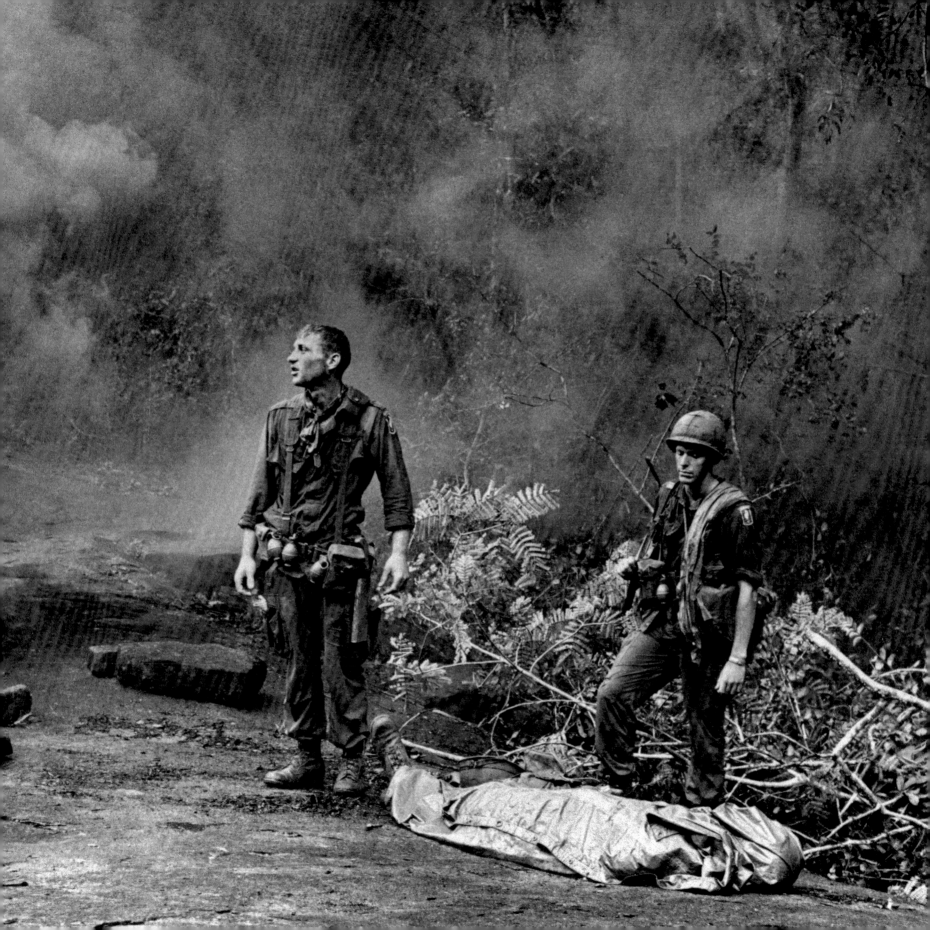

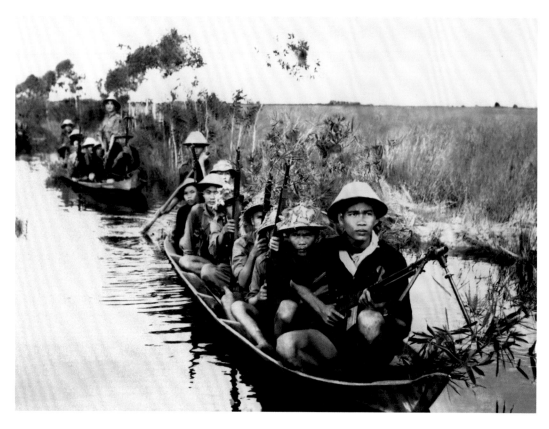

A Viet Cong patrol moves along a canal in sampans through an unidentified location in South Vietnam, 1966.

Photograph courtesy Vietnam News Agency.

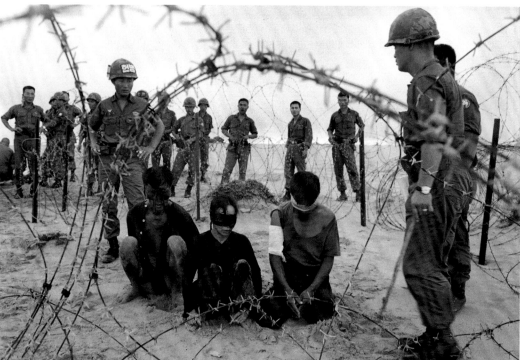

Two Vietnamese men and a woman sit blindfolded and bound in a barbed-wire enclosure awaiting interrogation, November 30, 1966.

The three, captured by South Korean troops of the White Horse Division in a cave twenty-four miles south of Tuy Hoa Air Base, turned out to be the political and administrative leaders of a mountain village controlled by the Viet Cong. The White Horse division was in Vietnam as part of the Republic of Korea's contribution to the war effort. More than five thousand South Korean soldiers would die during the conflict.

Photograph by Hong Seong-Chan.

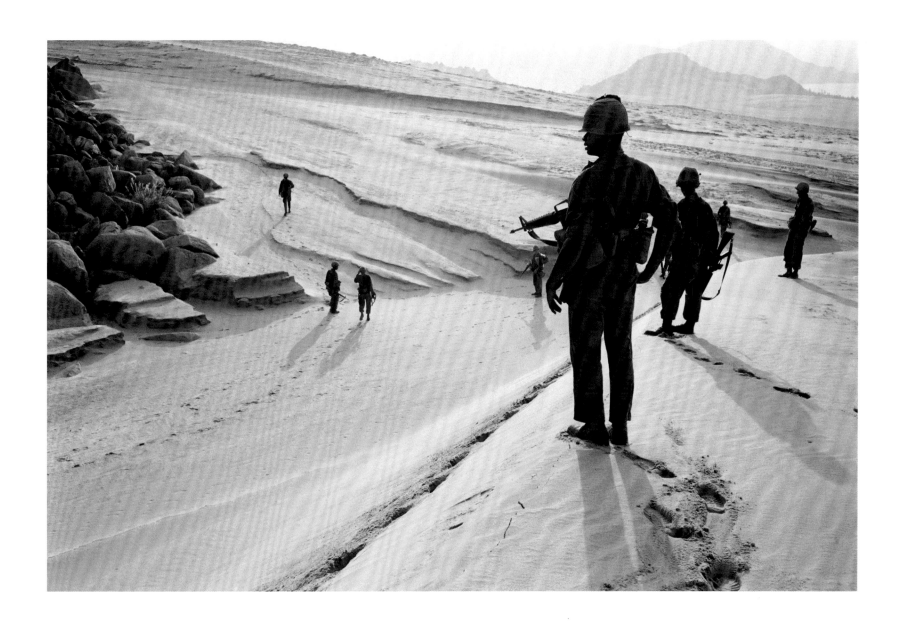

A 1st Cavalry Division reconnaissance unit overlooks the beach about twenty miles north of Qui Nhon, on the central coast of South Vietnam, during Operation Thayer II, December 1966.

The operation, which began on October 25, was a follow-up to an earlier search-and-destroy mission whose goal was to uproot insurgent forces, as well as the Viet Cong's political infrastructure, from Binh Dinh Province. It concluded in February 1967, after heavy losses on both sides.

Photograph by Henri Huet.

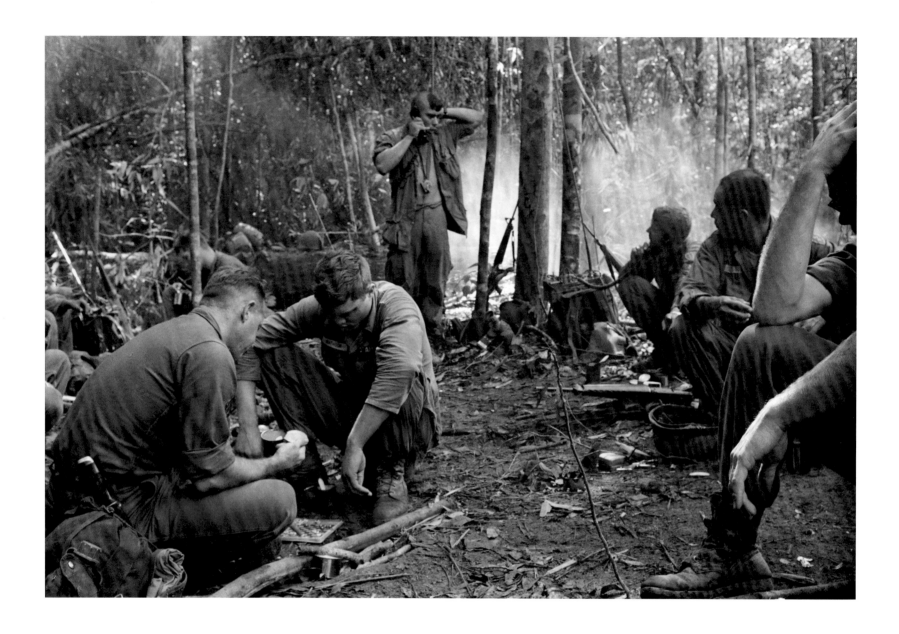

Two men of the 25th Infantry Division enjoy a game of chess along with their breakfast C rations in the mountainous jungle west of Pleiku. December 1966.

The men were taking part in Operation Paul Revere, a search-and-destroy mission under way since August near the Cambodian border. From left: 1st Sgt. Clifton Bergman of Spotsylvania, Virginia; E-4 Oscar Mathison of Wallingford, Kentucky; Spec. 4 James Billey (standing), of Hollywood, Florida; and Capt. Joseph Caudillo (far right), of Kerman, California. A fifth man, second from right in the background, is unidentified. Bergman and Caudillo were killed in separate operations in 1967; Bergman received the Silver Star for his actions.

Photograph by Robert Ohman.

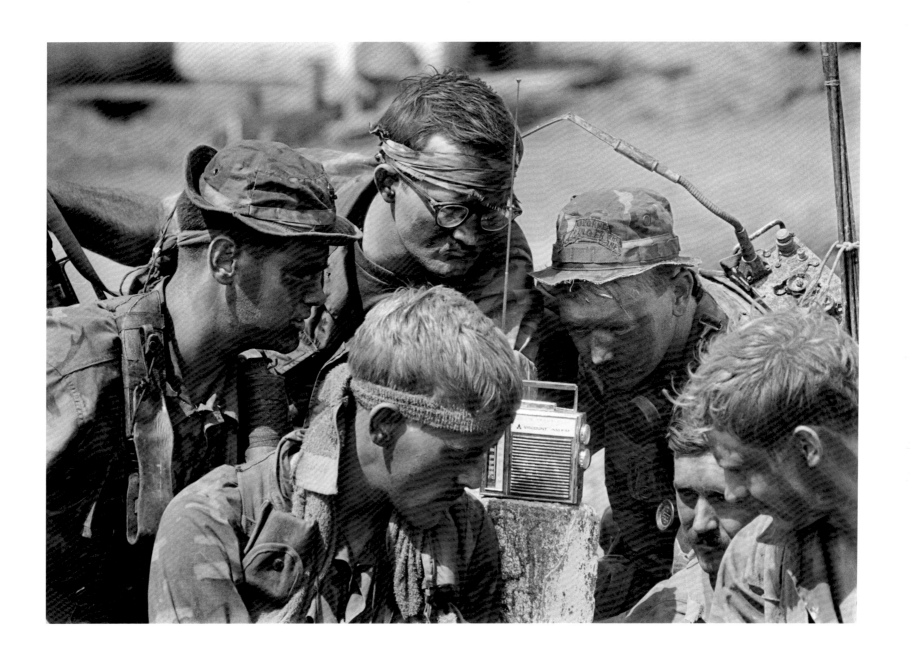

Soldiers gather around their transistor radio to listen to a broadcast, 1966.

Photograph by Oliver Noonan.

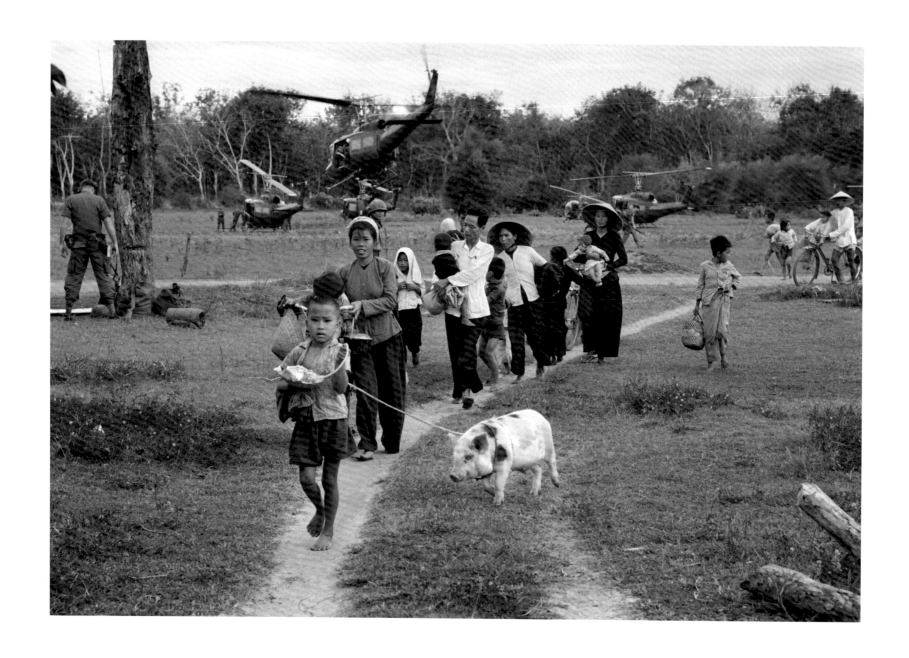

South Vietnamese families leave their homes at Ben Suc, in the Iron Triangle, January 11, 1967.

A battalion of the U.S. 1st Infantry Division surrounded the guerrilla-controlled town on the Saigon River and over several days evacuated the civilians for relocation at a refugee center north of Saigon. Then troops moved in with plows, bulldozers, and anti-mine tanks, burning down all the dwellings and other buildings, leveling cultivated fields, and destroying a network of tunnels used by the Viet Cong.

Photograph by Horst Faas.

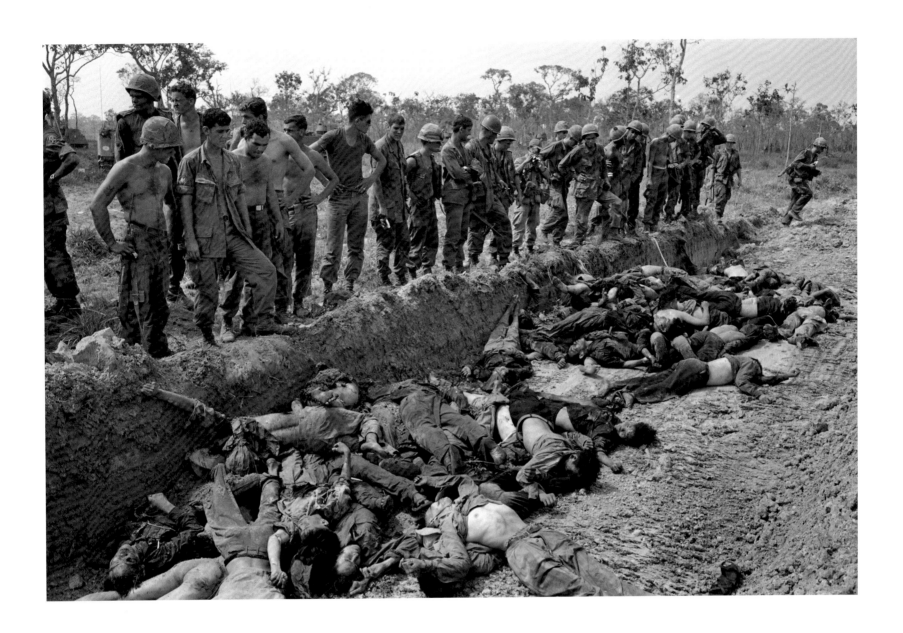

U.S. soldiers of the 3rd Brigade, 4th Infantry Division, look on a mass grave of insurgents after a daylong battle against the Viet Cong's 272nd Regiment in War Zone C, sixty miles northwest of Saigon, March 1967.

U.S. military command reported 423 Viet Cong killed in the action and put American losses at 30 dead, 109 wounded, and three missing. However, these official "body counts" often overstated the numbers of insurgents killed.

Photograph by Henri Huet.

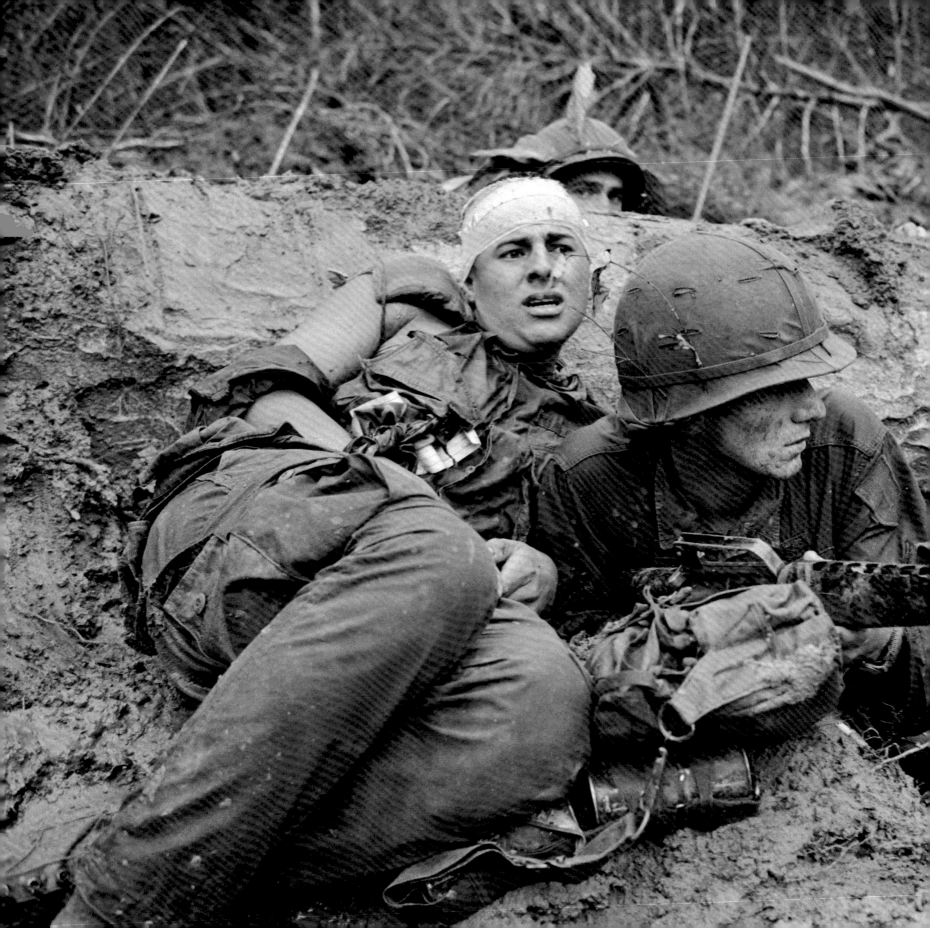

A soldier positioned over his rifle protects a wounded comrade as they crouch in thick mud during a battle near Phuoc Vinh, mid-June 1967, while another soldier peers over a log. In thirty minutes of fighting, six men were killed and twelve wounded from B Company, 1st Battalion, 16th Infantry Regiment, 1st Division.

Photograph by Henri Huet.

Gen. William C. Westmoreland and Robert McNamara wear muffler-type radio earphones as they ride in a helicopter toward the DMZ during a visit by the secretary of defense to South Vietnam, July 10, 1967.

By this time, McNamara was becoming increasingly convinced that U.S. military strategy would not lead to victory, and he would resign before year's end.

Photograph by John T. Wheeler.

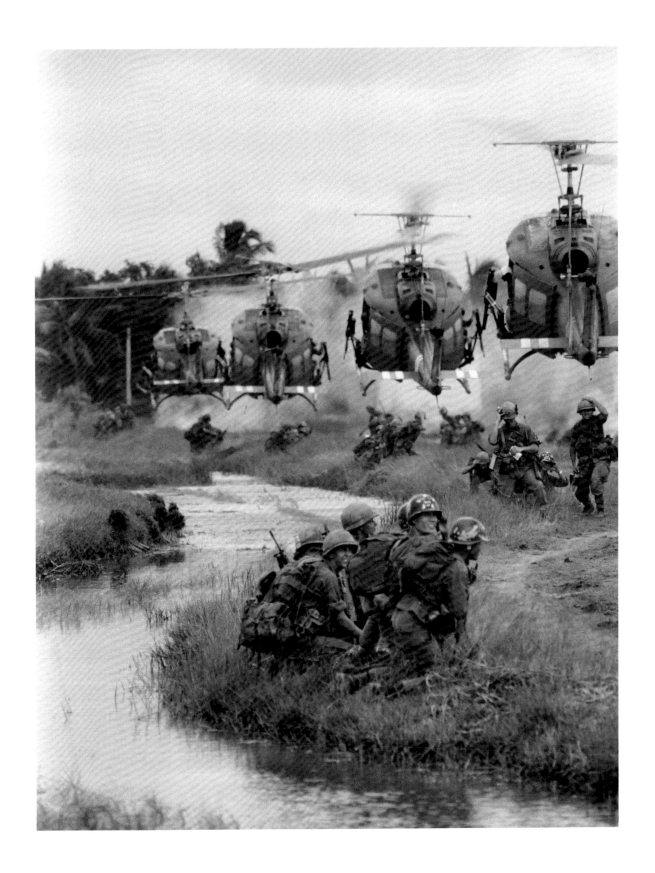

Ferrying South Vietnamese Rangers, helicopters of the U.S. 199th Light Infantry Brigade swoop into a landing zone on the fringe of a pineapple plantation, August 1967.

U.S. and South Vietnamese troops were taking part in a combined sweep of the area in the Mekong Delta sixteen miles southwest of Saigon.

Photograph by Dang Van Phuoc.

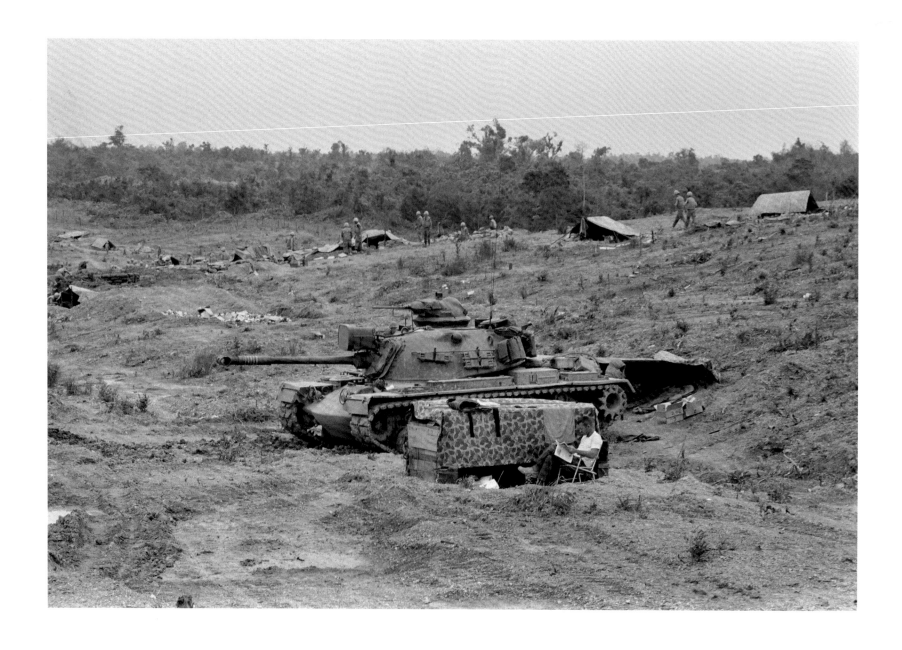

Taking advantage of a respite from North Vietnamese artillery bombardments, a Marine sits reading a magazine while staying close to his bunker and a friendly tank in Con Thien, October 1967.

The outpost, situated close to the DMZ, was a target of heavy shooting.

Photograph by Dang Van Phuoc.

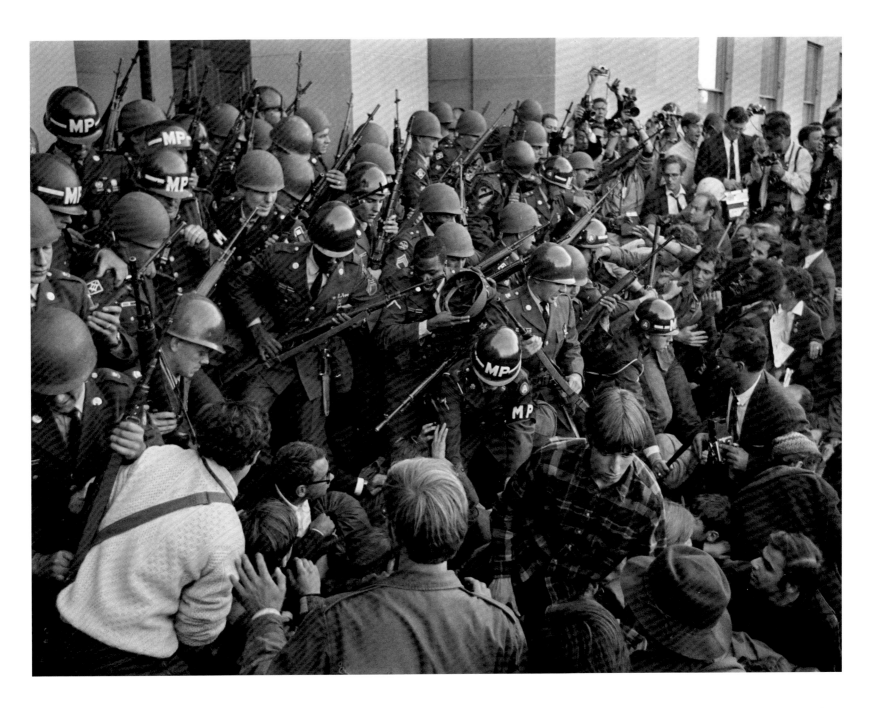

Military police, reinforced by U.S. Army troops, hold back antiwar demonstrators as they try to storm an entrance to the Pentagon, October 21, 1967.

Nearly one hundred thousand people gathered in Washington to protest the Vietnam War, and more than fifty thousand of them marched to the Department of Defense headquarters across the Potomac River in Arlington, Virginia.

AP Images Archive

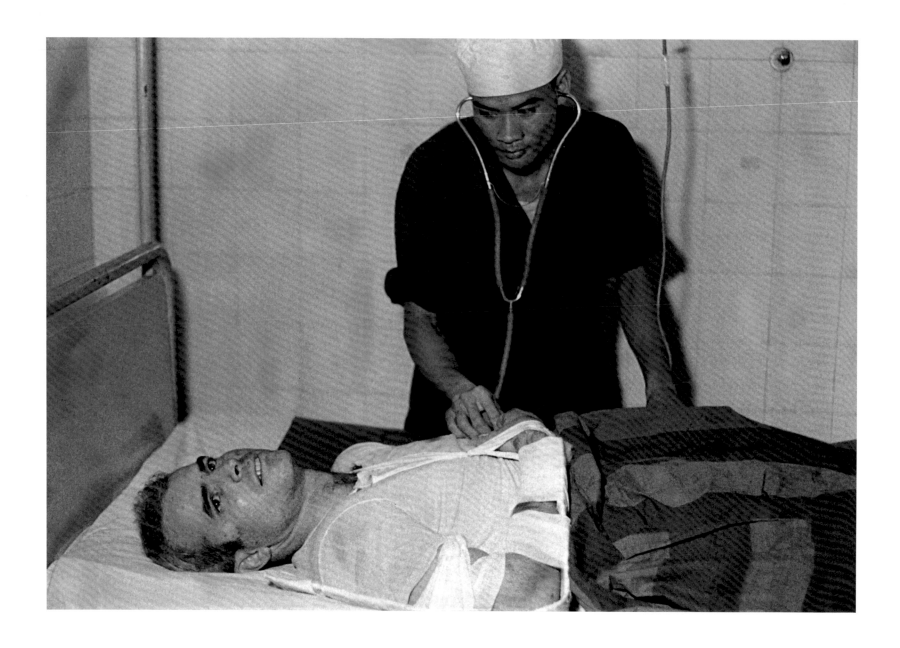

Prisoner of war Lt. Cmdr. John McCain is treated in a hospital in Hanoi, autumn 1967. He suffered multiple broken bones when his jet was shot down during a bombing mission over Hanoi on October 26, 1967.

He would be held in captivity with other POWs for more than five years, until early 1973.

Photograph by Van Luong courtesy Vietnam News Agency.

With gunfire crackling around him, a soldier of the 1st Cavalry Division lobs a grenade at an enemy machine-gun bunker in the opening minutes of a firefight near Binh Yen, twenty-three miles south of Da Nang, late October 1967.

Photograph by Bob Ohman.

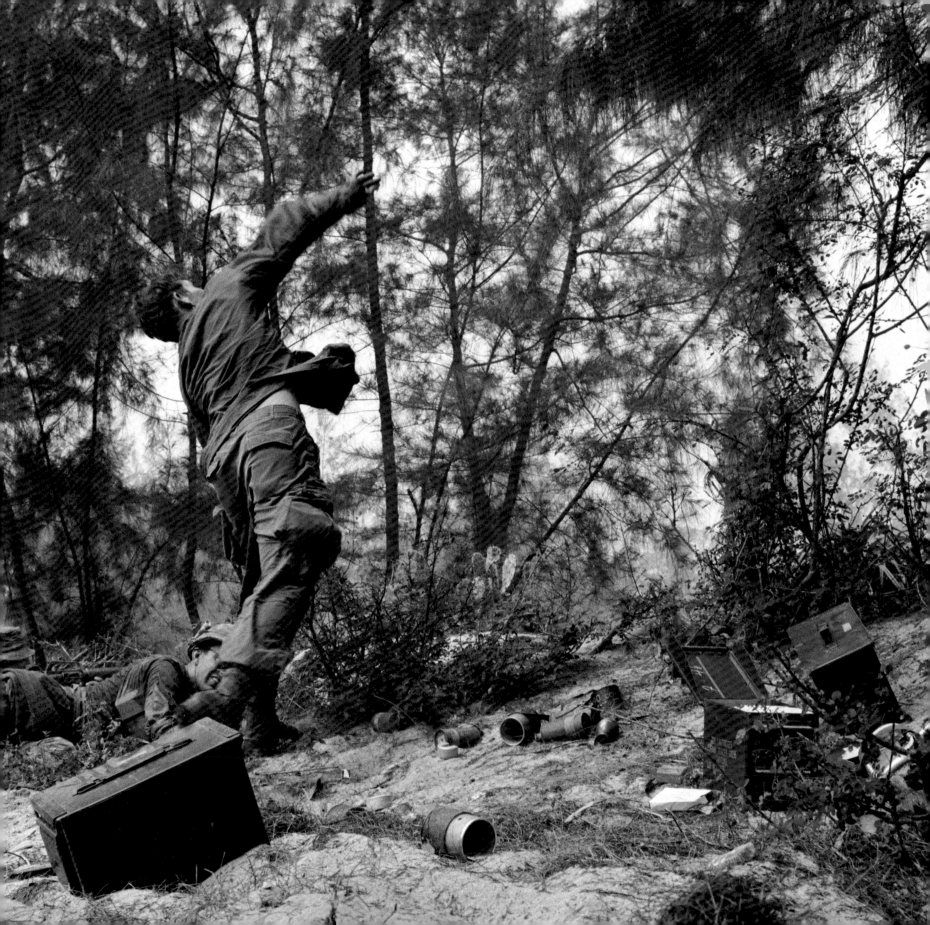

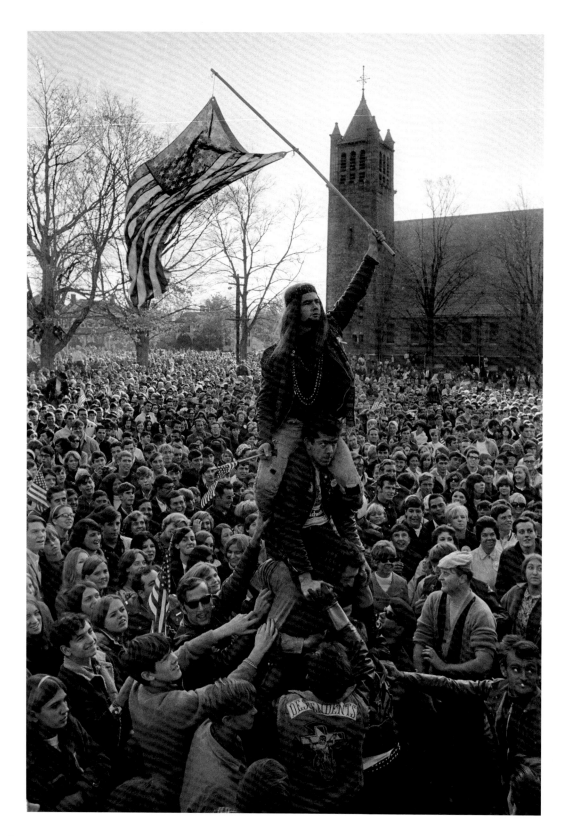

Held aloft by a human pyramid, a member of the Hell's Angels motorcycle club waves a flag at a rally in Wakefield, Massachusetts, supporting American men fighting in Vietnam, October 29, 1967.

The demonstration, organized by a local teenager, drew a crowd estimated by police at nearly twenty-five thousand to the common.

Photograph by J. Walter Green.

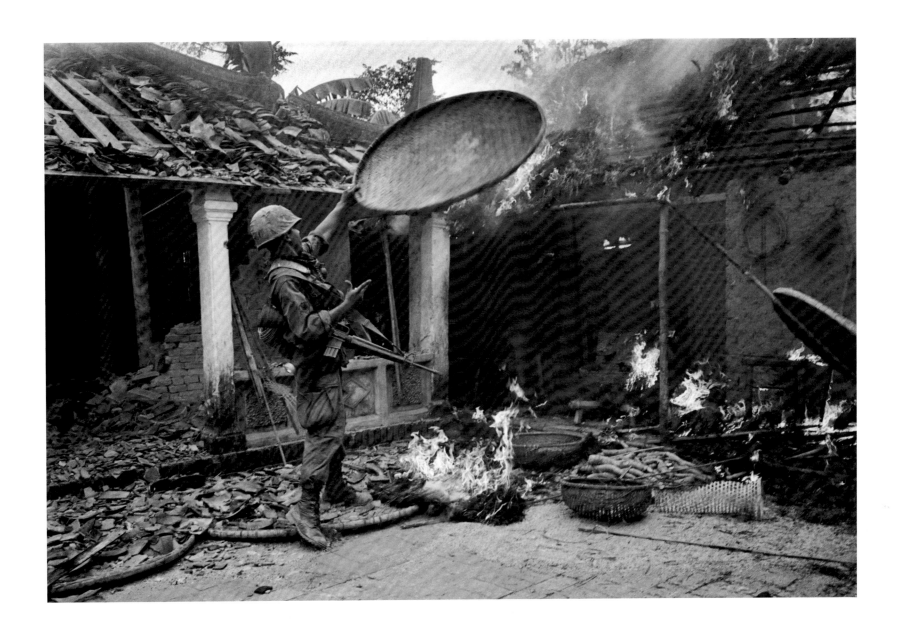

A 1st Cavalry Division soldier throws a rice basket onto the flames as his unit sweeps through a village near Tam Ky, 350 miles northeast of Saigon, October 27, 1967.

A peasant woman had tried to salvage the basket from the burning house, but U.S. troops were intent on destroying anything that might be of value to the Viet Cong.

Photograph by Dang Van Phuoc.

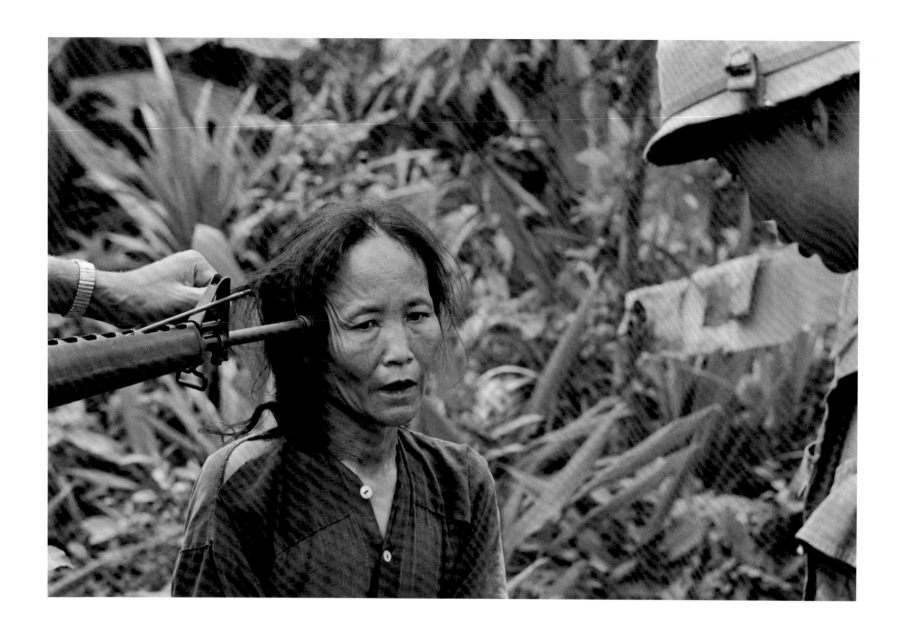

A Viet Cong suspect is questioned at gunpoint by a South Vietnamese police officer at Tam Ky. November 1967.

The M16 rifle is held by a U.S. soldier during an operation of the 101st Airborne Division, which was searching villages of the coastal plains for suspected Viet Cong enclaves.

AP Images Archive

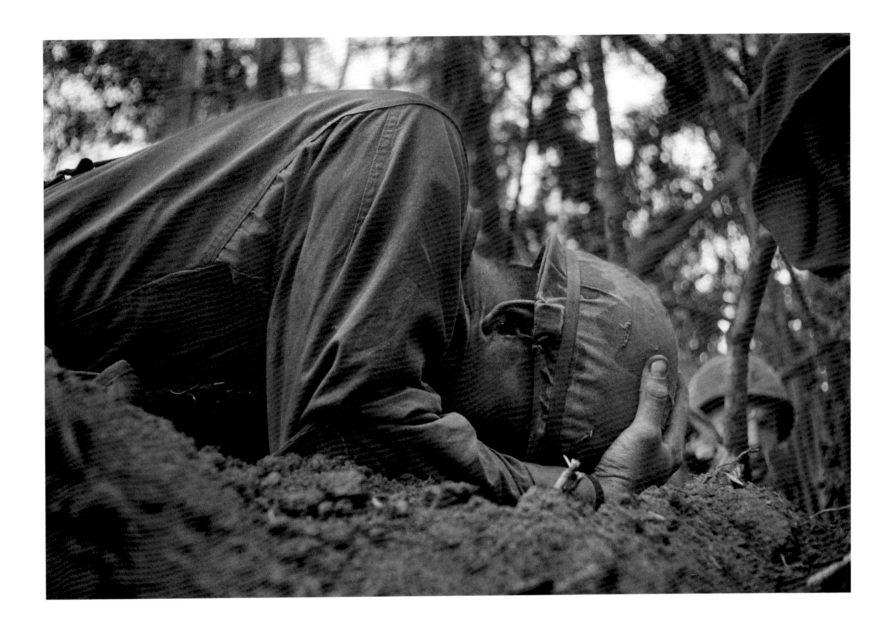

A paratrooper of the 173rd Airborne Brigade clutches his helmet as he hugs the ground to protect himself from a North Vietnamese mortar attack on Hill 875 during the battle of Dak To, November 21, 1967.

Photograph by Peter Arnett.

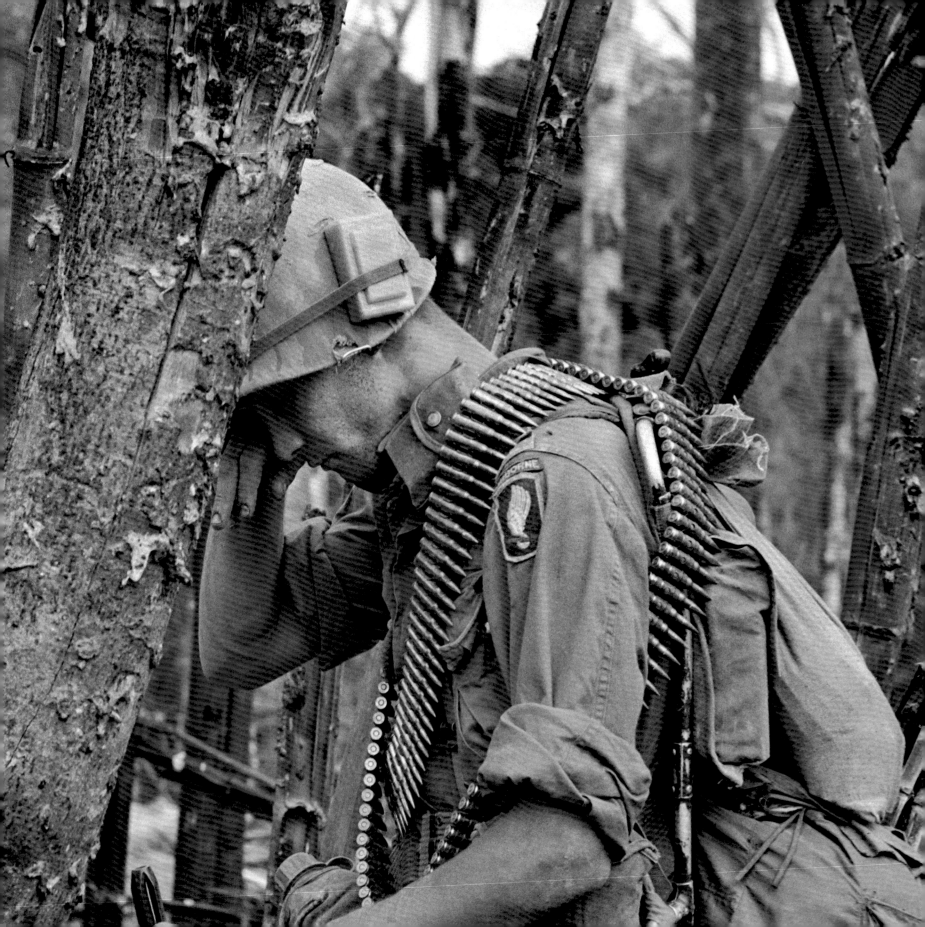

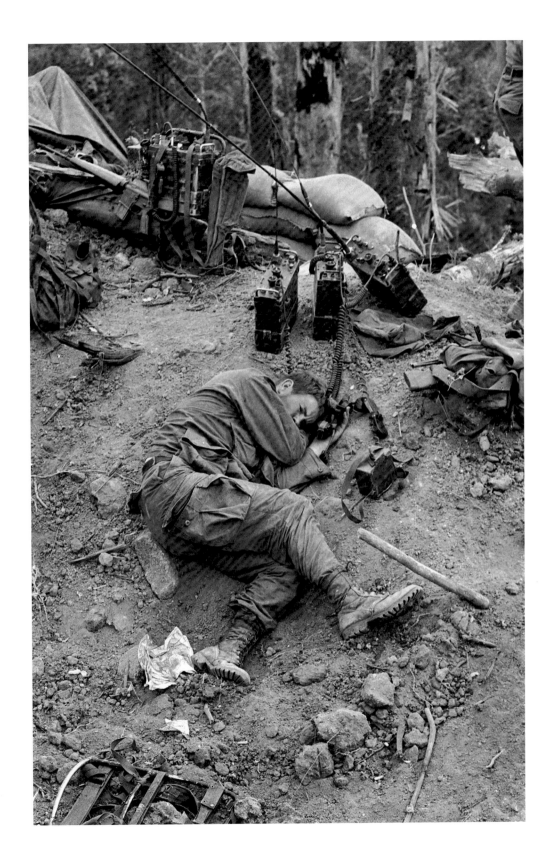

OPPOSITE: Weighed down with ammunition and other gear, a paratrooper of the 173rd Airborne Brigade leans against a battered tree wiping dust from his eyes at the conclusion of the battle of Hill 875, November 23, 1967.

The Americans fought entrenched North Vietnamese troops for four days and suffered more than one hundred fatalities before taking the crest of the hill, located near Dak To. The fighting was one of a series of engagements with the North Vietnamese that occurred during that time in the Central Highlands region near the borders of Laos and Cambodia.

AP Images Archive

A field phone operator with the 173rd Airborne Brigade grabs some rest but remains ready for calls with three handsets close by and a loudspeaker at his elbow on the crest of Hill 875, November 23, 1967.

Behind the sandbags stand trees that were splintered by U.S. artillery and aerial bombardment.

AP Images Archive

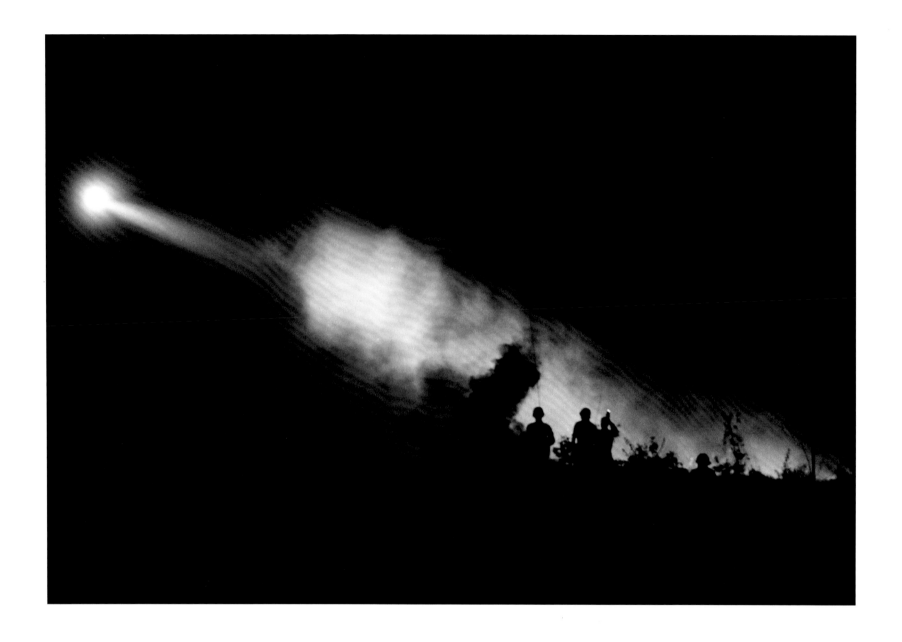

The landing light from a medevac helicopter cuts through the smoke of battle at Bu Dop near the Cambodian border, where a U.S. Special Forces camp was under attack. Troops are silhouetted as they move the most seriously wounded to the landing zone, late November 1967.

Photograph by Horst Faas.

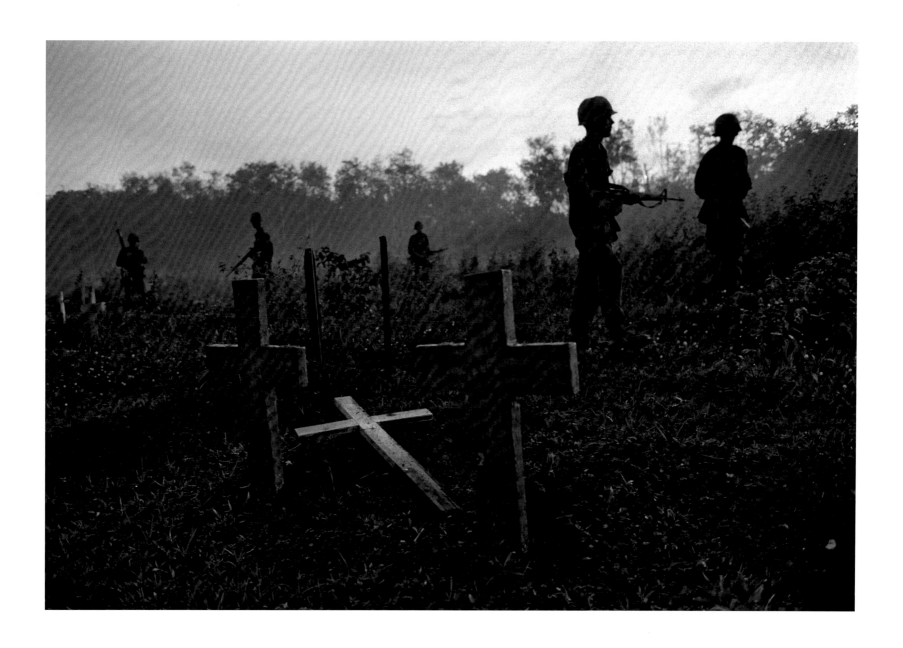

Troops of the 1st Infantry Division patrol in a cemetery outside the perimeter of the Bu Dop Special Forces camp, early December 1967.

One cross has been knocked down by mortar fire and another pockmarked by small arms fire. The cemetery marked the farthest penetration by the guerrillas before they were driven off by American and South Vietnamese defenders.

Photograph by Horst Faas.

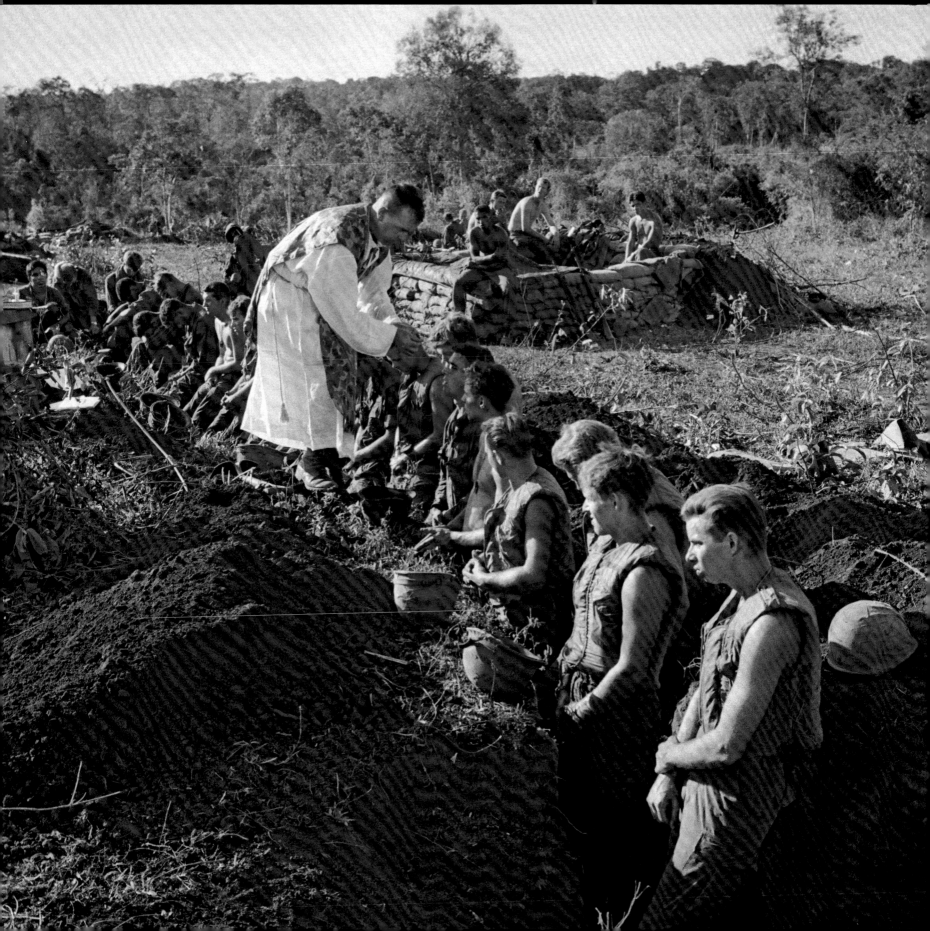

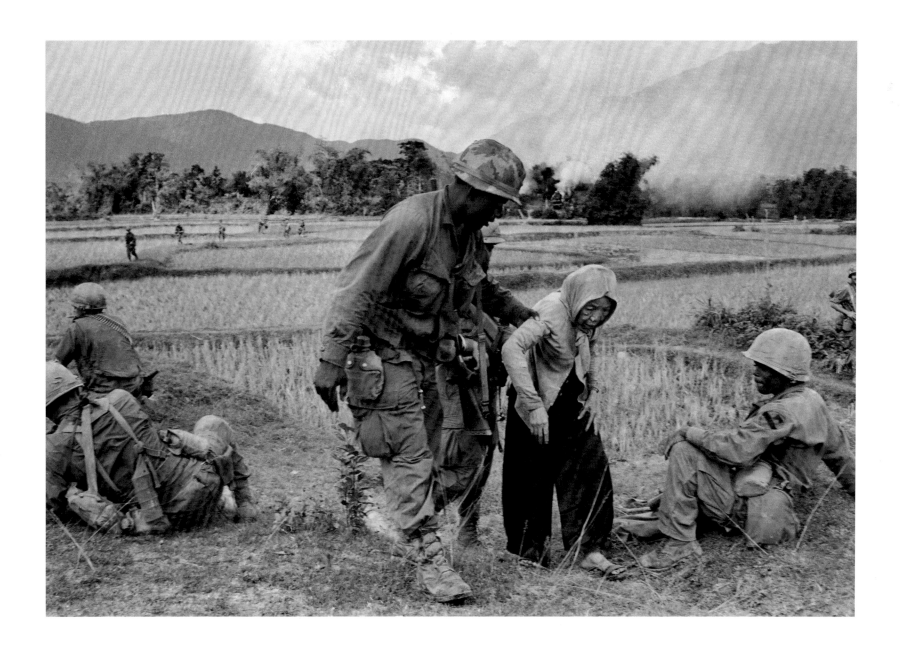

A chaplain gives communion to U.S. soldiers of the 1st Infantry Division at Bu Dop, December 5, 1967.

The area was under constant threat of mortar and rocket attack, so services were held in the trench for protection from incoming rounds.

Photograph by Horst Faas.

With a hillside obscured by smoke in the background, a U.S. soldier lends a helping hand to an aged Vietnamese woman who grew tired as she and her neighbors were being resettled from their village to a refugee camp, January 5, 1968.

Other villagers had refused to assist her because, according to custom, they would then have borne responsibility for her for the remainder of her life.

Photograph by Dang Van Phuoc.

guns and jet fighter-bombers on the streets of y

does the infliction of civilian casualties becom

as the enemy is destroyed ?

The answers to both these questions came in

of the battle for ben tre , a once placid meko

35,000.

"It became necessary to destroy the town to

u.s. major says.

The destruction of this provincial capital wa

50 hours.

ben Tre was one of 35 population centers att

forces in the upsurge of fighting last week. A

own city ? when

rrelevant as long

first few hours

delta city of

save it," a

rawn out over

ed by communist

inforced regimental-

TET AS TURNING POINT

1968

The campaign that would change the course of the war began on January 30, when the Viet Cong, aided by North Vietnamese troops, launched simultaneous attacks on 110 cities, towns, and U.S. bases throughout South Vietnam. The action was named the Tet Offensive because it occurred during the Lunar New Year celebration, which traditionally brought a cease-fire. Within days, American forces had turned back the onslaught and recaptured most areas, but some of the fighting went on for weeks.

North Vietnam had hoped to spark a general uprising that would overthrow the government of South Vietnam. That did not happen, and the offensive took a terrible toll on the Viet Cong, costing the guerrillas tens of thousands of fighters and crippling their infrastructure. Thereafter, they had to rely more and more on soldiers from the North.

But Tet gave the Viet Cong a huge psychological and political boost. Millions of Americans who had believed that the war was going well were shaken by images of guerrillas fighting inside the grounds of the U.S. Embassy. At CBS News headquarters in New York, Walter Cronkite, widely considered the most trusted newsman in the United States, saw word of the offensive come across the Associated Press wire and shouted to his producer: "What the hell is going on? I thought we were winning the war!" Cronkite then went to South

< Early in the Tet Offensive, Peter Arnett traveled to the Mekong Delta city of Ben Tre, one of many provincial capitals that had been overrun by insurgents during their wave of surprise attacks. In this February 7, 1968, story, he reports on the decision by the U.S. military to launch an overwhelming air and ground assault on the city in order to rout the Viet Cong, even though the attacks caused hundreds of civilian casualties. He quotes the infamous words of a U.S. major describing the rationale: "It became necessary to destroy the town to save it."

Saigon Bureau Records, AP Corporate Archives

Vietnam himself and in a prime-time special report told his audience, "We are mired in a stalemate."

An image from Tet that further galvanized antiwar sentiment was the photograph taken on a Saigon street by AP photographer Eddie Adams showing Gen. Nguyen Ngoc Loan, chief of police in South Vietnam, executing an unarmed guerrilla with a bullet to the head.

And there was the quote that seemed to capture the madness of the war. To rout the Viet Cong from the provincial capital of Ben Tre, allied commanders decided to bomb and shell the town, even though they knew it would kill many civilians. AP reporter Peter Arnett talked to a U.S. military official who explained, "It became necessary to destroy the town to save it."

Nowhere was Tet fought more viciously than in Hue, the ancient imperial capital of Vietnam. On January 30, some 6,000 soldiers from three North Vietnamese regiments marched in formation across the canal bridges on the southern outskirts. By the time the city was recaptured twenty-six days later, 70 percent of its homes and many historical treasures had been destroyed, and 142 Marines and 384 South Vietnamese had been killed. North Vietnamese losses were estimated in the thousands. Before they were beaten back, the Communists had executed hundreds of civilians—some estimates range as high as 2,800—and buried them in mass graves.

Westmoreland's response to Tet was to request more troops—206,000 in addition to the more than half million already in Vietnam. He did not get the troops; instead, on March 22, Johnson named him Army chief of staff—a move that had been in the works since the previous year. Westmoreland left South Vietnam for Washington in June, and Gen. Creighton Abrams Jr. took over.

Meanwhile, starting before Tet and continuing long after, from January 21 to early April, U.S. Marines at a base at Khe Sanh, sixty miles northwest of Hue, fought off a determined artillery assault by North Vietnamese forces. Westmoreland considered the base a vital "cork" blocking infiltration from the North. By the time U.S. forces finally overcame the siege after seventy-seven days, more than two hundred Marines had been killed and sixteen hundred wounded.

Back in the United States, 1968 was becoming a year of unparalleled social and political turmoil. Stunned by the strong showing of antiwar candidate Sen. Eugene McCarthy of Minnesota in New Hampshire's Democratic primary on March 12, Johnson declared nineteen days later that he would not seek reelection; on April 4, Dr. King was assassinated, his death triggering riots in major cities; Sen. Robert F. Kennedy of New York, who had begun running for president four days after the New Hampshire primary, was assassinated on June 5; in late August, antiwar demonstrators disrupted the Democratic National Convention in Chicago and were attacked by police on orders from Mayor Richard J. Daley; and protesting students took over college campuses from Columbia University to San Francisco State College.

Johnson's decision not to run again, coupled with his scaling back of the bombing of North Vietnam, helped persuade that nation to agree to preliminary peace talks, to begin May 10 in Paris.

On the eve of negotiations, the Viet Cong and North Vietnamese launched a mini–Tet Offensive, hoping to improve their bargaining position. More than one hundred cities, towns, and bases were shelled, and battles raged across six sections of Saigon. By the time these assaults ended, the U.S. command estimated that 5,000 Viet Cong and North Vietnamese had been killed. For the week ending May 11, the U.S. death toll was 562, and for the month of May nearly 2,000—both new highs for the war.

Finally, on November 1, Johnson ordered a complete bombing halt in return for Hanoi accepting South Vietnam as a partner in the peace talks. During a period of three years, eight months, and twenty-four days, American pilots had flown one hundred thousand missions and unloaded almost a half-million tons of bombs across North Vietnam. More than nine hundred American planes had been lost and nearly fifteen hundred airmen killed, captured, or listed as missing in action.

Days later, fresh from his victory in the presidential election, Richard M. Nixon promised a gradual troop withdrawal from Vietnam.

The year ended with 16,899 U.S. soldiers killed, by far the highest toll for any year of the war.

Dang Van Phuoc, 1966.

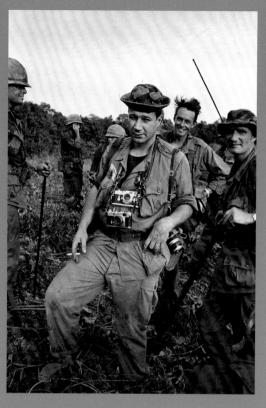

Eddie Adams with U.S. troops, 1966.

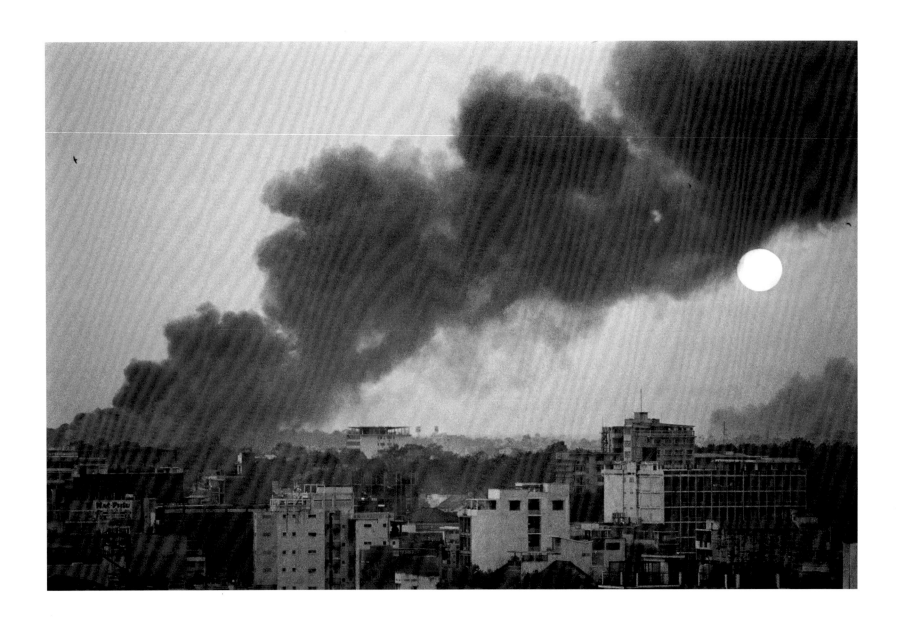

Smoke rises and the sun sets over battle-scarred Saigon, as fighting continues for a ninth consecutive day during the Tet Offensive, February 8, 1968.

Photograph by Eddie Adams.

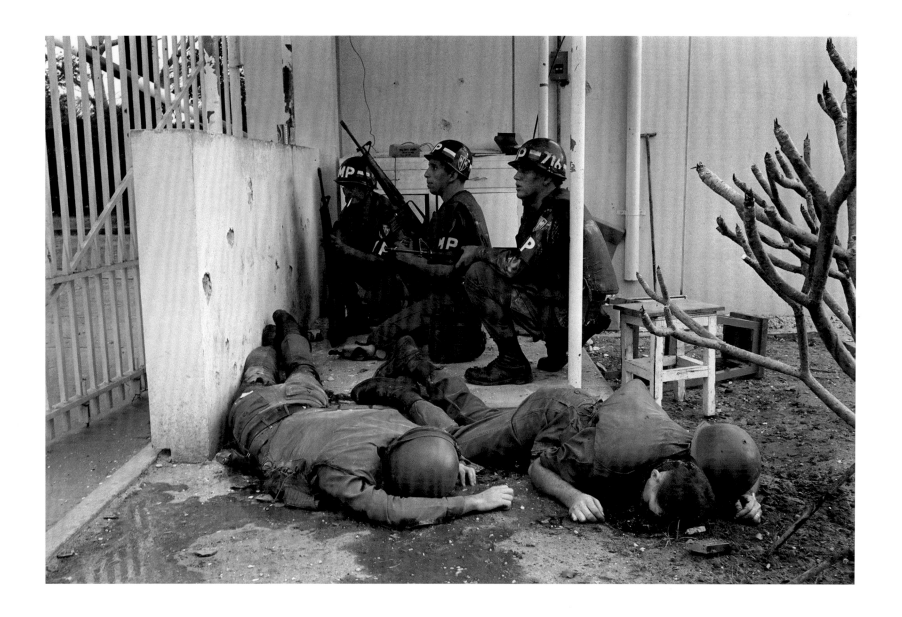

With dead U.S. soldiers in the foreground, military police take cover behind a wall at the entrance to the U.S. Embassy in Saigon on the second day of the Tet Offensive, January 31, 1968.

Early in the morning, a fifteen-man Viet Cong squad blew a hole in the high masonry wall surrounding the compound and gained access to the grounds. The guerrillas were beaten back after several hours, but the mere fact they had penetrated that far gave them a striking propaganda victory in the eyes of the American public.

Photograph by Hong Seong-Chan.

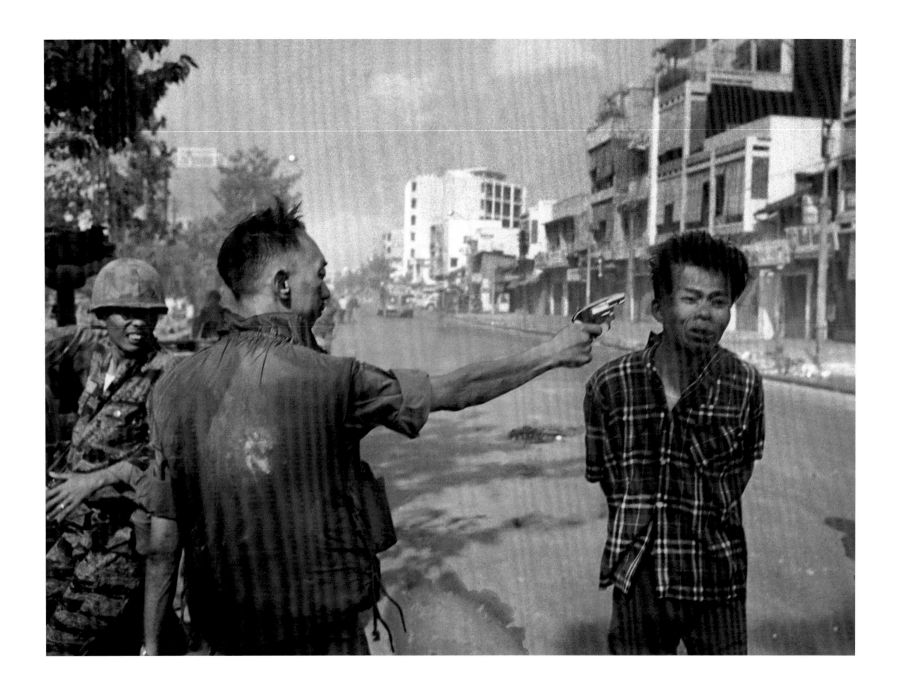

Gen. Nguyen Ngoc Loan, South Vietnamese chief of the national police, fires his pistol into the head of suspected Viet Cong official Nguyen Van Lem on a Saigon street early in the Tet Offensive, February 1, 1968.

Photographer Eddie Adams reported that after the shooting, Loan approached him and said, "They killed many of my people, and yours too," then walked away.

This photograph by Eddie Adams received the 1969 Pulitzer Prize for Spot News Photography.

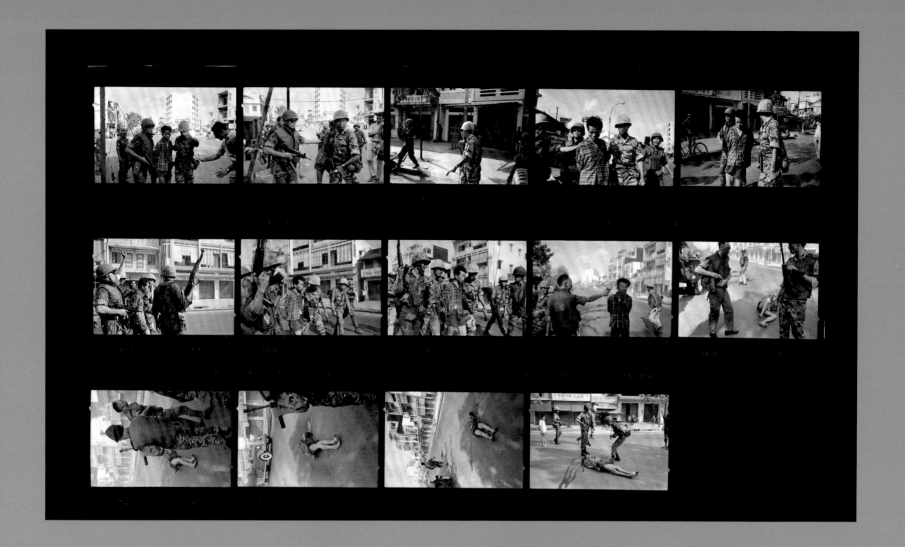

"So we got in the car, and we went to Cholon. . . . It was a mini-battle of South Vietnamese soldiers, police, and behind a pagoda there were some Viet Cong. . . . It was like a nothing story, so we started back and . . . we see them pulling this guy out of the building, they were like taking him by the hand . . . and they just kept walking up maybe about a hundred yards to the corner. . . . I was about five feet away from the prisoner—and to my left came this guy, I had no idea, I had a 35mm lens and a single-frame camera, and he went over and I see him go for his pistol. Well, when somebody goes for their pistol, they normally threaten, 'You're going to do this or I'm gonna shoot you,' and nothing ever happens. As soon as he waved his pistol, I took one frame. And that was the instant when he shot him. And I had no idea that he was gonna do this. And the U.S. Army asked for the picture. They wanted all the details of the camera: the model of the camera, the shutter speed the picture was taken at. . . . They found out the pistol that the bullet was shot from, and they said the bullet was still in his head when the picture was taken. I didn't even know I got him shooting him."

—Eddie Adams, from an interview with Hal Buell, April 22, 1998, for the AP Corporate Archives Oral History Program.

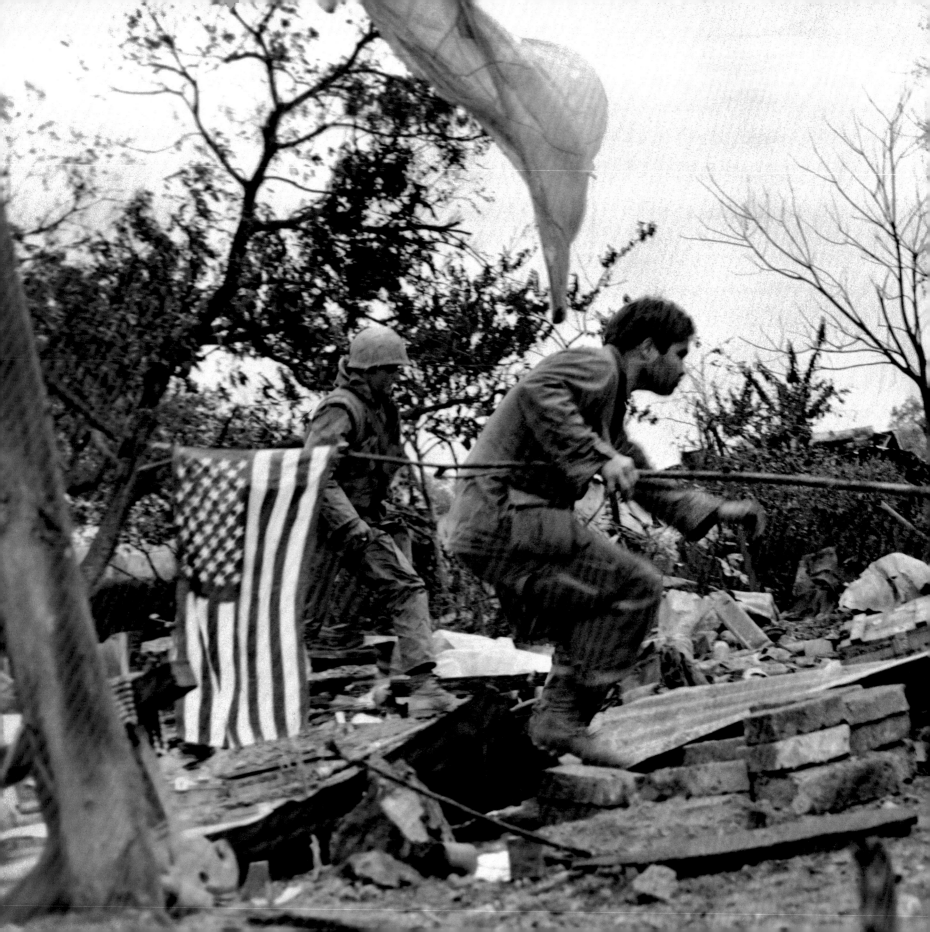

A Marine carries an American flag as he charges across a rubble-strewn courtyard inside the old citadel in Hue, February 20, 1968.

The Marines secured the flag atop a wall of the ancient fortress as fighting continued for a third straight week during the Tet Offensive.

Photograph by Bill Tuohy.

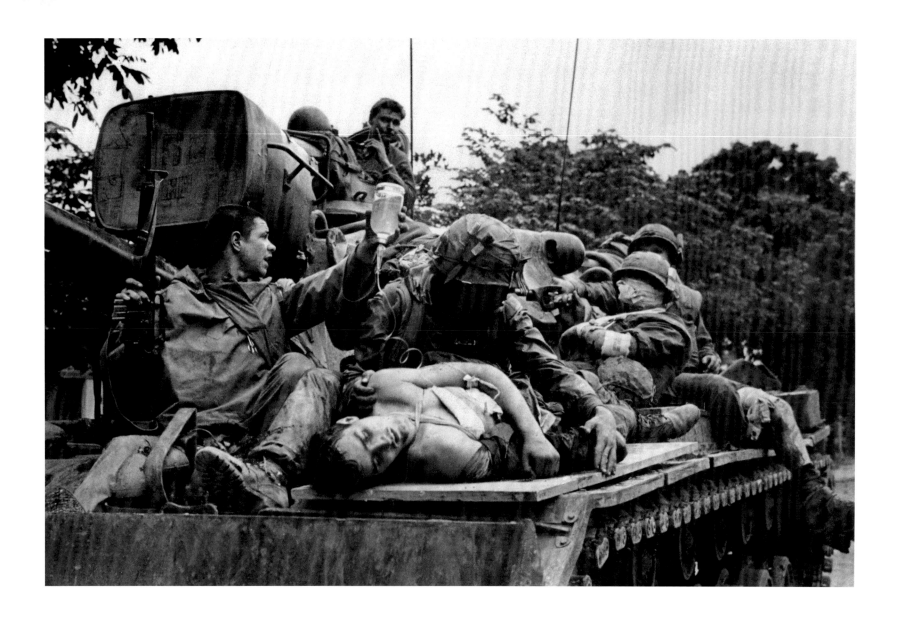

Marines transport their seriously wounded atop a U.S. Army tank through the streets of Hue toward a helicopter evacuation point, February 17, 1968.

Tanks were the only vehicles able to travel the streets because of rubble from buildings destroyed during the still-ongoing Tet Offensive. The Marines came under sniper fire several times on the journey.

AP Images Archive

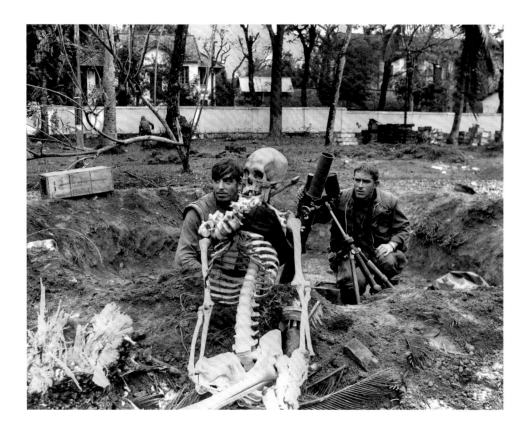

With a skeleton from a local medical school serving as a grisly mascot, Marines hunker down in their 81mm mortar position in the garden of Hue's provincial government head-quarters, February 1968.

AP Images Archive

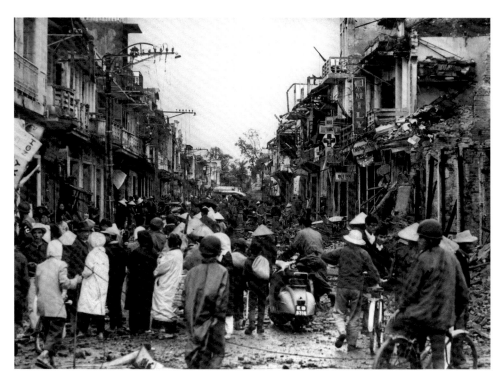

South Vietnamese soldiers, as well as shop owners and their families, move through the rubble of a main street in Hue, early March 1968.

Intense fighting left this and other areas of the city in ruins.

AP Images Archive

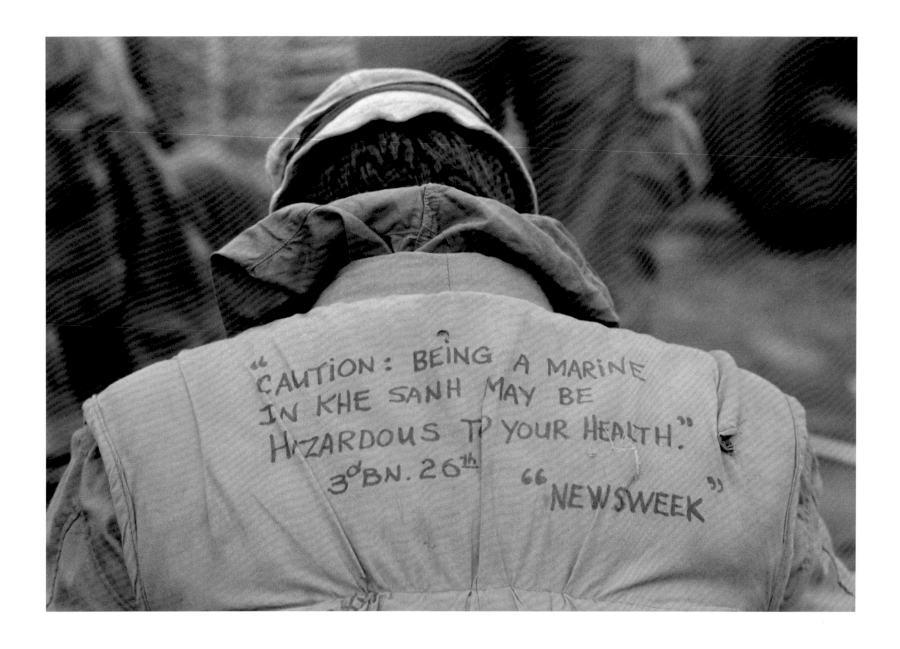

A Marine at Khe Sanh Combat Base displays a message written on the back of his flak jacket and attributed to *Newsweek* magazine, February 21, 1968.

Khe Sanh, sixty miles northwest of Hue, was kept under siege by the North Vietnamese through rocket and artillery attacks for seventy-seven days. More than two hundred Marines died in its defense. After successfully defending Khe Sanh, the U.S. demolished and abandoned the base in July.

Photograph by Rick Merron.

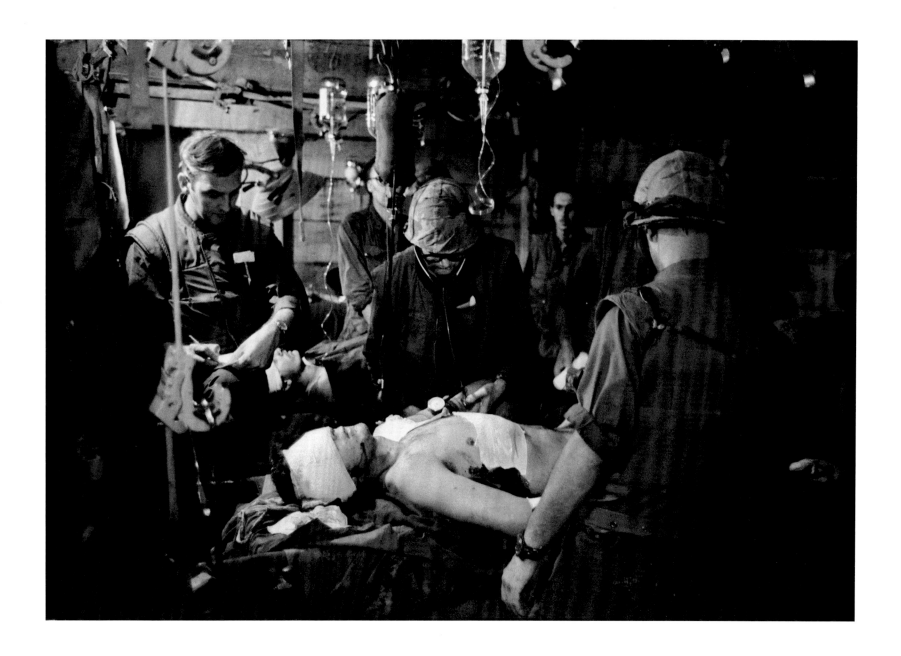

Dr. Joseph Wolfe (center) treats a wounded soldier while other physicians attend at Charlie Med, a makeshift underground hospital at the besieged Khe Sanh Marine base, March 1968.

Wolfe, from Rutledge, Tennessee, and the other doctors of the Marines' C Company, 3rd Medical Battalion, wore flak jackets in the combat conditions. At left is Dr. James Finnegan of Philadelphia.

Photograph by John T. Wheeler.

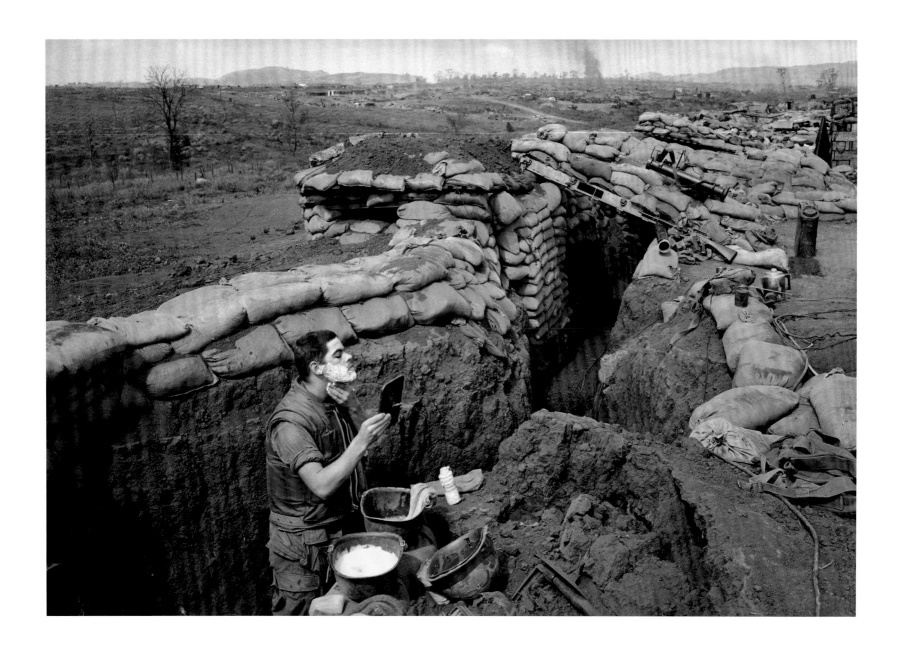

Marine Lance Cpl. Roland Ball of Tacoma, Washington, wearing his flak jacket, starts
the day with a shave in a trench at Khe Sanh, while the base is surrounded by North
Vietnamese regulars, March 2, 1968.

Ball was using a helmet as a sink and a rearview mirror taken from a military vehicle.
Despite the often-tense atmosphere at the base, sights like this were quite common.

Photograph by Eddie Adams.

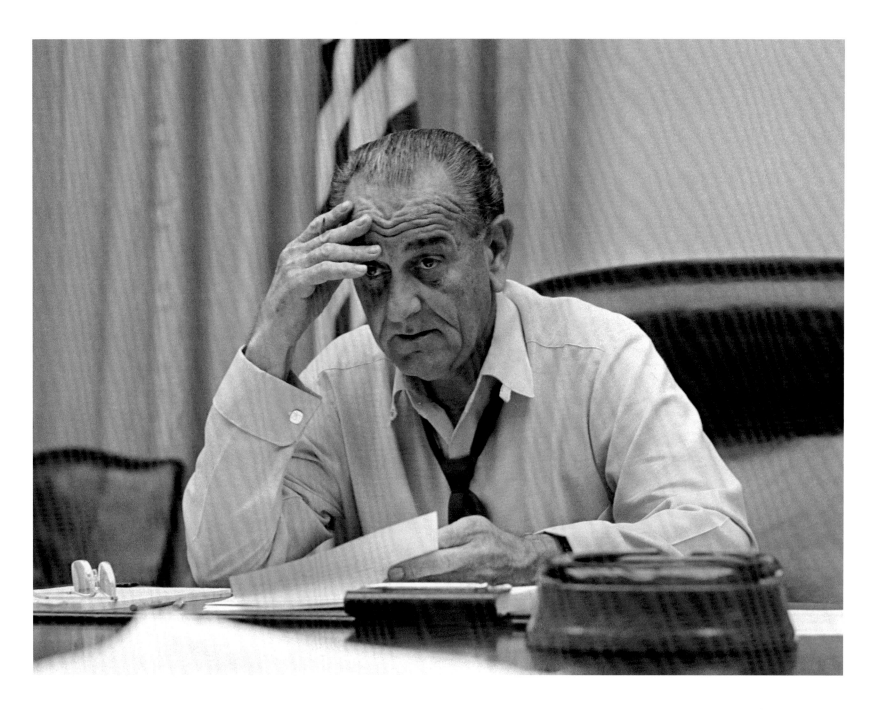

President Johnson in the White House Cabinet Room, working on a speech that would shock the nation when he announced, "I shall not seek and I will not accept the nomination of my party as your president," March 30, 1968.

In the speech, delivered the following night, Johnson also announced that the United States was scaling back its bombing of North Vietnam in hopes of spurring peace talks.

Photograph by Bob Daugherty.

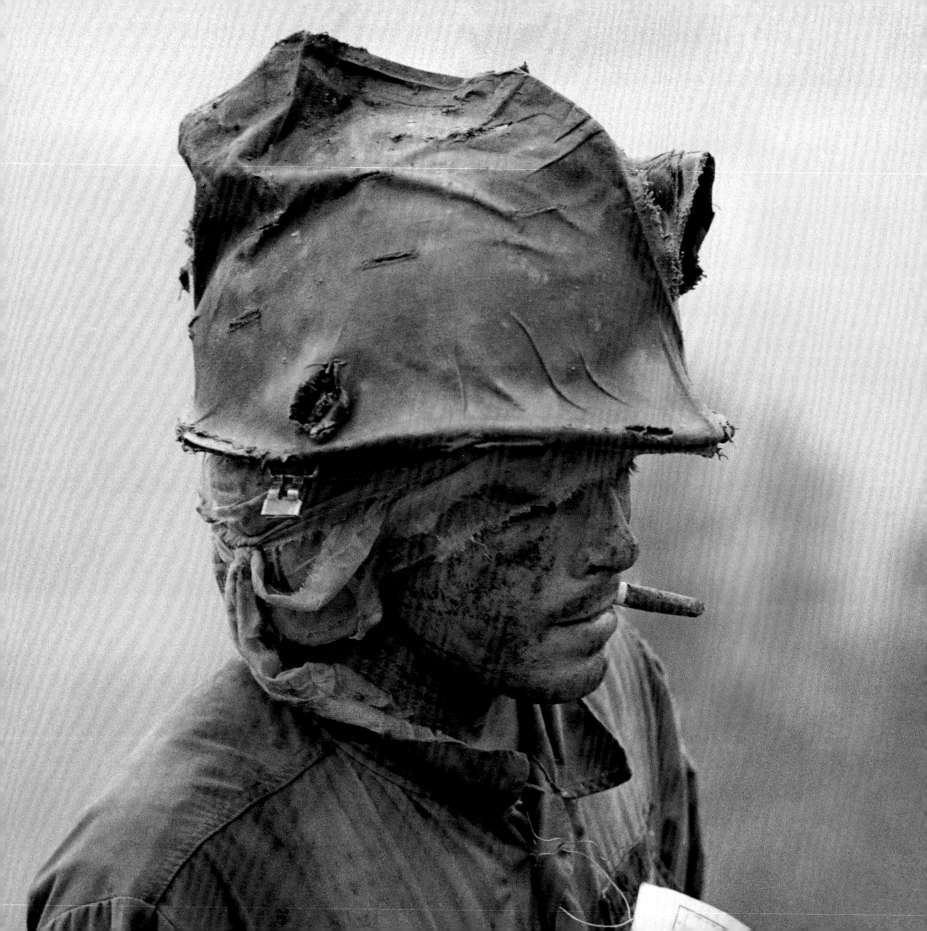

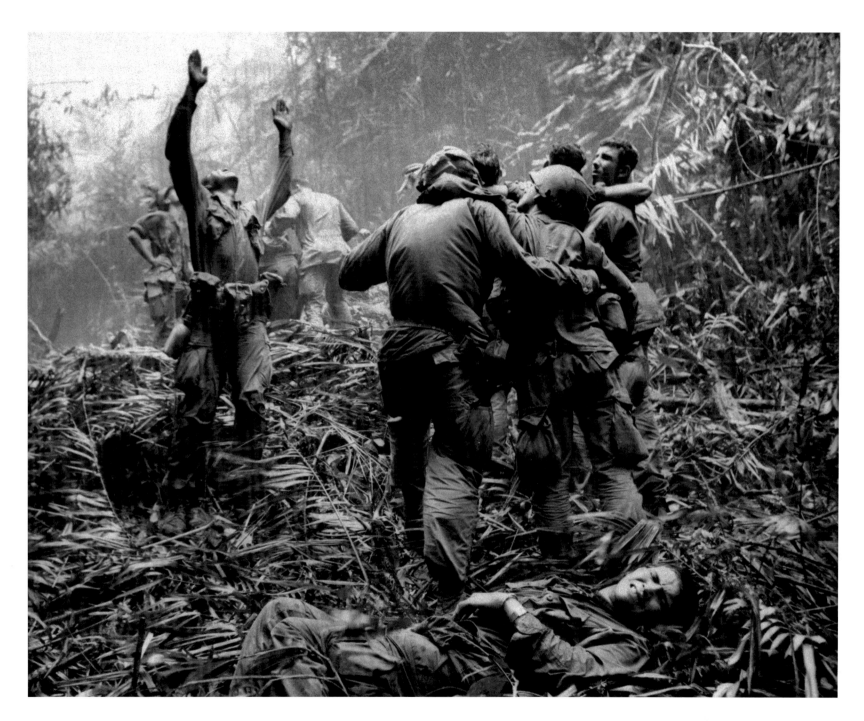

A 1st Cavalry Division soldier, wounded on Hill 549, waits for the morning mist to lift so he can be evacuated by helicopter, April 6, 1968.

The unit was hit by North Vietnamese artillery three miles southeast of the beleaguered Marine base at Khe Sanh.

Photograph by Dang Van Phuoc.

As fellow troopers aid wounded comrades, a paratrooper of A Company, 101st Airborne Division, guides a medevac helicopter through the jungle foliage to pick up casualties suffered during a five-day patrol near Hue, April 1968.

Photograph by Art Greenspon.

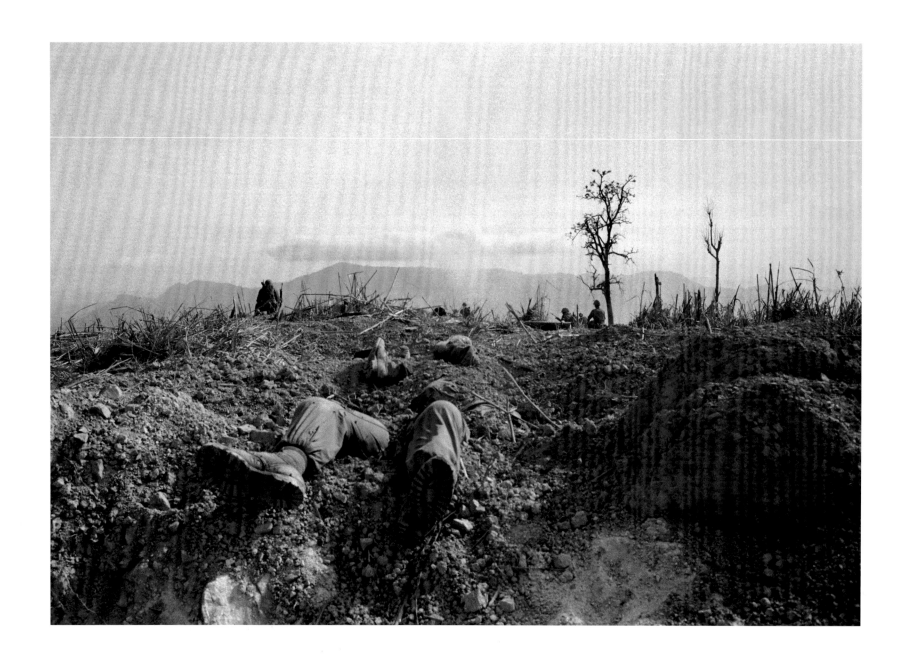

Bodies of U.S. Marines lie half-buried on Hill 689, about two and a half miles west of Khe Sanh, late April 1968.

Fellow Marines stand guard in the background after battling entrenched North Vietnamese troops for the hill.

AP Images Archive

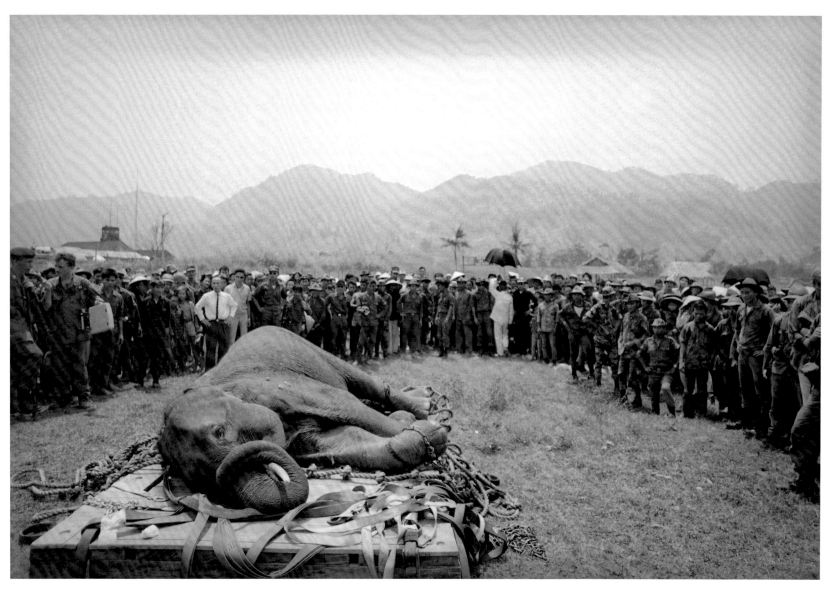

Still groggy from being tranquilized, an elephant lies on its padded pallet upon arrival in Tra Bong, a remote mountain village south of Da Nang, April 1968.

In what became known as Operation Barroom, Capt. John Gantt of the Green Berets organized a scheme to transport two elephants for work in a lumber mill. The elephants were purchased at Ban Don in the Central Highlands, then loaded into a C-130 airplane and flown three hundred miles to Da Nang, the closest airfield. There they were wrapped in cargo nets and fastened to cushioned wooden pallets; suspended under a pair of Marine Corps "Jolly Green Giant" helicopters, they flew the final sixty-five miles over the mountains to the tiny Tra Bong clearing. The operation took its nickname from the sound made by a flatulent elephant, but when the project became the subject of a 1995 Disney movie, it was called *Operation Dumbo Drop*.

Photograph by Eddie Adams.

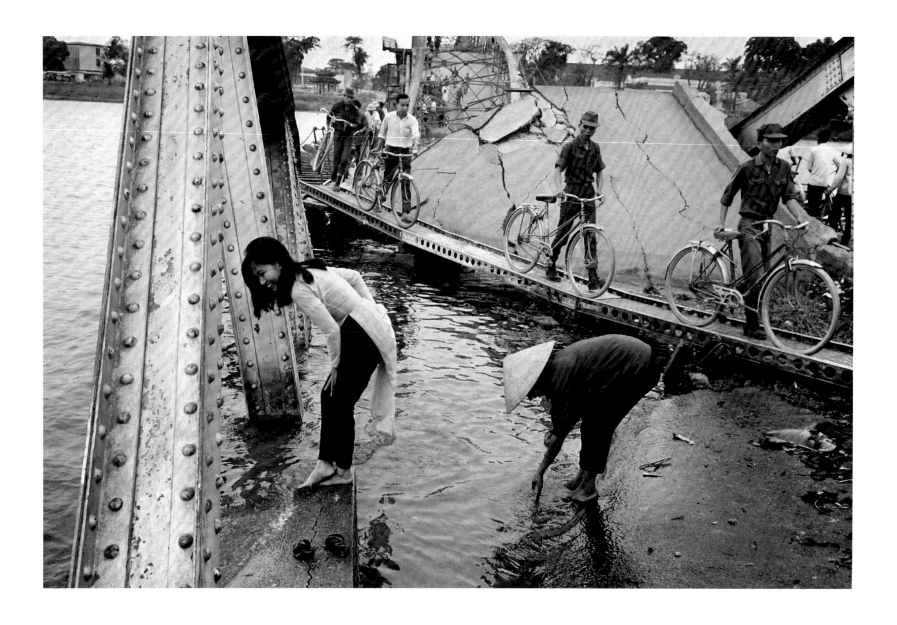

Two women pause to wash their feet as residents of Hue make their way carefully across the remains of a bombed bridge in the central city, April 16, 1968.

Photograph by Eddie Adams.

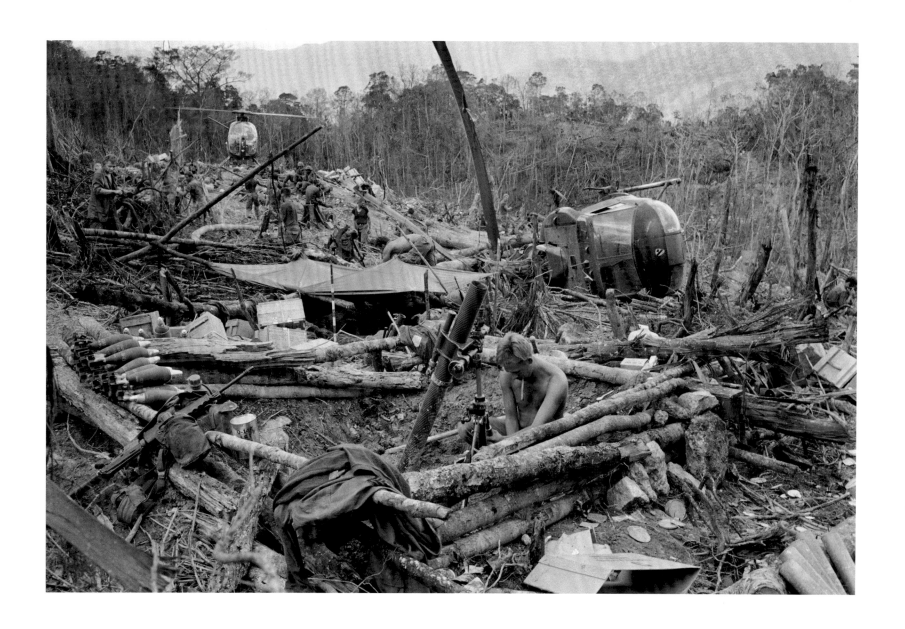

A shirtless 1st Cavalryman sets up a mortar at his unit's patrol base in the A Shau Valley during Operation Delaware, late April 1968.

A helicopter, downed by North Vietnamese antiaircraft fire, lies at right, while men clear away brush in the background. Delaware was the first major operation in two years in the supply area held by the North Vietnamese twenty-five miles west of Hue.

Photograph by Dang Van Phuoc.

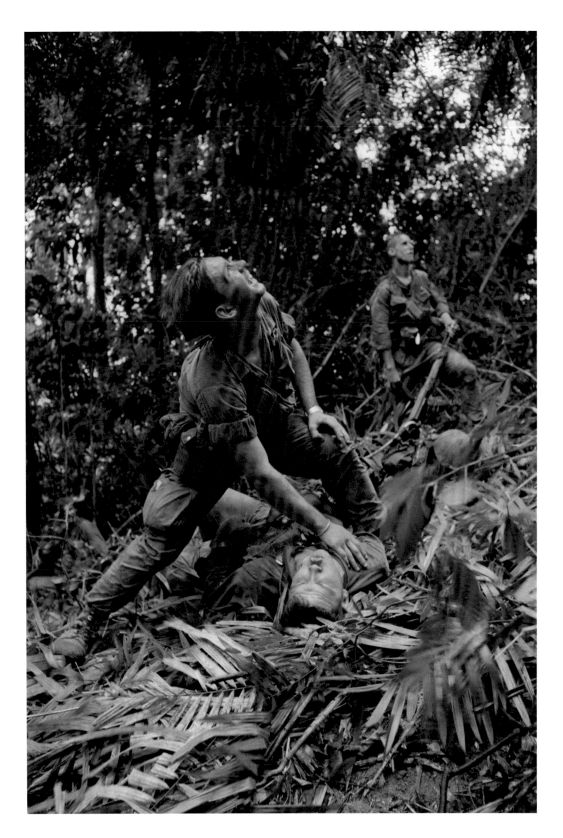

A medic looks up at a medevac helicopter while treating a wounded member of the 101st Airborne Division west of Hue, late April 1968.

The unit was on a five-day patrol through the insurgent-controlled area.

AP Images Archive

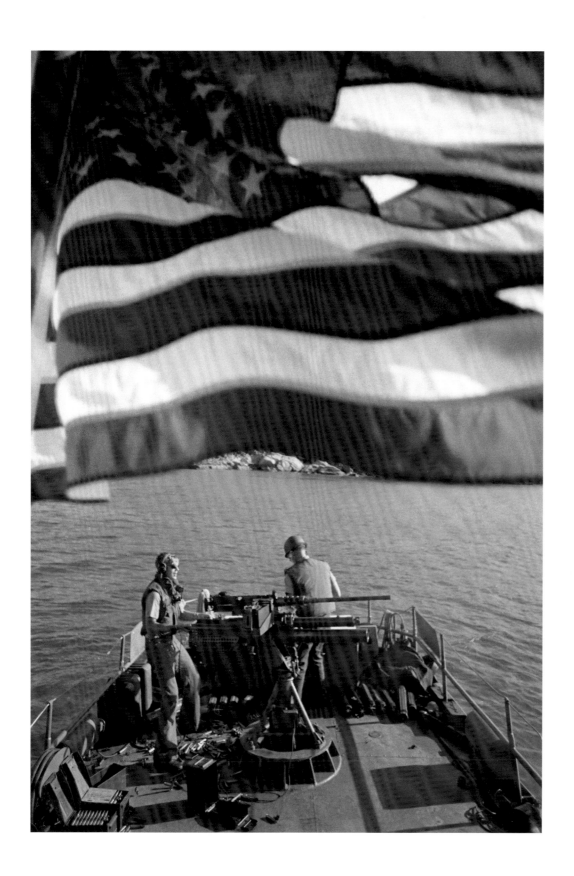

A Swift Boat on patrol, May 1968.

The aluminum Navy vessels were first used to patrol the coast but later deployed in interior waterways for such duties as intercepting Viet Cong arms shipments and transporting SEAL teams for counterinsurgency operations.

Photograph by Eddie Adams.

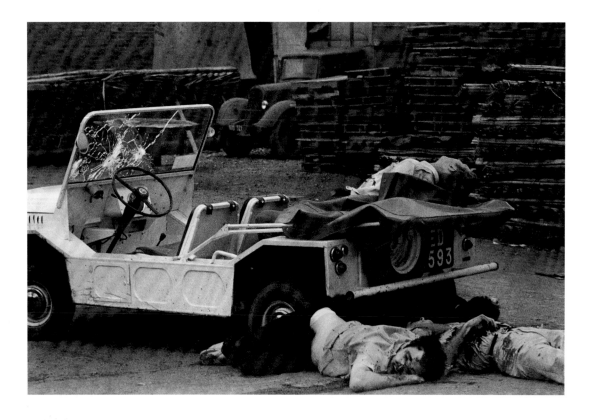

Four journalists lie dead after their Jeep was ambushed by Viet Cong in Cholon, the Chinese sector of Saigon, May 5, 1968.

Three were killed instantly: John Cantwell, an Australian; Ronald B. Laramy, a Briton; and Michael Birch of the Australian Associated Press. Bruce S. Pigott, an Australian, was killed execution-style after being wounded. A fifth man, Australian Frank Palmos, escaped. Journalists Wallace Terry of *Time* magazine and Zalin Grant of the *New Republic* braved the Viet Cong–controlled district to recover the bodies.

Photograph by Mike Morrow.

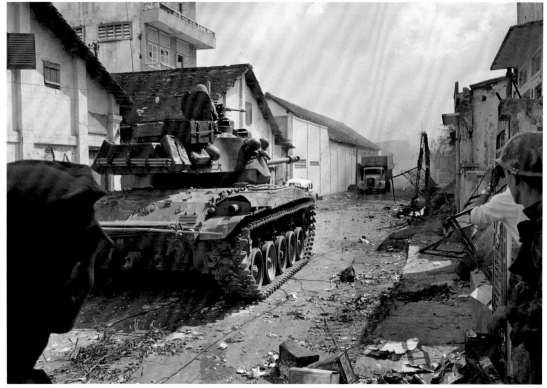

A South Vietnamese tank drives down an alley in the northeastern corner of Saigon after a Viet Cong squad moved into the area, harassing government troops on the fifth day of the mini–Tet Offensive, May 9, 1968.

Residents fled as the fighting began.

Photograph by Dang Van Phuoc.

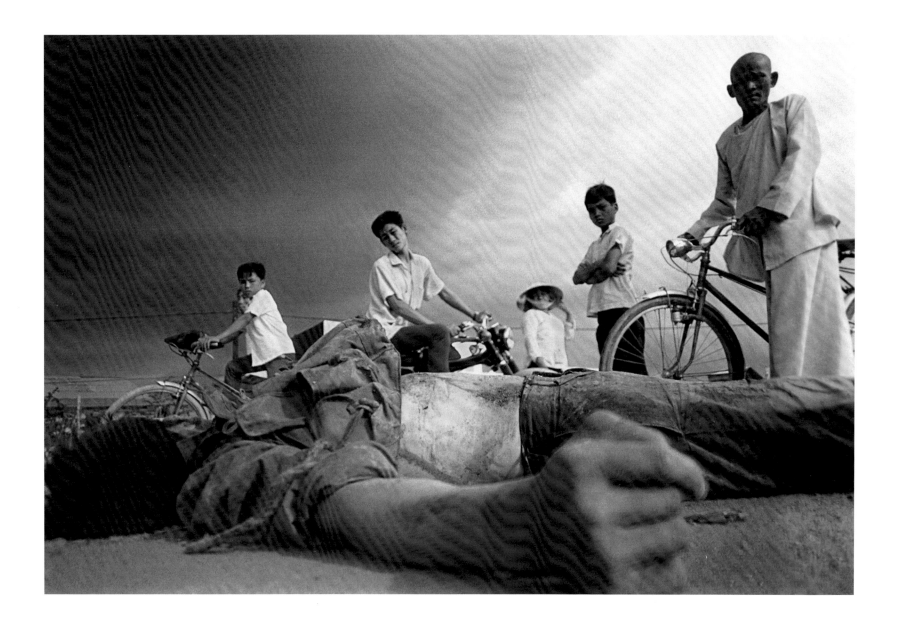

South Vietnamese civilians on bicycles pause to look at a guerrilla killed in Cholon during daylong fighting, May 5, 1968.

A group of Viet Cong had moved into the area following mortar barrages on different parts of the city. The fighting in Cholon was near an area that had been heavily hit during the Tet Offensive.

Photograph by Eddie Adams.

Delegations from the United States and North Vietnam gather for an early session of peace talks at the International Conference Center in Paris, May 13, 1968.

The talks stalled almost immediately over various issues—including even the size and shape of the table. Once they resumed later that year, negotiations continued off and on until January 1973, when Henry A. Kissinger and Le Duc Tho signed the agreement ending U.S. involvement in the war.

AP Images Archive

Civilians search through the debris of homes destroyed by Viet Cong rockets in downtown Saigon, May 19, 1968.

The attacks were timed to coincide with the seventy-eighth birthday of Ho Chi Minh.

AP Images Archive

Photojournalist Dana Stone looks at a makeshift memorial to nineteen U.S. Marines killed on a hilltop nine days earlier, six miles south of Khe Sanh. He accompanied a unit that had come to recover the bodies of their fellow Marines, June 19, 1968.

The American flag had covered the body of one of the dead.

Photograph by Henri Huet.

Antiwar protesters carrying Viet Cong flags swarm over a statue of Civil War Gen. John Logan in Chicago's Grant Park on the opening day of the Democratic National Convention, August 26, 1968.

Demonstrators clashed violently with police during the convention, which chose Vice President Humphrey as the party's presidential nominee. He would lose to Richard M. Nixon in November.

AP Images Archive

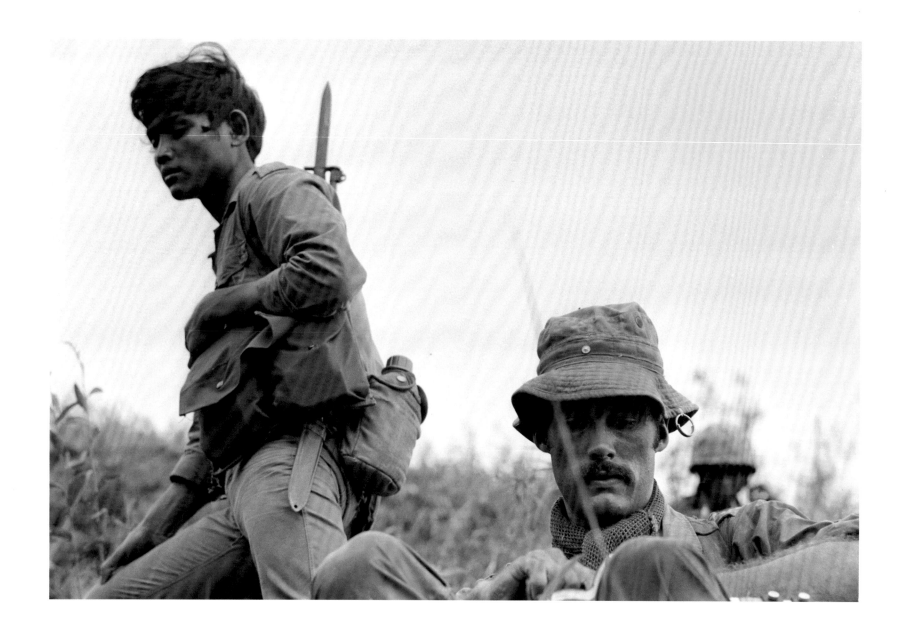

Sean Flynn, an American freelance photojournalist covering the war for *Time* magazine, is photographed during operations near a U.S. Special Forces camp at Ha Thanh in Quang Ngai Province, September 1968.

At left is a Montagnard mercenary, a hill tribesman fighting on the U.S. side. Flynn, son of the film actor Errol Flynn, disappeared along with the photographer of this picture, Dana Stone, on April 6, 1970, in Svay Rieng Province in eastern Cambodia. No reliable account of their disappearance has surfaced. The Clash album *Combat Rock*, released in 1982, includes the song "Sean Flynn," with the lyrics, "You know he heard the drums of war."

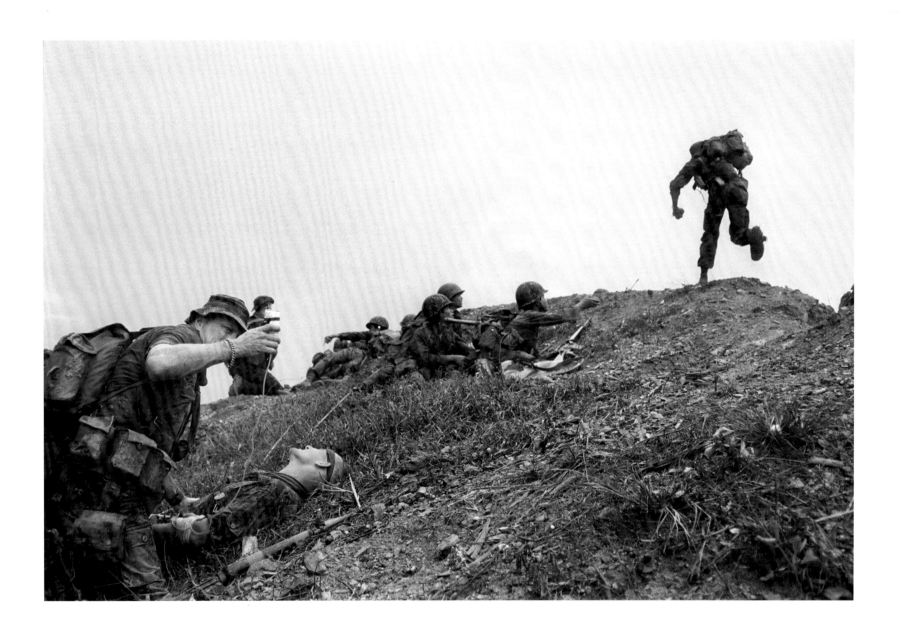

In the decisive moment of an hour-long battle fought at close range against North Vietnamese troops, a U.S. Special Forces trooper holding a grenade charges over the top of a hill at Ha Thanh, September 3, 1968.

At left, a medic treats an officer for wounds from a grenade.

Photograph by Dana Stone.

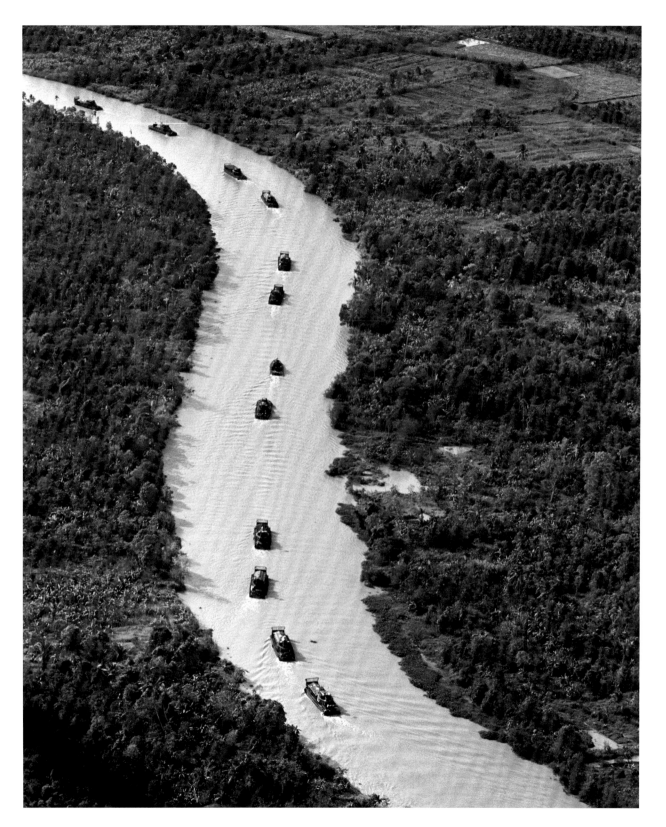

Armed landing craft carrying troops of the Mobile Riverine Force patrol a meandering tributary of the Mekong River in the southern part of South Vietnam, September 1968.

When contact was made with the Viet Cong, the troops would be put ashore while the ships provided covering fire.

Photograph by Henri Huet.

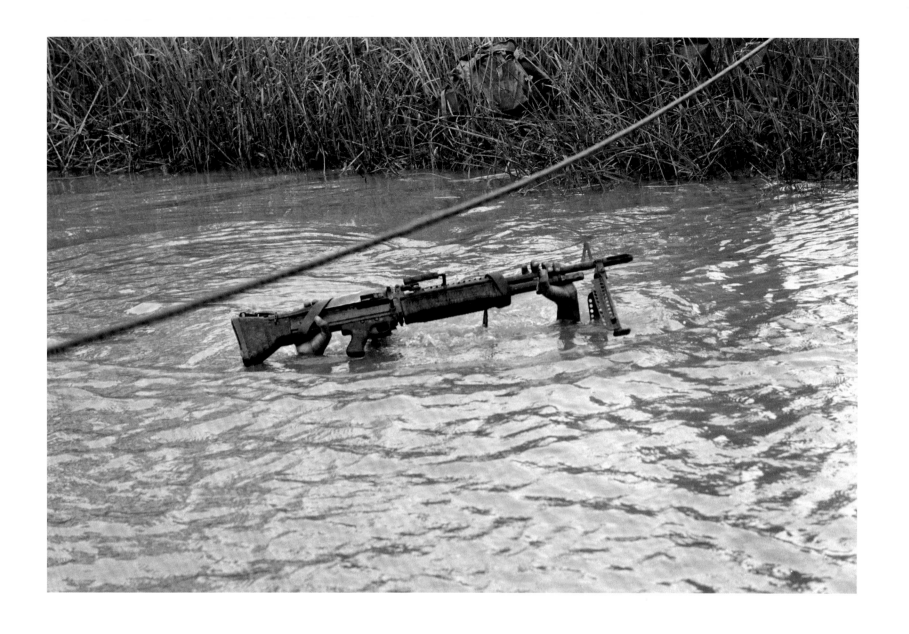

A six-foot-five machine gunner with the U.S. 9th Infantry Division is submerged except for his rifle as he crosses a muddy stream in the Mekong Delta south of Saigon, September 10, 1968.

Photograph by Henri Huet.

Fog drifts up from valleys below the DMZ as U.S. Marines of the 4th Regiment, 3rd Division, untangle air-dropped supplies, November 1968.

The Marines had made minor contact with hostile forces during a weeklong sweep to detect infiltration south of the DMZ.

AP Images Archive

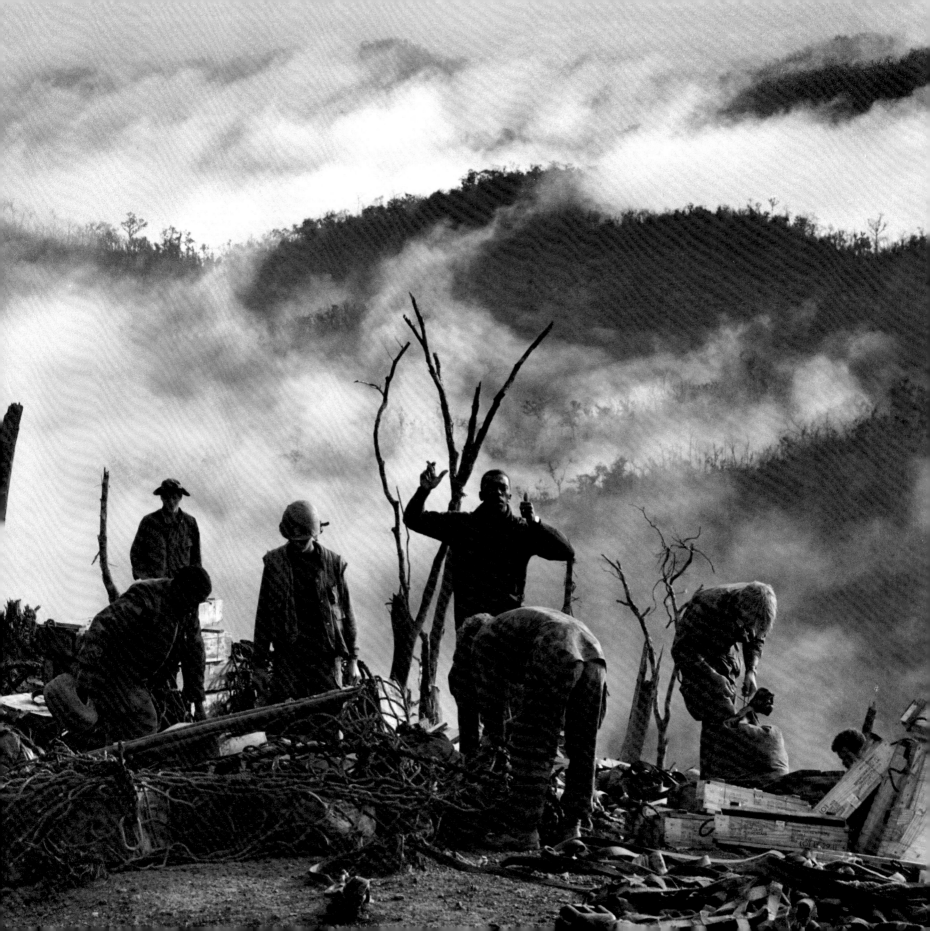

February 12,1971

AIR MAIL

Executive Newsphoto Editor Buell
New York

Dear Hal,

Please remove the following Saigon bureau camera e
inventory. It was lost in the chopper crash that kille

Nikon F body #6808119
Nikon F body #6581370
Nikkor 35mm lens #199755
Nikkor 105mm lens #148011
Nikkor 200mm lens #205780
Leica M body # 1113964
Leitz 35mm lens # 2065890

With y our approval I'll get together with Desfor
with Nikon equipment. We have no need for more Leitz e

Sir

ipment from our
Henri Huet.

replacing this
ipment here.

rely,

FROM PEAK TO PULLBACK

1969–71

Despite Nixon's pledge, U.S. troop strength actually increased in the early months of 1969, hitting an all-time high of 543,482 at the end of April. But he would soon announce a series of small withdrawals—25,000 in June, 35,000 more in September. By year's end, the number was down to 475,000, with 50,000 more due to come home by spring 1970.

Meanwhile, in March, in an effort to destroy Communist supply routes and base camps, Nixon gave the go-ahead to Operation Breakfast, the start of a secret bombing campaign inside neighboring Cambodia that would continue for fourteen months.

The new secretary of defense, Melvin Laird, made a fact-finding trip to South Vietnam, and on March 3 he recommended to Nixon the "de-Americanization" of the war—or as it later came to be called, Vietnamization. In June, Nixon met at Midway Island with Thieu, the South Vietnamese president, to prepare him for this new approach, under which the United States gradually turned over to his military a larger and larger share of fighting. The U.S. government promised to help build up and train South Vietnam's army to ease this transition. But in the coming years, the withdrawal of U.S. troops, along with reductions in military and economic aid, would

< *Two days after AP's Henri Huet and three other photographers were killed when their helicopter was shot down over Laos on February 10, 1971, the practical necessities of continuing to cover the war prompt this memo from Saigon Photo Editor James A. Bourdier. He itemizes the photo equipment lost along with Huet and seeks approval from Executive Photo Editor Hal Buell to obtain replacement gear. Besides Huet, those who died in the crash included Larry Burrows of* Life *magazine; Kent Potter of UPI; and Keisaburo Shimamoto, a Japanese freelancer on assignment for* Newsweek. *Also killed were seven South Vietnamese military personnel, including the four-man crew.*

Vietnam Staff Files, AP Corporate Archives

leave the South Vietnamese hopelessly vulnerable—especially since the Saigon government never was able to win widespread support from its own people.

Meanwhile, disillusionment mounted among U.S. forces, who were still mired in what most now saw as an unwinnable war. Fragging (the killing of unpopular officers), drug use, and desertion all were on the rise among the troops.

To an American public increasingly weary of the war, one episode in particular in early May seemed to symbolize its futility: the battle for what became known as Hamburger Hill. Ordered to capture Ap Bia mountain from the North Vietnamese on the Laotian border, U.S. troops, joined by three South Vietnamese battalions, had to make multiple attempts over ten days before they finally reached the top. The action cost the lives of forty-six Americans, with three hundred wounded—and within a month, the U.S. forces abandoned the hill and the North Vietnamese retook it. In a war that was more about wearing down the other side than seizing territory, the operation may have had a point, but Sen. Edward Kennedy of Massachusetts condemned it on the floor of the Senate as "senseless and irresponsible," adding, "American boys are too valuable to be sacrificed to a false sense of military pride."

In August 1969, Henry A. Kissinger, Nixon's national security adviser, and North Vietnamese representative Xuan Thuy met secretly in Paris to discuss peace talks that would be separate from the public negotiations. From early 1970 on, Kissinger would meet off and on with senior negotiator Le Duc Tho for more than three years until an agreement was sealed.

Antiwar sentiment increased still further in November when reporter Seymour Hersh disclosed details of a massacre by a U.S. Army unit of hundreds of unarmed civilians in the village of My Lai. Though the atrocity had occurred more than a year and a half earlier—on March 16, 1968—the revelations shocked the American public. Lt. William Calley, who had ordered his men to shoot everyone in the village and carried out some of the killings himself, was court-martialed and convicted of twenty-two counts of murder in 1971. He was sentenced to life in prison but served just three years of house arrest in his quarters at Fort Benning, Georgia.

For 1969, the U.S. death toll was 11,780, the first time the figure had shown a decline over a previous year. But even as the war was slowly winding down, it was about to widen geographically. In March 1970, the overthrow of Prince Norodom Sihanouk, the ruler of Cambodia, by a pro-American junta cleared the way for U.S. forces to invade border areas looking for North Vietnamese bases. By the time the Americans withdrew at the end of June, they left behind a chaotic situation in Cambodia. After years of turmoil, the Khmer Rouge would emerge in control and carry out the "killing fields" murders of more than 1 million people.

The Cambodian "incursion," announced at the end of April, triggered a new wave of U.S. protests. An estimated one hundred thousand demonstrators gathered in Washington, while campus protests erupted at more than four hundred colleges and universities. Students were shot to death in May by National Guardsmen at Kent State University in Ohio and by police at Jackson State College in Mississippi. These killings in turn prompted student strikes across the country.

In June, the Senate repealed the Tonkin Gulf Resolution and banned further use of combat troops in Laos and Cambodia.

By year's end, U.S. troop strength had fallen to 280,000.

The U.S. death toll for 1970 was 6,173.

Early in 1971 came the first major test of how effective South Vietnamese forces would prove in combat by themselves. The goal of Operation Lam Son 719, which lasted forty-six days in February and March, was to destroy North Vietnamese sanctuaries in the Laotian panhandle west of Khe Sanh and thereby sever the Ho Chi Minh Trail. But with U.S. forces now barred from entering Laos, the Americans were limited to providing air support, and the offensive collapsed under strong North Vietnamese resistance. Since the operation involved some of the most capable South Vietnamese forces, they ended up losing many of their best officers and men.

In June 1971, the *New York Times* began publishing the Pentagon Papers, a secret history of the Vietnam War dating back to 1945 and covering events to 1967. It revealed a long list of lies and distortions fed to the American public over the years and further inflamed public opinion against the war.

By November, Nixon announced another troop withdrawal, which when completed would lower the troop level to 139,000.

The U.S. death toll for 1971 was 2,415, the lowest number since 1965.

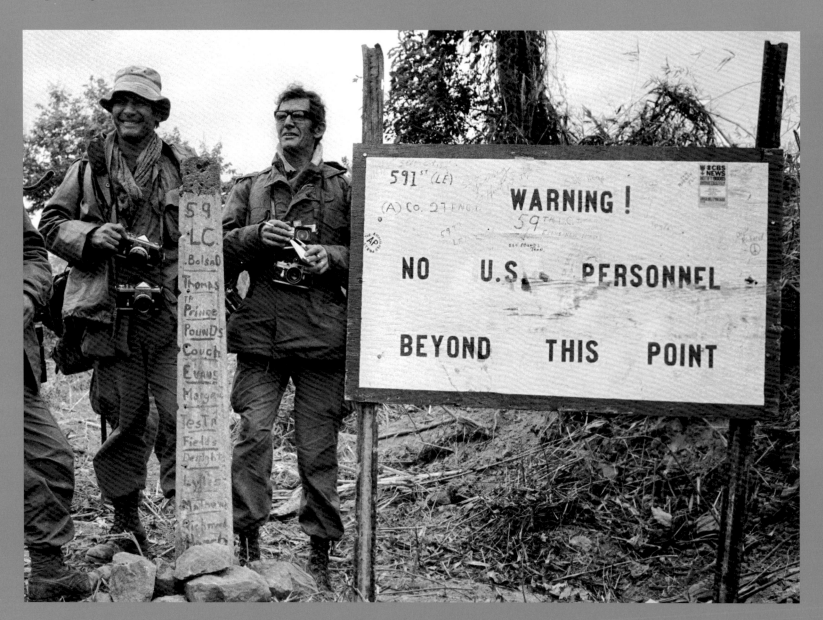

Henri Huet (left) and Larry Burrows of *Life* magazine, at the Laotian border in February 1971, just a few days before both were killed when their helicopter was shot down.

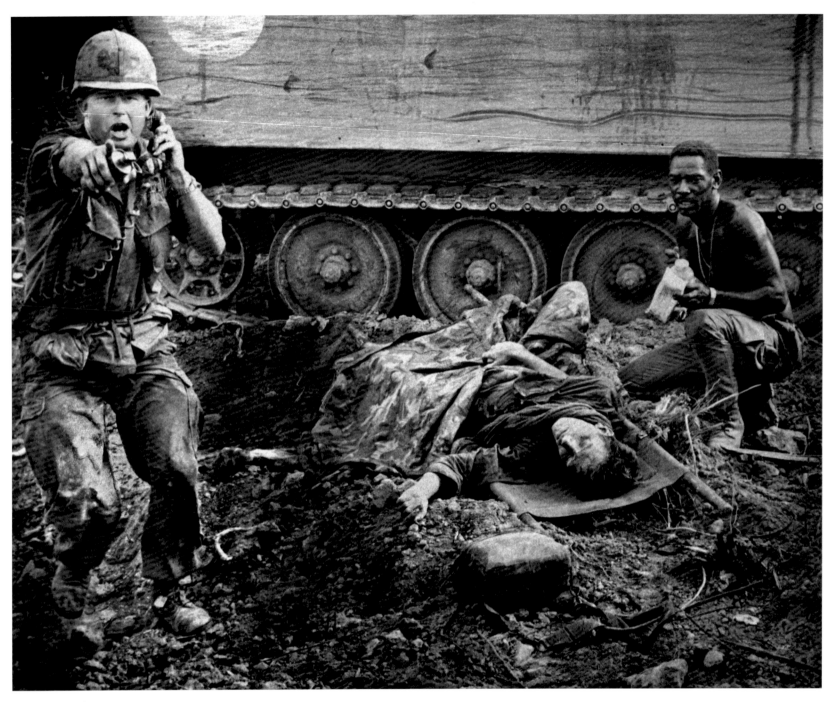

An officer shouts orders during a Viet Cong ambush near Saigon, 1969.

Sheltered beside an armored troop carrier, a wounded soldier awaiting evacuation is attended by a medic.

Photograph by Oliver Noonan.

A Cobra helicopter gunship pulls out of a rocket and strafing attack on a Viet Cong position near Cao Lanh in the Mekong Delta, January 22, 1969.

Craters caused by air and artillery strikes pock the ground. The area was largely uninhabited and scattered with abandoned rice paddies and small coconut groves.

Photograph by Graham McInerney.

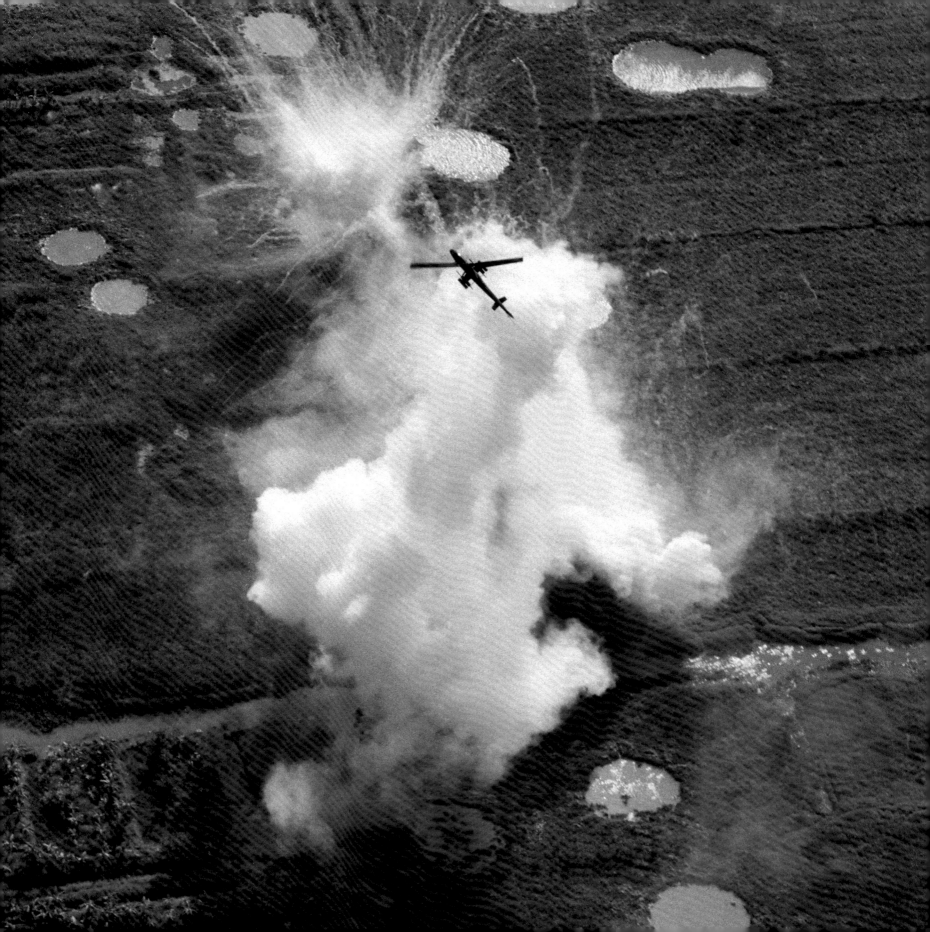

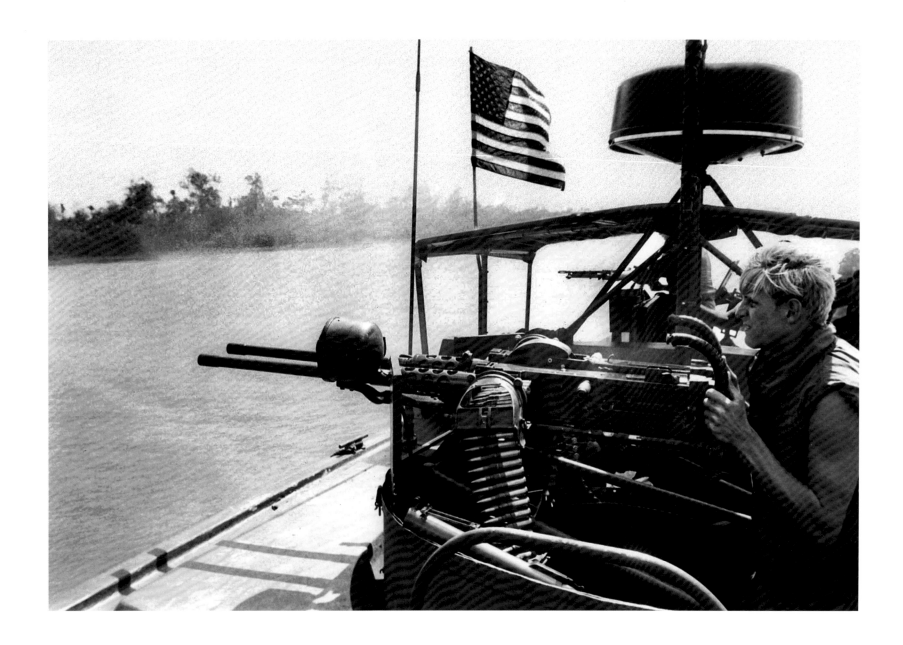

A Navy seaman aboard a PBR (Patrol Boat, River) fires twin machine guns into the free-fire zone on the shoreline along the Mekong Delta southwest of Saigon, February 1969.

Navy boats would often fire into the area in case Viet Cong troops were concealed in the canals of the delta.

AP Images Archive

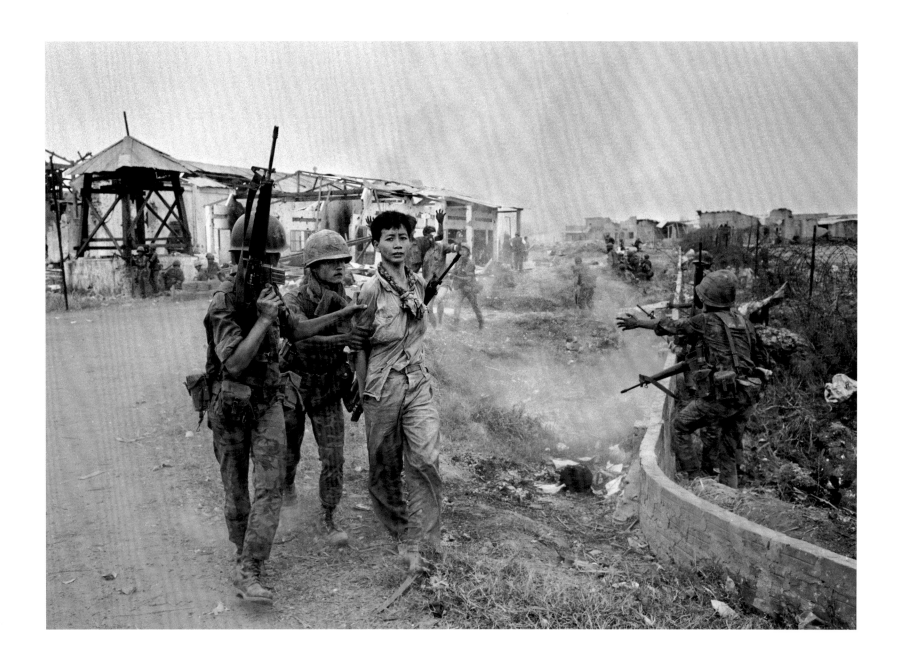

North Vietnamese prisoners are led away while South Vietnamese Rangers assault enemy positions in the ruins of Gia Kien, a suburb of Bien Hoa, February 27, 1969.

Photograph by Horst Faas.

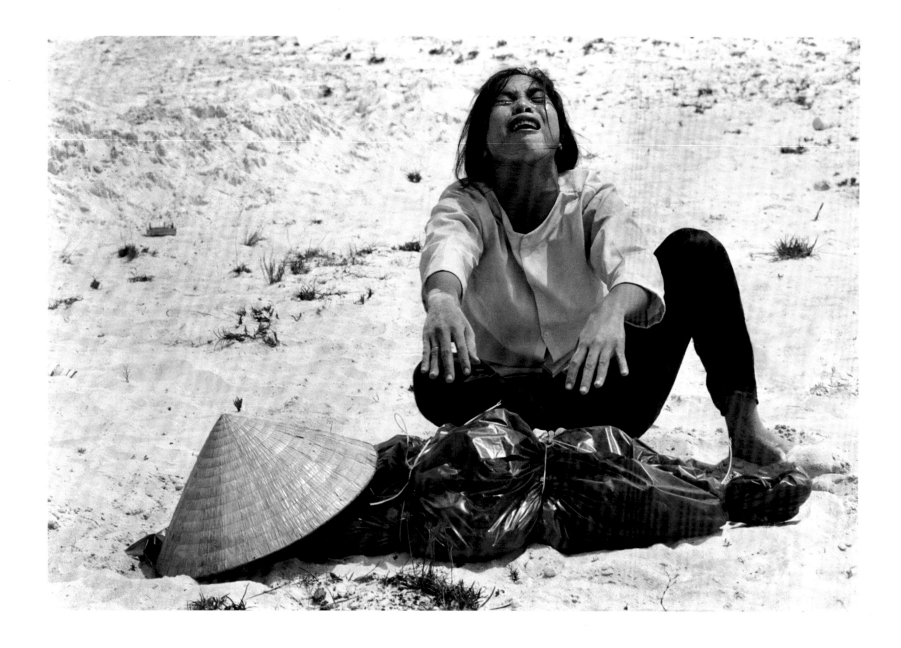

A woman mourns over the body of her husband after identifying him by his teeth and covering his head with her conical hat. The man's body was found with forty-seven others in a mass grave near Hue, April 11, 1969.

The victims were believed killed during the insurgent occupation of Hue as part of the Tet Offensive.

Photograph by Horst Faas.

A young woman covers her mouth as she stares into a mass grave where victims of a reported Viet Cong massacre are being exhumed near Dien Bai village, east of Hue, April 11, 1969.

The woman's husband, father, and brother had been missing since the Tet Offensive and were feared to be among those killed by insurgents.

Photograph by Horst Faas.

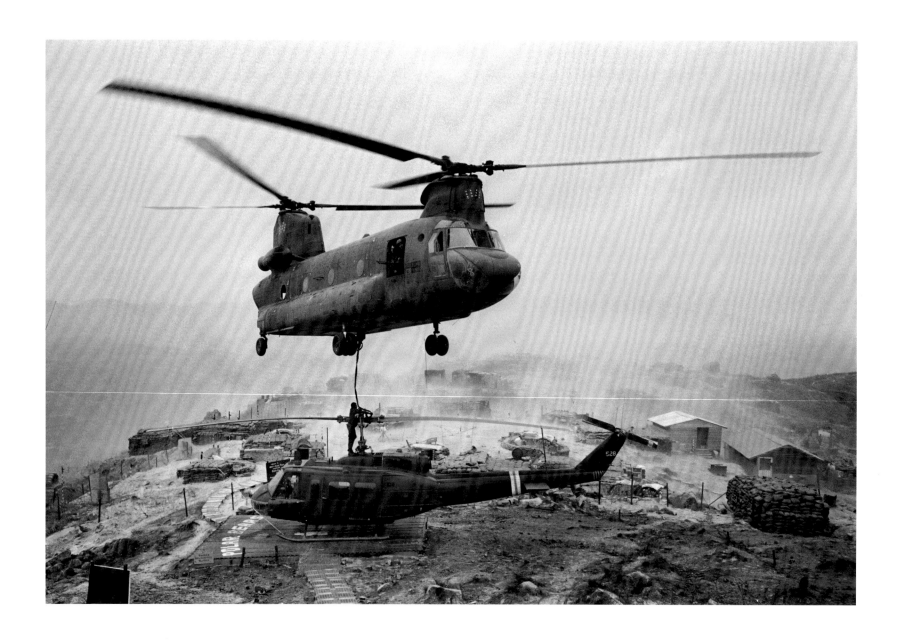

At a hilltop firebase west of Chu Lai, a huge Army CH-47 "Chinook" helicopter prepares to lift a smaller chopper to a base for repairs, April 27, 1969.

The smaller helicopter—a UH-1D "Huey"—had developed engine trouble, so its crew chief called in the local aerial towing service. One sturdy nylon strap was attached to the chopper's winch, and the two were off.

Photograph by Oliver Noonan.

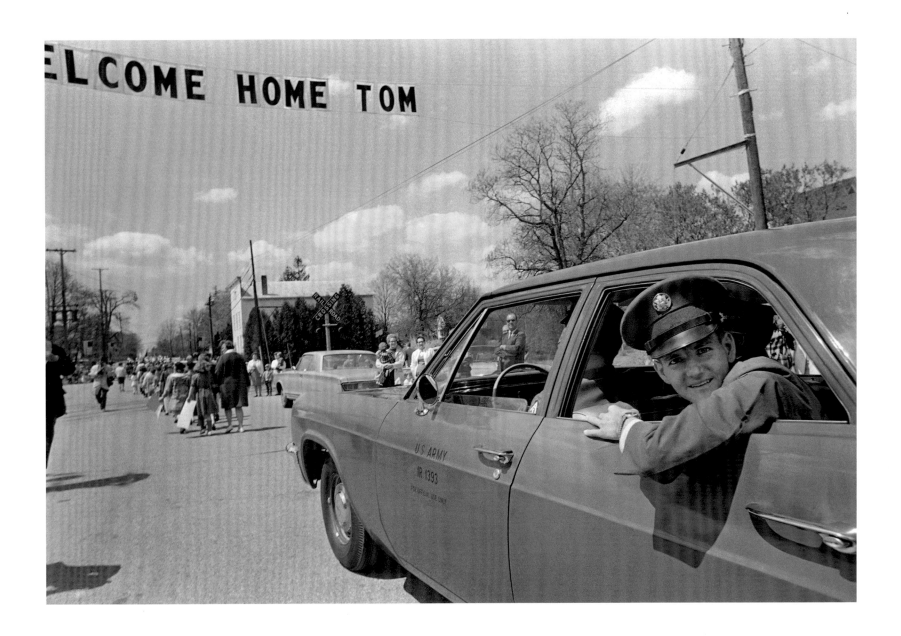

Thomas Van Putten, a twenty-one-year-old Army corporal who escaped from Viet Cong captivity after fourteen months, returns home to Caledonia, Michigan, April 30, 1969.

He had been captured near Tay Ninh while operating a road grader. In 1990, Van Putten had a leg amputated as a result of complications from injuries he suffered in captivity. He died in 2008 at age sixty-one.

Photograph by Richard Sheinwald.

OVERLEAF: A line of armored personnel carriers of the U.S. 25th Infantry Division makes its way back to base at dusk after three days of fighting the North Vietnamese near Dau Tieng, May 1969.

Just two hours earlier the unit had fought off an ambush. They suffered one dead and thirty-four wounded in the three-day operation.

Photograph by Oliver Noonan.

237

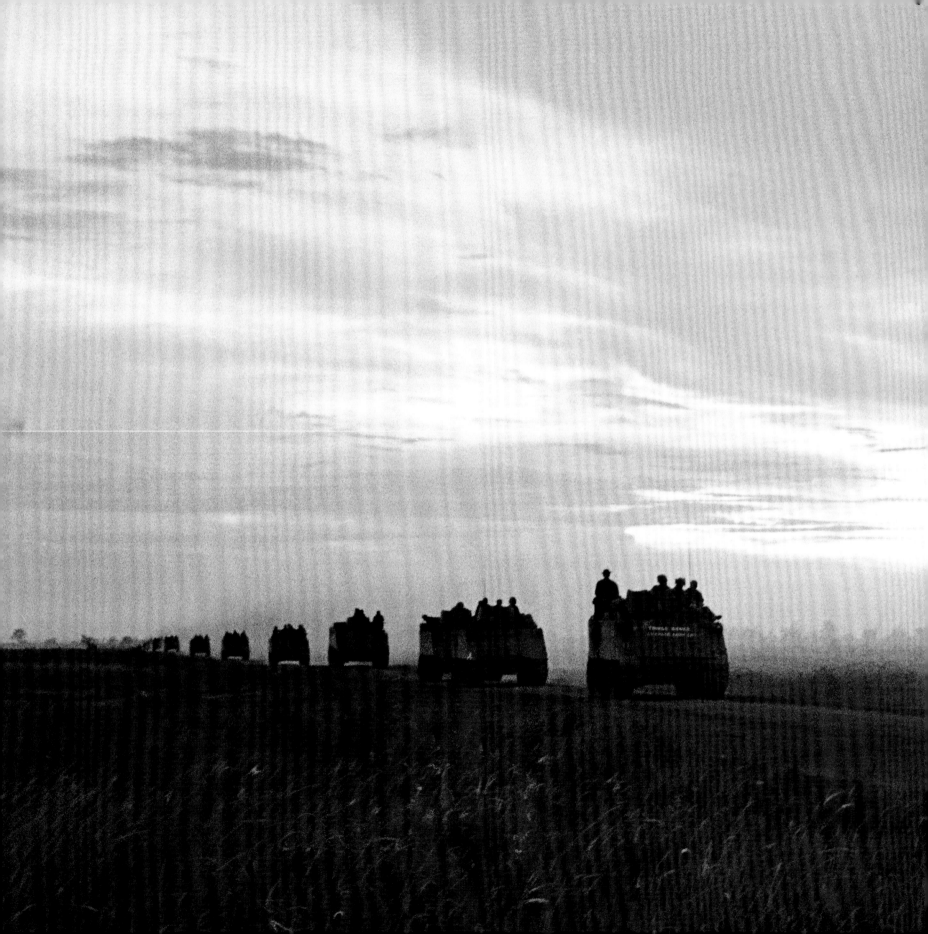

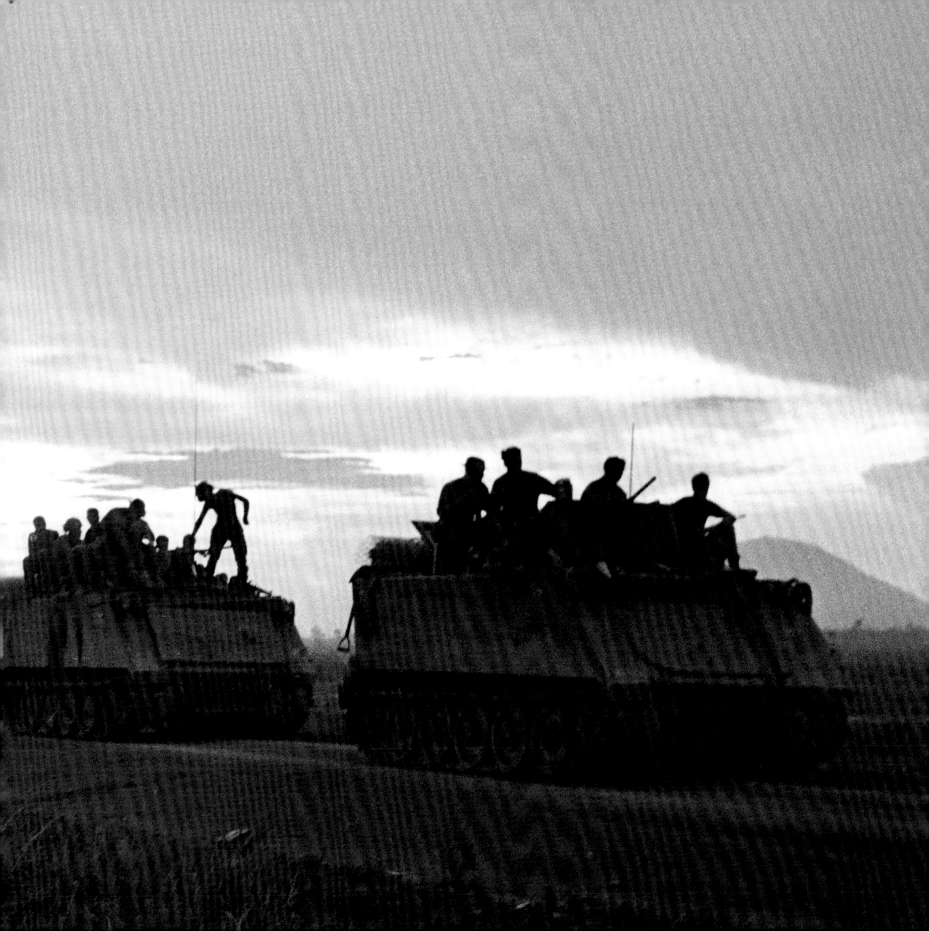

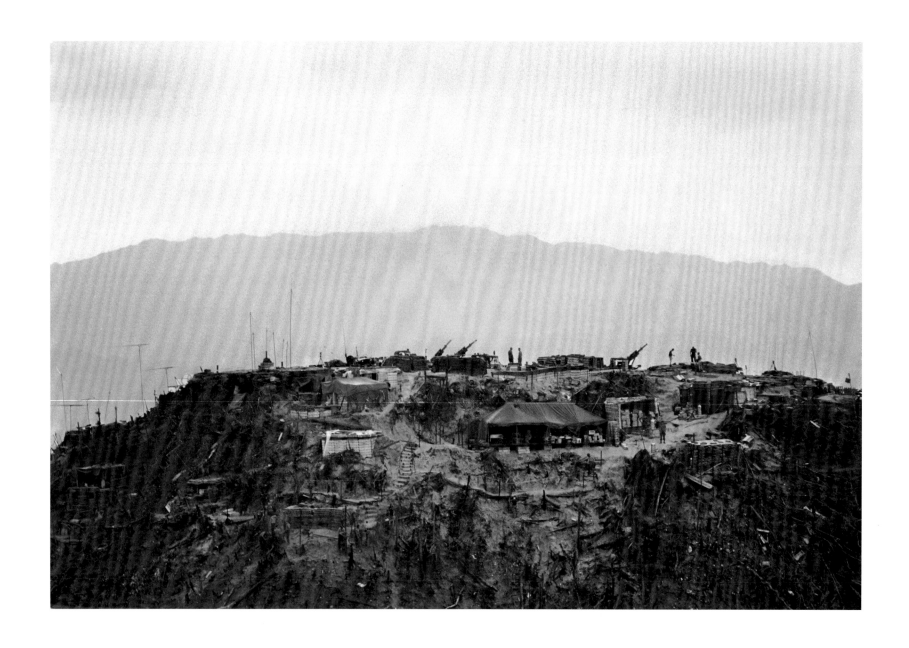

Firebase Berchtesgaden, on the eastern edge of the A Shau Valley, provides fire support for troops sweeping the insurgent-controlled valley in Operation Apache Snow, one of whose goals was the capture of Hamburger Hill, May 18, 1969.

The base was named after Hitler's Alpine retreat, which was occupied by U.S. soldiers in the closing days of World War II in Europe.

Photograph by Ghislain Bellorget.

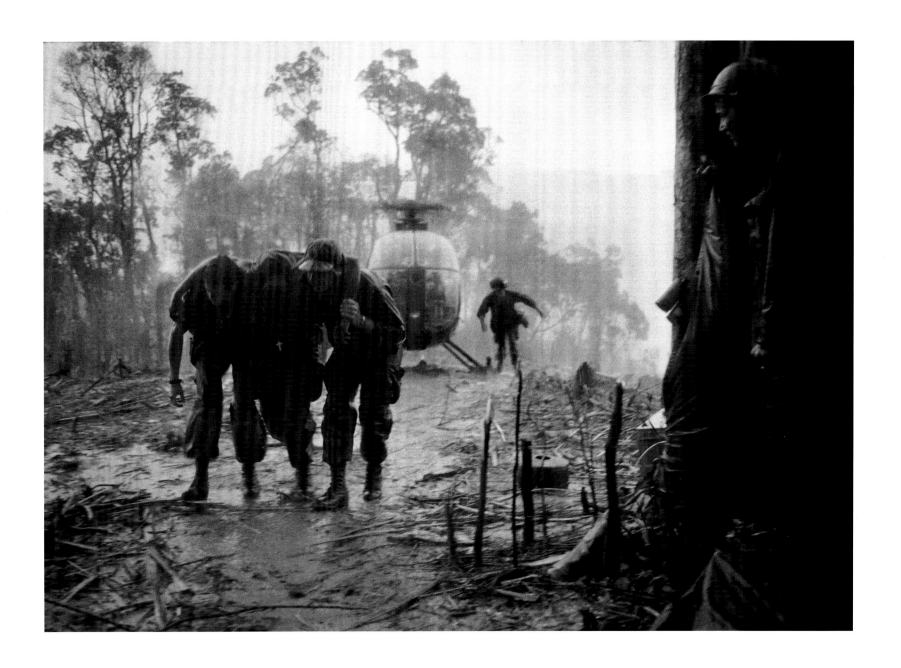

A wounded paratrooper of the 101st Airborne Division is helped through a blinding rainstorm by two medics after being evacuated from Ap Bia Mountain during the brutal ten-day battle for what came to be known as Hamburger Hill, May 1969.

U.S. and South Vietnamese forces eventually dislodged the North Vietnamese from the hill, but forty-six Americans were killed in the fighting, and the 101st abandoned the position less than a month later. The operation touched off a firestorm of political controversy in the United States.

Photograph by Hugh Van Es.

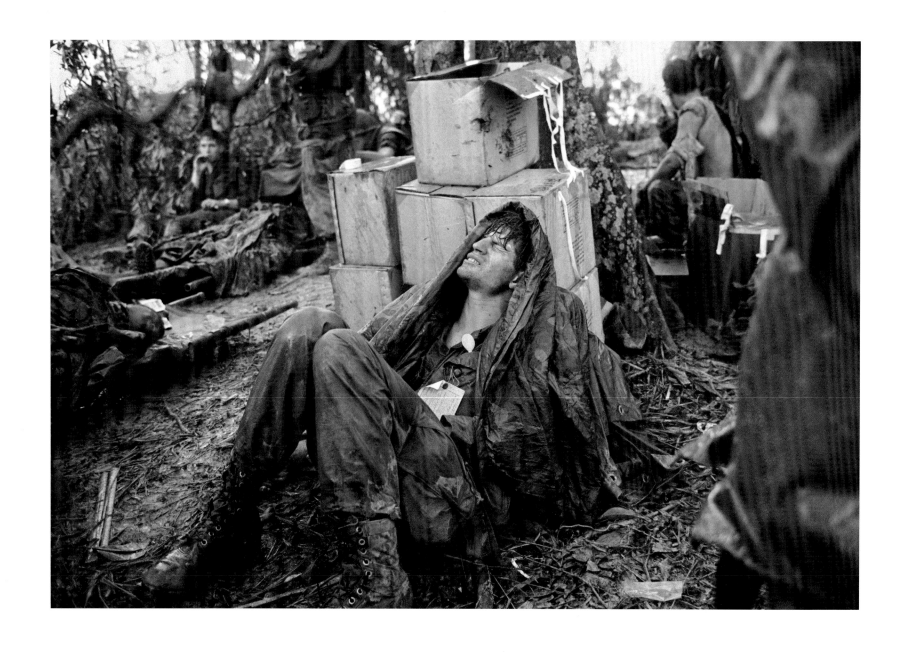

A U.S. paratrooper wounded in the battle for Hamburger Hill grimaces in pain as he awaits medical evacuation at base camp near the Laotian border, May 19, 1969.

Photograph by Hugh Van Es.

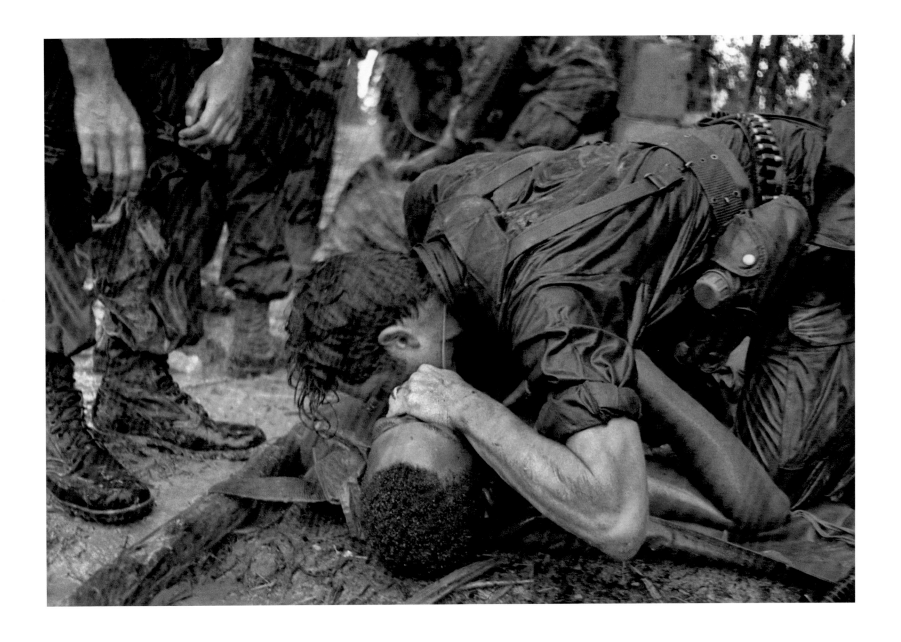

A medic of the 101st Airborne Division attempts to save the life of a fellow medic wounded during an assault against the North Vietnamese at Hamburger Hill, May 19, 1969.

The wounded medic later died.

Photograph by Hugh Van Es.

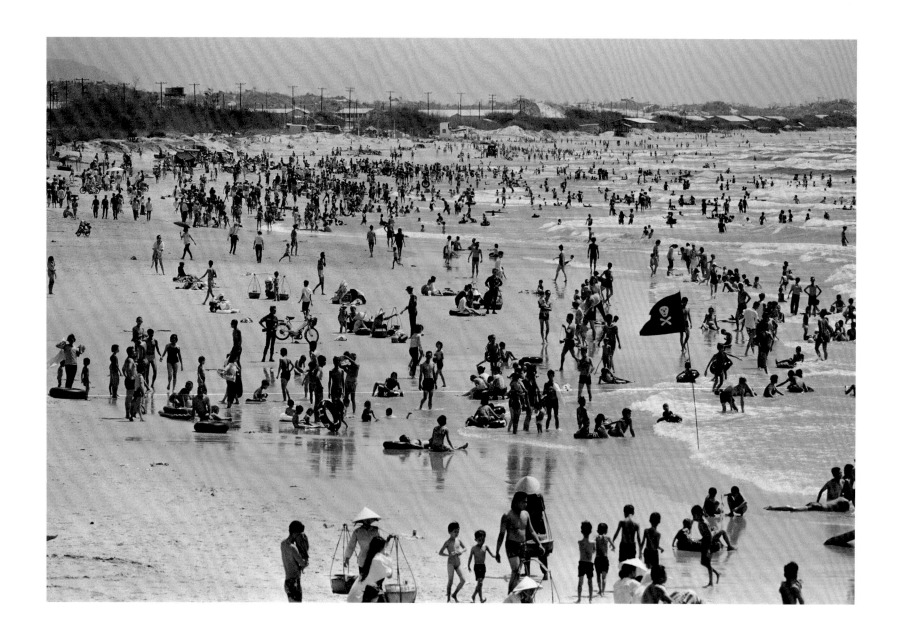

Beachgoers enjoy the water at Vung Tau, about seventy-five miles southeast of Saigon, June 1969.

The route from the capital was relatively safe during daylight hours, and cool sea breezes and gentle surf attracted large crowds.

Photograph by Horst Faas.

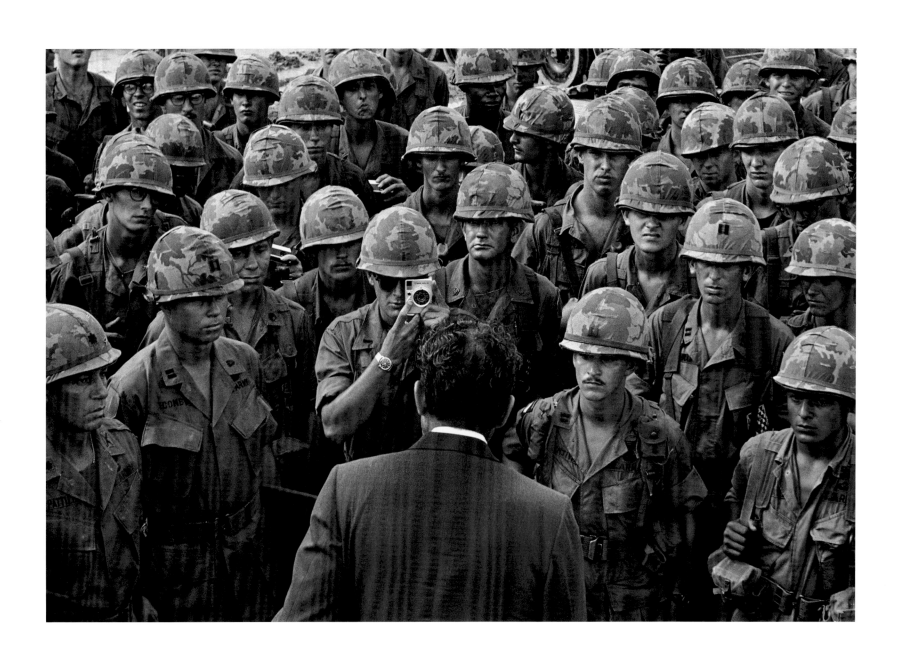

President Nixon meets with troops of the 1st Infantry Division at Di An, twelve miles northeast of Saigon, on his eighth visit to South Vietnam and his first as president, July 30, 1969.

During his five-and-a-half-hour stopover, Nixon also met with Nguyen Van Thieu, the South Vietnamese president, to discuss U.S. troop withdrawals and with senior military commanders to review tactics.

Photograph by Bob Daugherty.

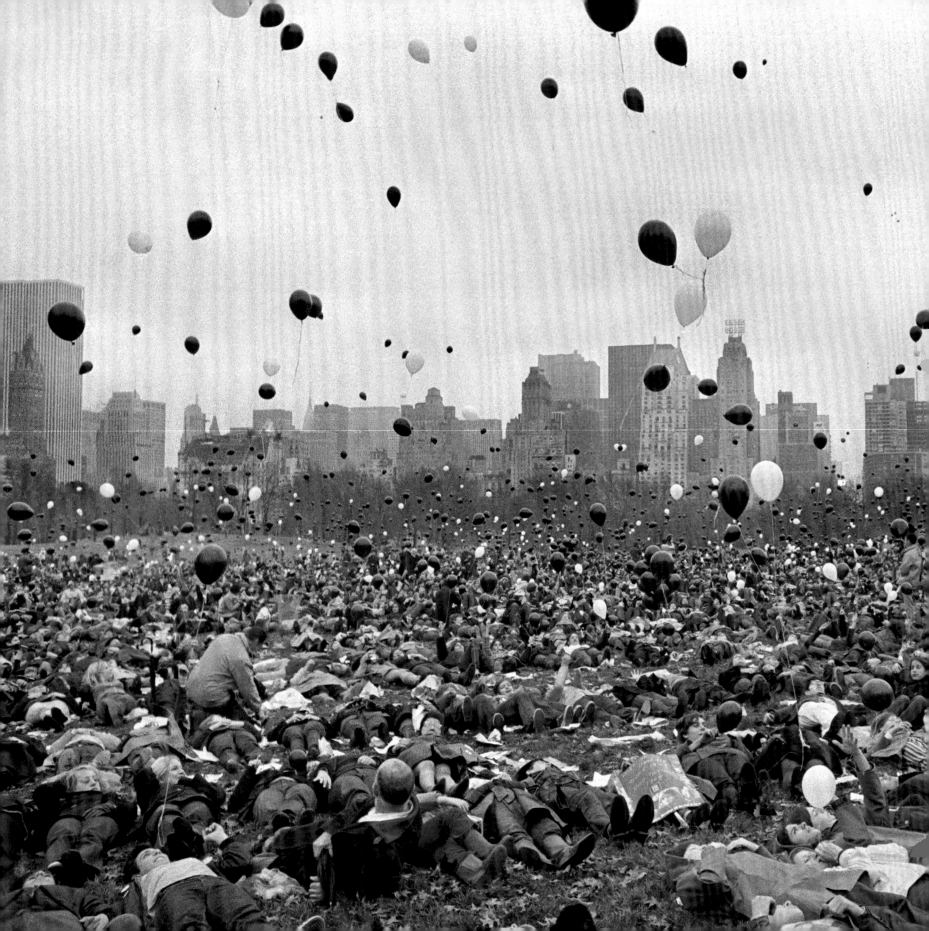

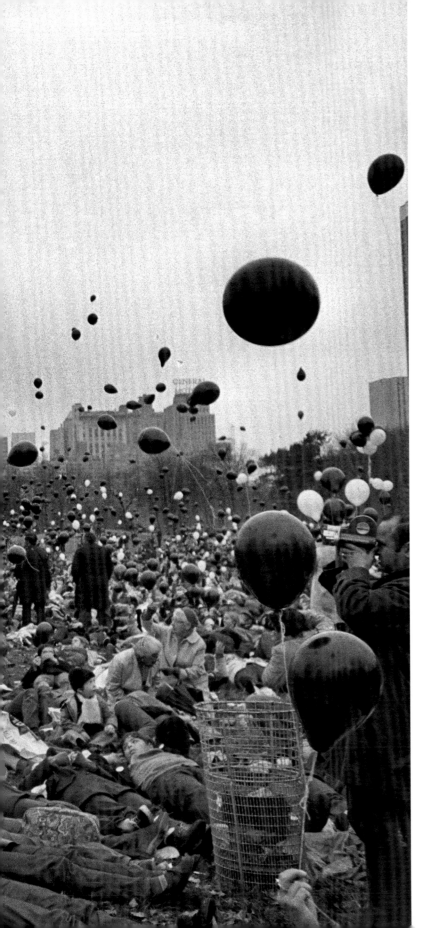

Antiwar demonstrators lie on the grass in the Sheep Meadow of New York's Central Park as hundreds of black and white balloons float skyward, November 14, 1969.

The Vietnam Moratorium Committee chose the black balloons to represent Americans who had died in Vietnam during the Nixon administration and the white balloons to symbolize those who would die if the war continued. One day later, the committee sponsored what was believed to be the largest antiwar protest in U.S. history, when an estimated half-million people gathered in Washington.

Photograph by J. Spencer Jones.

247

Freshly plowed rice paddies create
a checkerboard pattern in one of the
many valleys leading from the war-
torn lowlands of northern Binh Dinh
Province to the overgrown jungle
mountains of the interior, December
1969.

Photograph by Horst Faas.

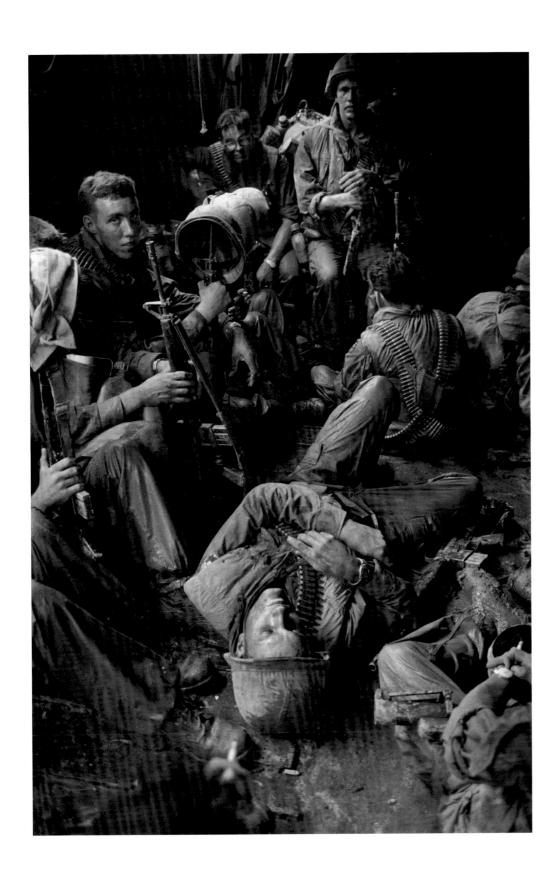

Soldiers of the 9th Infantry Division relax on the long boat trip back to their base camp after a day trudging through the overgrown coconut groves and canals of Kien Hoa Province in the Mekong Delta, January 14, 1969.

The unit made no contact with the enemy on this day.

Photograph by Henri Huet.

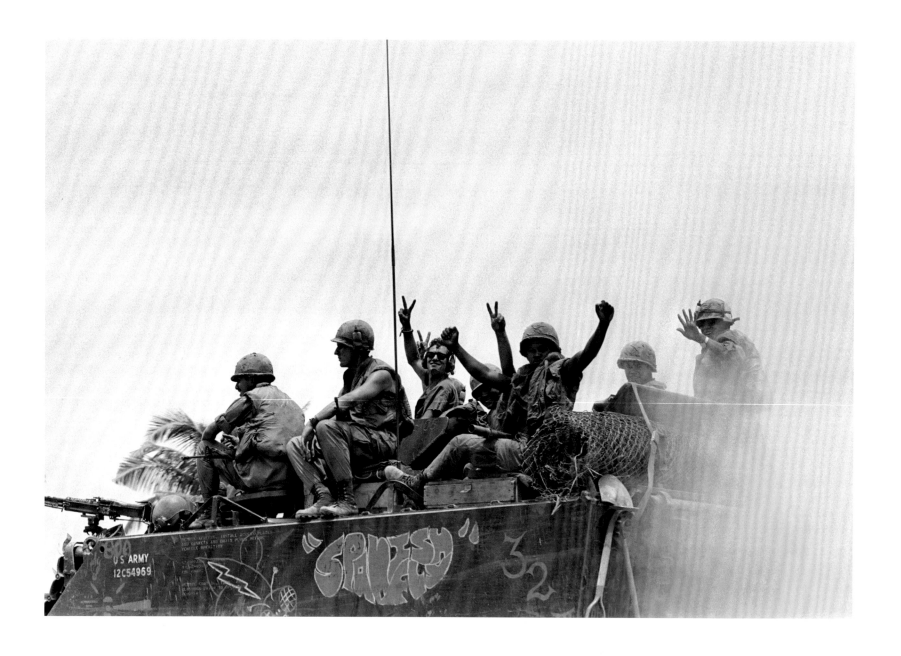

U.S. troops gesture with "V" signs and clenched fists as they ride into battle near the Cambodian border on an armored personnel carrier, April 1970.

President Nixon announced on April 30 that the United States was invading Cambodia in order to disrupt Viet Cong supply lines and to destroy bases being used to support operations in South Vietnam. The "incursion," as the government called it, lasted until the end of June.

Photograph by Le Ngoc Cung.

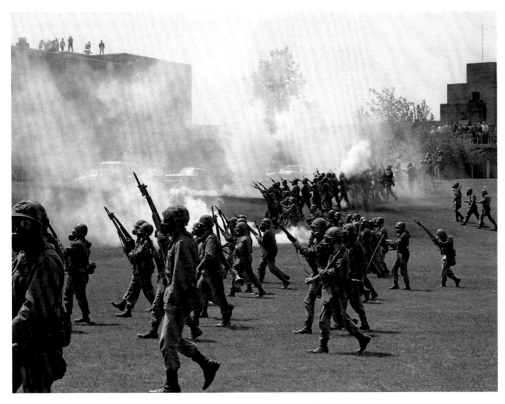

Ohio National Guardsmen move in on protesting students at Kent State University in Ohio, May 4, 1970.

Clouds of tear gas rise from the area where the guardsmen lobbed canisters to break up a noon rally of one thousand people on a grassy campus gathering spot. About twenty minutes later, as the guardsmen were retreating, they suddenly turned and fired into the crowd, killing four students and wounding nine. Exactly what prompted the shooting has never been explained.

Photograph by Don Roese, courtesy Akron Beacon Journal.

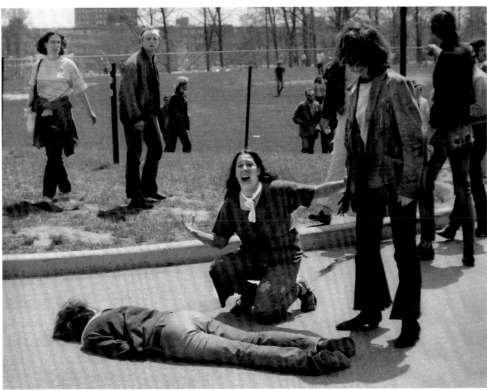

Mary Ann Vecchio gestures and screams as she kneels by the body of student Jeffrey Miller on the campus of Kent State University in Ohio, May 4, 1970.

Vecchio, a fourteen-year-old Florida runaway, had gotten caught up in the protest while visiting the campus.

This photograph by John Filo received the 1971 Pulitzer Prize for Spot News Photography.

Photograph courtesy John Filo.

251

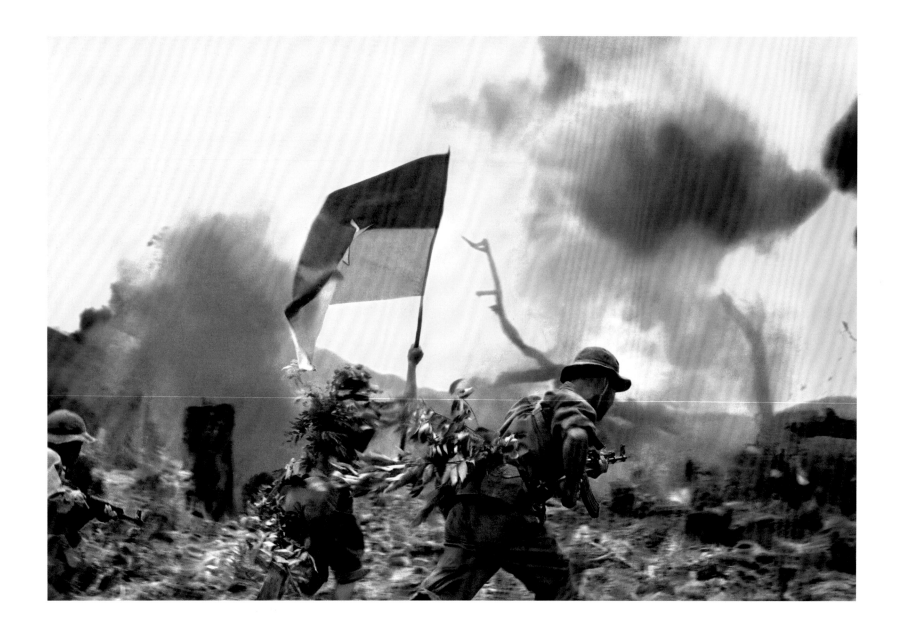

North Vietnamese soldiers attempt to take cover during fighting at Binh Tri Thien, near the Laotian border, May 1970.

Photograph courtesy Vietnam News Agency.

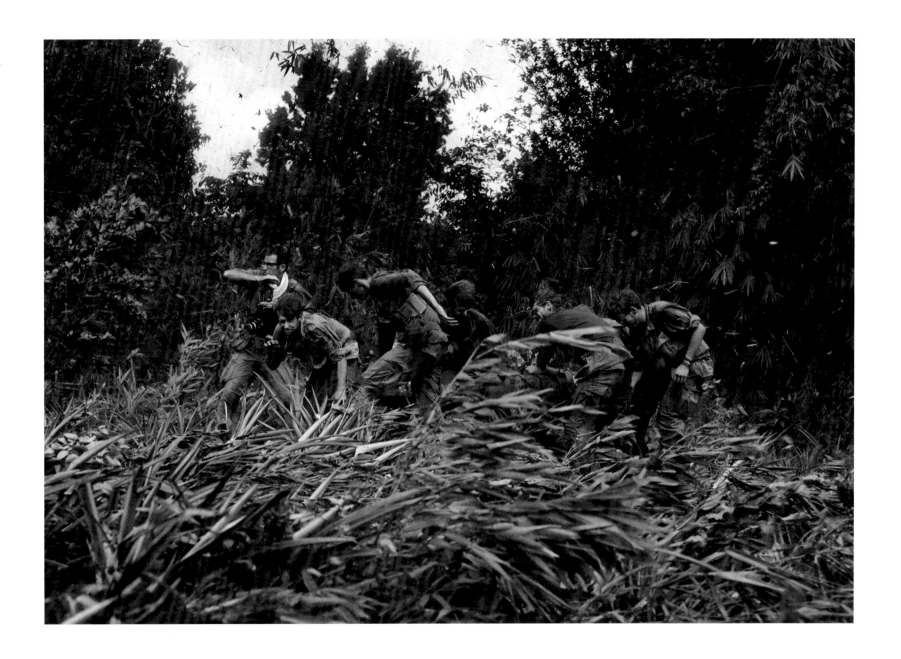

Life magazine photographer Larry Burrows (far left) struggles through elephant grass and the rotor wash of an American evacuation helicopter as he helps GIs carry a wounded soldier on a stretcher from the jungle to the chopper in Mimot, Cambodia, May 4, 1970.

The evacuation came during the U.S. incursion into Cambodia. Burrows was killed on February 10, 1971, along with the photographer who took this picture, Henri Huet, and two other photojournalists—Kent Potter of UPI and Keisaburo Shimamoto for *Newsweek*—when their helicopter was shot down over Laos. For many of his contemporaries, Burrows was considered the dean of photojournalists in Vietnam.

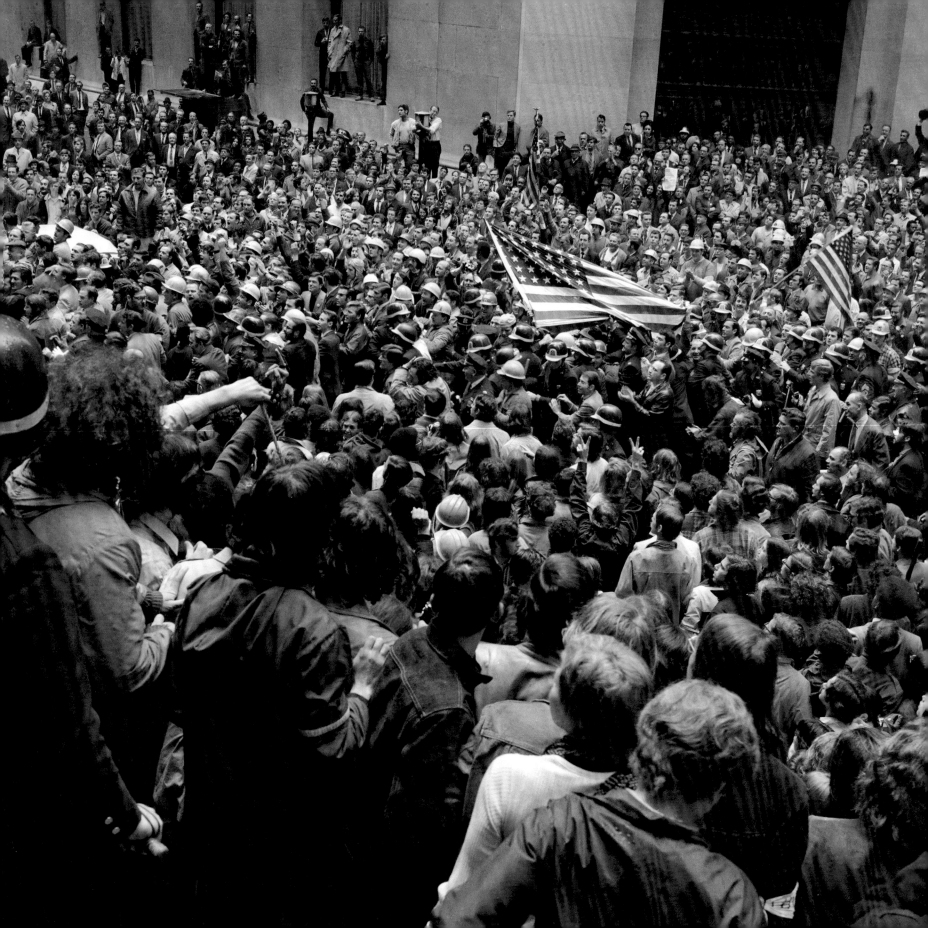

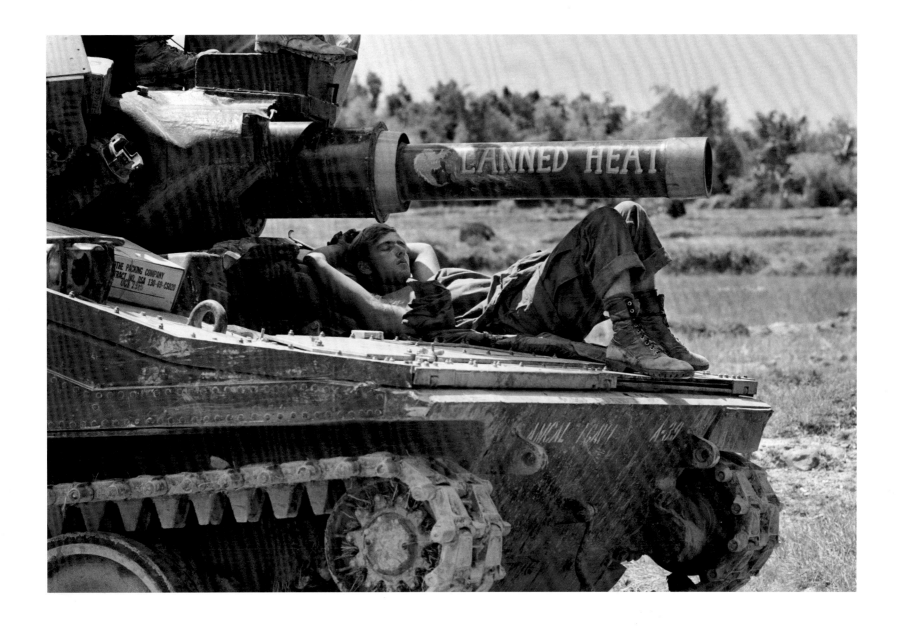

Construction workers wearing hard hats and carrying American flags force their way into a group of antiwar demonstrators in front of the New York Stock Exchange building, May 8, 1970.

The workers then led an impromptu parade up lower Broadway to City Hall chanting, "Impeach Lindsay," referring to John Lindsay, the political maverick who served as the city's mayor from 1966 to 1973.

Photograph by Ed Ford.

A trooper of the 23rd Infantry Division, more commonly known as the Americal Division, takes a midday nap under the barrel of his tank, northwest of Da Nang, June 1970.

The barrel bears the name of the popular rock band Canned Heat.

Photograph by Richard Brummett.

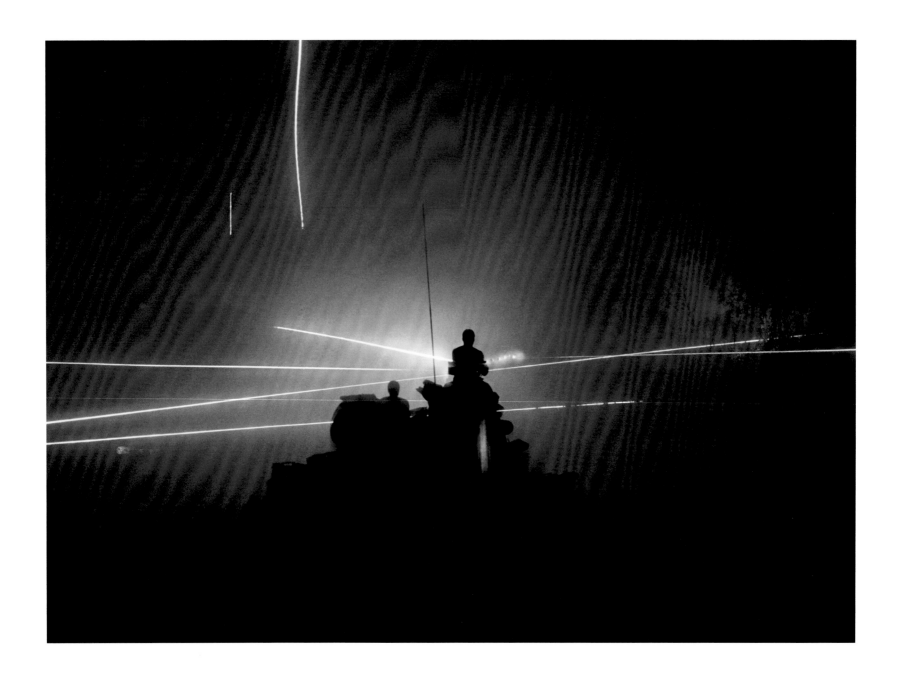

Soldiers of the U.S. 11th Armored Cavalry Regiment are silhouetted atop their tank by the glare of tracer bullets in Cambodia, June 26, 1970.

In an exercise known as "Mad Minute," the soldiers would spray the area around them with automatic weapons fire before they moved on, in case it was infiltrated by guerrilla patrols.

Photograph by Henri Huet.

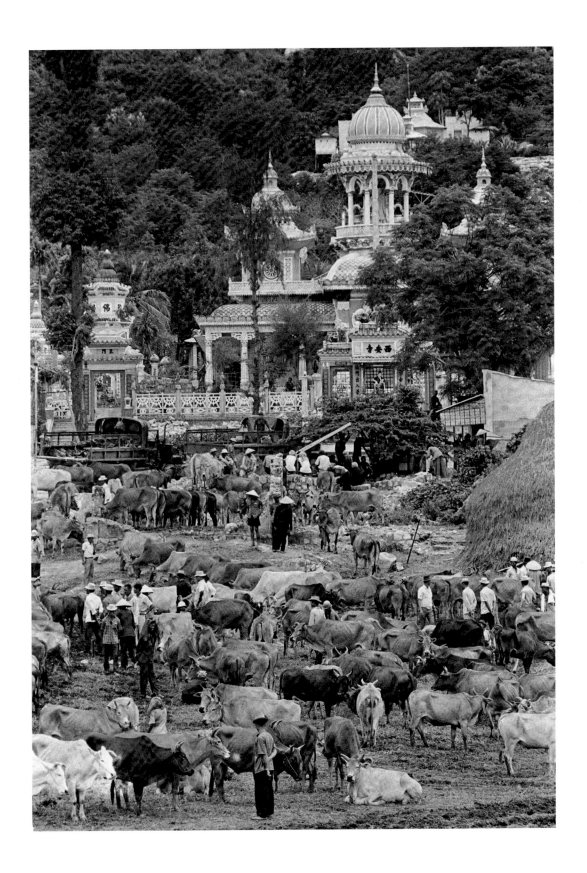

Black market brokers move through a herd of cattle in an open-air market outside Chau Doc, in the western portion of the Mekong Delta, July 14, 1970.

The cattle had been smuggled across the border from Cambodia. In the background, in front of a Buddhist temple, a convoy of trucks moves toward Cambodia for a military operation.

Photograph by Henri Huet.

257

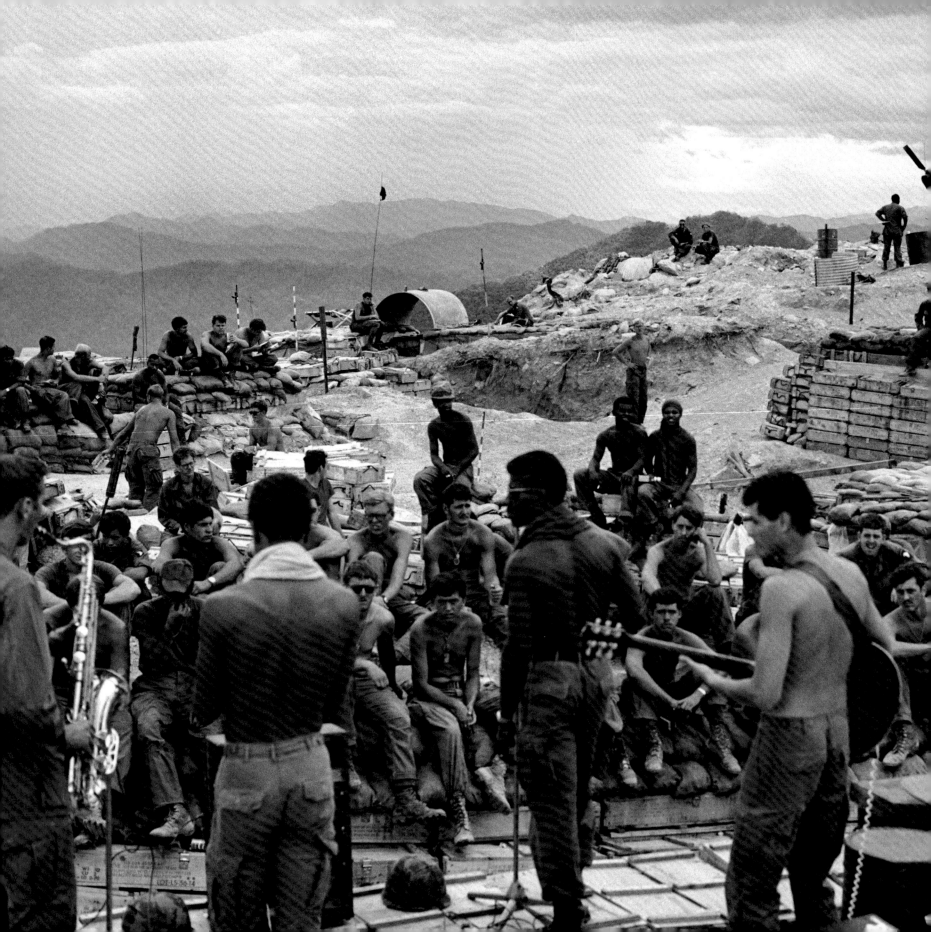

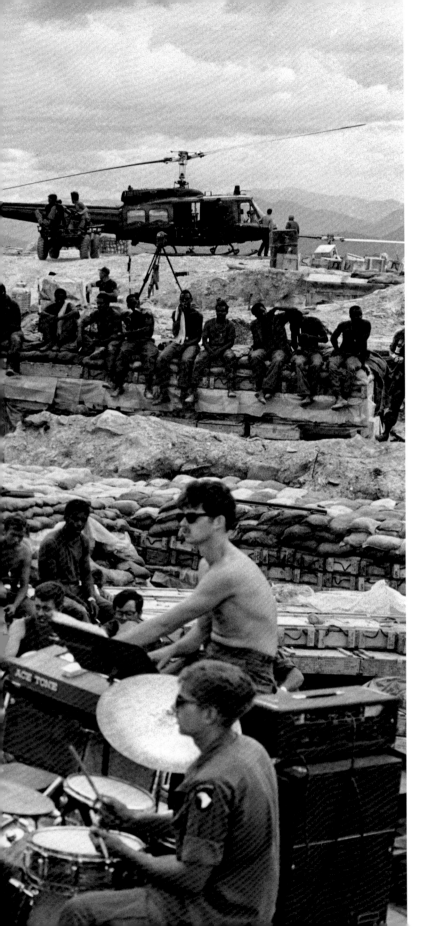

GIs of the 3rd Brigade, 101st Airborne Division, launch into a rock session while surrounded by symbols of the war—wooden bunkers, helicopter, and sandbags—July 1970.

The soldiers were dug in at Firebase Kathryn on a hill south of the DMZ.

Photograph by Giancarlo Meyer.

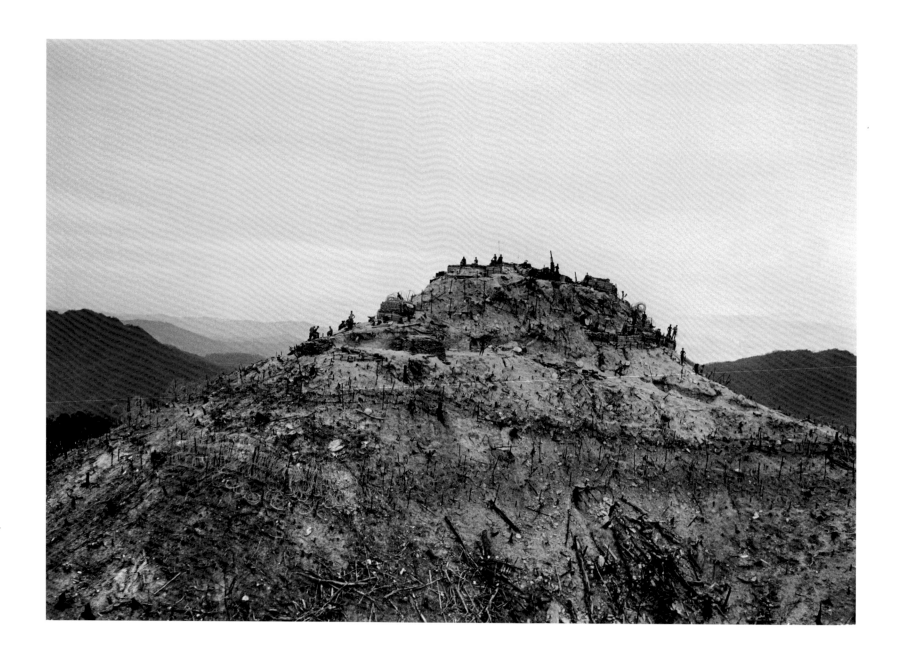

Once covered by jungle vegetation, Firebase Kathryn is manned by the 101st Airborne Division, August 1970.

Like many areas of the country, the hill was stripped bare by the spraying of chemical defoliants such as Agent Orange to deny ground cover to the Viet Cong. The base was one of several in the area that were intended to stem insurgent infiltration of coastal lowlands to the east. An artillery piece points skyward at the peak of the hill.

AP Images Archive

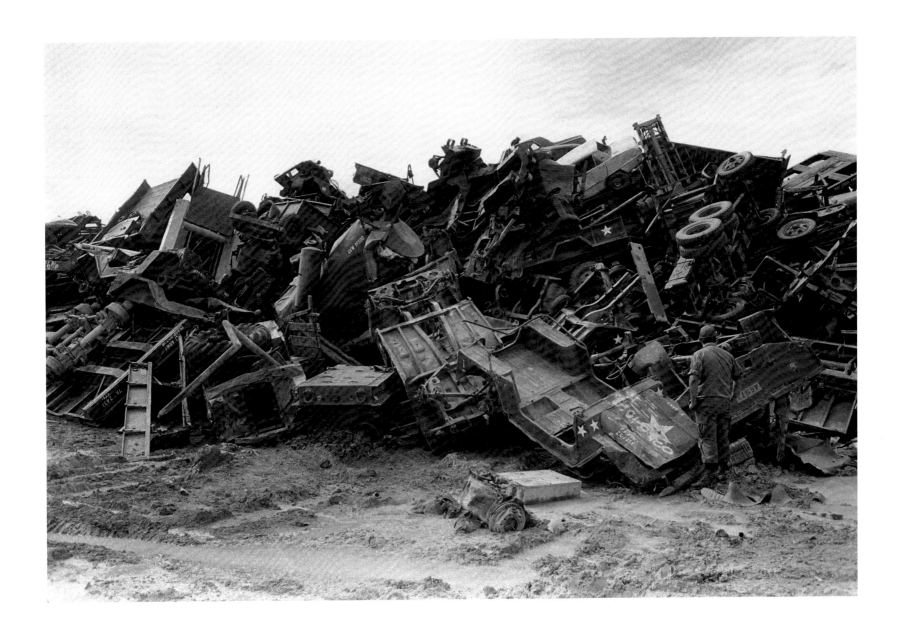

A mountain of military scrap generated by the war dwarfs a GI (lower right) at a supply center at Long Binh. November 1970.

The junked vehicles and other equipment were to be sold to private contractors, who stood to make a profit in the salvage business.

AP Images Archive

A Marine stands with Vietnamese children who watch their house burn in a village
twenty-five miles south of Da Nang, January 1971.

An allied patrol of Marines and South Vietnamese soldiers set the dwelling ablaze after
finding a cache of Viet Cong AK-47 ammunition hidden inside.

Photograph by Holger Jensen.

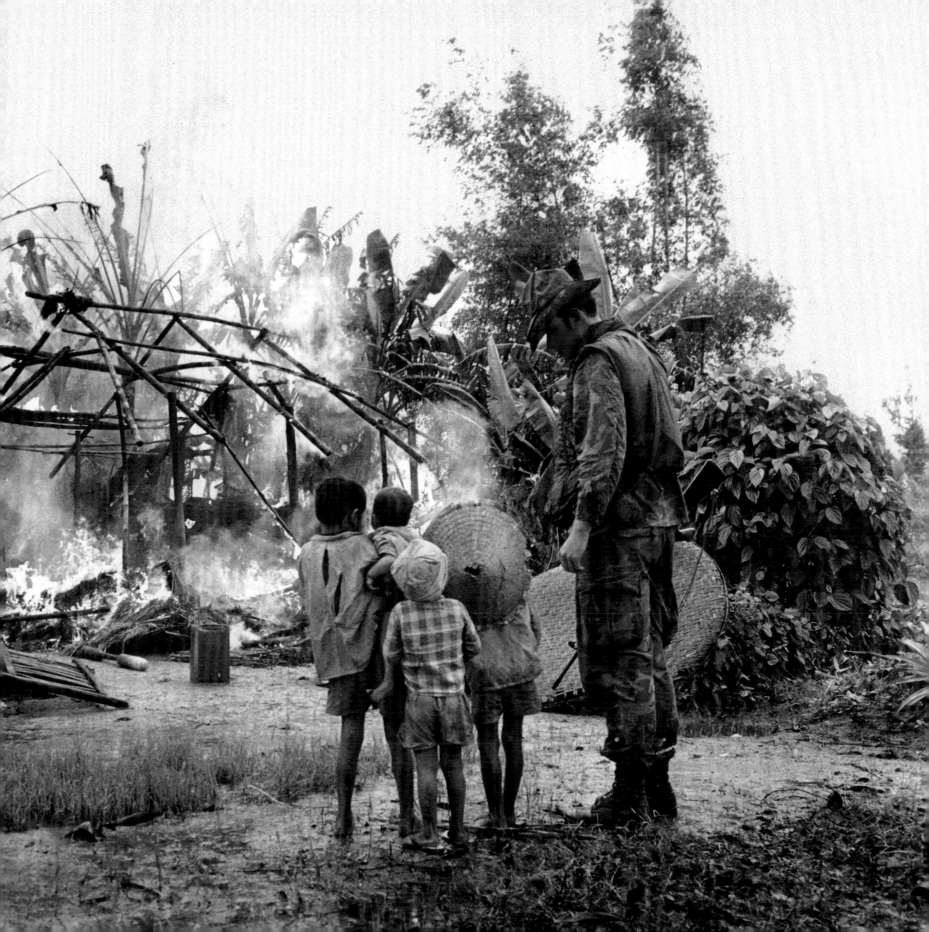

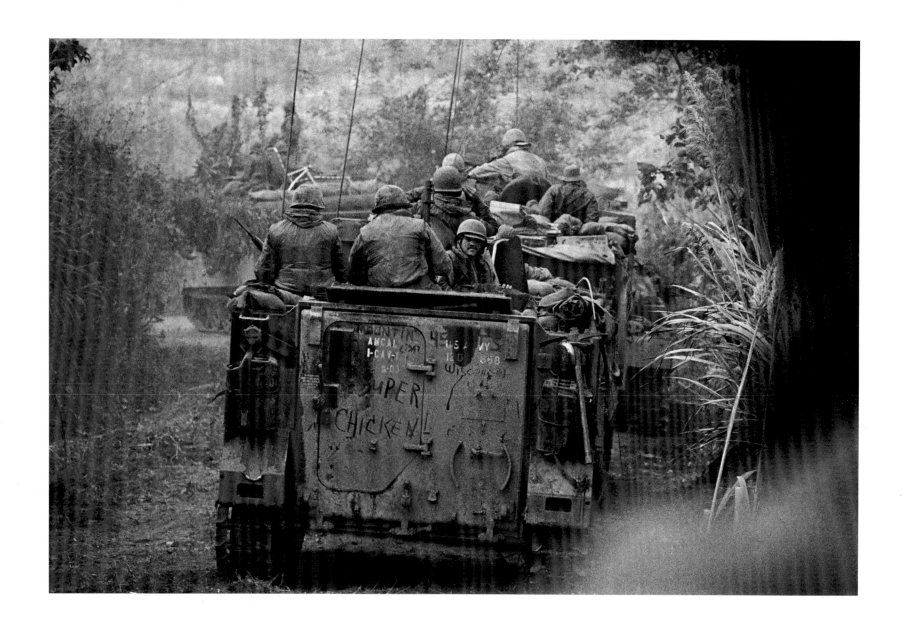

Soldiers of the Americal Division ride on armored personnel carriers toward the U.S. Special Forces camp at Lang Vei, half a mile from the Laotian border, February 1971.

The Americans—barred by U.S. law from crossing the border themselves—were clearing Route 9 to facilitate the South Vietnamese entry into Laos for Operation Lam Son 719. This photograph is from one of the last rolls of film shot by Henri Huet.

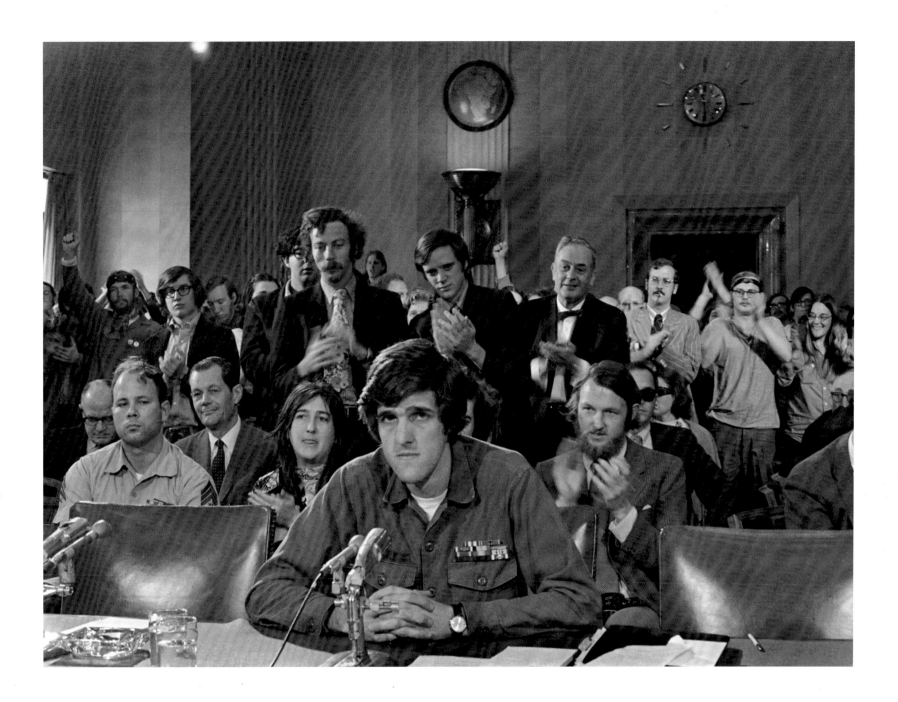

John Kerry, the twenty-seven-year-old former Navy lieutenant and leader of the Vietnam Veterans Against the War, testifies before the Senate Foreign Relations Committee in Washington, April 22, 1971.

Kerry, who received a Silver Star and a Bronze Star and was wounded three times in Vietnam, spoke about atrocities committed by U.S. troops and called for an end to the conflict. He would eventually serve as a U.S. senator from Massachusetts, and ran as the Democratic nominee for president in 2004, a campaign in which negative ads questioned his heroism as commander of a Swift Boat in Vietnam. In 2013, he was named secretary of state.

Photograph by Henry Griffin.

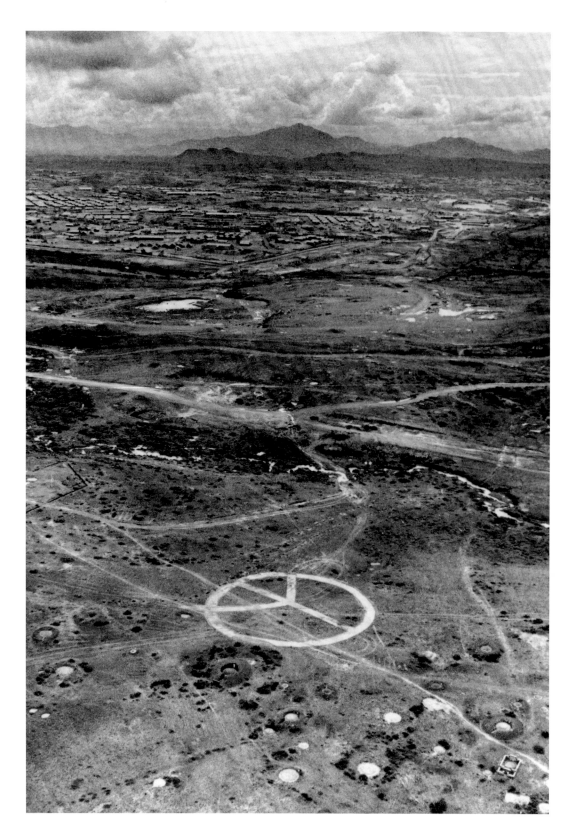

An aerial image shows a large peace sign, apparently gouged out of the countryside with a bulldozer, near Camp Eagle, headquarters of the 101st Airborne Division, in the northern part of South Vietnam, May 8, 1971.

By this time in the war, the peace sign had become a popular symbol among soldiers. The smaller pocks visible at the lower right are grave sites, built in circular mounds according to Vietnamese custom.

AP Images Archive

GIs are treated for heroin addiction at the U.S. Army amnesty center at Long Binh, August 1971.

With drug abuse on the rise among servicemen, the Army had instituted a new policy two months earlier: Every soldier leaving Vietnam was given a urinalysis test that detected heroin use within the previous five days; those with positive results were confined to a detoxification center until they could pass the test. At the same time, an amnesty program allowed soldiers to declare themselves addicts and receive treatment.

Photograph by Neal Ulevich.

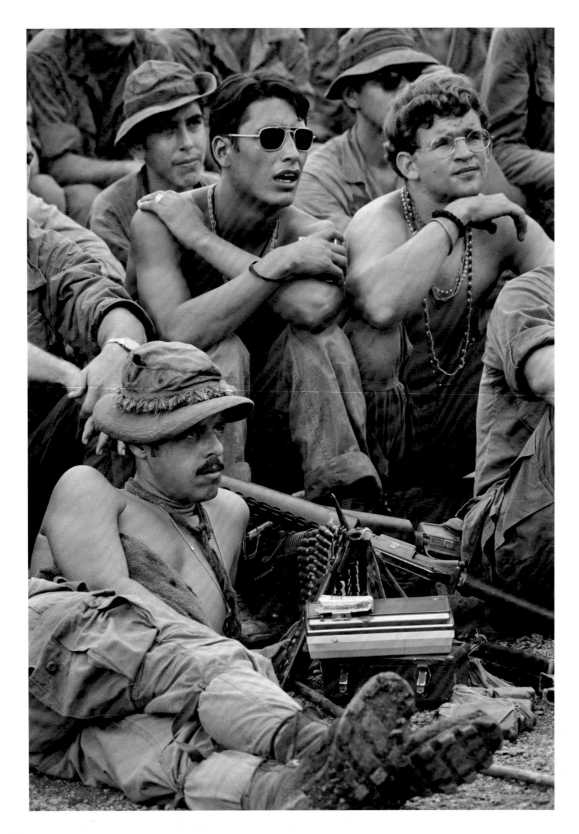

Troops of the 1st Cavalry Division watch the Miss America USO Show at Firebase Sherman, September 1971.

Beginning in 1967, the pageant sponsored annual touring shows for servicemen in Vietnam. The men had just returned from an operation in the field.

Photograph by Rick Merron.

Two soldiers play football on top of heavily sandbagged bunkers at Firebase Pace, sixty miles northwest of Saigon near the Cambodian border, October 1971.

The sandbagging served as protection against incoming rounds. Nearly all U.S. troops had been withdrawn from the firebase a week earlier.

Photograph by Rick Merron.

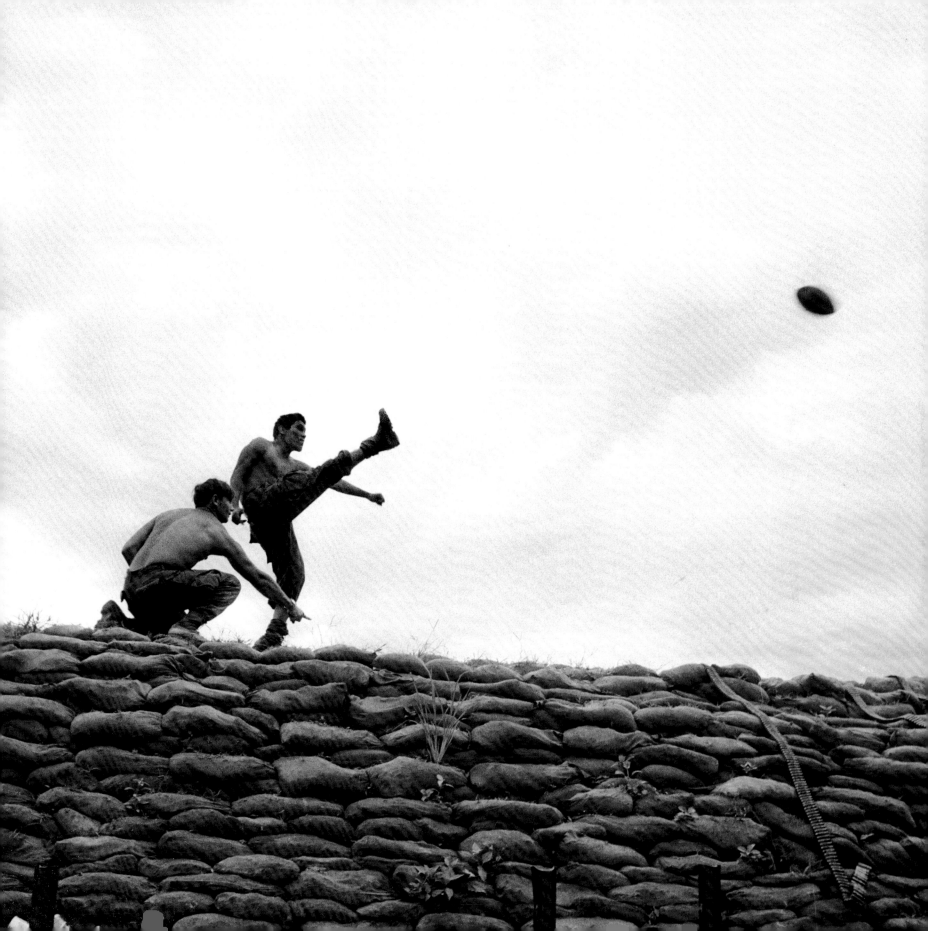

CAR BY A DEPARTING JAPANESE FRIEND. NEWSMEN WHO H

WITHOUT TIME TO PAY THEIR HOTEL BILLS OFFERED THOS

BEHIND ALL THE POSSESSIONS IN THE ROOMS IF THEY WO

NIGHTFALL: THE WORST FEARS START TO BE REALIZED

BREAKS OUT IN THE STREETS AROUND THE AP OFFICE IN

AS DRUNKEN SOLDIERS SHOOT OFF THEIR WEAPONS. SUDDE

IS CUT. COMMUNICATIONS WITH OUR NEW YORK OFFICE AR

IT IS RAINING HEAVILY OUTSIDE. YOU CAN'T SEE A TH

VIET CONG IN TOWN ALREADY? ONE WONDERS. DID THEY C

THE LIGHTS SOON GO ON AGAIN. THE SOLDIERS GO HOME

IT OFF. WE FILE OUR NIGHT REPORT AND THE FIRST DAY

THE AMERICANS IS OVER.

ENDIT

ARNETT/ESPER

I TAM-224 7ST

DEPARTED

STAYING

O PAY THE RENT.

SHOOTING

NTOWN SAIGON

Y ALL POWER

BROKEN.

. ARE THE

THE POWER?

SLEEP

THOUT

HEADING FOR THE FALL

1972–75

The Paris peace talks broke off in March 1972, and the North Vietnamese opened what was called the Easter Offensive. This operation, which lasted until October, was designed to improve the North's negotiating position, by capturing as much territory and destroying as many South Vietnamese army units as possible.

In response, the U.S. military resumed bombing North Vietnam, sending B-52s to attack supply dumps and petroleum storage sites in and around Hanoi and Haiphong. This campaign, known as Operation Linebacker, was carried out from May to October and marked the first continuous bombing since Johnson suspended it in November 1968. Nixon also ordered the mining of Haiphong Harbor. These U.S. moves succeeded in stopping the North Vietnamese offensive and brought Hanoi back to the negotiating table in Paris.

In October, Kissinger and Le Duc Tho reached agreement, and Nixon announced that "peace is at hand," shortly before he was re-elected in a landslide. But the words were premature: Thieu refused to sign as long as North Vietnamese troops remained in the South.

When talks broke down yet again, Nixon forced the issue by launching an even more aggressive bombing operation, known as Linebacker II or the "Christmas bombing." This operation, from December 18 to 29, saw the largest heavy bomber strikes by the Air Force since World War II.

< *In the final days of the war, Peter Arnett and Saigon bureau chief George Esper, who remained at their posts in the AP office along with reporter Matt Franjola, kept a diary that they filed at regular intervals to New York. This dispatch was sent on the night of April 30, 1975, a few hours after North Vietnamese and Viet Cong soldiers marched into the city. "We file our night report and the first day without the Americans is over," they write. Esper would continue to report from Saigon for five more weeks, at which point he was forced to leave on a Soviet jetliner that flew him to Laos.*

Various Wires Collection, AP Corporate Archives

The U.S. death toll for 1972 was 760. At the end of the year, there were about 24,200 U.S. troops still in Vietnam. The last U.S. Army combat unit—the 2nd Battalion, 196th Infantry Brigade—had left South Vietnam in August.

Once again, Nixon's tactics succeeded in getting the two sides back to the table, and in mid-January 1973, he was able to suspend U.S. military operations. Later that month, Kissinger and Tho agreed on a cease-fire, under largely the same terms proposed back in October. The Paris Peace Accords were signed on January 27.

That same day, Col. William B. Nolde, an officer in the U.S. Army, became the last official U.S. combat death of the war. Nolde, an adviser to the South Vietnamese in An Loc, was killed by artillery fire just hours before the cease-fire.

Starting in February, nearly six hundred American prisoners of war held by the North Vietnamese, Viet Cong, or Pathet Lao were released in what became known as Operation Homecoming.

On March 29, Nixon announced that "for the first time in twelve years, no American military forces are in Vietnam." However, there were still some military personnel and civilians at Tan Son Nhut Air Base, plus 150 Marines at the U.S. Embassy in Saigon.

That same month marked the end of the U.S. draft.

On July 1, Congress banned any funds for combat in Southeast Asia after August 15. Overall aid dropped from $2.1 billion to $700 million annually. The reduction worsened the political and economic instability of South Vietnam's government and hampered its ability to defend against a series of strategic raids launched by the North Vietnamese and Viet Cong over the coming months.

For 1973, the U.S. death toll was sixty-eight.

Seeing his grip on power threatened, Thieu announced a renewal of war in 1974, and in late April, South Vietnamese forces undertook what would prove to be their last major offensive: the battle of Svay Rieng. In this campaign, the South Vietnamese struck across the border into Cambodia and succeeded in disrupting the communications and logistics of a North Vietnamese division.

But the South Vietnamese lacked the ammunition, fuel, and other resources to continue on the attack elsewhere, and the North Vietnamese and Viet Cong soon regained the initiative.

As the year ended, North Vietnamese forces were battling in Phuoc Long Province, just sixty miles north of Saigon. One of the North's objectives was to find out whether U.S. involvement was truly over or whether the United States would honor a pledge by Nixon, who had since resigned as president, to retaliate against aggression. When the province fell into their hands on January 6, 1975, with no resistance by the United States, the North Vietnamese took it as a signal that they were free to continue moving south.

Just two American deaths were attributed to the war in 1974.

In February and March of 1975, the North Vietnamese attacked key cities in the Central Highlands. In response, Thieu abruptly ordered the withdrawal of all his forces from the Highlands to the larger coastal cities. Thousands of soldiers and civilians fled, turning the exodus into a panicky rout.

The city of Hue was occupied by the North Vietnamese on March 25.

As the end neared for the South Vietnamese regime, the U.S. government organized Operation Babylift, the evacuation of more than 2,000 orphans from Saigon, many of whom were subsequently adopted in the United States and other countries. The humanitarian effort got off to a shaky start: The initial flight, a C-5A Galaxy, crashed shortly after takeoff on April 4. Of 328 people aboard, 153 were killed.

On April 21, Thieu resigned, bitterly blaming the United States for moves that "led the South Vietnamese people to death." The South Vietnamese government was turned over to a neutralist, Duong Van Minh. Popularly known as "Big Minh" because he was six feet tall, he had served under Diem as a general and helped lead the 1963 coup that ousted him.

Anticipating the imminent fall of Saigon, President Ford, speaking at Tulane University in New Orleans on April 23, declared: "Today, America can regain the sense of pride that existed before Vietnam. But it cannot be achieved by refighting a war that is finished as far as America is concerned."

The last two Americans to die on Vietnamese soil were Marine Cpls. Charles McMahon Jr., twenty-one, of Woburn, Massachusetts, and Darwin Judge, nineteen, of Marshalltown, Iowa, who were killed in a rocket attack while providing security at Tan Son Nhut on April 29. Two more Americans would die late that night when their CH-46 "Sea Knight" helicopter crashed at sea near the USS *Hancock*, a Navy ship receiving evacuees from Saigon. They were Capt. William C. Nystul, twenty-nine, of Coronado, California, and Lt. Michael John Shea, twenty-five, of El Paso, Texas.

The next day, North Vietnamese and Viet Cong troops entered Saigon in triumph. George Esper, the AP's Saigon bureau chief and one of the few Western journalists still in Vietnam, stayed at his post and sent the bulletin that told the world of the war's end: "SAIGON (AP)—President Duong Van "Big" Minh of South Vietnam announced Wednesday an unconditional surrender to the forces of North Vietnam."

North Vietnamese Col. Bui Tin assured Minh: "Only the Americans have been beaten. If you are patriots, consider this a moment of joy."

During May, the United States became involved in a brief coda to the war—the *Mayaguez* affair with the Cambodians. Forces of the Khmer Rouge attacked and seized an American merchant ship, the *Mayaguez*, that was sailing off the Cambodian coast in international sea lanes. Ford sent in the Marines. The Khmer Rouge released the crew, but the Marines were unaware of this and attacked. Forty-one Marines and airmen died, with fifty wounded.

Including the *Mayaguez* casualties, the U.S. death toll for 1975 was sixty-two.

For the war as a whole, the Department of Defense lists U.S. fatalities at 58,220 as of the end of 2012. That number could increase in coming years as aging veterans die from causes that are linked to injuries suffered during the war. In addition, occasionally a death that occurred decades ago but was not considered war-related at the time is reclassified as new evidence comes to light.

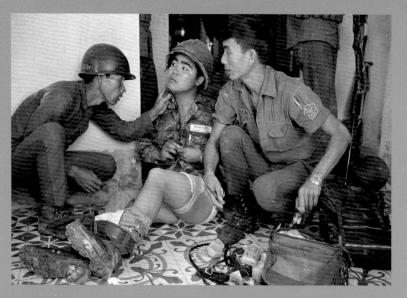

A wounded Nick Ut, attended by two South Vietnamese soldiers in July 1972 at Trang Bang, the same village where a month earlier Ut made his famous photo of Kim Phuc burned by napalm. *Photograph by Neal Ulevich.*

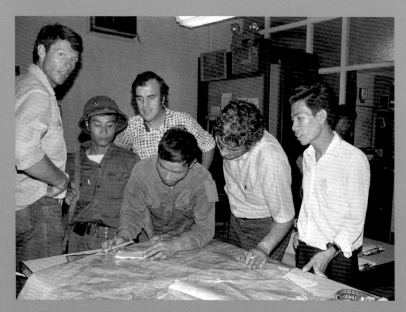

The last three staffers in the AP Saigon bureau—Matt Franjola (left), Peter Arnett (in back), and George Esper—with two North Vietnamese soldiers and a member of the Viet Cong on April 30, 1975, the day the government of South Vietnam surrendered. One of the soldiers is showing Esper the route of his final advance into the city.

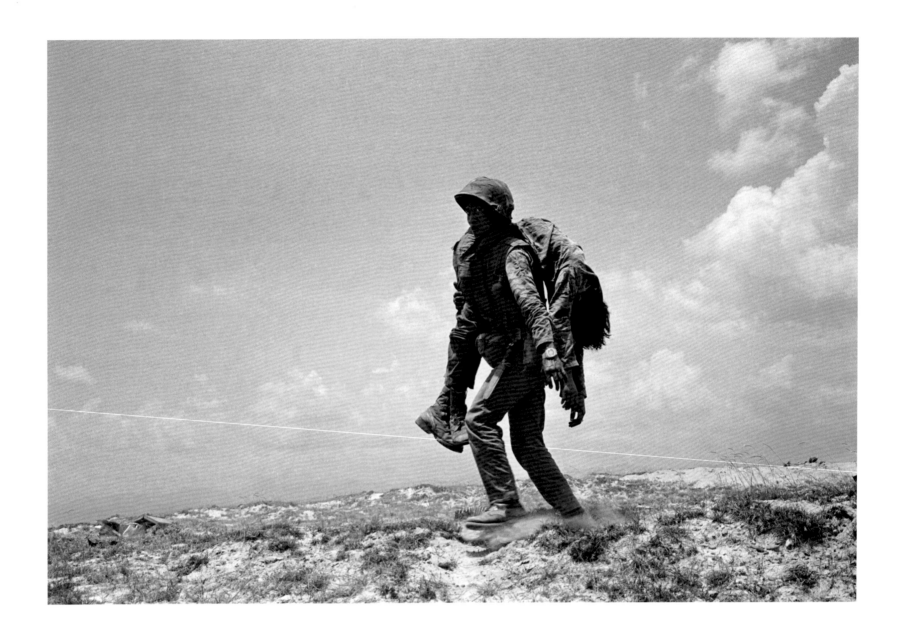

A South Vietnamese Marine carries the body of a comrade killed on Route 1, about seven miles south of Quang Tri, April 1972.

Marines were fighting to reopen the road in order to break the North Vietnamese siege of the provincial capital. The stretch of Route 1 running from Hue to Quang Tri had been dubbed "Street Without Joy" by the French two decades earlier, because convoys traveling on it were frequently subject to guerrilla ambushes.

Photograph by Koichiro Morita.

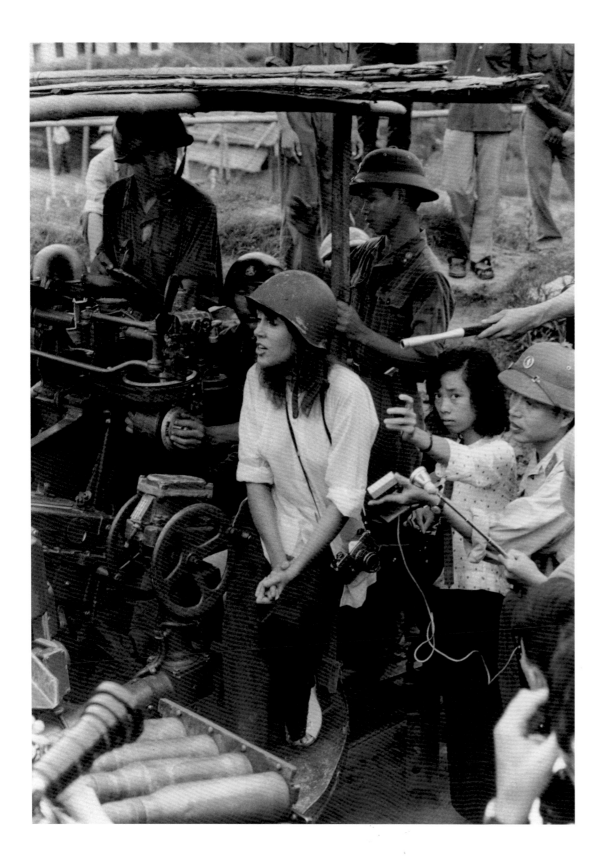

Seated on an antiaircraft gun, actress and activist Jane Fonda is surrounded by North Vietnamese soldiers and reporters as she sings an antiwar song near Hanoi, July 1972.

She is wearing a helmet and an *ao dai*, the Vietnamese national costume, consisting of a blouse and pantaloons. Fonda was in North Vietnam to "encourage" soldiers fighting against "American imperialist air-raiders." In a television interview sixteen years later, Fonda apologized to U.S. servicemen and their families for having posed in that manner, saying: "I will go to my grave regretting the photograph of me in an antiaircraft gun, which looks like I was trying to shoot at American planes. It hurt so many soldiers. It galvanized such hostility. It was the most horrible thing I could have done."

Photograph courtesy Nihon Denpa News.

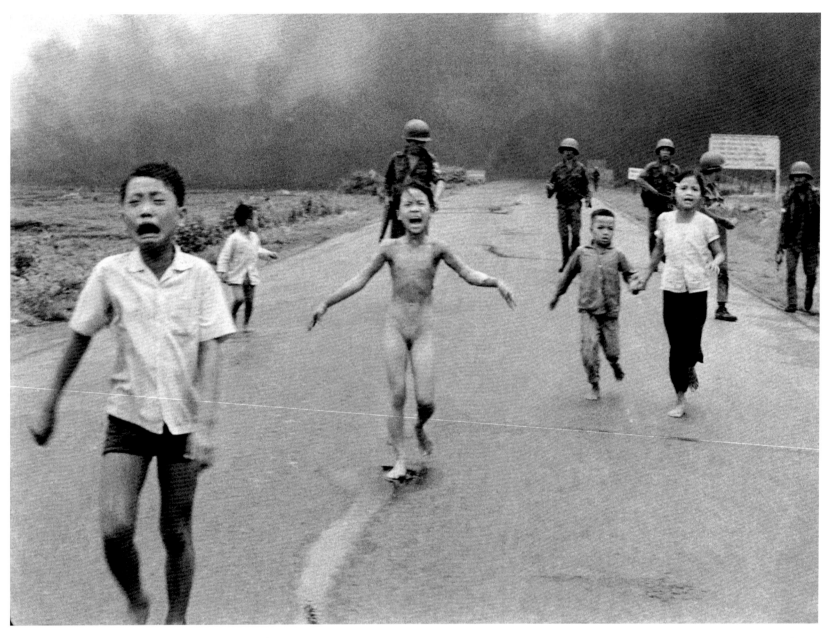

Severely burned in an aerial napalm attack, children run screaming for help down Route 1 near Trang Bang, followed by soldiers of the South Vietnamese army's 25th Division, June 8, 1972.

A South Vietnamese plane seeking Viet Cong hiding places accidentally dropped its flaming napalm on civilians and government troops instead. Nine-year-old Kim Phuc (center) had ripped off her burning clothes while fleeing. The other children (from left) are her brothers Phan Thanh Tam, who lost an eye, and Phan Thanh Phouc, and her cousins Ho Van Bon and Ho Thi Ting.

This photograph by Nick Ut received the 1973 Pulitzer Prize for Spot News Photography.

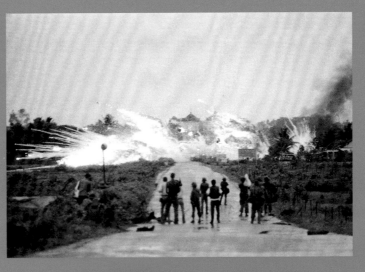

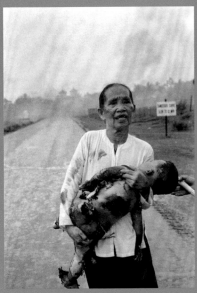

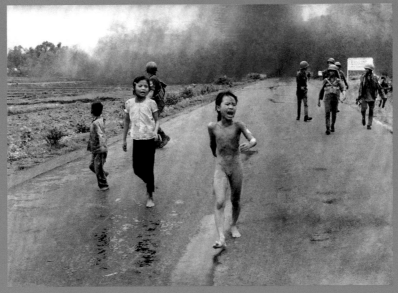

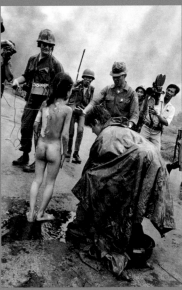

"I saw the one old lady carry the one-year-old boy . . . and baby die in her hand. . . . Then I see about five children run right at my camera . . . and she [Kim Phuc] cries, 'Help, help.' I cry, 'Get this kid in water, with her body.' And her uncle says, 'Please help my kid. Take her hospital.' I lay down my camera. I say, 'I got a van right here. And we'll take you to the hospital about twenty miles from here.' I have plenty of film of her already. I don't want she die. . . . She cry all the time in the van. I sit down talk to her, then I know her name after that. . . . I take her to Cu Chi hospital. Then I need hurry, go back to Saigon because I worried my film. I know I had a very good picture. . . . And so my friend Jackson [dark room assistant Yuichi "Jackson" Ishizaki] said, 'Nicky, do you have anything today?' I said, 'Yes, I have eight rolls of film right here.' And after film developed, black-and-white, about ten minutes, then he said, 'Nicky, what's here?' Said, 'Look at the girl, what is this? Why she don't have clothes?' And I tell him that she—you look at first pictures, the bomb napalm, that's why, she's bombed by napalm. And Jackson look at me like that. . . . She was nine years old and she burned too much of her body. And her father kept contacting me in AP office. Every time I have assignment on Highway One, I stop by, see her family. Then they know me very well. The kids call me uncle. Even Kim Phuc, today she call me uncle. And I always worry about her. She like niece or my daughter."

— Huynh Cong "Nick" Ut, from an interview with Hal Buell, August 15, 1997, for the AP Corporate Archives Oral History Program.

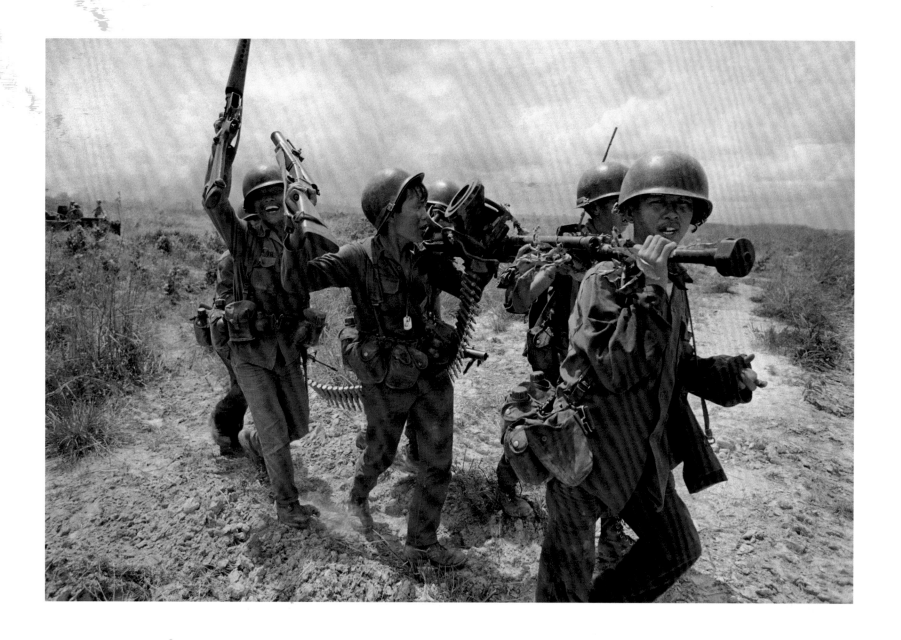

Elated South Vietnamese troops carry a North Vietnamese heavy machine gun as they retreat to a roadside ditch after knocking out a bunker near Route 13 north of Saigon, August 11, 1972.

The assault on the bunker cost the troops two armored personnel carriers. A second assault was beaten back by small arms and mortar fire.

Photograph by Neal Ulevich.

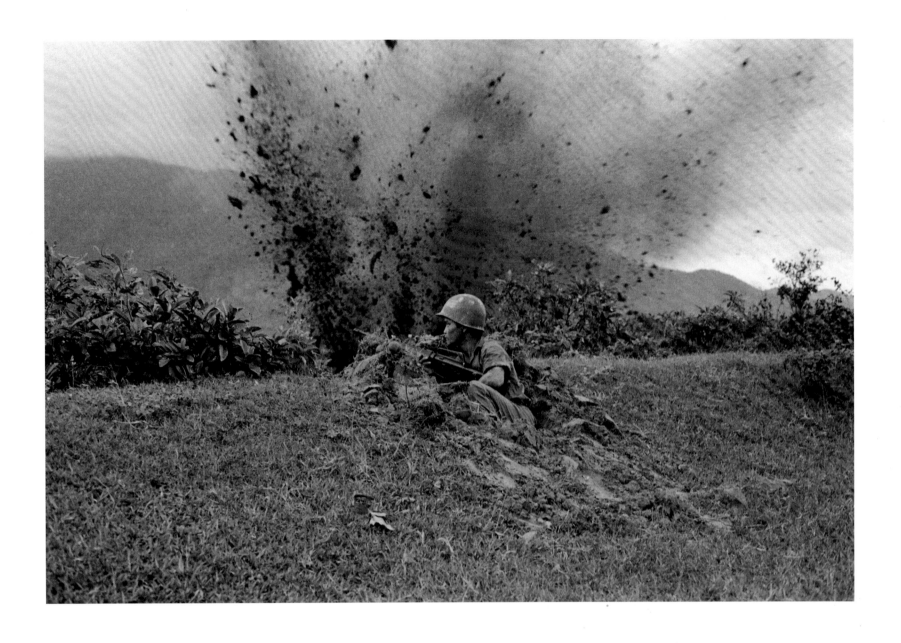

An incoming round explodes near a South Vietnamese trooper who is dug in along the
Hai Van Pass, south of Hue, November 1972.

Photographer Thai Khac Chuong was unaware that the soldier was being fired on at that
precise moment, and his camera caught the explosion before the man had time to react.

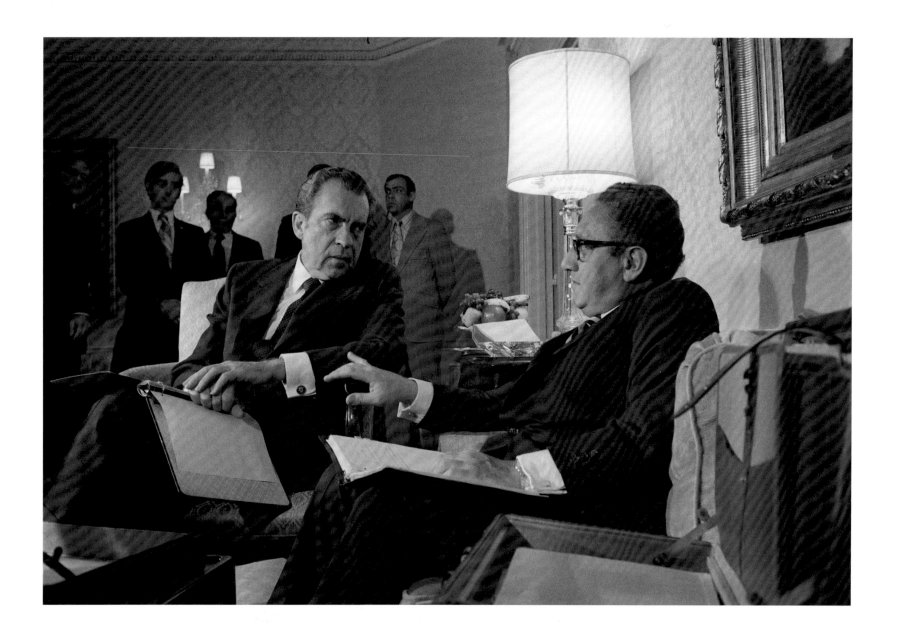

President Nixon confers with Henry Kissinger in New York after the national security adviser returned from a week of secret negotiations in Paris with North Vietnam's Le Duc Tho, November 25, 1972.

Less than a month later, with talks stalemated, Nixon launched the "Christmas bombing" of North Vietnam. That brought Hanoi back to the table, and the Paris Peace Accords, ending U.S. involvement in the war, would be signed January 27, 1973.

AP Images Archive

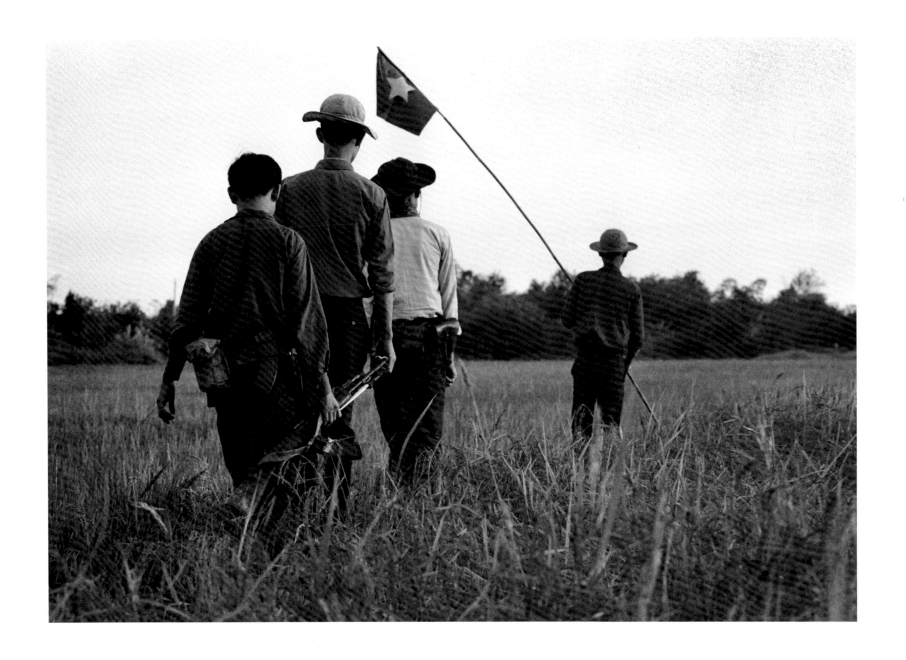

Carrying a Viet Cong flag, guerrillas cross open rice paddies while patrolling near the village of Binh Phu, February 1973.

Although fighting had eased in the wake of the cease-fire, guerrilla patrols continued in the village, fifty miles southwest of Saigon.

AP Images Archive

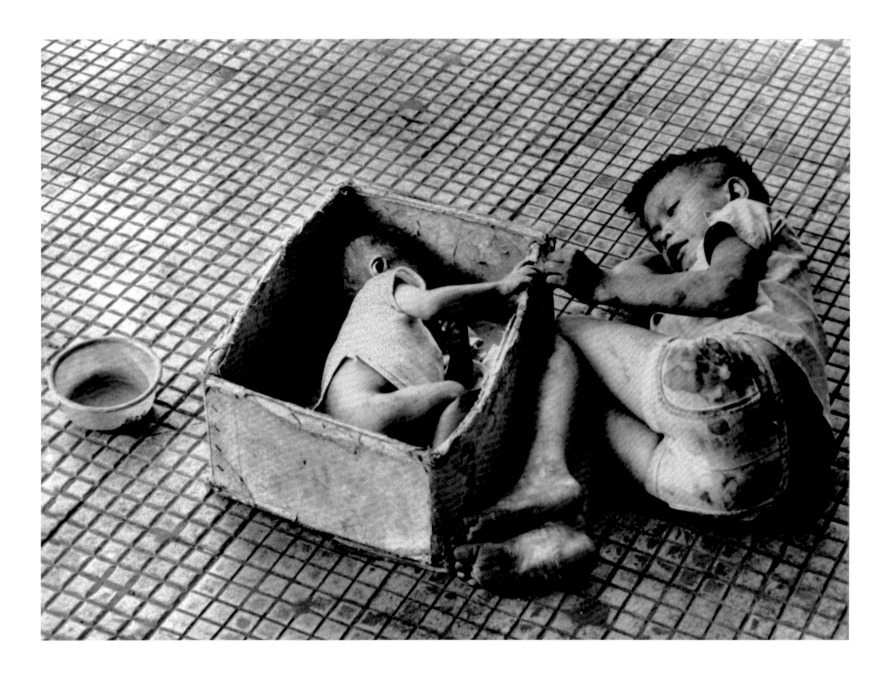

A baby girl lies in a cardboard box next to her brother, who begs on the streets of Saigon. February 1973.

When the photograph, taken by Chick Harrity, was published in U.S. newspapers, it inspired Americans to raise money to bring the baby, Tran Thie Het Nhanny, to the United States to undergo corrective surgery for a congenital heart defect. In 2005, Harrity was given a lifetime achievement award by the White House News Photographers Association, and at the dinner that honored him in Washington he was reunited with Nhanny, then living in Ohio, and with the woman who had adopted her, Evelyn Warren Heil.

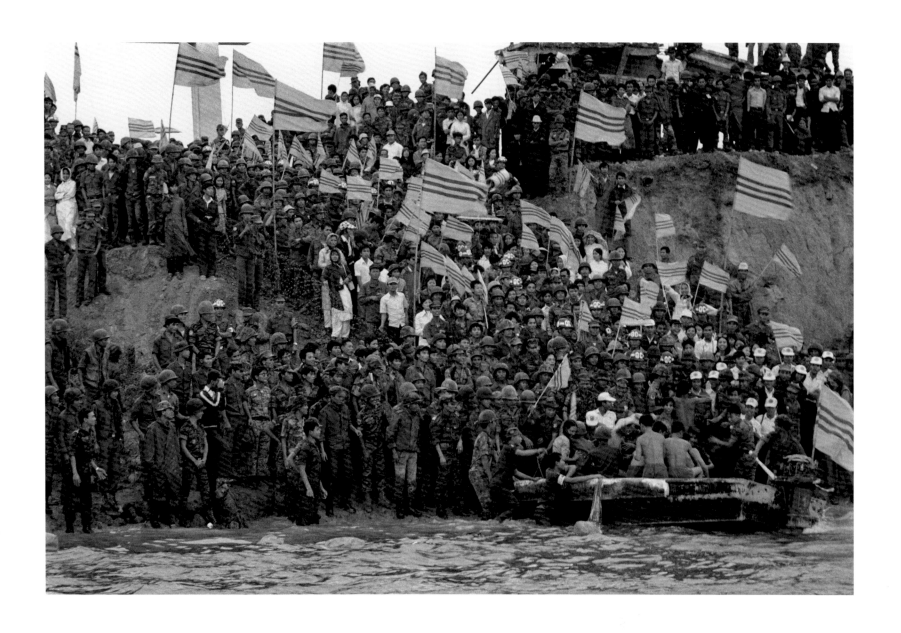

Several hundred soldiers and civilians, including family members, crowd the southern bank of the Thach Han River at Quang Tri to greet a boatload of newly freed South Vietnamese POWs arriving from across the river, March 1973.

The Viet Cong, who controlled the northern bank, had released three hundred prisoners.

Photograph by Tran Khiem.

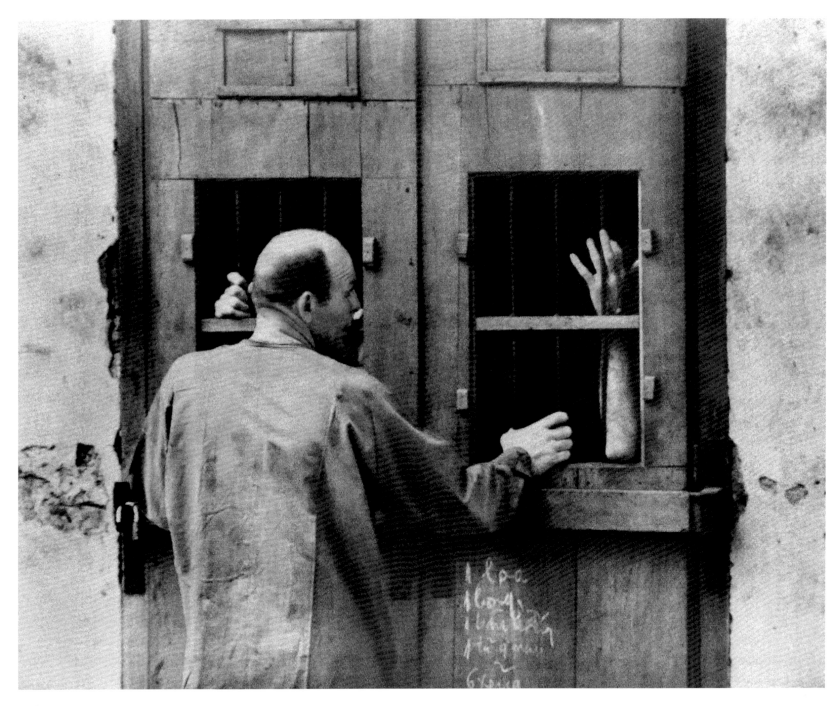

An American POW talks to fellow prisoners through a barred door at a detention camp in Hanoi, March 1973.

The release of all 591 U.S. captives had begun in February and would be completed by the end of March.

Photograph by Horst Faas.

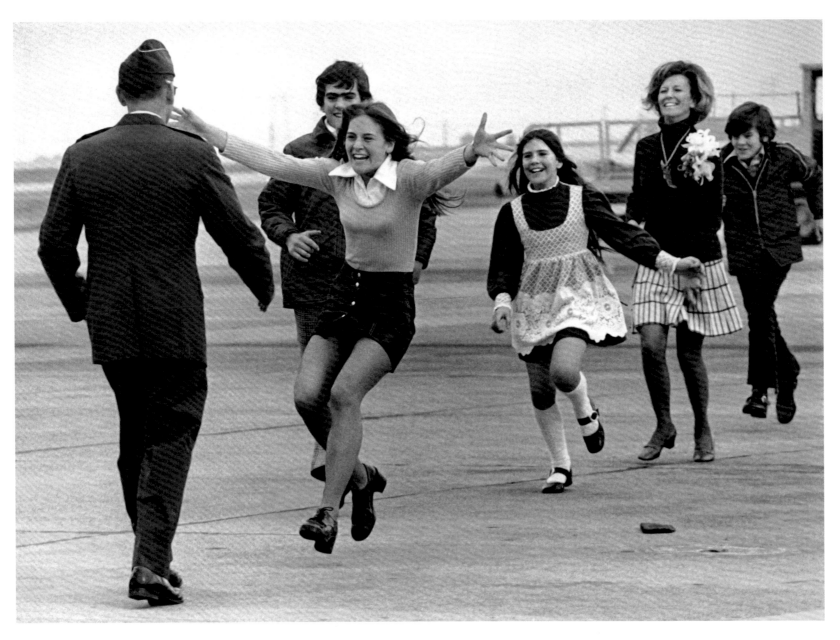

Lt. Col. Robert L. Stirm is greeted by his family at Travis Air Force Base in Fairfield, California, as he returns home from Vietnam after five and a half years as a prisoner of war, March 17, 1973.

In the lead is Stirm's daughter Lori, fifteen, followed by son Robert, fourteen; daughter Cynthia, eleven; wife, Loretta; and son Roger, twelve. Although the photo captured the nation's euphoria at the release of the POWs, the family's own story was not as happy. Stirm already knew that his wife was filing for divorce, and their marriage ended bitterly the following year.

This photograph by Sal Veder received the 1974 Pulitzer Prize for Feature Photography.

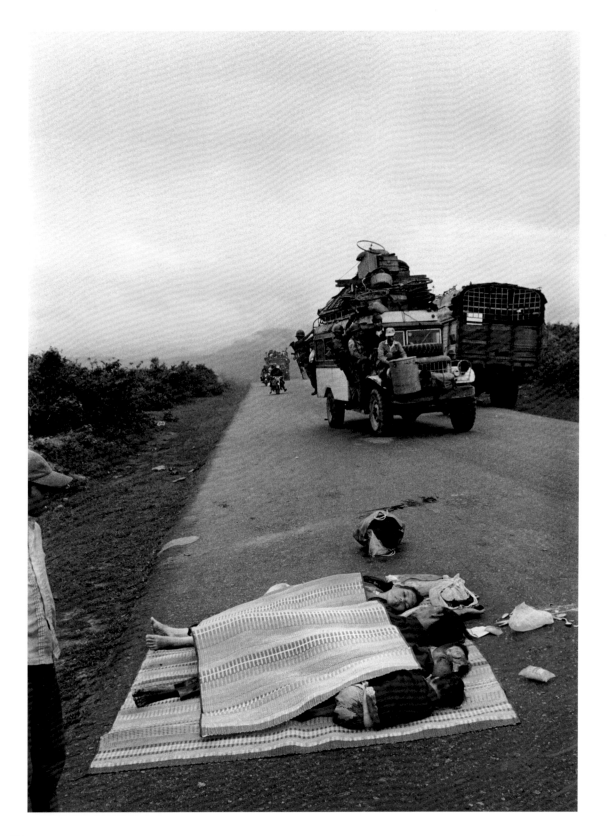

A Vietnamese family of four lie dead on the road at the Hai Van Pass, ten miles north of Da Nang, after they were killed in a traffic stampede as thousands of refugees from Hue and other northern points fled south, March 20, 1975.

Dozens of people were killed in such accidents during the exodus triggered by the South Vietnamese government's abandonment of the area.

Photograph by Tran Khiem.

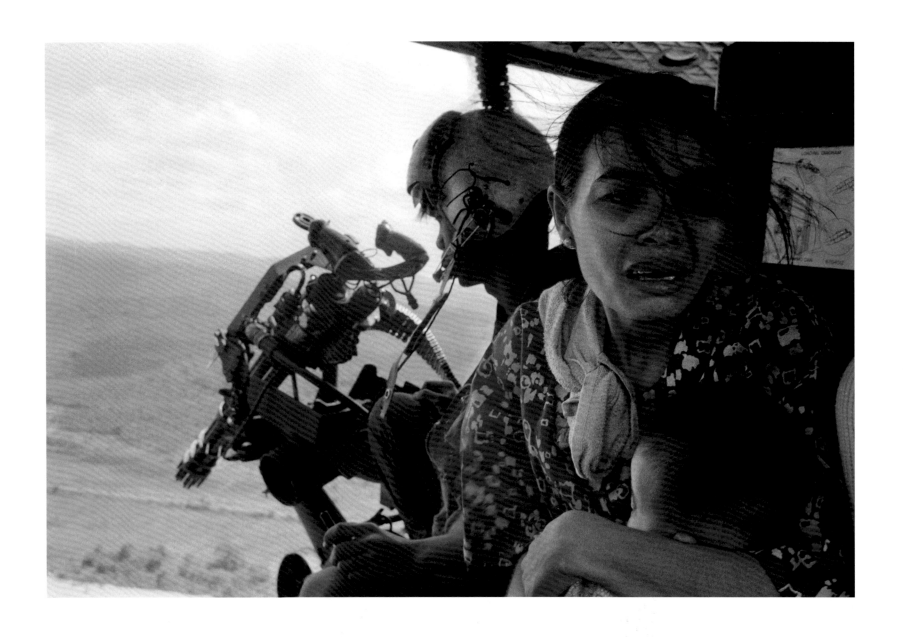

A refugee clutches her baby as a South Vietnamese government helicopter gunship carries them away near Tuy Hoa, 235 miles northeast of Saigon, March 1975.

Photograph by Nick Ut.

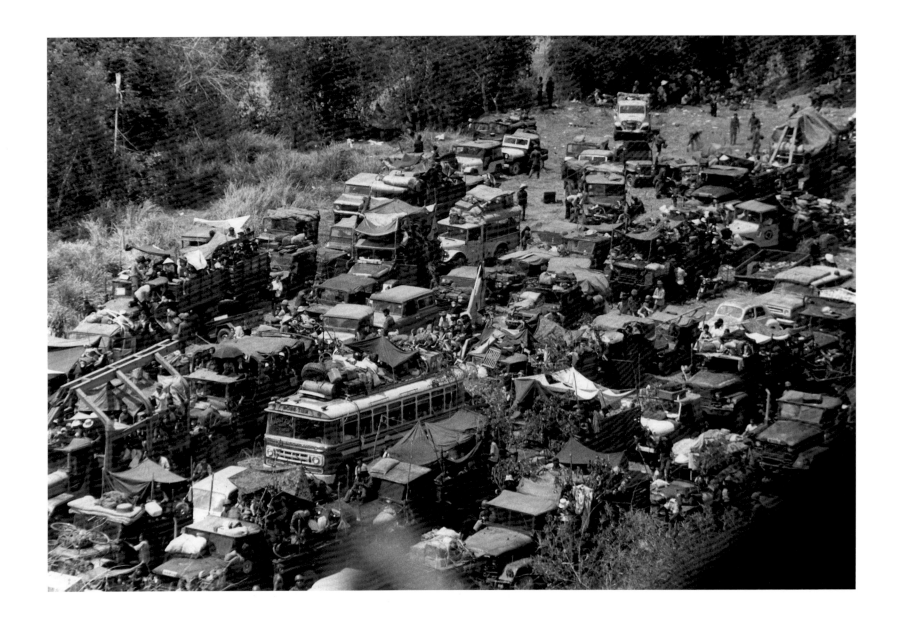

A chaotic jumble of buses, Jeeps, cars, and military trucks jam a heavily traveled road leading to the government-held central coast region of South Vietnam, late March 1975.

Thousands of civilians and soldiers were fleeing the northern and western provinces following an onslaught by North Vietnamese and Viet Cong forces.

Photograph by Nick Ut.

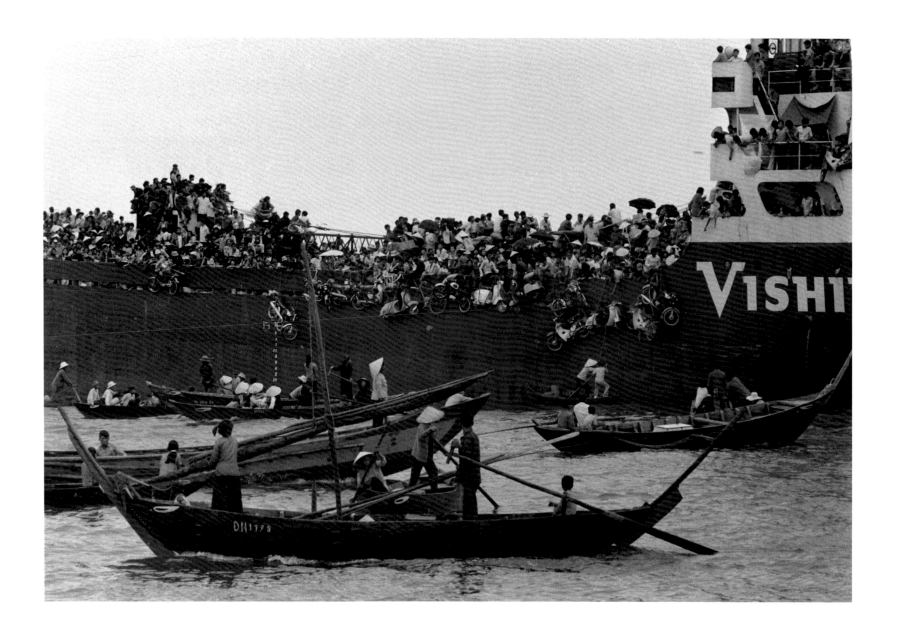

Valued motorbikes are hauled aboard a freighter packed with refugees as it leaves Da Nang, March 28, 1975, two days before the city's fall. A U.S.-financed sealift picked up civilians and deserting soldiers from boats in the harbor.

Photo by Tran Khiem.

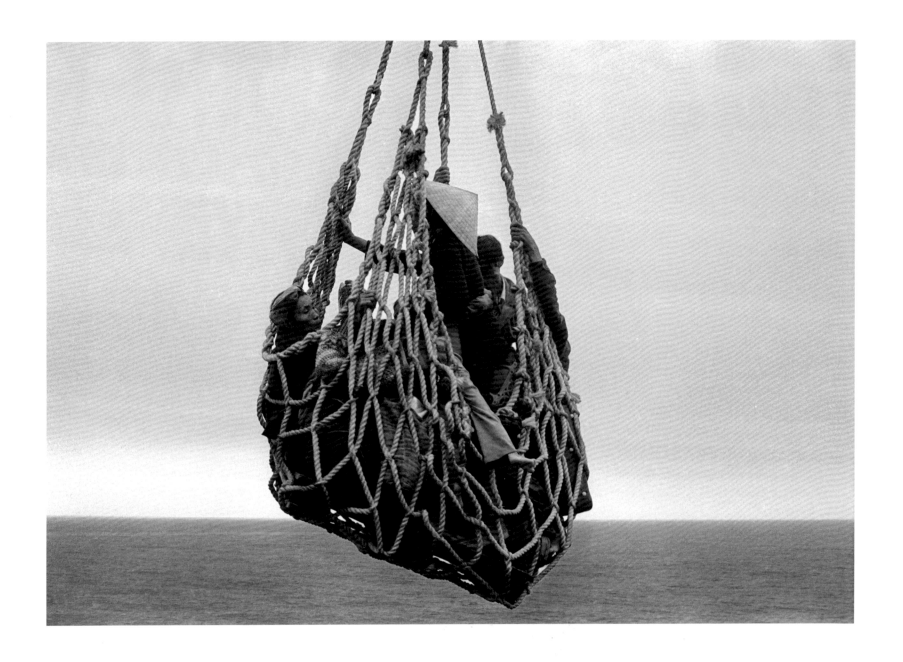

A cargo net lifts refugees from a barge onto the SS *Pioneer Contender* for evacuation from Da Nang, March 30, 1975.

It took eight hours for the freighter to load some six thousand people.

Photograph by Peter O'Loughlin.

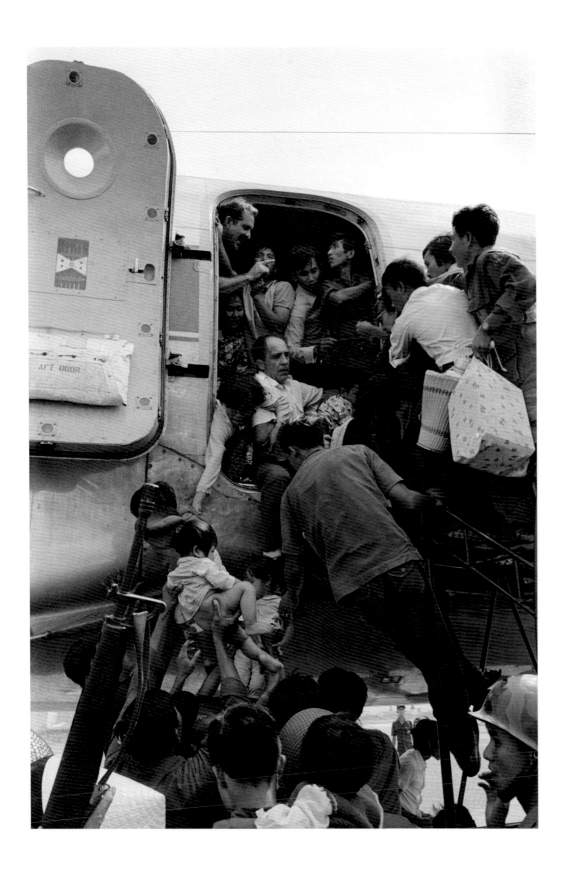

A U.S. civilian pilot in the aircraft
doorway tries to maintain order as
South Vietnamese civilians scramble
to get aboard during evacuatio
of the coastal town of Nha Trang,
April 1, 1975.

Thousands of civilians and soldiers
fought for space on any available
aircraft to Saigon following the fall of
Qui Nhon, farther to the north.

AP Images Archive

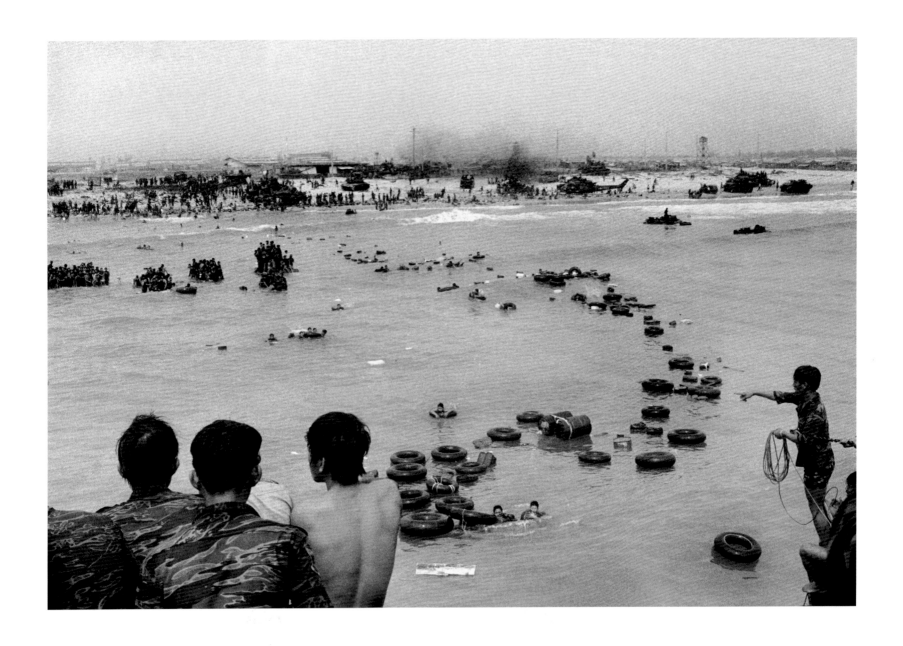

The view from an LST (Landing Ship, Tank) as six thousand South Vietnamese Marines evacuate the northern port city of Da Nang, March 29, 1975.

Some cling to inner tubes as they try to reach the amphibious vessel. On the beach are more Marines, along with the litter of abandoned armored personnel carriers, tanks, trucks, even a helicopter. In the far distance, smoke rises from Viet Cong rockets that slammed into the area, causing heavy casualties and creating panic among the men.

AP Images Archive

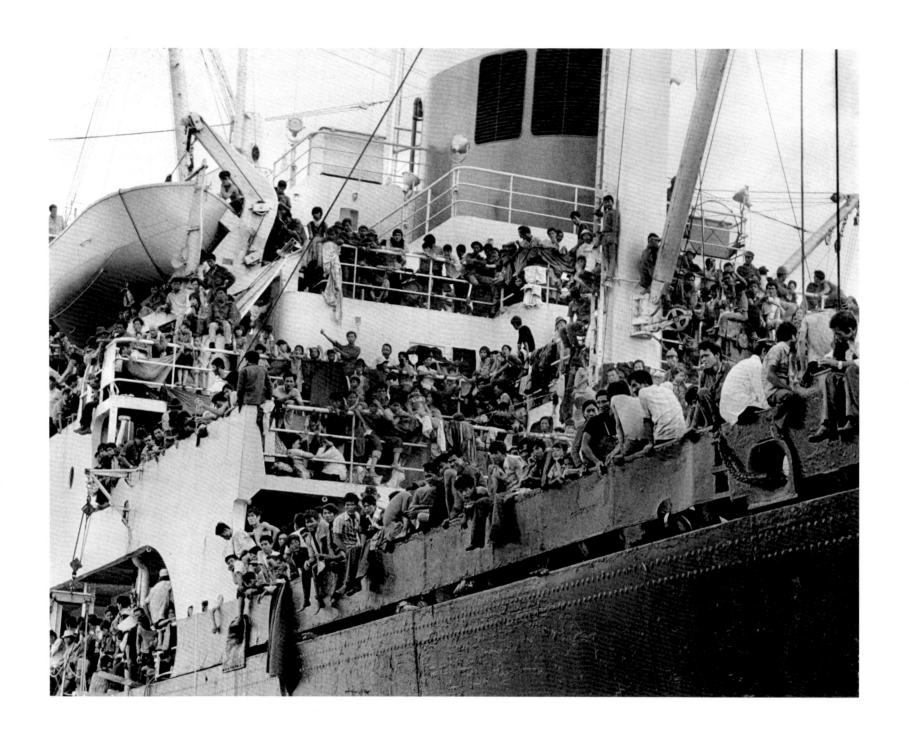

Vietnamese refugees crowd aboard the SS *Pioneer Contender* to be evacuated to areas farther south, April 1975.

Photograph by U.S. Navy.

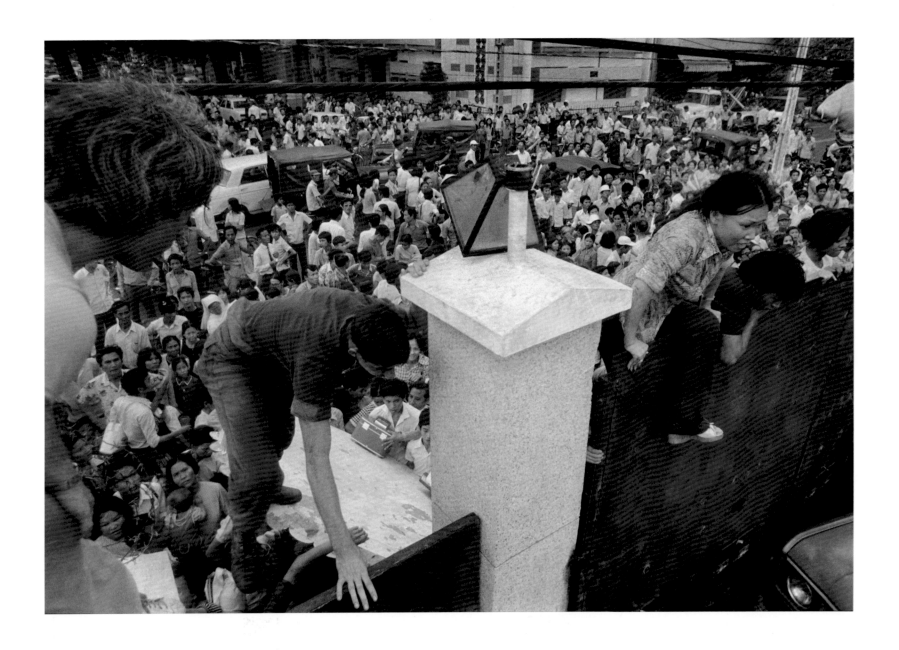

Desperate South Vietnamese scale the fourteen-foot wall of the U.S. Embassy in Saigon, trying to reach evacuation helicopters as the last Americans departed from Vietnam, April 29, 1975.

AP Images Archive

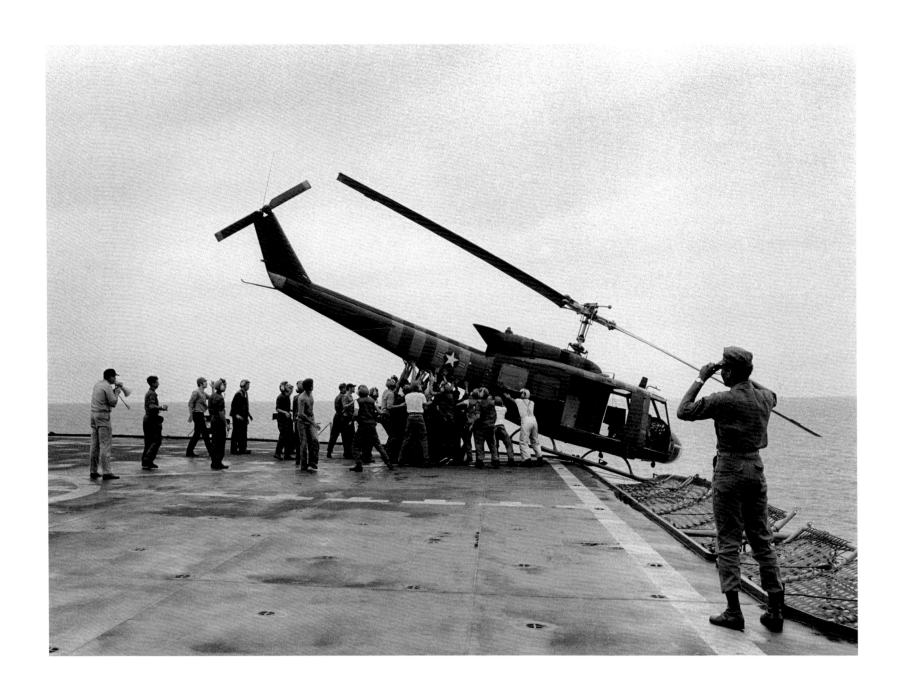

In the last, chaotic hours of the Vietnam War, U.S. Navy personnel aboard the USS *Blue Ridge* push a helicopter into the sea to make room on deck for more evacuation flights from Saigon, April 29, 1975.

AP Images Archive

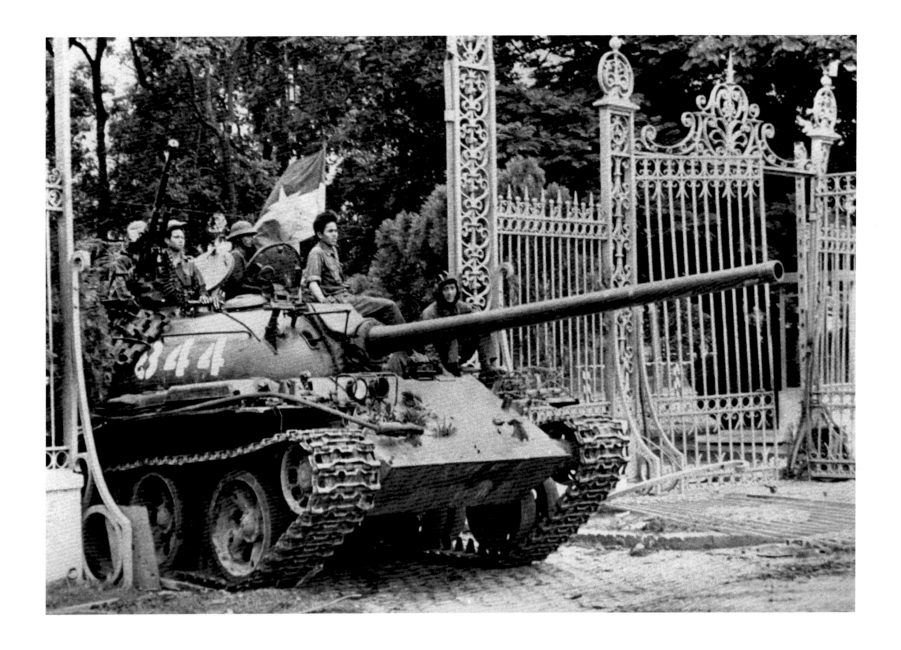

A tank filled with soldiers of the Provisional Revolutionary Government pushes through the gates of the presidential palace in Saigon following the surrender of the South Vietnamese government, May 1, 1975.

Photograph by Frances Starner.

South Vietnamese President Duong Van Minh walks out of Independence Palace one day after the surrender, May 1, 1975.

Minh, who held power for just two days, said he was handing over the government to the Communists to avoid further bloodshed. The new regime allowed him to remain free, and he lived in Vietnam until 1983, when he emigrated to France. He later moved to California, where he died in 2001. Minh was a general who had helped lead the coup against Diem back in 1963 and after that briefly led a junta that ran the country.

Photograph by Yves Billy.

297

`The Associated Press announces the reopening of its bureau in Vietnam after more than 18 years and thanks the Ministry of Foreign Affairs, and the Vietnam New Agency for their help and cooperation.

AND ALL OTHER GOVERMEN AGENC

We welcome any news announcements, news releases and invitations to new conferences and other events.

Our bureau is located at 18 Tran Hung Dao Street in Hanoi.

Telephone: 84-4-250732
 84-4-250733

Fax Number: 84-4-250786

George Esper, the bureau chief, can be reached after hours at 84-4-265540, Room 127.

Thanking you in advance for all your help.

 George Esper
 Bureau Chief

 Bruce Stanley
 Reporter

RECONCILIATION

On his first day in office in 1977, President Carter unconditionally pardoned tens of thousands of men who had evaded the Vietnam War draft, many of them by moving to Canada.

Following the fall of the South Vietnamese government, hundreds of thousands of refugees fled that country in overcrowded boats. The United States and other nations granted asylum to many of these "boat people."

In the decades after the war, new information came to light about the use of Agent Orange. After years of denial by the military, the U.S. General Accounting Office released a report indicating that thousands of troops had been exposed to the herbicide. And veterans began to cite Agent Orange as the cause of health problems ranging from skin rashes to cancer to birth defects in their children. Similar problems, including a high incidence of miscarriages and congenital malformations, were reported among the Vietnamese.

In 1984, a class-action lawsuit brought by American veterans against the major manufacturers was settled out of court for $180 million. A suit on behalf of millions of Vietnamese, however, was dismissed by a U.S. court in 2005 on grounds that supplying the defoliant did not amount to a war crime and that the Vietnamese plaintiffs had not established that Agent Orange had caused their health problems. Dow Chemical, which manufactured Agent Orange, continues to maintain on its website that "the very substantial body of human evidence on Agent Orange does not establish that veterans' illnesses are caused by Agent Orange."

In 1982, the Vietnam Veterans Memorial, designed by architecture student Maya Lin, opened in Washington. Its centerpiece consists of two black granite walls in the shape of a V, below ground level, listing (in chronological order) the names of all Americans killed in the war.

The United States restored diplomatic ties with Vietnam in 1995, and Douglas "Pete" Peterson, who had been a POW for more than six years, would later be named U.S. ambassador.

That same year, McNamara published a memoir, *In Retrospect*, in which he wrote: "We of the Kennedy and Johnson administrations who participated in the decisions about Vietnam acted according to what we thought were the principles and traditions of this nation. We made our decisions in light of those values. Yet we were wrong, terribly wrong."

< Eighteen years after he was forced to leave, George Esper returned to Vietnam to reopen an AP bureau—this time in Hanoi. In this draft of an October 1993 memo, he writes to news sources such as NGOs, embassies, and UN agencies letting them know AP is back in business. In addition to reporter Bruce Stanley, Esper's initial staff included Nick Ut as photographer. The re-establishment of an AP presence came amid improving relations between the United States and Vietnam, with the U.S. government easing its trade embargo and Vietnam relaxing press controls. The AP obtained a license from the Treasury Department to open the bureau and exchange news with the government-run Vietnam News Agency.

Geroge Esper Papers, AP Corporate Archives

ACKNOWLEDGMENTS

This book was conceived by Tom Curley when he was president and CEO of The Associated Press. Tom wanted to ensure there was a public record of AP's unparalleled coverage of the Vietnam War. Upon his retirement in 2012, I embraced the project wholeheartedly.

The impact that AP coverage had on the course of the war in Vietnam cannot be overstated. I hope this book will go a long way toward helping current and future generations understand the complexities and the long-term impact of that war.

Gary Pruitt, President and CEO

The Associated Press

With thanks to the following for their work on *Vietnam: The Real War*

Pete Hamill	Santos Chaparro
Mike Silverman	Duong Duc Dung
Charles Zoeller	Hélène Gédouin
Valerie Komor	Steven Kasher
Eric Himmel	Dang Van Phuoc
Paul Colford	Richard Pyle
Ellen Hale	Francesca Pitaro
Alyssa Adams	Laurent Rebours
Peter Arnett	Richard Slovak
John Gall	Seymour Topping
Anet Sirna-Bruder	Nick Ut
David Blatty	Staff of the AP Images photo
Chris Brummitt	libraries in New York and
Hal Buell	London

All photos from the AP Images photo collection, unless otherwise indicated. Photos of AP staffers are courtesy Alyssa Adams, the collection of Horst Faas, Richard Pyle, AP Corporate Archives, and AP Images.

INDEX

Designer: John Gall
Production Manager: Anet Sirna-Bruder

Library of Congress Control Number: 2013009614

ISBN: 978-1-4197-0864-0

Text copyright © 2013 Mike Silverman
Photographs copyright © 2013 The Associated Press

Printed and bound in China
10 9 8 7 6 5 4 3 2 1

Abrams books are available at special discounts when purchased in quantity for
premiums and promotions as well as fundraising or educational use. Special editions can
also be created to specification. For details, contact specialsales@abramsbooks.com or
the address below.

ABRAMS
THE ART OF BOOKS SINCE 1949

115 West 18th Street
New York, NY 10011
www.abramsbooks.com

LONGWOOD PUBLIC LIBRARY
800 Middle Country Road
Middle Island, NY 11953
(631) 924-6400
longwoodlibrary.org

LIBRARY HOURS

Monday-Friday	9:30 a.m. - 9:00 p.m.
Saturday	9:30 a.m. - 5:00 p.m.
Sunday (Sept-June)	1:00 p.m. - 5:00 p.m.